Anchor Hocking
1940-Prese

Philip Hopper

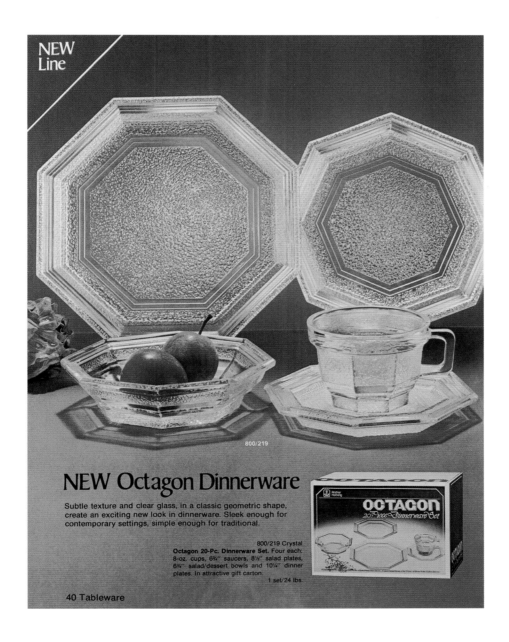

Schiffer Publishing Ltd ®

4880 Lower Valley Road, Atglen, PA 19310 USA

Dedication

My wife and I always look forward to our trips to the Lancaster/Logan, Ohio, area. The Hocking Valley is simply gorgeous, there are plenty of antique shops to visit, and the area has some of the friendliest people I have ever met.

Visiting the Logan Antique Mall has always been one of the highlights of our trip. What is more uplifting than a smile? This is exactly what you get when you go to the Logan Antique Mall in Logan, Ohio. No matter how gloomy the day, you are always greeted with a smile when you enter the door.

Katie Spriggs, Mike LeMay, and Joyce Fox are always there to help, always willing to stop work and listen to one of my long-winded stories, and always have the unique, positive, can-do attitude. I forget about the weather, taxes, monthly bills, the price of gasoline, and a host of other world problems once I pass through the door to the mall. It is amazing what a smile can do and I thank God each day for people like those at the Logan Antique Mall. I think the world would certainly be a much better place if we could only learn how to clone Katie, Mike, or Joyce!

Copyright © 2003 by Philip Hopper
Library of Congress Control Number: 2003106778

Designed by Ellen J. (Sue) Taltoan
Type set in Americana XBd BT/Humanist 521 BT

ISBN: 0-7643-1915-9
Printed in China
1 2 3 4

Published by Schiffer Publishing Ltd.
4880 Lower Valley Road
Atglen, PA 19310
Phone: (610) 593-1777; Fax: (610) 593-2002
E-mail: Info@schifferbooks.com
Please visit our web site catalog at **www.schifferbooks.com**
We are always looking for people to write books on new and related subjects. If you have an idea for a book please contact us at the above address.

This book may be purchased from the publisher.
Include $3.95 for shipping.
Please try your bookstore first.
You may write for a free catalog.

In Europe, Schiffer books are distributed by
Bushwood Books
6 Marksbury Ave.
Kew Gardens
Surrey TW9 4JF England
Phone: 44 (0)20-8392-8585
Fax: 44 (0)20-8392-9876
E-mail: Bushwd@aol.com
Free postage in the UK. Europe: air mail at cost

Contents

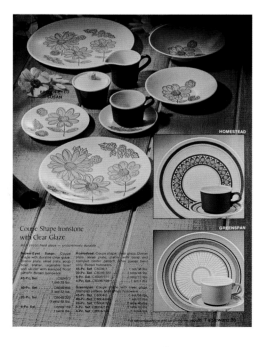

Foreword

I had a difficult time trying to decide how to organize this book to make it "user friendly." The items are not listed by the time period when they were manufactured (i.e., during the Fire King years, depression, etc.). Instead, items are grouped into basic categories (i.e., ashtrays, punch sets, etc.). With a few exceptions, all the illustrations are pages taken directly from the Anchor Hocking catalogs (1940 to the present). I have over 2,500 pages of catalogs, advertising proofs, blueprints, and other memorabilia. I selected the best page that displayed the majority of any specific pattern. There may be other pieces in any particular pattern, as the company did not always include every item in the catalogs or in any one year.

Certain items (i.e., mugs) were not included in the book since they are so common and easy to identify. I tried to pick items that collectors would not identify as Anchor Hocking. Several of the patterns given names by collectors (i.e., Diamond Line, Criss-Cross, High Point, etc.) were listed to show that the company never did attach a name to some of the earlier patterns.

Introduction

Pricing

The prices in the book are only a guide. They are retail prices for mint condition glassware. Several factors will have an effect of glassware prices: regional availability, depth and consistency in coloring, the presence or absence of Anchor Hocking markings in the glass or as paper labels, and relative rarity of the piece. Certain items will command higher prices if they are sets in the original packaging. I would also consider labeled pieces (paper or marks embedded in the glass) to command a ten to twenty percent increase in price over unmarked pieces. Prices will drop considerably for glassware that is chipped, scratched, cracked, or deformed. No matter what any reference book states, the bottom line is ...

Glassware is only worth what someone is willing to pay for it!

Resources Available to Collectors

Collectors today have a great variety of resources available. With the advent of the "electronic age", collecting capabilities have been greatly expanded. I can honestly state this book would not have been possible without using the vast resources available, especially on the internet. Below I have listed the resources collectors can use for locating antiques and glassware, however, realize this list is not all-inclusive.

Internet Resources

Without leaving the comfort of your home or office, you can search worldwide for items to add to your collection. Presently, there are both antique dealers and auctions services on the internet.

eBay Auction Service: The eBay Auction Service provides a continually changing source of items. This internet service contains over 3,000,000 items in 371 categories. Internet users can register as both buyers and/or sellers. The majority of the items remain on the "auction block" for seven days. You can search the auction database for specific items. A list of items will be presented following the search. For example, you might want to find a Fire King Jadeite vase made by Anchor Hocking. Because the seller enters the item's description in the database, you often have to anticipate how the item is described. Don't limit the searches. In this case, you might have to search under Jadeite, hocking, fireking (no space), fire king (with the space), or vase to find the item you want.

Internet Antique Malls: There are several internet antique malls I have found to be extremely useful in locating glassware. Each mall contains numerous individual dealers with items for sale. The malls I used are listed below:

1. TIAS Mall – (http://www.tias.com/)
2. Collector Online Mall – (http://www.collectoronline.com/)
3. Facets Mall – (http://www.facets.net/facets/shopindx.htm)
4. Depression Era Glass and China Megashow – (http://www.glassshow.com/)
5. Cyberattic Antiques and Collectibles – (http://cyberattic.com/)

Glass shows, antique shops, and flea markets:

All collectors still enjoy searching the deep dark crevices of the local antique shops and flea markets. Many of the best "finds" in my personal collection were located in flea markets and "junk" shops. Most of the dealers in glass shows have a good working knowledge of glassware, so "real finds" are not too plentiful.

Periodicals:

Both the *Depression Glass Magazine* and *The Daze, Inc.* are periodicals which will greatly enhance your collecting abilities. Along with the numerous advertisements for glassware, there are informative articles on all facets of collecting glassware.

Word of Mouth:

This is one resource so often overlooked. Let others know what you are looking for. Consider expanding you search by including friends, relatives, and other collectors. This book could not have been written without the help of many fellow collectors.

Do not limit you collecting to only one resource. Remember the items you seek are out there ... somewhere!

Request for Additional Information

I am always seeking information concerning Anchor Hocking's glassware production. Much of the information about the company is not available in a printed format. This book will undoubtedly be updated and it is imperative new information be made available to collectors. If you have any information you would like to share with the "collector world," please contact me at the following address:

Philip L. Hopper
6126 Bear Branch Drive
San Antonio, Texas 78222-3440
E-mail: rrglass@satx.rr.com

Please be patient if you need a response. I will make every effort to provide prompt feedback on you inquiries. Include a self-addressed, stamped envelope if you desire a written response.

History of Anchor Hocking

Common stock certificate for the Anchor Cap Corporation.

Common stock certificate for the Anchor Cap Corporation.

Common stock certificate for the Anchor Hocking Glass Corporation.

Anchor Hocking first came into existence when Isaac J. Collins and six friends raised $8,000 to buy the Lancaster Carbon Company, Lancaster, Ohio, when it went into receivership in 1905. The company's facility was known as the Black Cat from all the carbon dust. Mr. Collins, a native of Salisbury, Maryland, had been working in the decorating department of the Ohio Flint Glass Company when this opportunity arose. Unfortunately the $8,000 that was raised was not sufficient to purchase and operate the new company, so Mr. Collins enlisted the help of Mr. E. B. Good. With a check for $17,000 provided by Mr. Good, one building, two day-tanks, and fifty employees, Mr. Collins was able to begin operations at the Hocking Glass Company.

The company, named for the Hocking River near which the plant was located, made and sold approximately $20,000 worth of glassware in the first year. Production was expanded with the purchase of another day-tank. This project was funded by selling $5,000 in stock to Thomas Fulton, who was to become the Secretary-Treasurer.

Just when everything seemed to be going well, tragedy struck the company in 1924 when the Black Cat was reduced to ashes by a tremendous fire. Mr. Collins and his associates were not discouraged. They managed to raise the funding to build what is known as Plant 1 on top of the ashes of the Black Cat. This facility was specifically designed for the production of glassware. Later in that same year, the company also purchased controlling interest in the Lancaster Glass Company (later called Plant 2) and the Standard Glass Manufacturing Company with plants in Bremen and Canal Winchester, Ohio.

The development of a revolutionary machine that pressed glass automatically would save the company when the Great Depression hit. The new machine raised production rates from one item per minute to over thirty items per minute. When the 1929 stock market crash hit, the company responded by developing a fifteen-mold machine that could produce ninety pieces of blown glass per minute. This allowed the company to sell tumblers "two for a nickel" and survive the depression when so many other companies vanished.

Hocking Glass Company entered the glass container business in 1931 with the purchase of fifty percent of the General Glass Company, which in turn acquired Turner Glass Company of Winchester, Indiana. In 1934, Anchor Hocking Glass and its subsidiary developed the first one-way beer bottle.

Anchor Hocking Glass Corporation came into existence on December 31, 1937, when the Anchor Cap and Closure Corporation and its subsidiaries merged with the Hocking Glass Company. The Anchor Cap and Closure Corporation had closure plants in Long Island City, New York, and Toronto, Canada, and glass container plants in Salem, New Jersey, and Connellsville, Pennsylvania.

Anchor Hocking Glass Corporation continued to expand into other areas of production such as tableware, closure and sealing machinery, and toiletries and cosmetic containers through the expansion of existing facilities and the purchase of Baltimore, Maryland, based Carr-Lowry Glass Company and the west coast Maywood Glass. In the 1950s, the corporation established the Research and Development Center in Lancaster, Ohio, purchased the Tropical Glass and Container Company in Jacksonville, Florida, and built a new facility in San Leandro, California, in 1959.

In 1962, the company built a new glass container plant in Houston, Texas, while also adding a second unit to the Research and Development Center, known as the General Development Laboratory. In 1963 Zanesville Mold Company in Ohio became an Anchor Hocking Corporation subsidiary. The company designed and manufactured mold equipment for Anchor Hocking.

The word "Glass" was dropped from the company's name in 1969 because the company had evolved into an international company with an infinite product list. They had entered the plastic market in 1968 with the acquisition of Plastics Incorporated in St. Paul, Minnesota. They continued to expand their presence in the plastic container market with the construction of a plant in Springdale, Ohio. This plant was designed to produce blown mold plastic containers. Anchor Hocking Corporation entered the lighting field in September 1970 with the purchase of Phoenix Glass Company in Monaca, Pennsylvania. They also bought the Taylor, Smith & Taylor Company, located in Chester, West Virginia, to make earthenware, fine stoneware, institutional china dinnerware, and commemorative collector plates.

Over the years, several changes occurred in the company. Phoenix Glass Company was destroyed by fire on 15 July 1978, Shenango China (New Castle, Pennsylvania) was purchased in 28 March 1979, Taylor, Smith & Taylor was sold on 30 September 1981, and on 1 April 1983 the company decided to divest its interest in the Glass Container Division to an affiliate of the Wesray Corporation. The Glass Container Division was to be known as the Anchor Glass Container Corporation with seven manufacturing plants and its office in Lancaster, Ohio.

The Newell Corporation acquired the Anchor Hocking Corporation on 2 July 1987. With this renewed influx of capital, several facilities were upgraded and some less profitable facilities were either closed or sold. The Clarksburg, West Virginia, facility was closed in November 1987, Shenango China was sold on 22 January 1988, and Carr-Lowry Glass was sold on 12 October 1989. Today, Anchor Hocking enjoys the financial backing and resources as one of the eighteen decentralized Newell companies that manufacture and market products in four basic markets: house wares, hardware, home furnishings, and office products. You may recognize such familiar Newell companies such as Intercraft, Levolor Home Fashions, Anchor Hocking Glass, Goody Products, Anchor Hocking Specialty Glass, Sanford, Stuart Hall, Newell Home Furnishings, Amerock, BerzOmatic, or Lee/Rowan.

Earlier in 2001, Newell Corporation entered into negotiations with Libbey Glass for the purchase and transfer of Anchor Hocking Glass Corporation. After months of negotiations, Libbey Glass withdrew their offer in the midst of serious objections by the federal government. It looks like Anchor Hocking will celebrate its 100th anniversary in 2005 after all!

Identification Marks

Over the years Anchor Hocking has used several identification marks on their glassware. In 1980, the company issued a limited edition 75th anniversary ashtray, pictured below, which portrays the corporate identification marks. During the photographing, the marks on the ashtray were blackened with a magic marker so they would show up clearly. Originally, when the Hocking Glass Company was established in 1905, the company used the mark seen on the left side of the ashtray. This mark was used from 1905 until 1937, when it was replaced by the more familiar anchor over H mark (center of ashtray) to illustrate the merger of the Hocking Glass Company and the Anchor Cap Company. Finally, in October 1977, the company adopted a new symbol (right side of the ashtray), an anchor with a modern, contemporary appearance to further the new corporate identity.

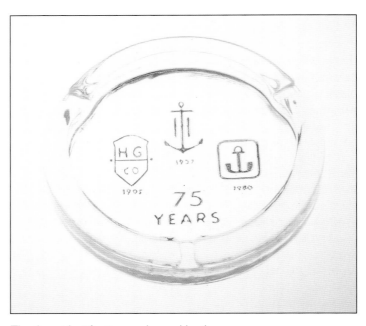

The three identification marks used by the company.

The 75th anniversary ashtray in the original box, $50-55.

The mark of the Hazel Atlas Glass Company is often confused as being a mark for Anchor Hocking Glass Company. If this were the mark for Anchor Hocking, the letters would be reversed with the capital "A" over the lower case "h".

Catalog Identification

Anchor Hocking used a series of numbers and letters to denote glassware identification in the catalogs. Starting with a basic design number, the company placed a letter (prefix) in front of the number to denote the color and cut or glass type selection. The following is a listing of the letter designations generally used throughout the catalogs:

No prefix - Crystal
E - Forest Green
F - Laser Blue
H - Crystal Fire King
J - Cut Glass
L - Luster Shell
N - Honey Gold
R - Royal Ruby
T - Avocado
Y - Spicy Brown
W - White

For pitchers and glasses, each item of a particular pattern was given its own designation to indicate the capacity. Below are the common capacity designations:

63 - 6 oz. fruit juice
65 - 11 oz. tumbler
69 - 15 oz. iced tea
92 - 19 oz. large iced tea
93 - 22 oz. giant iced tea
3375 - 32 oz. giant sized ice tea
86 - 86 oz. capacity of pitcher

The patterns were also given specific designations. Below is a listing of some common Forest Green pattern designations:

325 - Colonial Lady
351 - Leaf Design
352 - Polka Dots
5612 - Spinning Wheel and Churn
5613 - Wild Geese
5614 - Floral and Diamond
5615 - Gazelle
5705 - Gold and White Vintage
5807 - White Lace

Putting this all together, the #E92/5612 would indicate a Forest Green tumbler (E), 19 oz. large iced tea (92), in the Spinning Wheel and Churn pattern (5612).

What Is Glass?

Most people were taught that there are three states of matter in the universe: solids, liquids, and gasses. So, how would you classify glass? People, who have hit a car window during an automobile accident or leaned on a glass counter in a department store would say that glass is a solid. Well, that is not the case. A solid, by definition, is any material that retains its shape without being contained. Glass is constantly flowing and does not retain it shape. Now the process is extremely slow. Glass is termed a super cooled liquid because it is solid and molecular motion only ceases when glass is at -459.69 degrees Fahrenheit (absolute zero). At this temperature, which has never been achieved, glass would become a solid. If a substance was a solid, it should have a melting point. There are no melting points listed for glass since it is always a liquid except at absolute zero. When companies process glass, they are not melting the glass; they are only making it more fluid. The hotter the glass gets, the more fluid it becomes.

Have you ever noticed that old glass windows tend to rattle as they get older? They also are wavy in appearance. How does this happen and why are the lines in a window always horizontal? First, since glass is a super cooled liquid that is always in motion, it is being constantly pulled downward by gravity. The process is very, very slow. Over a number of years, the glass begins to form irregular wavy lines on the surface. The top of a pane of glass is becoming thinner and the bottom becoming thicker. Eventually, the glass at the top of the windowpane becomes so thin that it is loose in the frame. Any loud noise, gust of wind or strong movement within the building will cause the top of the windowpane to move and rattle.

Now consider what happens when someone hits a baseball through that old window. After the ball has shattered the windowpane, the top pieces fall out easily. But the bottom pieces remain firmly affixed in the window frame. Over the years, as gravity pulled the glass downward, the thickness of the windowpane was increasing at the bottom edge. This wedged the glass between the putty and window frame. Even with the ball rocketing through the window, the lower portion of the window remained firmly in place while the top pieces fell out of the frame. Even in the horror movies you see people injured by the glass falling out of the top of the frame while the bottom pieces remain firmly in place. They are not using old windows, they just happen to be recreating what would really happen when an old window is broken.

Fire King Glass Versus Regular Glass

Confusion exists over the differences between Fire King and regular soda lime glass. Fire King is not a brand name for glass, it is a type of glass. Fire King is borosilicate glass made by melting a combination of sand with sodium borate. This glass melts at a temperature about 200 degrees Fahrenheit higher than regular soda lime glass. Borosilicate glass is noted for its very low expansion coefficient. It can be used in ovens for cooking, but not on the stove. During the making of Fire King glass, the furnace emits boron compounds that are environmentally "unfriendly" and corrosive to the

brick lining in the glass furnaces. For these reasons, Fire King glass is reasonably expensive to produce.

What we know as "regular" glass is a melted mixture of sand, soda ash (anhydrous sodium carbonate), and limestone (calcium carbonate). It has an expansion rate three times that of borosilicate glass. When heated unevenly (i.e., on a stove), the heated portions near the hot stove elements will expand at three times the rate of the unheated portions. This will cause internal stress points to form in the glass. If the stress becomes sufficient, cracking will occur.

Purple Glass

I'm sure every collector has heard the story of the set of glassware that turned purple because it sat in "Aunt Hilda's" front window for years. While this story has a lot of appeal, it is not based on fact.

Sand used in glassmaking contains small amounts of iron. The iron causes glass to take on a color ranging from green to blue. In early glassmaking, companies tried to produce cheap clear glass. Manganese was added to the glass batch to counteract the unwanted aqua hue caused by iron present in the sand. In glass having a "high" manganese content, a chemical reaction can take place. If this glass is exposed to ultraviolet light, the colorless substance magically turns purple. The intensity of the color is dependent upon the manganese content of the individual glass and the intensity of the ultraviolet light the glass was exposed to.

Another part of the equation is the property of ultraviolet light. Have you ever received a sunburn sitting in front of a closed glass window or sitting in a car with all the windows up? The answer is "No." Ultraviolet light will not pass through glass. That is why solariums are constructed ... so you can get the benefits of direct sunlight without exposure to the potentially harmful ultraviolet light. What does this all mean?

Because ultraviolet light will not pass through glass (i.e., your house windows), "Aunt Hilda's" glassware sitting in the window or on the dining room table could not turn purple. The glass would have to be taken outside or artificially "purpled" with a high intensity ultraviolet light. This is a trick bottle collectors have used for years. You can build racks and line the bottles up in direct sunlight for months or buy a high intensity ultraviolet light and drastically shorten the process.

The story about "Aunt Hilda's" glass turning purple sounds great, but it is not based on any physical or chemical process!

Anchor Hocking Glass Museum

Since I started collecting Anchor Hocking glass, I have always heard and read about the infamous "morgue." The "morgue" is located at Anchor Hocking's Lancaster, Ohio, plant. The "morgue" contains examples of glass production spanning many years. I have toured the area on more than one occasion and found it to be very interesting. Access to the "morgue" is severely limited because the area is located in the middle of the production facility. Most of the glass in the "morgue" is later production and generally only covers production at the Lancaster, Ohio, plant. The glass is displayed on large roller shelves. The glass is crowded, unlabelled, not well organized, and very difficult to observe because the roller shelves can only be separated by about three to four feet. I did not see examples of Anchor Hocking's bottle production, but there are limited examples of glass produced in other divisions of the company. Overall, it was an interesting piece of Anchor Hocking history to see and an exciting experience.

I think it is important for everyone to actually see the glass that Anchor Hocking produced, so I built a facility to display my collection of over 9,000 pieces of Anchor Hocking glass. All the glass pictured in my books will be on display in the museum. There will also be some extremely rare pieces of Anchor Hocking glass on display that will be featured in upcoming books. The museum will not have regular hours of operation so the collection can only be viewed by calling the museum on a phone number that is published on the museum website. I designed, built, and totally financed the facility over the last forty-eight months. The museum was officially opened on October 1, 2002. We are already planning a second facility to display an extensive collection of boxed sets, company catalogs, blueprints, and advertising proofs. The next time you are in San Antonio to visit the famous Alamo and Riverwalk, be sure to stop in and see the Anchor Hocking Glass Museum. Information about the museum may be found at http://www.anchorhockingmuseum.com.

Catalog Pricing Scheme

The original Anchor Hocking catalogs usually had grouped pictures with up to twenty pieces of glass in any one picture. To simplify matters, each individual piece of glass in the photograph was identified with either a number (i.e., 1, 2, etc.) or letter(s) (i.e., A, B, CC, etc.). The numbers or letters in the photograph were used to determine where the items were on the price list. In the price lists developed for the book, there will be either a letter or number in parenthesis behind the item number or description. This number or letter in parenthesis refers to the letter beside the item in the photograph in the catalog.

Chapter One
Established Patterns

AMANDA

Amanda Listed in the 1982 New Products Catalog

Cat. Item No.	Price
4100/226	$20-30 per set
4100/228	$15-20 per set
4100/227	$15-20 per set
4100/224	$25-40 per set
4100/225	$15-25 per set
4100/230	$3-5 each piece
4100/231	$5-10 each piece
4100/220	$1-2 each piece
4100/218	$1-2 each piece
4100/217	$1-2 each piece
4100/219	$1-2 each piece
4100/221	$1-2 each piece
4100/222	$2-4 each piece
4100/223	$4-5 each piece

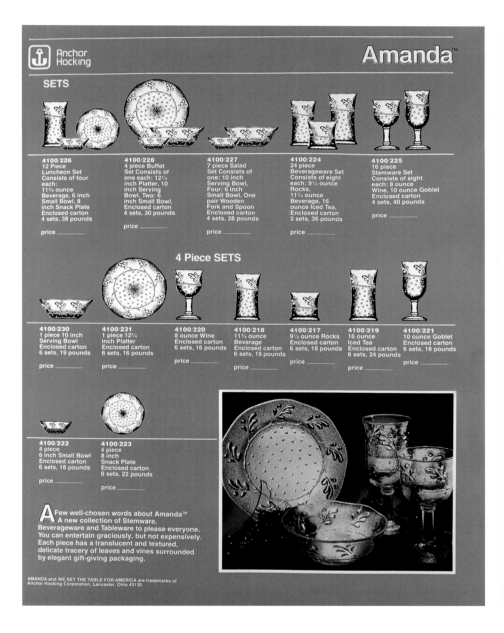

Anchor Hocking Amanda™

SETS

4100/226
12 Piece Luncheon Set Consists of four each: 11¾ ounce Beverage, 6 inch Small Bowl, 8 inch Snack Plate Enclosed carton 4 sets, 38 pounds

price _____

4100/228
4 piece Buffet Set Consists of one each: 12¼ inch Platter, 10 inch Serving Bowl, Two: 6 inch Small Bowl, Enclosed carton 4 sets, 30 pounds

price _____

4100/227
7 piece Salad Set Consists of one: 10 inch Serving Bowl, Four: 6 inch Small Bowl, One pair Wooden Fork and Spoon Enclosed carton 4 sets, 28 pounds

price _____

4100/224
24 piece Beverageware Set Consists of eight each: 9½ ounce Rocks, 11¾ ounce Beverage, 16 ounce Iced Tea, Enclosed carton 2 sets, 36 pounds

price _____

4100/225
16 piece Stemware Set Consists of eight each: 8 ounce Wine, 10 ounce Goblet Enclosed carton 4 sets, 40 pounds

price _____

4 Piece SETS

4100/230
1 piece 10 inch Serving Bowl Enclosed carton 6 sets, 19 pounds

price _____

4100/231
1 piece 12¼ inch Platter Enclosed carton 6 sets, 16 pounds

price _____

4100/220
8 ounce Wine Enclosed carton 6 sets, 16 pounds

price _____

4100/218
11¾ ounce Beverage Enclosed carton 6 sets, 19 pounds

price _____

4100/217
9½ ounce Rocks Enclosed carton 6 sets, 18 pounds

price _____

4100/219
16 ounce Iced Tea Enclosed carton 6 sets, 24 pounds

price _____

4100/221
10 ounce Goblet Enclosed carton 6 sets, 18 pounds

price _____

4100/222
4 piece 6 inch Small Bowl Enclosed carton 6 sets, 18 pounds

price _____

4100/223
4 piece 8 inch Snack Plate Enclosed carton 6 sets, 22 pounds

price _____

A Few well-chosen words about Amanda™ A new collection of Stemware, Beverageware and Tableware to please everyone. You can entertain graciously, but not expensively. Each piece has a translucent and textured, delicate tracery of leaves and vines surrounded by elegant gift-giving packaging.

AMANDA and WE SET THE TABLE FOR AMERICA are trademarks of Anchor Hocking Corporation, Lancaster, Ohio 43130.

ANCHOR HOCKING COOKWARE

Cookware Listed in the 1956 Catalog

Cat. Item No.	Price
D2006/32	$10-15
D2007/32	$10-15
D2008/32	$12-15
D2009/32	$12-15
D2010/32	$15-20
D2011/56	$6-8
2000	$8-10
2026	$3-5
2027	$3-5
2028	$3-5
2029	$3-5
2030	$3-5
D2000/101	$30-40
D2000/102	$40-50

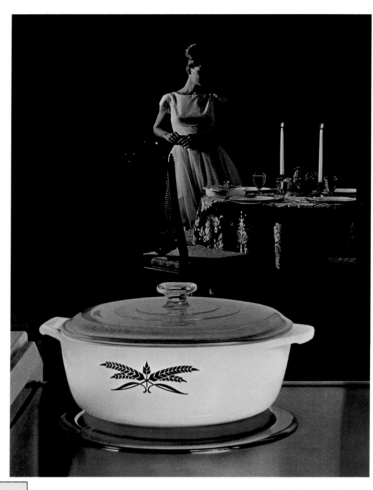

Anchor Hocking cookware.

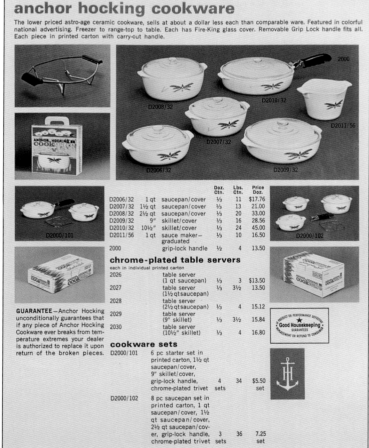

anchor hocking cookware

The lower priced astro-age ceramic cookware, sells at about a dollar less each than comparable ware. Featured in colorful national advertising. Freezer to range-top to table. Each has Fire-King glass cover. Removable Grip Lock handle fits all. Each piece in printed carton with carry-out handle.

			Doz. Ctn.	Lbs. Ctn.	Price Doz.
D2006/32	1 qt	saucepan/cover	1/3	11	$17.76
D2007/32	1½ qt	saucepan/cover	1/3	13	21.00
D2008/32	2½ qt	saucepan/cover	1/3	20	33.00
D2009/32	9"	skillet/cover	1/3	16	28.56
D2010/32	10½"	skillet/cover	1/3	24	45.00
D2011/56	1 qt	sauce maker—graduated	1/3	10	16.50
2000		grip-lock handle	½	4	13.50

chrome-plated table servers
each in individual printed carton

2026	table server (1 qt saucepan)	1/3	3	$13.50
2027	table server (1½ qt saucepan)	1/3	3½	13.50
2028	table server (2½ qt saucepan)	1/3	4	15.12
2029	table server (9" skillet)	1/3	3½	15.84
2030	table server (10½" skillet)	1/3	4	16.80

GUARANTEE—Anchor Hocking unconditionally guarantees that if any piece of Anchor Hocking Cookware ever breaks from temperature extremes your dealer is authorized to replace it upon return of the broken pieces.

cookware sets

D2000/101	6 pc starter set in printed carton, 1½ qt saucepan/cover, 9" skillet/cover, grip-lock handle, chrome-plated trivet	4 sets	34	$5.50 set
D2000/102	8 pc saucepan set in printed carton, 1 qt saucepan/cover, 1½ qt saucepan/cover, 2½ qt saucepan/cover, grip-lock handle, chrome-plated trivet	3 sets	36	7.25 set

Good Housekeeping GUARANTEE

ANGELICA

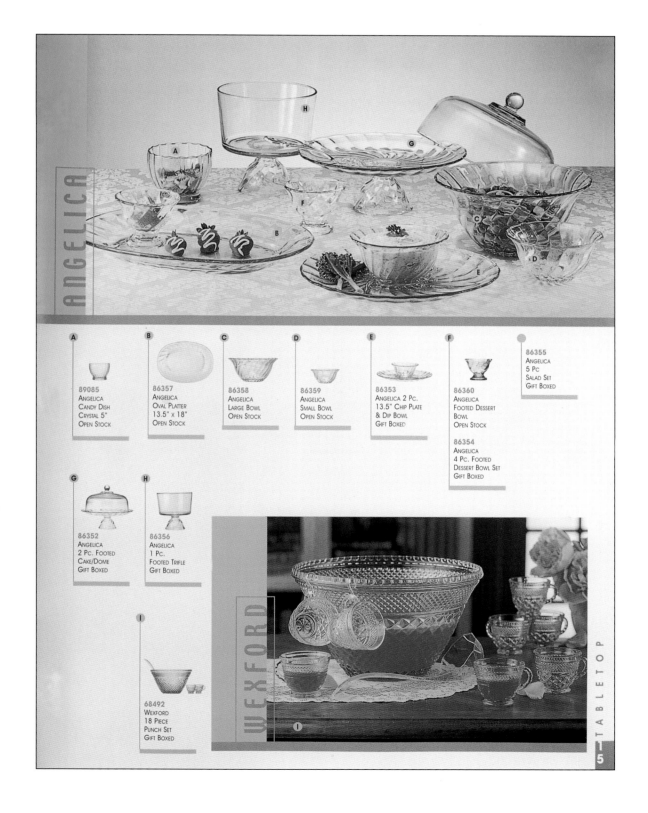

A
89085
ANGELICA
CANDY DISH
CRYSTAL 5"
OPEN STOCK

B
86357
ANGELICA
OVAL PLATTER
13.5" x 18"
OPEN STOCK

C
86358
ANGELICA
LARGE BOWL
OPEN STOCK

D
86359
ANGELICA
SMALL BOWL
OPEN STOCK

E
86353
ANGELICA 2 PC.
13.5" CHIP PLATE
& DIP BOWL
GIFT BOXED

F
86360
ANGELICA
FOOTED DESSERT
BOWL
OPEN STOCK

86354
ANGELICA
4 PC. FOOTED
DESSERT BOWL SET
GIFT BOXED

86355
ANGELICA
5 PC
SALAD SET
GIFT BOXED

G
86352
ANGELICA
2 PC. FOOTED
CAKE/DOME
GIFT BOXED

H
86356
ANGELICA
1 PC.
FOOTED TRIFLE
GIFT BOXED

I
68492
WEXFORD
18 PIECE
PUNCH SET
GIFT BOXED

TABLETOP

15

13

ANNIVERSARY ROSE DINNERWARE

Anniversary Rose Listed in the 1965 Catalog

Cat. Item No.	Price
W4679/29	$5-8
W4629/29	$4-6
W4674/29	$10-12
W4638/29	$12-15
W4667/29	$15-20
W4646/29	$12-15
W4678/29	$20-30
W4647/29	$25-30
W4653/29	$15-20
W4654/29	$10-12
W4600/63	$60-80
W4600/64	$200+
W4600/65	$300+
W4600/67	$500+
W114	$8-12

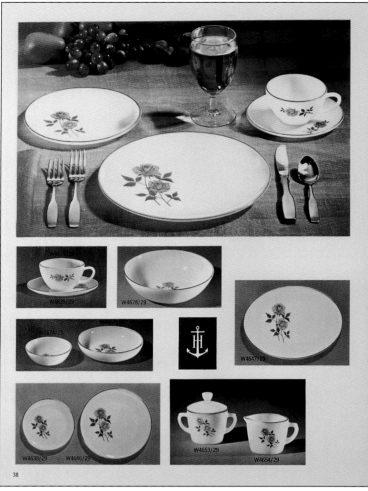

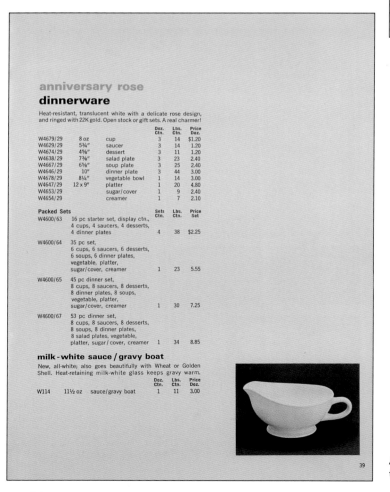

anniversary rose
dinnerware

Heat-resistant, translucent white with a delicate rose design, and ringed with 22K gold. Open stock or gift sets. A real charmer!

			Doz. Ctn.	Lbs. Ctn.	Price Doz.
W4679/29	8 oz	cup	3	14	$1.20
W4629/29	5¾"	saucer	3	14	1.20
W4674/29	4⅝"	dessert	3	11	1.20
W4638/29	7⅜"	salad plate	3	23	2.40
W4667/29	6⅝"	soup plate	3	25	2.40
W4646/29	10"	dinner plate	3	44	3.00
W4678/29	8¼"	vegetable bowl	1	14	3.00
W4647/29	12 x 9"	platter	1	20	4.80
W4653/29		sugar/cover	1	9	2.40
W4654/29		creamer	1	7	2.10

Packed Sets		Sets Ctn.	Lbs. Ctn.	Price Set
W4600/63	16 pc starter set, display ctn., 4 cups, 4 saucers, 4 desserts, 4 dinner plates	4	38	$2.25
W4600/64	35 pc set, 6 cups, 6 saucers, 6 desserts, 6 soups, 6 dinner plates, vegetable, platter, sugar/cover, creamer	1	23	5.55
W4600/65	45 pc dinner set, 8 cups, 8 saucers, 8 desserts, 8 dinner plates, 8 soups, vegetable, platter, sugar/cover, creamer	1	30	7.25
W4600/67	53 pc dinner set, 8 cups, 8 saucers, 8 desserts, 8 soups, 8 dinner plates, 8 salad plates, vegetable, platter, sugar/cover, creamer	1	34	8.85

milk-white sauce/gravy boat

New, all-white; also goes beautifully with Wheat or Golden Shell. Heat-retaining milk-white glass keeps gravy warm.

			Doz. Ctn.	Lbs. Ctn.	Price Doz.
W114	11½ oz	sauce/gravy boat	1	11	3.00

Anniversary Rose listed in the 1965 catalog.

BROWNSTONE OVENWARE

Brownstone Fire-King Listed in the 1974 Catalog

Cat. Item No.	Price
WH437/7425 (A)	$8-12
WH438/7425 (B)	$8-12
W435/7425 (C)	$5-8
WH433/7425 (D)	$8-12
W429/7425 (E)	$5-8
W432/7425 (F)	$5-8
W441/7425 (G)	$5-8
W434/7425 (H)	$1-2

Fire-King® Ovenware

picture ref.	description	item order no.	doz. per shipper	lbs. per shipper	price doz.
	BROWNSTONE				
A	1½ qt. casserole/cover	WH437/7425	½	20	
B	2 qt. casserole/cover	WH438/7425	½	23	
C	8" sq. cake pan	W435/7425	½	17	
D	1½ qt. oval casserole/cover	WH433/7425	½	22	
E	9" round cake dish	W429/7425	½	14	
F	1½ qt. utility baking dish	W432/7425	½	12	
G	5 x 9" deep loaf pan	W441/7425	½	12	
H	6 oz. dessert/custard	W434/7425	4	17	
	HOT POPPY				
I	9" round cake dish	W429/7113	½	14	
J	10" deep pie plate	W470/7113	1	24	
K	1½ qt. oval casserole/clear cover	WH433/7113	½	22	
L	1 qt. casserole/clear cover	WH436/7113	½	16	
M	1½ qt. casserole/clear cover	WH437/7113	½	20	
N	1½ qt. utility baking dish	W432/7113	½	12	
O	5 x 9" deep loaf pan	W441/7113	½	12	
P	6 oz. dessert/custard	W434/7113	4	17	
Q	5" soup/cereal bowl	W310G/7113	1	7	
R	8 oz. mug	W312G/7113	1	8	
S	12 oz. individual oval casserole	W478/7113	3	21	
T	12 oz. French casserole w/plastic lid	W240M/7113	2	17	
U	8" sq. cake pan	W435/7113	½	17	

NOTE: *Blue item number indicates new product and/or packaging.*
See Index for additional listings of Brownstone and Hot Poppy bulk and gift items.

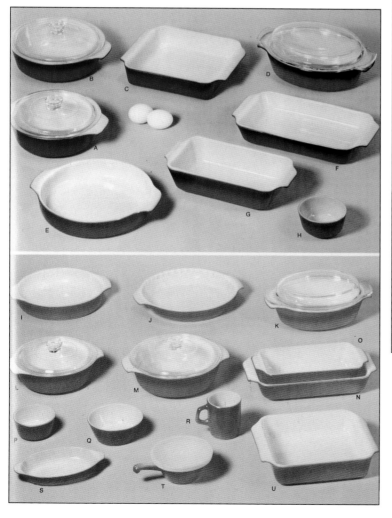

The Hot Poppy ovenware is priced under its specific title and not included here.

CANDLEGLOW OVENWARE

Candleglow Fire-King Ovenware Listed in the 1970 Catalog

Cat. Item No.	Price
W240-E/73 (1)	$2-4
W436/73 (2)	$10-12
W437/73 (3)	$10-12
W438/73 (4)	$12-15
W439/73 (5)	$12-15
W433/73 (6)	$10-15
W429/73 (7)	$8-12
W434/73 (8)	$1-2
W441/73 (9)	$8-12
W431/73 (10)	$8-12
W435/73 (11)	$8-12
W432/73 (12)	$8-12
W400/473 (AA)	$20-30
W400/518 (BB)	$50-75
W400/444	$40-50
W400/445	$25-35

FIRE-KING OVENWARE CANDLEGLOW PATTERN CANDLEWARMER SET	Carton Sets Lbs.	Price Set
(AA) W400/473 3 pc. Candleglow candlewarmer set packed in die-cut air cell gift box. Set contains 1½ qt. casserole and cover, candlewarmer with candle and walnut finished handles. (030411)	4 21	$2.75

12 PC. OVEN COOKERY STARTER SET

	Carton Sets Lbs.	Price Set
(BB) W400/518 12 pc. Candleglow oven cookery set in RSC ctn. with full color label. Each set contains four 12 oz. individual casseroles, one 1½ qt. casserole/cover, 1½ qt. utility dish, 8" sq. cake dish, 2½ qt. mixing bowl, 9" pie plate, 8 oz. measuring cup and 10" gourmet whisk. (128645)	2 39	5.00

CANDLEGLOW OVENWARE SETS

	Carton Sets Lbs.	Price Set
W400/444 11 pc. Candleglow ovenware set. Set contains six 6 oz. custard cups and one 1½ qt. casserole with milk-white knob cover, 5 x 9" loaf pan, 8¾ x 12¼" utility pan 8" cake pan. (017921) (not illustrated)	4 57	3.75
W400/445 7 pc. Candleglow ovenware starter set. Set contains four 6 oz. custard cups, one 1 qt. casserole with milk-white knob cover and 5 x 9" loaf pan. (017913) (not illustrated)	4 27	2.00

FIRE-KING OVENWARE CANDLEGLOW PATTERN BULK PACKED	Carton Doz. Lbs.	Price Doz.
(1) W240-E/73 12 oz. French casserole/no cover (019992)	2 17	$2.40
(2) W436/73 1 qt. casserole with milk-white knob cover (017681)	½ 16	7.35
(3) W437/73 1½ qt. casserole with milk-white knob cover (017699)	½ 20	8.34
(4) W438/73 2 qt. casserole with milk-white knob cover (017715)	½ 23	9.88
(5) W439/73 3 qt. casserole with milk-white knob cover (017798)	½ 31	13.75
(6) W433/73 1½ qt. oval casserole with milk-white au gratin cover (017707)	½ 22	8.34
(7) W429/73 9" round cake pan (017780)	½ 14	6.54
(8) W434/73 6 oz. custard cup (017673)	4 17	1.25
(9) W441/73 5 x 9" loaf pan (017723)	½ 12	7.35
(10) W431/73 2 qt. utility pan (017749)	½ 20	9.88
(11) W435/73 8" square cake pan (017731)	½ 17	7.74
(12) W432/73 1½ qt. utility dish (017640)	½ 15	7.35

Replacement Offer: If dish ever breaks from normal oven heat, and instructions have been followed, your dealer will replace it upon being properly notified.

Candleglow ovenware listed in the 1970 catalog.

CANYON GOLD

Canyon Gold Listed in the 2002 Catalog

Cat. Item No.	Price
87672R (A)	$2-4
87673R (B)	$5-8
87675 (C)	$8-10
87671 (D)	$8-10
87674R (E)	$4-5
87655R (F)	$5-8
86362	$10-15 per set

Cat. Item No.	Price
86364	$12-15 per set
86363	$10-12 per set
87656R (G)	$1-2
87657R (H)	$1-2
87659R (I)	$1-2
87658R (J)	$1-2
86365 (K)	$10-12

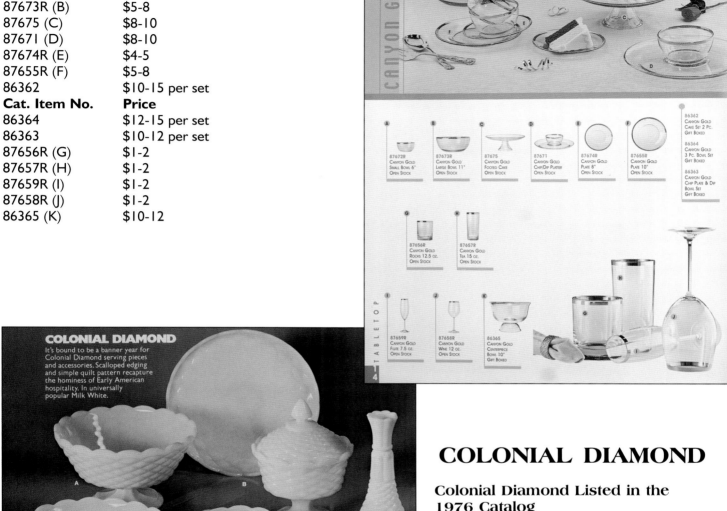

COLONIAL DIAMOND

It's bound to be a banner year for Colonial Diamond serving pieces and accessories. Scalloped edging and simple quilt pattern recapture the homeness of Early American hospitality. In universally popular Milk White.

COLONIAL DIAMOND

Colonial Diamond Listed in the 1976 Catalog

Cat. Item No.	Price
W4302E (A)	$8-10
W4346 (B)	$5-8
W4378 (C)	$4-5
W4370 (D)	$5-10
W4352 (E)	$10-15

Cat. Item No.	Price
W4371 (F)	$1-3
W4375 (G)	$2-4
W4372 (H)	$6-10
W4301E	$12-15 (not shown)

photo ref.	description	glass color	item order no.	doz.	lbs.	price doz.
A	9⅜" centerpiece (individual Gift Carton)	Milk White	W4302E	⅓	17	
B	11" plate	Milk White	W4346	½	15	
C	9⅜" bowl	Milk White	W4378	½	18	
D	6½" x 13" divided tray	Milk White	W4370	½	15	
E	6⅝" x 8⅞" candy dish/cover	Milk White	W4352	½	19	
F	8⅞" bud vase	Milk White	W4371	3	35	
G	5½" salad bowl	Milk White	W4375	3	25	
H	6½" x 13" serving tray	Milk White	W4372	½	14	
	11"cake plate (illustrated on page 111)	Milk White	W4301E	⅓	14	

NOTE: Blue item indicates new product and/or packaging.
See index for additional listings of Milk White bulk and gift items.

COPPER TINT OVENWARE

Copper Tint Fire-King Ovenware Listed in the 1965 Catalog

Cat. Item No.	Price
L424	$2-4
L405	$5-10
L406	$8-10
L407	$8-10
L497	$10-12
L467	$10-15
L408	$10-15
L488	$12-15
L235	$5-8
L460	$5-8
L450	$8-10
L452	$8-10
L409	$10-15
L410	$5-10
L411	$5-10
L400/186	$35-40
L400/393	$20-30

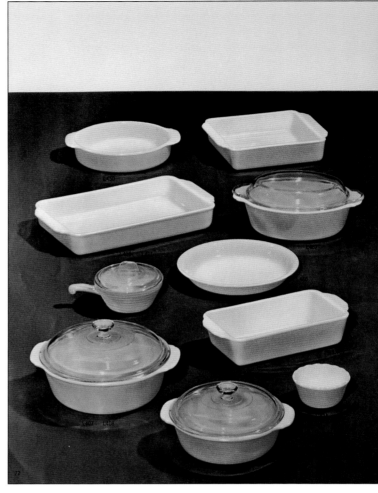

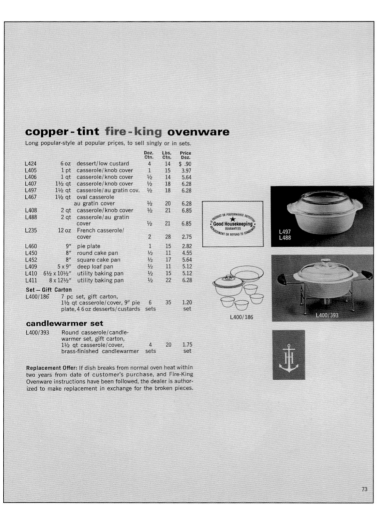

copper-tint fire-king ovenware

Long popular-style at popular prices, to sell singly or in sets.

			Doz. Ctn.	Lbs. Ctn.	Price Doz.
L424	6 oz	dessert/low custard	4	14	$.90
L405	1 pt	casserole/knob cover	1	15	3.97
L406	1 qt	casserole/knob cover	½	14	5.64
L407	1½ qt	casserole/knob cover	½	18	6.28
L497	1½ qt	casserole/au gratin cov.	½	18	6.28
L467	1½ qt	oval casserole au gratin cover	½	20	6.28
L408	2 qt	casserole/knob cover	½	21	6.85
L488	2 qt	casserole/au gratin cover	½	21	6.85
L235	12 oz	French casserole/ cover	2	28	2.75
L460	9″	pie plate	1	15	2.82
L450	8″	round cake pan	½	11	4.55
L452	8″	square cake pan	½	17	5.64
L409	5 x 9″	deep loaf pan	½	11	5.12
L410	6½ x 10½″	utility baking pan	½	15	5.12
L411	8 x 12½″	utility baking pan	½	22	6.28

Set – Gift Carton

L400/186		7 pc set, gift carton, 1½ qt casserole/cover, 9″ pie plate, 4 6 oz desserts/custards	6 sets	35	1.20 set

candlewarmer set

L400/393		Round casserole/candle-warmer set, gift carton, 1½ qt casserole/cover, brass-finished candlewarmer	4 sets	20	1.75 set

Replacement Offer: If dish breaks from normal oven heat within two years from date of customer's purchase, and Fire-King Ovenware instructions have been followed, the dealer is authorized to make replacement in exchange for the broken pieces.

L497 L488

L400/186 L400/393

Copper Tint Ovenware
listed in the 1965 catalog.

COUNTRY LOVE OVENWARE

Country Love Listed in the 1982 New Products Catalog

Cat. Item No.	Price
W441/526	$8-10
W435/526	$8-10
W436/526	$10-15
W437/526	$10-15
W438/526	$12-15
W432/526	$8-10
W431/526	$10-12

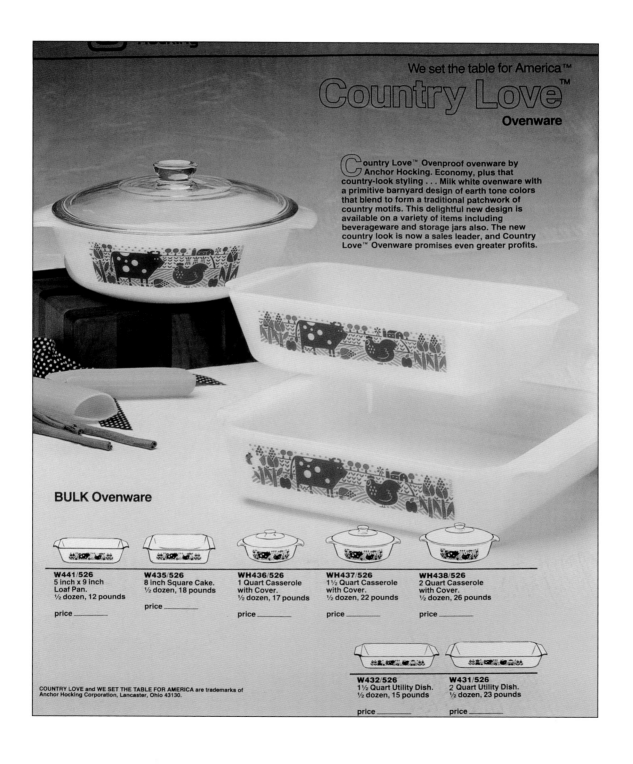

We set the table for America™

Country Love™
Ovenware

Country Love™ Ovenproof ovenware by Anchor Hocking. Economy, plus that country-look styling . . . Milk white ovenware with a primitive barnyard design of earth tone colors that blend to form a traditional patchwork of country motifs. This delightful new design is available on a variety of items including beverageware and storage jars also. The new country look is now a sales leader, and Country Love™ Ovenware promises even greater profits.

BULK Ovenware

W441/526 5 inch x 9 inch Loaf Pan. ½ dozen, 12 pounds	W435/526 8 inch Square Cake. ½ dozen, 18 pounds	WH436/526 1 Quart Casserole with Cover. ½ dozen, 17 pounds	WH437/526 1½ Quart Casserole with Cover. ½ dozen, 22 pounds	WH438/526 2 Quart Casserole with Cover. ½ dozen, 26 pounds
price ___	price ___	price ___	price ___	price ___

W432/526 1½ Quart Utility Dish. ½ dozen, 15 pounds	W431/526 2 Quart Utility Dish. ½ dozen, 23 pounds
price ___	price ___

COUNTRY LOVE and WE SET THE TABLE FOR AMERICA are trademarks of Anchor Hocking Corporation, Lancaster, Ohio 43130.

CRYSTAL CLEAR OVENWARE

Cat. Item No.	Price
H408	$10-15
H488	$10-15
H450	$5-10
H452	$5-10
H409	$8-10
H410	$5-10
H411	$8-10
H412	$10-12
H446	$5-8
H447	$5-8
H448	$6-10
H449	$8-10
H400/361	$30-40
H400/95	$50-60

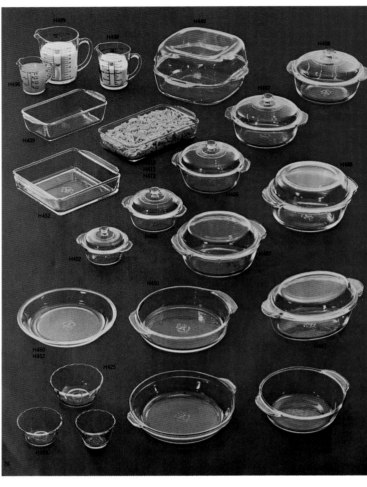

crystal clear fire-king ovenware

Cat.			Doz. Ctn.	Lbs. Ctn.	Price Doz.
H422	5 oz	standard custard	4	14	$.72
H424	6 oz	dessert/low custard	4	15	.75
H425	10 oz	deep pie dish	3	18	.90
H496	8 oz	measuring cup black graduations	1	8	1.74
H498	16 oz	measuring pitcher black graduations	1	13	3.26
H499	1 qt	measuring pitcher black graduations	½	12	4.91
H460	9"	pie plate	1	16	2.25
H461	9"	deep pie plate	1	19	3.81
H462	10"	pie plate	1	21	3.26
H402	8 oz	indiv. casserole/cover	2	20	2.25
H405	1 pt	casserole/knob cover	1	17	3.26
H406	1 qt	casserole/knob cover	½	14	4.91
H407	1½ qt	casserole/knob cover	½	19	5.41
H497	1½ qt	casserole/au gratin cov.	½	19	5.41
H467	1½ qt	oval casserole au gratin cover	½	20	5.41
H408	2 qt	casserole/knob cover	½	21	6.02
H488	2 qt	casserole/au gratin cov.	½	21	6.02
H450	8"	round cake pan	½	12	3.81
H452	8"	square cake pan	½	16	4.91
H409	5 x 9"	deep loaf pan	½	12	4.36
H410	6½ x 10½"	utility pan - 1½ qt	½	15	4.36
H411	8 x 12½"	utility pan - 2 qt	½	23	5.41
H412	9½ x 14⅛"	utility pan - 3 qt	½	29	8.00
H446	1 qt	baker/pudding	1	15	2.70
H447	1½ qt	baker/no cover	½	11	3.26
H448	2 qt	baker/no cover	½	13	3.81
H449		2 pc double roaster, gift carton—3 quart	⅓	29	11.88

Sets — Gift Packed

H400/361		7 pc set, gift carton, 1 qt casserole/cover, 9" pie plate, 4 6oz desserts/custards	6 sets	31	1.00 set
H400/95		12 pc set, gift carton, 1½ qt casserole/cover, 9" pie plate, 5 x 9" loaf pan, 6½ x 10½" baking pan, 1 qt pudding pan, 6 6 oz desserts/custards	4 sets	50	2.10 set

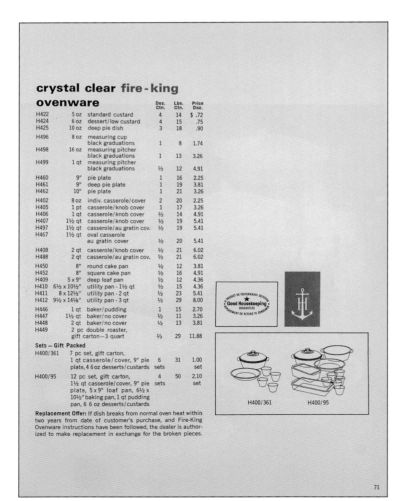

★ PRODUCT OF PERFORMANCE PROVEN
Good Housekeeping GUARANTEES
REPLACEMENT OR REFUND TO CONSUMER

H400/361 H400/95

Replacement Offer: If dish breaks from normal oven heat within two years from date of customer's purchase, and Fire-King Ovenware instructions have been followed, the dealer is authorized to make replacement in exchange for the broken pieces.

71

Crystal Clear Ovenware Listed in the 1965 Catalog

Cat. Item No.	Price
H422	$1-2
H424	$2-3
H425	$2-3
H496	$5-8
H498	$5-10
H499	$8-12
H460	$5-8
H461	$12-15
H462	$8-10
H402	$4-5
H405	$5-8
H406	$8-10
H407	$10-12
H497	$8-12
H467	$10-15

Crystal Clear Fire-King Ovenware listed in the 1956 catalog.

FLEURETTE

Advertising Proof Listing the Fleurette Pattern

Cat. Item No.	Price
W4679/58	$4-5
W4629/58	$2-3
W4674/58	$4-5
W4637/58	$12-15
W4638/58	$10-15
W4667/58	$12-15
W4641/58	$5-10
W4678/58	$12-15
W4647/58	$15-20
W4653/58	$10-12
W4654/58	$5-10
W4600/4	$50-60
W4600/1	$60-80
W4600/2	$200+
W4600/3	$300+

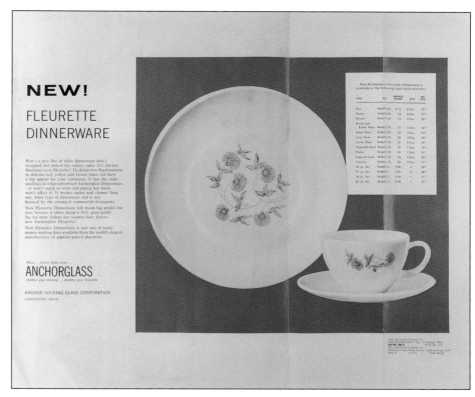

This is the advertising proof for the *Chain Store Age* magazine. This is one of the foremost magazines in which companies display their products.

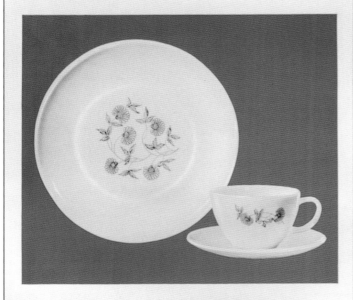

Fleurette was also advertised in the *Crockery & Glass Journal* in April 1958.

GOLDEN ANNIVERSARY DINNERWARE

Golden Anniversary Dinnerware Listed in the 1956 Catalog

Cat. Item No.	Price
W4179/50	$5-6
W4129/50	$2-4
W4174/50	$4-6
W4138/50	$5-8
W4141/50	$8-12
W4167/50	$8-12
W4178/50	$12-15
W4147/50	$15-20
W4153/50	$5-10
W4154/50	$5-10

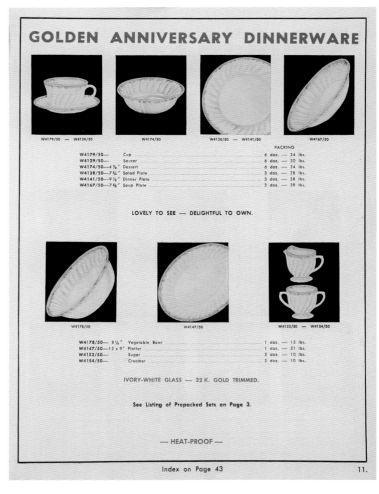

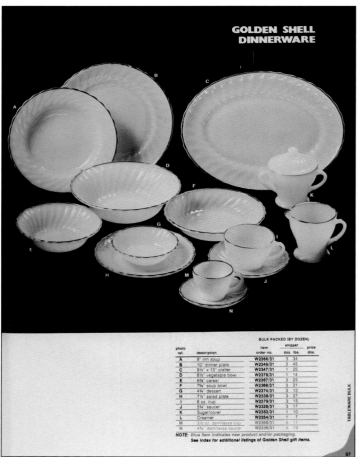

GOLDEN SHELL DINNERWARE

Golden Shell Dinnerware Listed in the 1976 Catalog

Cat. Item No.	Price
W2366/31 (A)	$12-15
W2346/31 (B)	$8-10
W2347/31 (C)	$10-15
W2378/31 (D)	$10-15
W2367/31 (E)	$10-12
W2368/31 (F)	$12-15
W2374/31 (G)	$10-15
W2338/31 (H)	$4-8
W2379/31 (I)	$3-5
W2329/31 (J)	$1-3
W2353/31 (K)	$8-10
W2354/31 (L)	$4-6
W2369/31 (M)	$5-10
W2339/31 (N)	$6-8

HARVEST DINNERWARE

Harvest Dinnerware Listed in the 1971 Catalog

Cat. Item No.	Price
W4647/77 (A)	$10-12
W4643/77 (B)	$5-8
W4644/77 (C)	$5-8
W4678/77 (D)	$10-12
W4667/77 (E)	$8-10
W4646/77 (F)	$5-8
W4674/77 (G)	$5-8
W4638/77 (H)	$5-8
W4649/77 (I)	$2-4
W4659/77 (J)	$3-5

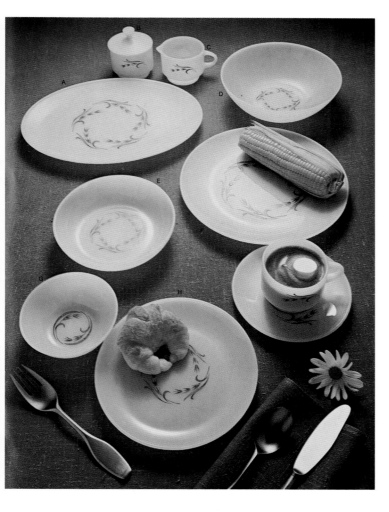

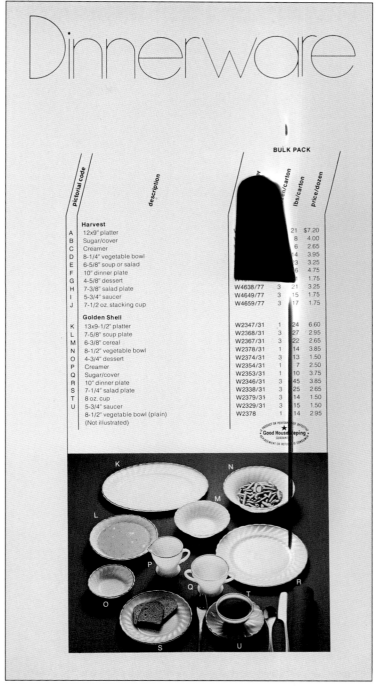

Dinnerware

BULK PACK

Pictorial code	description	item no.	/carton	lbs/carton	price/dozen
	Harvest				
A	12x9" platter			21	$7.20
B	Sugar/cover			8	4.00
C	Creamer			6	2.65
D	8-1/4" vegetable bowl			14	3.95
E	6-5/8" soup or salad			3	3.25
F	10" dinner plate			6	4.75
G	4-5/8" dessert				1.75
H	7-3/8" salad plate	W4638/77	3	21	3.25
I	5-3/4" saucer	W4649/77	3	15	1.75
J	7-1/2 oz. stacking cup	W4659/77	3	17	1.75
	Golden Shell				
K	13x9-1/2" platter	W2347/31	1	24	6.60
L	7-5/8" soup plate	W2368/31	3	27	2.95
M	6-3/8" cereal	W2367/31	3	22	2.65
N	8-1/2" vegetable bowl	W2378/31	1	14	3.85
O	4-3/4" dessert	W2374/31	3	13	1.50
P	Creamer	W2354/31	1	7	2.50
Q	Sugar/cover	W2353/31	1	10	3.75
R	10" dinner plate	W2346/31	3	45	3.85
S	7-1/4" salad plate	W2338/31	3	25	2.65
T	8 oz. cup	W2379/31	3	14	1.50
U	5-3/4" saucer	W2329/31	3	15	1.50
	8-1/2" vegetable bowl (plain) (Not illustrated)	W2378	1	14	2.95

Good Housekeeping

The Golden Shell dinnerware is priced under its specific title and not included here.

HARVEST AMBER OVENWARE

Harvest Amber Fire-King Ovenware Listed in the 1976 Catalog

Cat. Item No.	Price
M433W (A)	$8-10
M434W (B)	$2-3
M319 (C)	$5-6
M460W (D)	$5-8
M438W (E)	$10-12
M441W (F)	$6-8
M436W (G)	$8-10
M432W (H)	$6-8
M437W (I)	$10-12
M435W (J)	$6-10
M111E (K)	$5-6
M431W (L)	$8-10

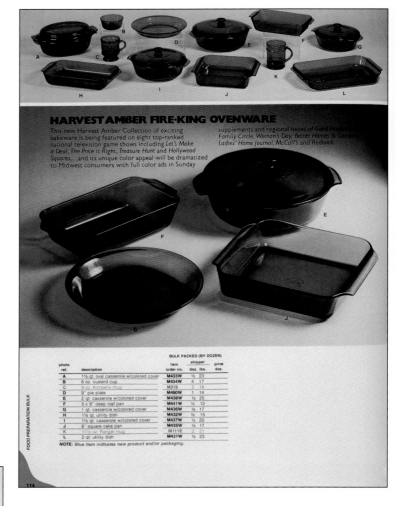

HARVEST AMBER FIRE-KING OVENWARE

This new Harvest Amber Collection of exciting bakeware is being featured on eight top-ranked national television game shows including *Let's Make a Deal, The Price is Right, Treasure Hunt* and *Hollywood Squares*...and its unique color appeal will be dramatized to Midwest consumers with full color ads in Sunday supplements and regional issues of *Good Housekeeping, Family Circle, Woman's Day, Better Homes & Gardens, Ladies' Home Journal, McCall's* and *Redbook.*

BULK PACKED (BY DOZEN)

photo ref.	description	item order no.	shipper doz. lbs.	price doz.
A	1½ qt. oval casserole w/colored cover	M433W	½ 23	
B	6 oz. custard cup	M434W	4 17	
C	9 oz. Kimberly mug	M319	2 16	
D	9" pie plate	M460W	1 14	
E	2 qt. casserole w/colored cover	M438W	½ 25	
F	5 x 9" deep loaf pan	M441W	½ 12	
G	1 qt. casserole w/colored cover	M436W	½ 17	
H	1½ qt. utility dish	M432W	½ 15	
I	1½ qt. casserole w/colored cover	M437W	½ 20	
J	8" square cake pan	M435W	½ 17	
K	11½ oz. Ranger mug	M111E	2 21	
L	2 qt. utility dish	M431W	½ 23	

NOTE: Blue item indicates new product and/or packaging.

FOOD PREPARATION BULK

114

Suburbia, the dinnerware great in handily planned sets is handsomely packaged in four-color gift-display cartons and die-cut display cartons as well.

MEADOW GREEN COMPLETER SET

	Carton Sets Lbs.	Price Set
W4600/88 5 pc. Meadow Green completer set in die-cut display carton. with shrink film wrap and carry-out handle. Each set contains one vegetable bowl, platter, creamer and sugar/cover. (102798)	4 18	$2.25

MEADOW GREEN STARTER SET GIFT PACKED

W4600/85 16 pc. Meadow Green starter set in gift display ctn. with shrink film wrap and carry-out handle. Each set contains four stacking cups, saucers, soup/salad bowls and dinner plates. (086439)	4 47	4.40

MEADOW GREEN 20 PC. SET

W4600/91 20 pc. Meadow Green dinnerware set in die-cut display ctn. with shrink film wrap and carry-out handle. Each set contains four stacking cups, saucers, salad plates, dinner plates and soup bowls. (102830)	2 30	5.50

MEADOW GREEN 45 PC. SET

W4600/80 45 pc. Meadow Green dinnerware set in shipping ctn. with full color label. Each set contains eight stacking cups, saucers, desserts, soup/salad bowls, dinner plates and one vegetable bowl, platter, sugar/cover and creamer. (086447)	1 31	9.88

60

HOMESTEAD COMPLETER SET

W4600/89 5 pc. Homestead completer set in die-cut display ctn. with shrink film wrap and carry-out handle. Each set contains one vegetable bowl, platter, creamer and sugar/cover. (102806)	4 18	2.25

HOMESTEAD STARTER SET GIFT PACKED

W4600/83 16 pc. Homestead starter set in gift display ctn. with shrink film wrap and carry-out handle. Each set contains four stacking cups, saucers, soup/salad bowls and dinner plates. (086835)	4 47	4.40

HOMESTEAD 20 PC. SET

W4600/92 20 pc. Homestead dinnerware set in die-cut display ctn. with shrink film wrap and carry-out handle. Set contains four stacking cups, saucers, salad plates, dinner plates and soup bowls. (102848)	2 30	5.50

HOMESTEAD 45 PC. SET

W4600/84 45 pc. Homestead dinnerware set in shipping ctn. with full color label. Each set contains eight stacking cups, saucers, desserts, soup/salad bowls, dinner plates and one vegetable bowl, platter, creamer and sugar/cover. (086843)	1 31	9.88

MEADOW GREEN (heat resistant) **BULK PACKED**

	Carton Doz. Lbs.	Price Doz.
(1) W4659/6768 7½ oz. stacking cup (086348)	3 16	$1.65
(2) W4649 5¾" plain saucer (009282)	3 15	1.20
(3) W4674/75 4¾" dessert (086355)	3 11	1.65
(4) W4667/75 6⅝" soup or salad bowl (086389)	3 23	3.00
(5) W4638/75 7⅜" salad plate (086363)	3 21	3.00
(6) W4646/75 10" dinner plate (086371)	3 48	4.50
(7) W4678/75 8¼" vegetable bowl (086397)	1 14	3.75
(8) W4647/75 12 x 9" platter (086405)	1 21	6.50
(9) W4643/6768 sugar/cover (086413)	1 8	3.75
(10) W4644/6768 creamer (086421)	1 6	2.40

HOMESTEAD (heat resistant) **BULK PACKED**

(11) W4659/6770 7½ oz. stacking cup (086744)	3 16	1.65
(12) W4649 5¾" plain saucer (009282)	3 15	1.20
(13) W4674/76 4¾" dessert (086751)	3 11	1.65
(14) W4667/76 6⅝" soup or salad bowl (086785)	3 23	3.00
(15) W4638/76 7⅜" salad plate (086769)	3 21	3.00
(16) W4646/76 10" dinner plate (086777)	3 44	4.50
(17) W4678/76 8¼" vegetable bowl (086793)	1 14	3.75
(18) W4647/76 12 x 9" platter (086801)	1 21	6.50
(19) W4643/6770 sugar/cover (086819)	1 8	3.75
(20) W4644/6770 creamer (086827)	1 6	2.40

HOMESTEAD

17 18 19 20 15 14 13 16 11 12

HOMESTEAD DINNERWARE

Homestead Listed in the 1970 Catalog

Cat. Item No.	Price
W4659/6770 (11)	$6-8
W4649 (12)	$5-8
W4674/76 (13)	$6-8
W4667/76 (14)	$12-15
W4638/76 (15)	$10-12
W4646/76 (16)	$12-15
W4678/76 (17)	$15-20
W4647/76 (18)	$15-20
W4643/6770 (19)	$10-12
W4644/6770 (20)	$5-8
W4600/89	$20-30
W4600/83	$30-50
W4600/92	$80-100
W4600/84	$200+

HOSPITALITY OVENWARE

Hospitality Fire-King Ovenware Listed in the 1976 Catalog

Cat. Item No.	Price	Cat. Item No.	Price
W1400/205 (A)	$15-20	W1429 (F)	$8-10
WM1436 (B)	$10-12	W1434 (G)	$3-5
WM1430 (C)	$8-10	W1441 (H)	$8-10
WM1438 (D)	$10-12	W1460 (I)	$10-12
W1452 (E)	$12-15	W1409 (J)	$8-10

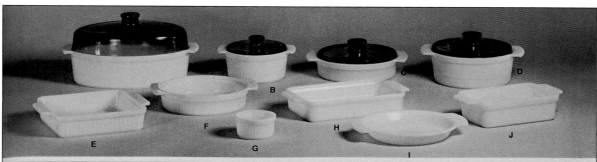

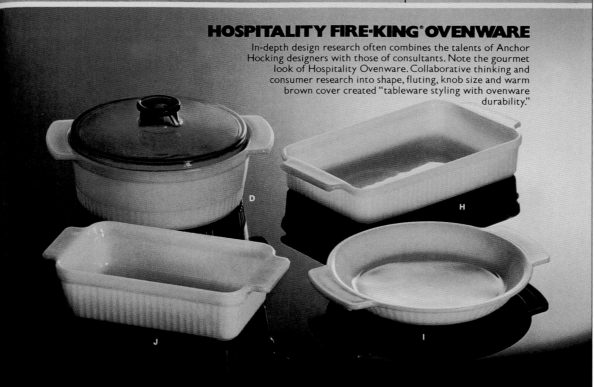

HOSPITALITY FIRE-KING® OVENWARE

In-depth design research often combines the talents of Anchor Hocking designers with those of consultants. Note the gourmet look of Hospitality Ovenware. Collaborative thinking and consumer research into shape, fluting, knob size and warm brown cover created "tableware styling with ovenware durability."

OVENPROOF BY ANCHOR HOCKING

photo ref.	description	item order no.	BULK PACKED (BY DOZEN)		
			shipper doz.	lbs.	price doz.
A	3 qt. oval roaster w/Harvest Amber cover (in Individual Carton)	W1400/205	⅓	31	
B	1 qt. deep casserole w/Harvest Amber cover	WM1436	½	16	
C	1 qt. casserole w/Harvest Amber Cover	WM1430	½	23	
D	2 qt. casserole w/Harvest Amber cover	WM1438	½	28	
E	8" square cake dish	W1452	½	16	
F	8" round cake pan/open baker	W1429	½	14	
G	7 oz. custard	W1434	4	21	
H	1½ qt. utility dish	W1441	½	16	
I	9" pie plate	W1460	1	10	
J	1 qt. loaf pan	W1409	½	13	

***NOTE:** Blue item indicates new product and/or packaging.*

FOOD PREPARATION BULK

115

HOT POPPY OVENWARE

Hot Poppy Fire-King Ovenware Listed in the 1972 Catalog

Cat. Item No.	Price
WH433/7113 (A)	$12-15
W435/7113 (B)	$8-10
W470/7113 (C)	$10-12
WH436/7113 (D)	$12-15
WH437/7113 (E)	$12-15
W441/7113 (F)	$8-10
W432/7113 (G)	$10-12
W429/7113 (H)	$8-10
W312G/7113 (I)	$1-2
W434/7113 (J)	$2-3
W240M/7113 (K)	$4-5
W310G/7113 (L)	$2-3

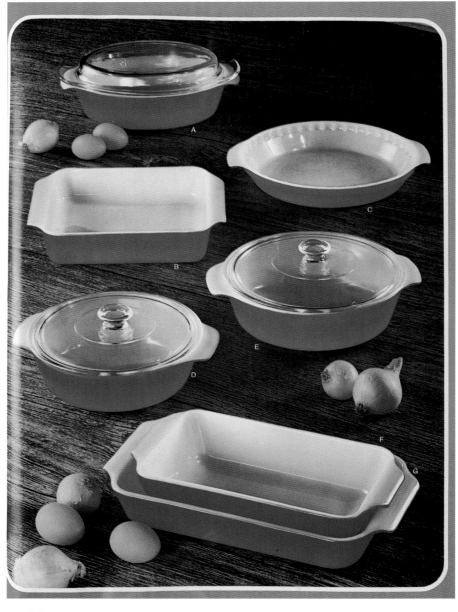

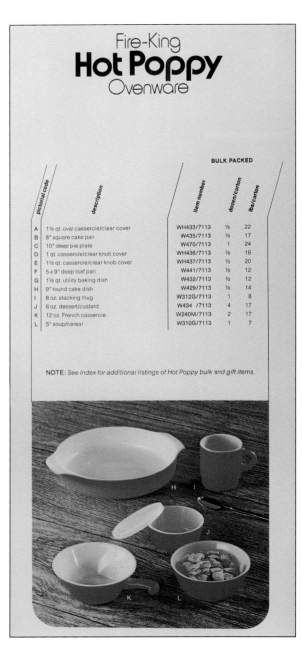

Fire-King Hot Poppy Ovenware

pictorial code	description	item number	BULK PACKED	
			dozen/carton	lbs/carton
A	1½ qt. oval casserole/clear cover	WH433/7113	½	22
B	8" square cake pan	W435/7113	½	17
C	10" deep pie plate	W470/7113	1	24
D	1 qt. casserole/clear knob cover	WH436/7113	½	16
E	1½ qt. casserole/clear knob cover	WH437/7113	½	20
F	5 x 9" deep loaf pan	W441/7113	½	12
G	1½ qt. utility baking dish	W432/7113	½	12
H	9" round cake dish	W429/7113	½	14
I	8 oz. stacking mug	W312G/7113	1	8
J	6 oz. dessert/custard	W434 /7113	4	17
K	12 oz. French casserole	W240M/7113	2	17
L	5" soup/cereal	W310G/7113	1	7

NOTE: See Index for additional listings of Hot Poppy bulk and gift items.

Hot Poppy Fire-King Ovenware listed in the 1972 catalog.

IVORY OVENWARE

Ivory Fire-King Listed in the 1949 Catalog

Cat. Item No.	Price
W405	$10-15
W406	$12-15
W407	$15-20
W408	$15-20
W450	$10-12
W451	$12-15
W460	$5-10

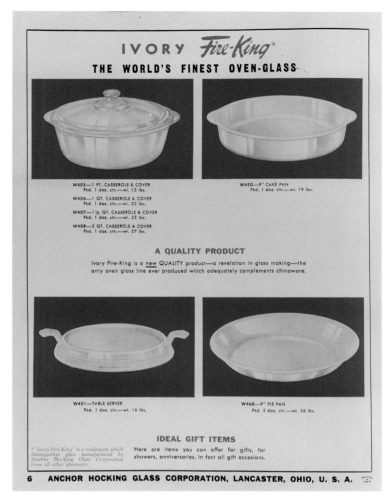

IVORY *Fire-King**
THE WORLD'S FINEST OVEN-GLASS

W405—1 PT. CASSEROLE & COVER
Pkd. 1 doz. ctn.—wt. 13 lbs.

W406—1 QT. CASSEROLE & COVER
Pkd. 1 doz. ctn.—wt. 23 lbs.

W407—1½ QT. CASSEROLE & COVER
Pkd. 1 doz. ctn.—wt. 32 lbs.

W408—2 QT. CASSEROLE & COVER
Pkd. 1 doz. ctn.—wt. 37 lbs.

W450—9" CAKE PAN
Pkd. 1 doz. ctn.—wt. 19 lbs.

A QUALITY PRODUCT

Ivory Fire-King is a new QUALITY product—a revelation in glass making—the only oven glass line ever produced which adequately complements chinaware.

W451—TABLE SERVER
Pkd. 1 doz. ctn.—wt. 16 lbs.

W460—9" PIE PAN
Pkd. 2 doz. ctn.—wt. 26 lbs.

IDEAL GIFT ITEMS

"Ivory Fire-King" is a trademark which distinguishes glass manufactured by Anchor Hocking Glass Corporation from all other glassware.

Here are items you can offer for gifts, for showers, anniversaries, in fact all gift occasions.

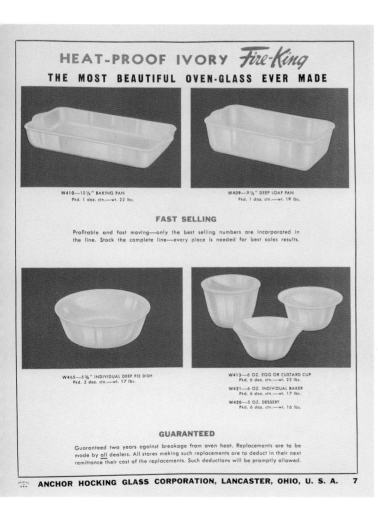

HEAT-PROOF IVORY *Fire-King*
THE MOST BEAUTIFUL OVEN-GLASS EVER MADE

W410—10½" BAKING PAN
Pkd. 1 doz. ctn.—wt. 22 lbs.

W409—9½" DEEP LOAF PAN
Pkd. 1 doz. ctn.—wt. 19 lbs.

FAST SELLING

Profitable and fast moving—only the best selling numbers are incorporated in the line. Stock the complete line—every piece is needed for best sales results.

W465—5⅜" INDIVIDUAL DEEP PIE DISH
Pkd. 3 doz. ctn.—wt. 17 lbs.

W413—6 OZ. EGG OR CUSTARD CUP
Pkd. 6 doz. ctn.—wt. 23 lbs.

W421—6 OZ. INDIVIDUAL BAKER
Pkd. 6 doz. ctn.—wt. 17 lbs.

W420—5 OZ. DESSERT
Pkd. 6 doz. ctn.—wt. 16 lbs.

GUARANTEED

Guaranteed two years against breakage from oven heat. Replacements are to be made by all dealers. All stores making such replacements are to deduct in their next remittance their cost of the replacements. Such deductions will be promptly allowed.

Ivory Fire-King Listed in the 1949 Catalog

Cat. Item No.	Price
W410	$10-12
W409	$10-12
W465	$8-10
W413	$12-15
W421	$5-8
W420	$5-8

Ivory Fire-King Listed in the 1949 Catalog

Cat. Item No.	Price
W400	$100-125 with original box
W401	$35-45 with original box

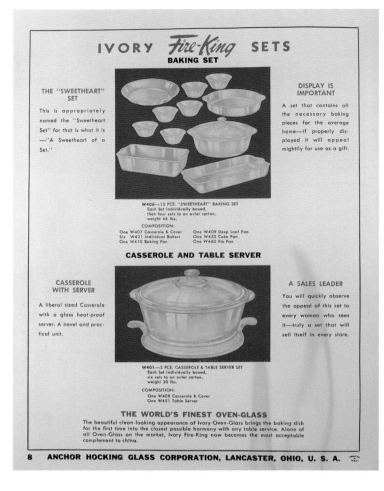

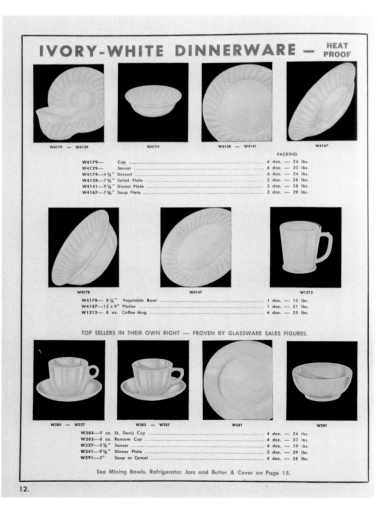

IVORY WHITE DINNERWARE

Ivory-White Dinnerware Listed in the 1956 Catalog

Cat. Item No.	Price
W4179	$8-10
W4129	$2-5
W4174	$8-10
W4138	$8-10
W4141	$10-15
W4167	$10-15
W4178	$20-30
W4147	$25-30
W1212	$5-10
W384	$10-12
W383	$5-10
W327	$2-5
W341	$8-10
W291	$12-15

JADEITE

Jadeite Fire-King Listed in the 1949 Catalog

Cat. Item No.	Price
G3879	$5-8
G3829	$5-8
G3838	$15-20
G3841	$15-20
G3878	$35-40
G3853	$25-30
G3854	$15-20
G3874	$10-15
G3875	$20-25
G3867	$20-30
G3874	$30-40

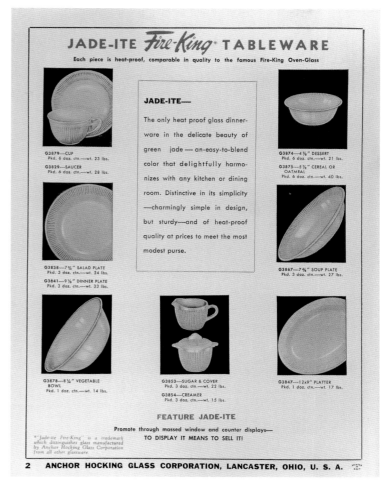

Ivory and Jadeite Fire-King Listed in the 1949 Catalog

Cat. Item No.	Price
W384	$5-10
W327	$2-5
W291	$10-15
W341	$5-10
W383	$5-10
W327	$2-5
W1212	$3-8
G1212	$5-10
G384	$15-20
G327	$5-8
G291	$25-30
G341	$20-25
G383	$20-25
G327	$5-8

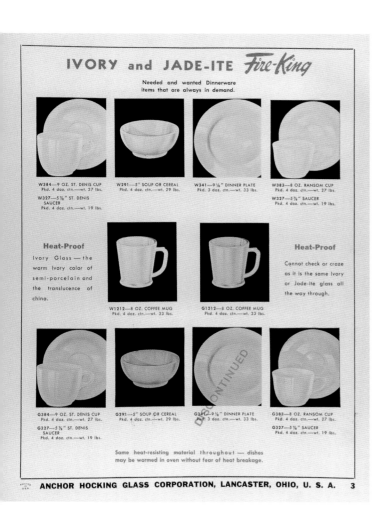

Jadeite Fire-King Novelty Items Listed in the 1949 Catalog

Cat. Item No.	Price
G846	$10-15
G847	$10-15
G800/131	$150+
G807	$15-20
G810	$15-20
G820	$20-30
G388	$25-35
G997	$35-45
G822	$25-35

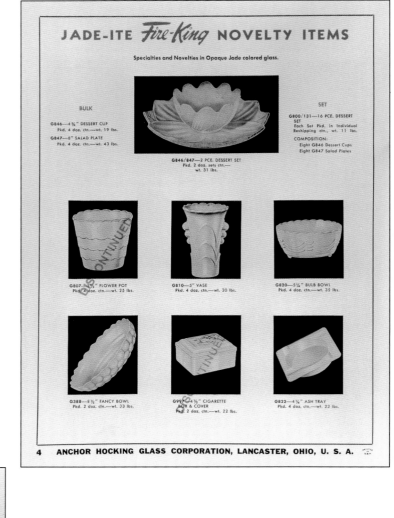

Jadeite Fire-King Kitchenware Listed in the 1949 Catalog

Cat. Item No.	Price
G4156	$20-30
G4157	$20-30
G4158	$25-30
G4159	$30-35
G3400/73	$150+
G4100/1	$150+
G3400/74	$200+
G786	$40-50
G3494	$30-40
G3499	$50-75

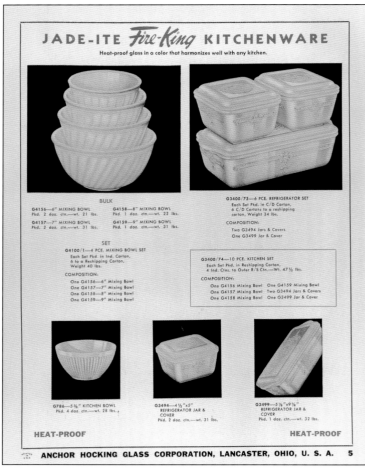

Jadeite Restaurant Ware Listed in the 1967 Institutional Glassware Catalog

Cat. Item No.	Price
G216	$50-75
G207	$15-20
G215	$10-15
G299	$10-15
G295	$5-10
G212	$20-30
G308	$60-75
G305	$30-35
G294	$15-20
G309	$40-50
G300	$40-50
G315	$10-15
G306	$20-25
G297	$10-15
G292	$25-35
G311	$35-45

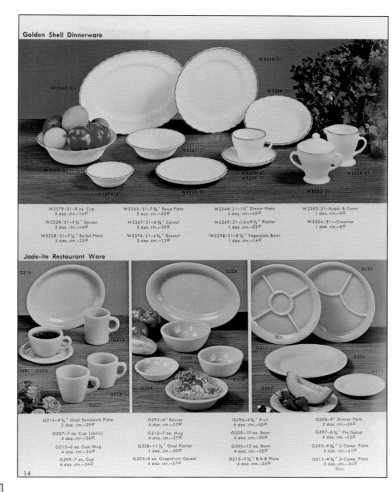

Golden Shell Dinnerware

Jade-ite Restaurant Ware

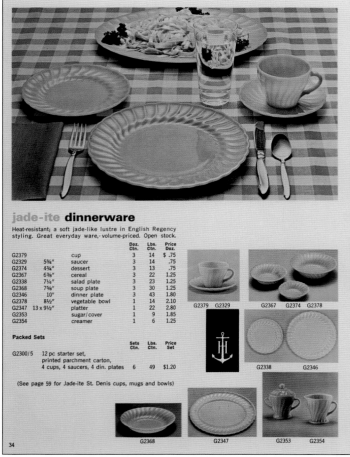

jade-ite dinnerware

Heat-resistant; a soft jade-like lustre in English Regency styling. Great everyday ware, volume-priced. Open stock.

		Doz. Ctn.	Lbs. Ctn.	Price Doz.
G2379	cup	3	14	$.75
G2329	5¾" saucer	3	14	.75
G2374	4¾" dessert	3	13	.75
G2367	6⅜" cereal	3	22	1.25
G2338	7¼" salad plate	3	23	1.25
G2368	7⅞" soup plate	3	30	1.25
G2346	10" dinner plate	3	43	1.80
G2378	8½" vegetable bowl	1	14	2.10
G2347	13 x 9½" platter	1	22	2.80
G2353	sugar/cover	1	9	1.85
G2354	creamer	1	6	1.25

Packed Sets

		Sets Ctn.	Lbs. Ctn.	Price Set
G2300/5	12 pc starter set, printed parchment carton, 4 cups, 4 saucers, 4 din. plates	6	49	$1.20

(See page 59 for Jade-ite St. Denis cups, mugs and bowls)

Jadeite Dinnerware Listed in the 1965 Catalog

Cat. Item No.	Price
G2379	$5-8
G2329	$5-8
G2374	$12-15
G2367	$25-35
G2338	$15-20
G2368	$30-35
G2346	$25-30
G2378	$30-40
G2347	$45-55
G2353	$50-75
G2354	$20-30
G2300/5	$100+

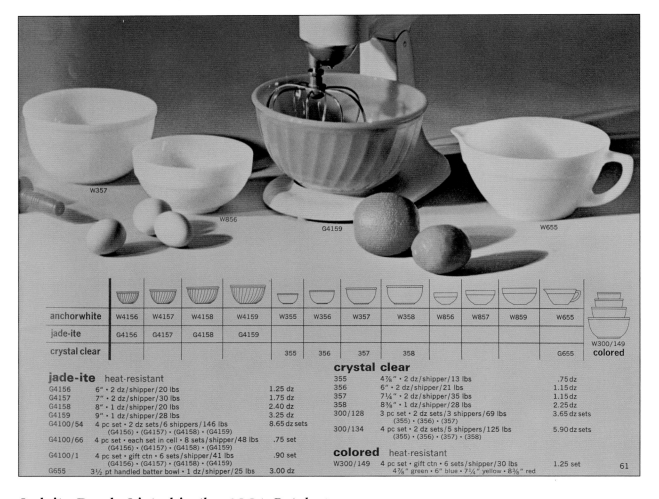

anchorwhite	W4156	W4157	W4158	W4159	W355	W356	W357	W358	W856	W857	W859	W655
jade-ite	G4156	G4157	G4158	G4159								
crystal clear					355	356	357	358				G655

W300/149 colored

jade-ite heat-resistant

G4156	6" • 2 dz/shipper/20 lbs	1.25 dz
G4157	7" • 2 dz/shipper/30 lbs	1.75 dz
G4158	8" • 1 dz/shipper/20 lbs	2.40 dz
G4159	9" • 1 dz/shipper/28 lbs	3.25 dz
G4100/54	4 pc set • 2 dz sets/6 shippers/146 lbs (G4156) • (G4157) • (G4158) • (G4159)	8.65 dz sets
G4100/66	4 pc set • each set in cell • 8 sets/shipper/48 lbs (G4156) • (G4157) • (G4158) • (G4159)	.75 set
G4100/1	4 pc set • gift ctn • 6 sets/shipper/41 lbs (G4156) • (G4157) • (G4158) • (G4159)	.90 set
G655	3½ pt handled batter bowl • 1 dz/shipper/25 lbs	3.00 dz

crystal clear

355	4⅞" • 2 dz/shipper/13 lbs	.75 dz
356	6" • 2 dz/shipper/21 lbs	1.15 dz
357	7¼" • 2 dz/shipper/35 lbs	1.15 dz
358	8⅜" • 1 dz/shipper/28 lbs	2.25 dz
300/128	3 pc set • 2 dz sets/3 shippers/69 lbs (355) • (356) • (357)	3.65 dz sets
300/134	4 pc set • 2 dz sets/5 shippers/125 lbs (355) • (356) • (357) • (358)	5.90 dz sets

colored heat-resistant

W300/149	4 pc set • gift ctn • 6 sets/shipper/30 lbs 4⅞" green • 6" blue • 7¼" yellow • 8⅜" red	1.25 set

61

Jadeite Bowls Listed in the 1964 Catalog

Cat. Item No.	Price
G4156	$20-30
G4157	$20-30
G4158	$25-30
G4159	$30-35
G4100/54	$150+
G4100/66	$150+
G4100/1	$150+
G655	$25-35

LUSTRE SHELL DINNERWARE

Lustre Shell Dinnerware Listed in the 1976 Catalog

Cat. Item No.	Price	Cat. Item No.	Price
L2347 (A)	$20-25	L2329 (H)	$3-4
L2346 (B)	$10-12	L2378 (I)	$12-15
L2338 (C)	$6-10	L2374 (J)	$6-8
L2367 (D)	$12-15	L2368 (K)	$10-12
L2369 (E)	$12-15	L2366 (L)	$10-15
L2339 (F)	$8-10	L2353 (M)	$10-12
L2379 (G)	$5-6	L2354 (N)	$8-10

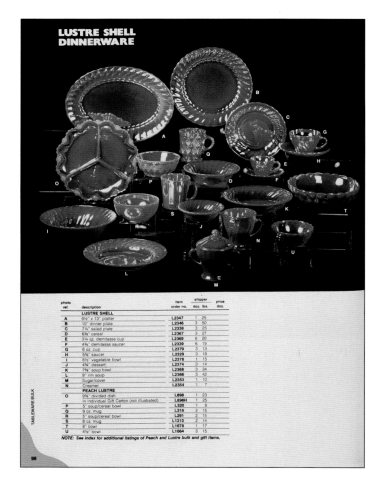

LUSTRE SHELL DINNERWARE

photo ref.	description	item order no.	shipper doz.	lbs.	price doz.
	LUSTRE SHELL				
A	9½" x 13" platter	L2347	1	25	
B	10" dinner plate	L2346	3	50	
C	7¼" salad plate	L2338	3	25	
D	5⅞" cereal	L2367	3	27	
E	3¼ oz. demitasse cup	L2369	6	20	
F	4¾" demitasse saucer	L2339	6	19	
G	8 oz. cup	L2379	3	13	
H	5¾" saucer	L2329	3	18	
I	8½" vegetable bowl	L2378	1	15	
J	4¾" dessert	L2374	3	14	
K	7¾" soup bowl	L2368	3	34	
L	9" rim soup	L2366	3	42	
M	Sugar/cover	L2353	1	10	
N	Creamer	L2354	1	7	
	PEACH LUSTRE				
O	9¾" divided dish	L898	1	23	
	In individual Gift Carton (not illustrated)	L896H	1	25	
P	5" soup/cereal bowl	L320	1	8	
Q	9 oz mug	L319	2	15	
R	5" soup/cereal bowl	L291	1	8	
S	8 oz mug	L1212	2	14	
T	8" bowl	L1678	1	17	
U	4½" bowl	L1664	3	15	

NOTE: See index for additional listings of Peach and Lustre bulk and gift items.

TABLEWARE BULK

98

MEADOW GREEN DINNERWARE

Meadow Green Dinnerware Listed in the 1970 Catalog

Cat. Item No.	Price
W4659/6768 (1)	$3-4
W4649 (2)	$1-2
W4674/75 (3)	$3-5
W4667/75 (4)	$5-8
W4638/75 (5)	$4-6
W4646/75 (6)	$5-8
W4678/75 (7)	$8-10
W4647/75 (8)	$10-15
W4643/6768 (9)	$8-10
W4644/6768 (10)	$5-8

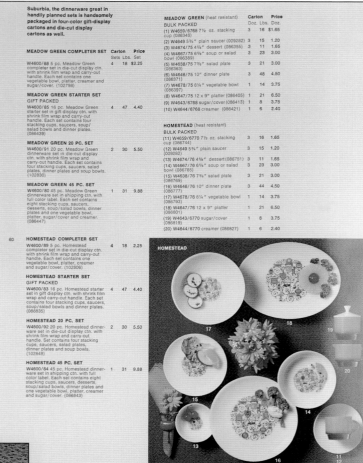

Suburbia, the dinnerware great in handily planned sets is handsomely packaged in four-color gift-display cartons and die-cut display cartons as well.

MEADOW GREEN COMPLETER SET

	Carton Sets Lbs.	Price Set
W4600/88 5 pc. Meadow Green completer set in die-cut display ctn. with shrink film wrap and carry-out handle. Each set contains one vegetable bowl, platter, creamer and sugar/cover. (102798)	4 18	$2.25

MEADOW GREEN STARTER SET GIFT PACKED

W4600/85 16 pc. Meadow Green starter set in gift display ctn. with shrink film wrap and carry-out handle. Each set contains four stacking cups, saucers, soup/salad bowls and dinner plates. (086439)	4 47	4.40

MEADOW GREEN 20 PC. SET

W4600/91 20 pc. Meadow Green dinnerware set in die-cut display ctn. with shrink film wrap and carry-out handle. Each set contains four stacking cups, saucers, salad plates, dinner plates and soup bowls. (102830)	2 30	5.50

MEADOW GREEN 45 PC. SET

W4600/80 45 pc. Meadow Green dinnerware set in shipping ctn. with full color label. Each set contains eight stacking cups, saucers, desserts, soup/salad bowls, dinner plates and one vegetable bowl, platter, sugar/cover and creamer. (086647)	1 31	9.88

60

HOMESTEAD COMPLETER SET

W4600/89 5 pc. Homestead completer set in die-cut display ctn. with shrink film wrap and carry-out handle. Each set contains one vegetable bowl, platter, creamer and sugar/cover. (102806)	4 18	2.25

HOMESTEAD STARTER SET GIFT PACKED

W4600/83 16 pc. Homestead starter set in gift display ctn. with shrink film wrap and carry-out handle. Each set contains four stacking cups, soup/salad bowls and dinner plates. (086835)	4 47	4.40

HOMESTEAD 20 PC. SET

W4600/92 20 pc. Homestead dinnerware set in die-cut display ctn. with shrink film wrap and carry-out handle. Set contains four stacking cups, saucers, salad plates, dinner plates and soup bowls. (102848)	2 30	5.50

HOMESTEAD 45 PC. SET

W4600/84 45 pc. Homestead dinnerware set in shipping ctn. with full color label. Each set contains eight stacking cups, saucers, desserts, soup/salad bowls, dinner plates and one vegetable bowl, platter, creamer and sugar/cover. (086843)	1 31	9.88

MEADOW GREEN (heat resistant) **BULK PACKED**

	Carton Doz. Lbs.	Price Doz.
(1) W4659/6768 7½ oz. stacking cup (086348)	3 16	$1.65
(2) W4649 5¾" plain saucer (009282)	3 15	1.20
(3) W4674/75 4¾" dessert (086355)	3 11	1.65
(4) W4667/75 6⅝" soup or salad bowl (086389)	3 23	3.00
(5) W4638/75 7⅞" salad plate (086363)	3 21	3.00
(6) W4646/75 10" dinner plate (086371)	3 48	4.50
(7) W4678/75 8¼" vegetable bowl (086397)	1 14	3.75
(8) W4647/75 12 x 9" platter (086405)	1 21	6.50
(9) W4643/6768 sugar/cover (086413)	1 8	3.75
(10) W4644/6768 creamer (086421)	1 6	2.40

HOMESTEAD (heat resistant) **BULK PACKED**

	Doz. Lbs.	Doz.
(11) W4659/6770 7½ oz. stacking cup (086744)	3 16	1.65
(12) W4649 5¾" plain saucer (009282)	3 15	1.20
(13) W4674/76 4¾" dessert (086751)	3 11	1.65
(14) W4667/76 6⅝" soup or salad bowl (086785)	3 23	3.00
(15) W4638/76 7⅞" salad plate (086769)	3 21	3.00
(16) W4646/76 10" dinner plate (086777)	3 44	4.50
(17) W4678/76 8¼" vegetable bowl (086793)	1 14	3.75
(18) W4647/76 12 x 9" platter (086801)	1 21	6.50
(19) W4643/6770 sugar/cover (086819)	1 8	3.75
(20) W4644/6770 creamer (086827)	1 6	2.40

HOMESTEAD

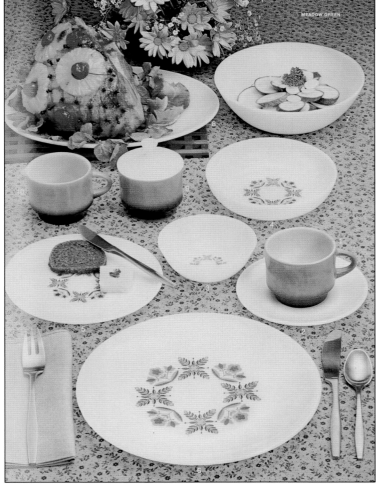

Meadow Green dinnerware listed in the 1970 catalog.

MEADOW GREEN OVENWARE

Meadow Green Ovenware Listed in the 1970 Catalog

Cat. Item No.	Price
W436/75 (1)	$8-12
W437/75 (2)	$10-12
W438/75 (3)	$10-15
W433/75 (4)	$10-15
W429/75 (5)	$8-10
W439/75 (6)	$12-15
W240-E/75 (7)	$4-6
W312/75 (8)	$3-5
W434/75 (9)	$3-5
W310/75 (10)	$5-8
W435/75 (11)	$8-10
W432/75 (12)	$8-10
W431/75 (13)	$8-12
W441/75 (14)	$5-10
W400/535 (AA)	$20-30
W600/130 (BB)	$20-30

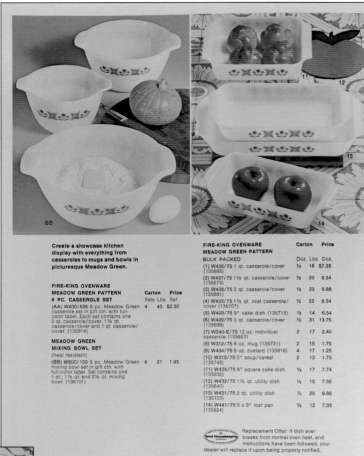

Create a showcase kitchen display with everything from casseroles to mugs and bowls in picturesque Meadow Green.

FIRE-KING OVENWARE
MEADOW GREEN PATTERN
6 PC. CASSEROLE SET

	Carton	Price
	Sets Lbs.	Set
(AA) W400/535 6 pc. Meadow Green casserole set in gift ctn. with full-color label. Each set contains one 2 qt. casserole/cover, 1½ qt. casserole/cover and 1 qt. casserole/cover. (135814)	4 43	$2.50

MEADOW GREEN
MIXING BOWL SET
(heat resistant)

	Carton	Price
(BB) W600/130 3 pc. Meadow Green mixing bowl set in gift ctn. with full-color label. Set contains one 1 qt., 1½ qt. and 2½ qt. mixing bowl. (136101)	4 21	1.95

FIRE-KING OVENWARE
MEADOW GREEN PATTERN
BULK PACKED

	Carton		Price
	Doz.	Lbs.	Doz.
(1) W436/75 1 qt. casserole/cover (135665)	½	16	$7.35
(2) W437/75 1½ qt. casserole/cover (135673)	½	20	8.34
(3) W438/75 2 qt. casserole/cover (135681)	½	23	9.88
(4) W433/75 1½ qt. oval casserole/cover (135707)	½	22	8.34
(5) W429/75 9" cake dish (135715)	½	14	6.54
(6) W439/75 3 qt. casserole/cover (135699)	½	31	13.75
(7) W240-E/75 12 oz. individual casserole (135657)	2	17	2.40
(8) W312/75 8 oz. mug (135731)	2	15	1.75
(9) W434/75 6 oz. custard (135616)	4	17	1.25
(10) W310/75 5" soup/cereal (135749)	2	13	1.75
(11) W435/75 8" square cake dish (135632)	½	17	7.74
(12) W432/75 1½ qt. utility dish (135640)	½	15	7.35
(13) W431/75 2 qt. utility dish (135723)	½	20	9.88
(14) W441/75 5 x 9" loaf pan (135624)	½	12	7.35

Replacement Offer: If dish ever breaks from normal oven heat, and instructions have been followed, your dealer will replace it upon being properly notified.

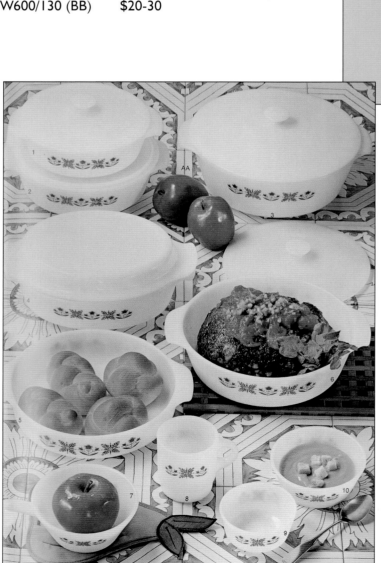

Meadow Green ovenware listed in the 1970 catalog.

MILK WHITE

Milk White Listed in the 1965 Catalog

Cat. Item No.	Price
W696	$3-5
W692	$5-8
W659	$5-8
W1664	$1-2
W1678	$5-10
W543	$3-5
W546	$5-8
W657	$8-12
W619	$10-15
W617	$10-15
W604	$12-15
W618	$12-15

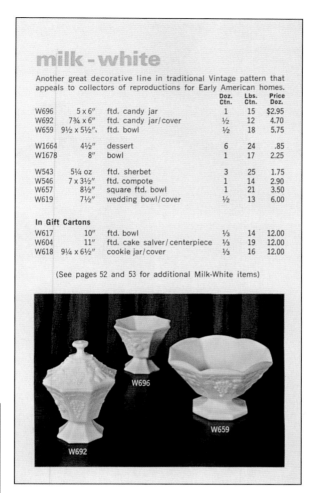

milk-white

Another great decorative line in traditional Vintage pattern that appeals to collectors of reproductions for Early American homes.

			Doz. Ctn.	Lbs. Ctn.	Price Doz.
W696	5 x 6"	ftd. candy jar	1	15	$2.95
W692	7¾ x 6"	ftd. candy jar/cover	½	12	4.70
W659	9½ x 5½"	ftd. bowl	½	18	5.75
W1664	4½"	dessert	6	24	.85
W1678	8"	bowl	1	17	2.25
W543	5¼ oz	ftd. sherbet	3	25	1.75
W546	7 x 3½"	ftd. compote	1	14	2.90
W657	8½"	square ftd. bowl	1	21	3.50
W619	7½"	wedding bowl/cover	½	13	6.00
In Gift Cartons					
W617	10"	ftd. bowl	⅓	14	12.00
W604	11"	ftd. cake salver/centerpiece	⅓	19	12.00
W618	9¼ x 6½"	cookie jar/cover	⅓	16	12.00

(See pages 52 and 53 for additional Milk-White items)

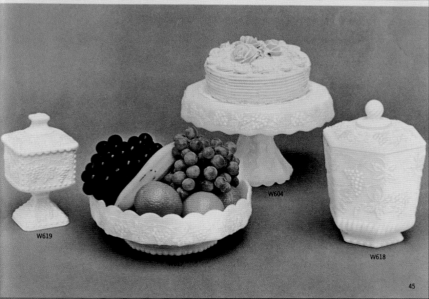

Milk White listed in the 1965 catalog.

MISS AMERICA

Miss America Tableware Listed in the Butler Brothers Catalog

Item Description	Price (Rose)	Price (Crystal)
Footed sherbets	$15-20	$10-12
Cups	$20-25	$10-12
Saucers	$8-10	$4-6
Cereal dishes	$20-25	$15-20
Creamer	$15-20	$10-12
Sugar	$15-20	$10-12
5" Footed compote	$25-30	$15-20
Salt and pepper	$60-80	$30-40
10 1/4" Vegetable dish	$30-35	$12-15
12 1/4" Platter	$30-40	$20-25
11 1/2" Covered candy dish	$200-225	$100-125
5 3/4" Bread and butter	$12-15	$8-10
8 1/2" Salad plate	$40-50	$10-12
10 1/4" Dinner plate	$35-40	$20-25
12" Cake plate	$50-60	$35-40

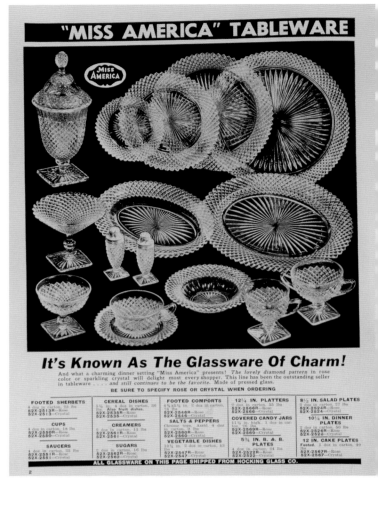

"MISS AMERICA" TABLEWARE

It's Known As The Glassware Of Charm!

And what a charming dinner setting "Miss America" presents! The lovely diamond pattern in rose color or sparkling crystal will delight most every shopper. This line has been the outstanding seller in tableware and still continues to be the favorite. Made of pressed glass.

BE SURE TO SPECIFY ROSE OR CRYSTAL WHEN ORDERING

ALL GLASSWARE ON THIS PAGE SHIPPED FROM HOCKING GLASS CO.

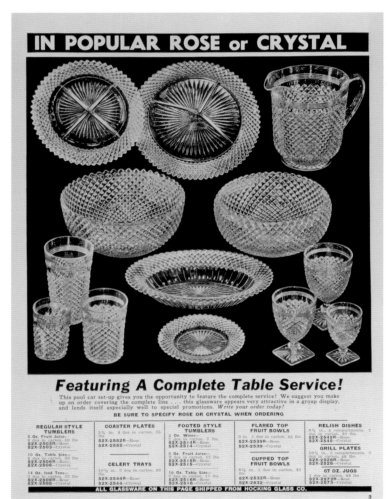

IN POPULAR ROSE or CRYSTAL

Featuring A Complete Table Service!

This pool car set-up gives you the opportunity to feature the complete service! We suggest you make up an order covering the complete line . . . this glassware appears very attractive in a group display, and lends itself especially well to special promotions. Write your order today!

BE SURE TO SPECIFY ROSE OR CRYSTAL WHEN ORDERING

ALL GLASSWARE ON THIS PAGE SHIPPED FROM HOCKING GLASS CO.

Miss America Tableware Listed in the Butler Brothers Catalog

Item Description	Price (Rose)	Price (Crystal)
5 oz. Fruit juice	$50-60	$20-25
10 oz. Table size	$40-45	$15-20
14 oz. Iced tea	$90-100	$30-35
5 3/4" Coaster plate	$12-15	$8-10
10 1/2" Celery tray	$30-35	$15-20
3 oz. Footed wine	$90-100	$20-25
5 oz. Footed fruit juice	$100-125	$30-35
10 oz. Footed table	$60-70	$20-30
9" Flared top bowl	$75-80	$50-55
8 1/2" Cupped top bowl	$100-125	$60-70
8 3/4" Relish dish	$30-35	$15-20
10 1/4" Grill plate	$30-40	$12-15
67 oz. Jug	$150-175	$70-80

MOONSTONE

Moonstone Listed in the catalogs in the late 1940s

Cat. Item No.	Price
M2779	$8-10
M2729	$5-8
M2740	$12-15
M2769	$10-12
M2766	$10-12
M2755	$12-15
M2772	$12-15
M2767	$12-15
M2722	$20-25
M2799	$20-25
M2782	$8-10

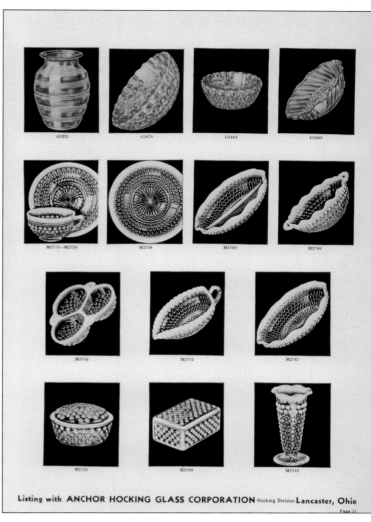

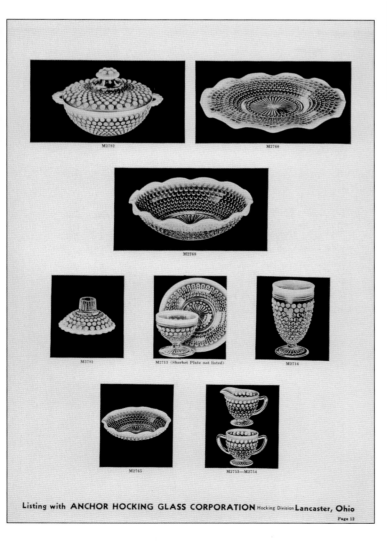

Moonstone Listed in the catalogs in the late 1940s

Cat. Item No.	Price
M2792	$25-30
M2760	$20-30
M2768	$20-25
M2781	$5-8 each
M2713	$5-8
M2716	$18-20
M2765	$8-10
M2753	$8-10
M2754	$8-10

NATURE'S BOUNTY OVENWARE

Nature's Bounty Fire-King Ovenware Listed in the 1975 Catalog

Cat. Item No.	Price
W432/190 (A)	$8-10
W441/190 (B)	$10-12
W431/190 (C)	$10-15
WH439/190 (D)	$10-15
W312/190 (E)	$8-10
WH438/190 (F)	$10-12
W434/190 (G)	$5-6
W435/190 (H)	$8-10
W429/190 (I)	$8-10
WH433/190 (J)	$10-12
WH436/190 (K)	$8-10
WH437/190 (L)	$10-12

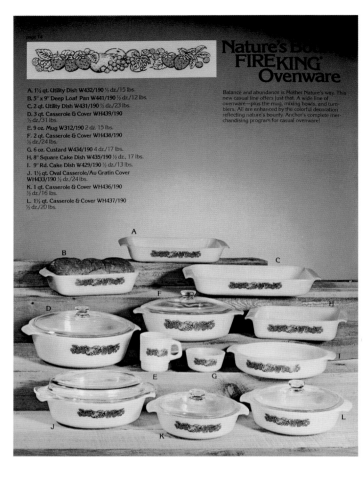

Nature's Bounty
FIRE KING
Ovenware

A. 1½ qt. Utility Dish W432/190 ½ dz./15 lbs.
B. 5" x 9" Deep Loaf Pan W441/190 ½ dz./12 lbs.
C. 2 qt. Utility Dish W431/190 ½ dz./23 lbs.
D. 3 qt. Casserole & Cover WH439/190 ½ dz./31 lbs.
E. 9 oz. Mug W312/190 2 dz. 15 lbs.
F. 2 qt. Casserole & Cover WH438/190 ½ dz./24 lbs.
G. 6 oz. Custard W434/190 4 dz./17 lbs.
H. 8" Square Cake Dish W435/190 ½ dz., 17 lbs.
I. 9" Rd. Cake Dish W429/190 ½ dz./13 lbs.
J. 1½ qt. Oval Casserole/Au Gratin Cover WH433/190 ½ dz./24 lbs.
K. 1 qt. Casserole & Cover WH436/190 ½ dz./16 lbs.
L. 1½ qt. Casserole & Cover WH437/190 ½ dz./20 lbs.

Balance and abundance is Mother Nature's way. This new casual line offers just that. A wide line of ovenware—plus the mug, mixing bowls, and tumblers. All are enhanced by the colorful decoration reflecting nature's bounty. Anchor's complete merchandising program for casual ovenware!

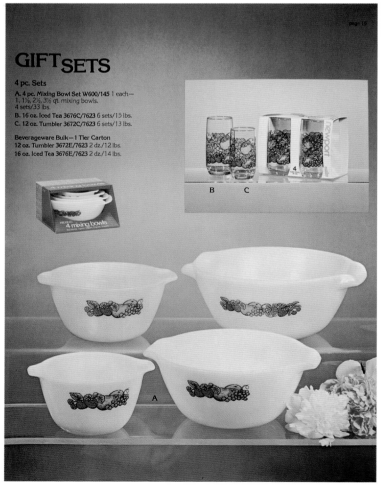

GIFT SETS

4 pc. Sets

A. 4 pc. Mixing Bowl Set W600/145 1 each— 1. 1½, 2½, 3½ qt. mixing bowls. 4 sets/33 lbs.
B. 16 oz. Iced Tea 3676C/7623 6 sets/15 lbs.
C. 12 oz. Tumbler 3672C/7623 6 sets/13 lbs.

Beverageware Bulk—1 Tier Carton
12 oz. Tumbler 3672E/7623 2 dz./12 lbs.
16 oz. Iced Tea 3676E/7623 2 dz./14 lbs.

Nature's Bounty Gift Sets Listed in the 1975 Catalog

Cat. Item No.	Price
W600/145 (A)	$35-50
3676C/7623 (B)	$1-2 per glass
3672C/7623 (C)	$1-3 per glass
3672E/7623	$8-10 per set of 4 glasses
3676E/7623	$8-10 per set of 4 glasses

OCTAGON

The Octagon pattern was introduced in 1978. The pattern is listed in Crystal; however, the only pieces I have been able to locate are the large and small bowl in Honey Gold. The pieces I have are marked with the "anchor in the square" mark near the top rim. There are not enough pieces of the pattern on the market to establish the collector's value.

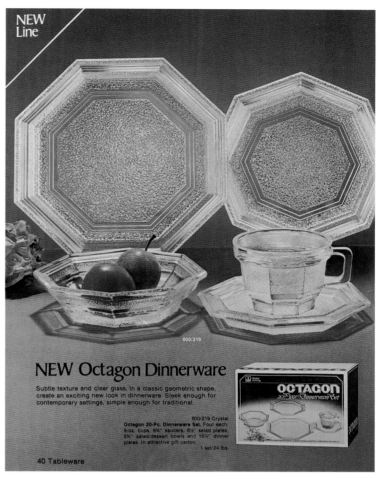

Octagon listed in the 1978 Gift Selection catalog.

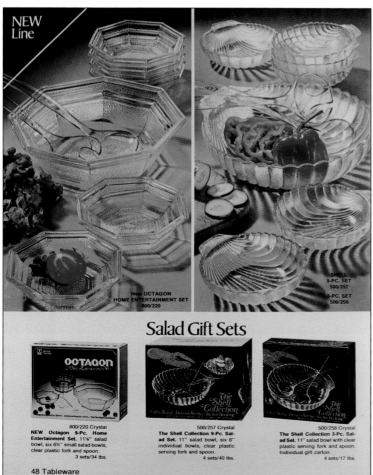

Octagon listed in the 1978 Gift Selection catalog.

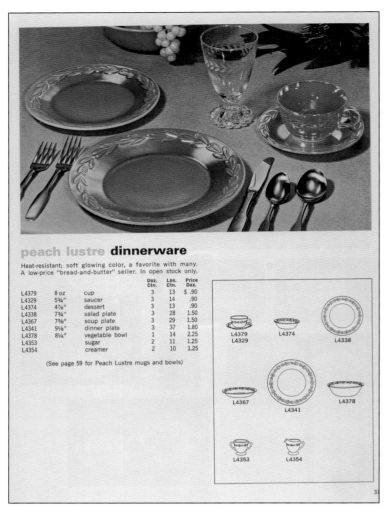

peach lustre **dinnerware**

Heat-resistant; soft glowing color, a favorite with many.
A low-price "bread-and-butter" seller. In open stock only.

			Doz. Ctn.	Lbs. Ctn.	Price Doz.
L4379	8 oz	cup	3	13	$.90
L4329	5¾"	saucer	3	14	.90
L4374	4⅞"	dessert	3	13	.90
L4338	7¾"	salad plate	3	28	1.50
L4367	7⅝"	soup plate	3	29	1.50
L4341	9⅛"	dinner plate	3	37	1.80
L4378	8¼"	vegetable bowl	1	14	2.25
L4353		sugar	2	11	1.25
L4354		creamer	2	10	1.25

(See page 59 for Peach Lustre mugs and bowls)

PEACH LUSTRE DINNERWARE

Peach Lustre Dinnerware Listed in the 1965 Catalog

Cat. Item No.	Price	Cat. Item No.	Price
L4379	$3-5	L4341	$8-10
L4329	$1-3	L4378	$8-10
L4374	$4-5	L4353	$5-8
L4338	$8-10	L4354	$5-8
L4367	$12-15		

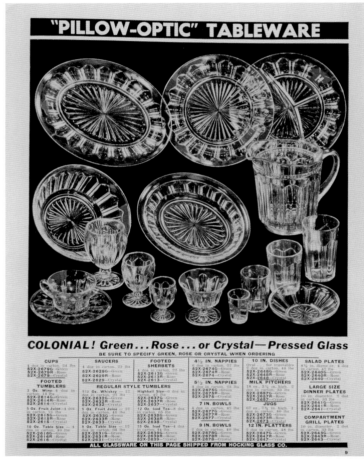

PILLOW-OPTIC (COLONIAL KNIFE AND FORK)

It is interesting that this pattern is known as Colonial Knife and Fork to glass collectors, yet it was called Pillow-Optic by Butler Brothers. I wonder where they found the name?

Pillow Optic Listed in the Butler Brothers Catalog

Item Description	Price (Rose)	Price (Green)	Price (Crystal)
Cups	$12-14	$10-12	$3-5
3 oz. Footed wine	$20-15	$20-25	$8-10
5 oz. Footed juice	$20-25	$20-25	$8-10
10 oz. Table	$25-30	$25-30	$8-10
Saucer	$8-10	$8-10	$4-5
1 1/2 oz. Whiskey	$15-20	$15-20	$10-12
5 oz. Fruit juice	$20-25	$20-25	$10-12
9 oz. Table	$15-20	$15-20	$10-12
Highball	$20-25	$25-30	$12-15
12 oz. Iced tea	$50-55	$50-55	$20-25

Item Description	Price (Rose)	Price (Green)	Price (Crystal)
15 oz. Iced tea	$60-70	$70-80	$35-40
4 1/2" Nappy	$15-20	$15-20	$10-12
5 1/2" Nappy	$60-70	$100-110	$20-30
7" Bowl	$60-70	$60-70	$15-20
9" Bowl	$30-40	$30-40	$20-25
10" Oval dish	$40-45	$40-45	$15-20
18 oz. Milk pitcher	$60-70	$30-40	$20-25
67 oz. Jug	$60-70	$60-70	$30-40
12" Platter	$35-40	$30-40	$15-20
8 1/2" Salad plate	$10-15	$10-15	$6-8
10" Dinner plate	$60-70	$70-80	$20-25
10" Grill plate	$25-30	$20-25	$10-15

PINK SWIRL DINNERWARE

Pink Swirl Dinnerware Listed in the 1956 Catalog

Cat. Item No.	Price
M4179	$5-10
M4129	$5-8
M4174	$8-10
M4138	$8-12
M4141	$10-15
M4146	$25-30
M4167	$20-25
M4177	$35-40
M4178	$25-30
M4143	$10-12
M4144	$8-12

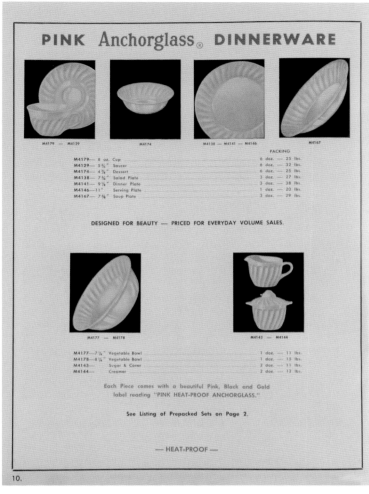

PINK *Anchorglass*® DINNERWARE

	PACKING
M4179— 8 oz. Cup	6 doz. — 25 lbs.
M4129— 5½" Saucer	6 doz. — 32 lbs.
M4174— 4¾" Dessert	6 doz. — 25 lbs.
M4138— 7¾" Salad Plate	3 doz. — 27 lbs.
M4141— 9⅛" Dinner Plate	3 doz. — 38 lbs.
M4146—11" Serving Plate	1 doz. — 20 lbs.
M4167— 7⅝" Soup Plate	3 doz. — 29 lbs.

DESIGNED FOR BEAUTY — PRICED FOR EVERYDAY VOLUME SALES.

M4177—7¼" Vegetable Bowl	1 doz. — 11 lbs.
M4178—8¼" Vegetable Bowl	1 doz. — 15 lbs.
M4143— Sugar & Cover	2 doz. — 11 lbs.
M4144— Creamer	2 doz. — 12 lbs.

Each Piece comes with a beautiful Pink, Black and Gold
label reading "PINK HEAT-PROOF ANCHORGLASS."

See Listing of Prepacked Sets on Page 2.

— HEAT-PROOF —

10.

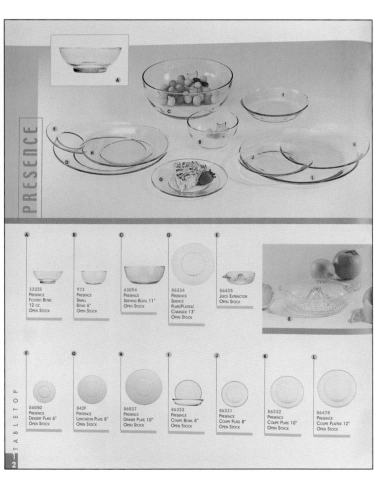

PRESENCE

Presence Listed in the 2002 Catalog

Cat. Item No.	Price
3322S (A)	$1-2
973 (B)	$2-3
63094 (C)	$5-8
86334 (D)	$8-10
86435 (E)	$5-8
86050 (F)	$1-2
842F (G)	$2-3
86037 (H)	$5-8
86333 (I)	$3-5
86331 (J)	$3-5
86332 (K)	$5-8
86478 (L)	$8-10

PRIMROSE DINNERWARE

Primrose Dinnerware Listed in the 1961-2 Catalog

Cat. Item No.	Price
W4679/62	$3-4
W4629/62	$1-2
W4674/62	$3-5
W4638/62	$4-6
W4641/62	$5-8
W4667/62	$8-10
W4678/62	$12-15
W4647/62	$15-20
W4653/62	$5-8
W4654/62	$5-8

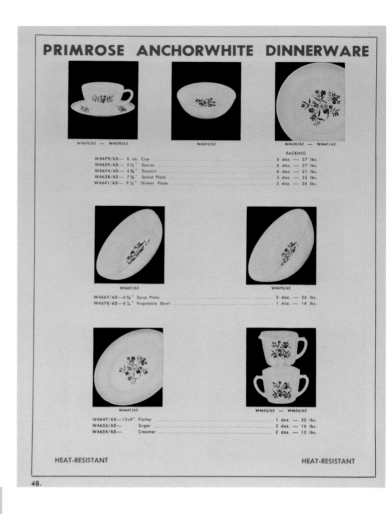

PRIMROSE ANCHORWHITE DINNERWARE

W4679/62 — W4629/62 W4674/62 W4638/62 — W4641/62

		PACKING
W4679/62 — 8 oz. Cup		6 doz. — 27 lbs.
W4629/62 — 5⅜" Saucer		6 doz. — 27 lbs.
W4674/62 — 4⅝" Dessert		6 doz. — 21 lbs.
W4638/62 — 7⅜" Salad Plate		3 doz. — 23 lbs.
W4641/62 — 9⅛" Dinner Plate		3 doz. — 36 lbs.

W4667/62 W4678/62

W4667/62 — 6⅝" Soup Plate	3 doz. — 26 lbs.
W4678/62 — 8½" Vegetable Bowl	1 doz. — 14 lbs.

W4647/62 W4653/62 — W4654/62

W4647/62 — 12x9" Platter	1 doz. — 20 lbs.
W4653/62 — Sugar	2 doz. — 16 lbs.
W4654/62 — Creamer	2 doz. — 12 lbs.

HEAT-RESISTANT HEAT-RESISTANT

48.

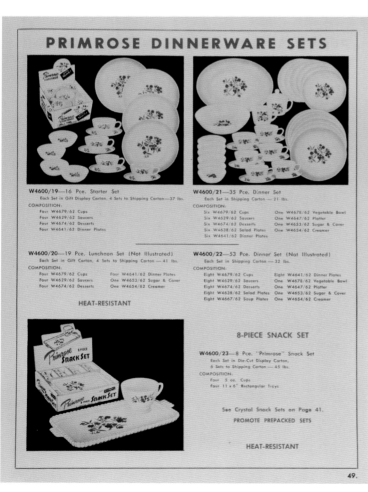

PRIMROSE DINNERWARE SETS

W4600/19—16 Pce. Starter Set
Each Set in Gift Display Carton, 4 Sets to Shipping Carton—37 lbs.
COMPOSITION:
Four W4679/62 Cups
Four W4629/62 Saucers
Four W4674/62 Desserts
Four W4641/62 Dinner Plates

W4600/21—35 Pce. Dinner Set
Each Set in Shipping Carton — 21 lbs.
COMPOSITION:
Six W4679/62 Cups One W4678/62 Vegetable Bowl
Six W4629/62 Saucers One W4647/62 Platter
Six W4674/62 Desserts One W4653/62 Sugar & Cover
Six W4638/62 Salad Plates One W4654/62 Creamer
Six W4641/62 Dinner Plates

W4600/20—19 Pce. Luncheon Set (Not Illustrated)
Each Set in Gift Carton, 4 Sets to Shipping Carton — 41 lbs.
COMPOSITION:
Four W4679/62 Cups Four W4641/62 Dinner Plates
Four W4629/62 Saucers One W4653/62 Sugar & Cover
Four W4674/62 Desserts One W4654/62 Creamer

W4600/22—53 Pce. Dinner Set (Not Illustrated)
Each Set in Shipping Carton — 32 lbs.
COMPOSITION:
Eight W4679/62 Cups Eight W4641/62 Dinner Plates
Eight W4629/62 Saucers One W4678/62 Vegetable Bowl
Eight W4674/62 Desserts One W4647/62 Platter
Eight W4638/62 Salad Plates One W4653/62 Sugar & Cover
Eight W4667/62 Soup Plates One W4654/62 Creamer

HEAT-RESISTANT

8-PIECE SNACK SET

W4600/23—8 Pce. "Primrose" Snack Set
Each Set in Die-Cut Display Carton,
6 Sets to Shipping Carton — 45 lbs.
COMPOSITION:
Four 5 oz. Cups
Four 11 x 6" Rectangular Trays

See Crystal Snack Sets on Page 41.
PROMOTE PREPACKED SETS

HEAT-RESISTANT

49.

Primrose Dinnerware Listed in the 1961-2 Catalog

Cat. Item No.	Price
W4600/19	$100-125 with original box
W4600/20	$125-150 with original box
W4600/21	$150-175 with original box
W4600/22	$200-300 with original box
W4600/23	$40-50 with original box

PRIMROSE OVENWARE

Primrose Ovenware Listed in the 1961-2 Catalog

Cat. Item No.	Price
W424/62	$3-5
W405/62	$10-15
W406/62	$12-15
W407/62	$15-15
W408/62	$15-20
W467/62	$15-20
W450/62	$12-15
W452/62	$12-15
W409/62	$15-20
W410/62	$12-15
W411/62	$15-20

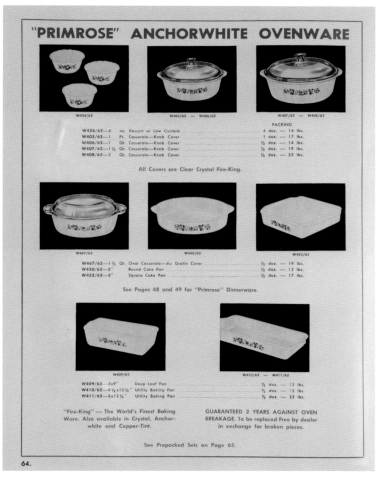

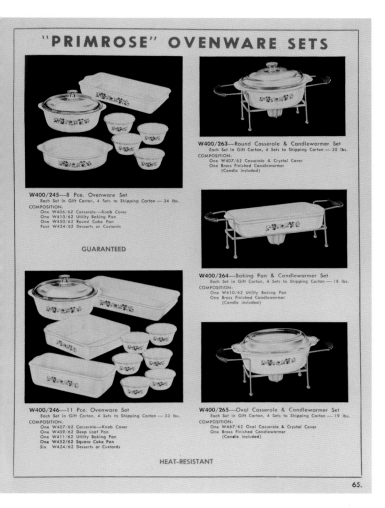

Primrose Ovenware Listed in the 1961-2 Catalog

Cat. Item No.	Price
W400/245	$75-80 with original box
W400/246	$80-100 with original box
W400/263	$40-50 with original box
W400/264	$33-40 with original box
W400/265	$40-50 with original box

ROYAL LUSTRE DINNERWARE

Royal Lustre Listed in the 1976 Catalog

Cat. Item No.	Price
L346 (A)	$10-12
L366 (B)	$15-20
L347 (C)	$20-25
L378 (D)	$15-20
L374 (E)	$5-8

Cat. Item No.	Price
L338 (F)	$5-8
L379 (G)	$8-10
L329 (H)	$3-5
L369 (I)	$12-15
L339 (J)	$15-20

ROYAL LUSTRE

			BULK PACKED (BY DOZEN)		
photo ref.	description	item order no.	shipper doz.	shipper lbs.	price doz.
A	10" dinner plate	L346	3	49	
B	9" rim soup	L366	3	40	
C	9-¾" x 13" oval platter	L347	1	23	
D	8½" vegetable bowl	L378	1	16	
E	4-¾" dessert	L374	3	13	
F	7-⅜" salad plate	L338	3	29	
G	6-¾ oz. cup	L379	3	14	
H	5-⅞" saucer	L329	3	18	
I	2½ oz. demitasse cup	L369	6	15	
J	4-¾" demitasse saucer	L339	6	23	

NOTE: *Blue item indicates new product and/or packaging.*
See index for additional listings of Royal Lustre bulk and gift items.

TABLEWARE BULK

95

SANDWICH

The sales brochure lists the Sandwich pattern in sets. I priced individual items in each set. If the item was listed in more that one set, it was only priced once.

Crystal Sandwich Listed in the 1953 Sales Brochure

Item/Set No.	Price
1400/22 6 1/2" Cereal bowl	$10-12
1400/7 9 oz. Water tumbler	$8-10
1400/29 Footed sherbet	$6-8
1400/10 6 1/2" Scalloped bowl	$8-10
1400/10 8" Serving bowl	$10-15
1400/30 Punch bowl	$25-30
1400/30 Punch cup	$3-4
1400/21 7" Dessert plate	$10-15
1400/9 2 Quart pitcher	$40-50
1400/19 Cookie jar	$30-35
1400/24 12" Serving plate	$15-20

Crystal Sandwich Listed in the 1953 Sales Brochure

Item/Set No.	Price	Item/Set No.	Price
1400/28 Coffee cup	$3-5	1400/20 Butter and cover	$40-50
1400/28 Saucer	$3-4	1400/20 5 3/4" Oval bowl	$12-15
1400/5 7" Scalloped bowl	$8-12	1400/23 Footed tumbler	$30-35
1400/5 8" Scalloped bowl	$8-12	1400/14 9" Snack plate	$5-10
1400/26 Punch bowl base	$30-40	1400/14 Snack cup	$3-5
1400/20 Creamer	$8-10	1400/11 36 oz. Juice pitcher	$35-45
1400/20 Sugar	$8-10		

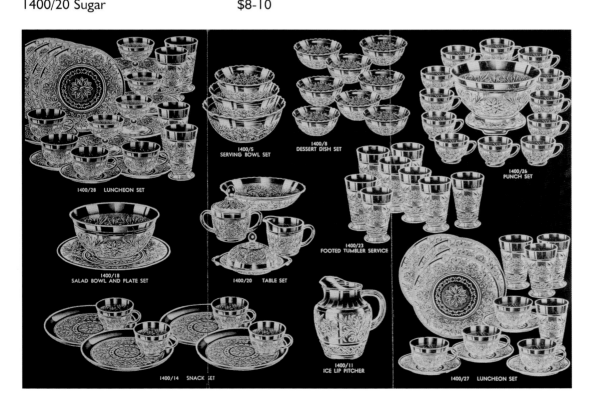

Crystal Sandwich Listed in the 1955 Sales Brochure

Item/Set No.	Price
1403	$6-8
1401	$8-10
1473	$12-15
1474	$15-20
1459	$35-45
1487	$40-50
1453	$8-10
1454	$8-10
1455	$40-50
1456	$12-15
1426	$8-10
1427	$8-12

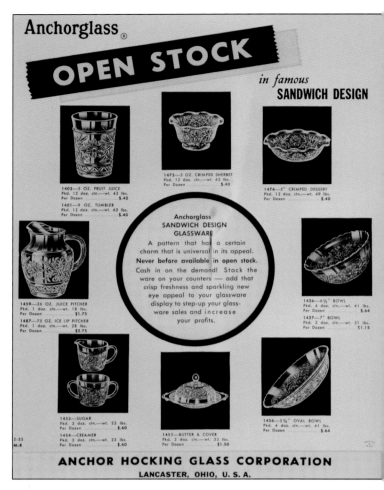

SAPPHIRE DINNERWARE

Sapphire Fire-King Tableware Listed in the 1949 Catalog

Cat. Item No.	Price
B1650	$4-5
B1628	$1-2
B1630	$4-5
B1641	$8-10
B1667	$15-20
B1664	$12-15
B1665	$12-15
B1678	$15-20
B1646	$15-20

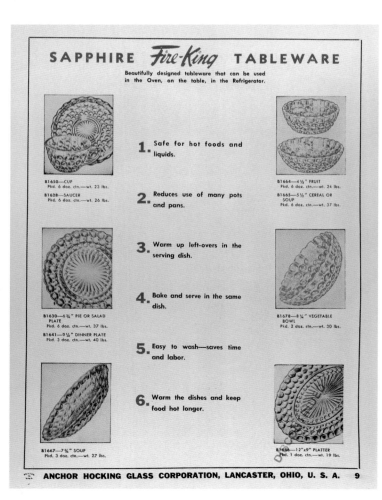

SAPPHIRE OVENWARE

Sapphire Fire-King Ovenware Listed in the 1949 Catalog

Cat. Item No.	Price
B3405	$15-20
B3406	$15-20
B3407	$20-25
B3408	$20-25
B3445	$8-10
B3446	$10-15
B3447	$12-15
B3448	$15-20
B3400/71	$40-50
B3449	$70-80
B3497	$20-25
B3498	$20-25
B3493	$15-20
B3443	$10-12

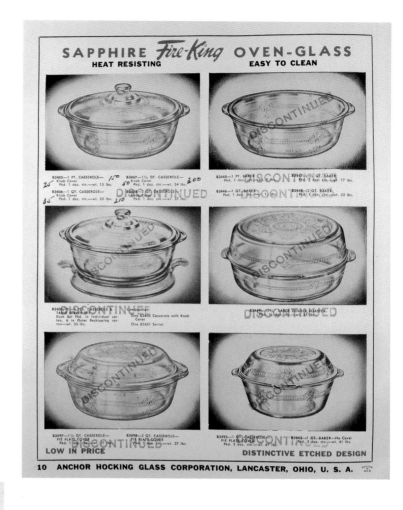

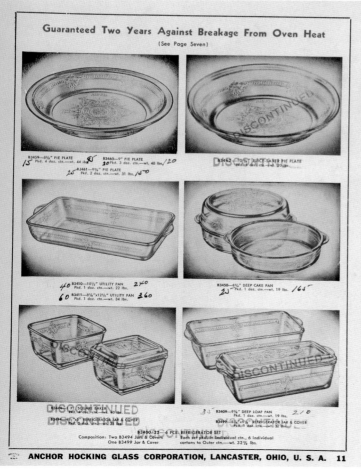

Sapphire Fire-King Ovenware Listed in the 1949 Catalog

Cat. Item No.	Price
B3459	$8-10
B3460	$10-12
B3461	$10-12
B3462	$125-150
B3410	$25-30
B3411	$40-50
B3450	$30-40
B3444	$8-10
B3494	$12-15
B3409	$20-25
B3499	$35-45
B3400/22	$80-100 with original box

Sapphire Fire-King Ovenware Listed in the 1949 Catalog

Cat. Item No.	Price
B3402	$12-15
B3465	$20-25
B3457	$15-20
B3420	$5-8
B3421	$5-8
B3413	$5-8
B97	$20-25
B3412	$25-30
B3468	$25-35
B3464	$15-20
B5	$5-8

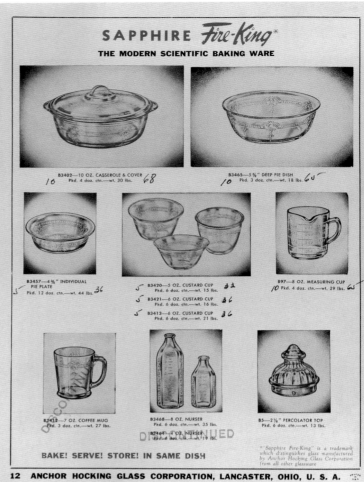

SAVANNAH

Savannah Listed in the 2002 Catalog

Cat. Item No.	Price
86114C (A)	$1-2
86115C (B)	$2-3
86232C (C)	$5-8
86109 (D)	$5-8 per set
86116 (E)	$1-2
86107 (E)	$5-8 per set
86106 (F)	$10-12 per set
86117 (G)	$10-12
86108 (H)	$10-12
86105 (I)	$8-12
86104 (J)	$10-15

SHELL

The Shell pattern was generally made in Crystal with the 6" salad plate made in Royal Ruby. The Royal Ruby plates are marked with the "anchor over H" emblem near the tab handle, while the Crystal Shell pieces are unmarked. The iridescent Aurora finish was applied to a limited number of pieces. The 1979 Bulk Catalog lists five sizes of glasses for the Shell Pattern. The glasses seem to be some of the hardest pieces to find in this pattern.

Shell Listed in the 1978 Gift Selection Catalog

Catalog Item Description	Price
9 3/4" Dinner plate	$4-5
9 3/4" Snack plate (not shown)	$5-8
6" Salad/dessert plate	$3-5
8" Salad/dessert plate	$5-8
5 3/4" Saucers	$2-4
7 oz. Cups	$1-2
12 oz. Handled soup	$10-15
5" Diameter bowl	$3-5
11" Diameter salad bowl (not shown)	$10-12
10" Sectioned plate	$10-15

20-PC. DINNERWARE SET
500/264

The Shell Collection

An intriguing reproduction of nature's own handiwork. Subtle frosted texture and graceful scallops offer a pleasing complement for mealtime, snack-time anytime.

500/264 Crystal
The Shell Collection 20-Pc. Dinnerware Set. 4 each: 7-oz. cups, 5¾" saucers; 8" salad/dessert plates; 12-oz. handled soups; 9¾" dinner plates. Gift carton.
2 sets/48 lbs.

42 Tableware

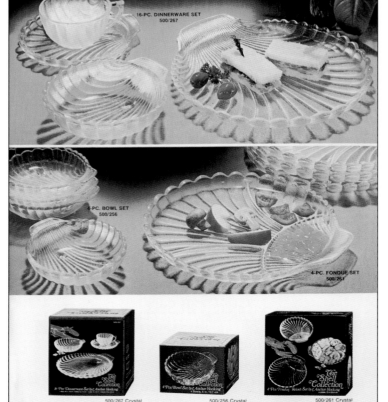

16-PC. DINNERWARE SET
500/267

4-PC. BOWL SET
500/256

4-PC. FONDUE SET
500/261

500/267 Crystal
The Shell Collection 16-Pc. Dinnerware Set. 4 each: 7-oz. cups, 5¾" saucers; 6" salad/dessert bowls; 9¾" dinner plates. In gift carton.
2 sets/34 lbs.

500/256 Crystal
The Shell Collection 4-Pc. Serving Bowl Set. Four 5" diameter bowls. In gift carton.
6 sets/12 lbs.

500/261 Crystal
The Shell Collection 4-Pc. Fondue/Relish Set. Four 10" sectioned plates. In gift carton.
4 sets/36 lbs.

See index for additional listings of Shell gift items. Tableware 43

3 5/8" Coaster (not shown)	$2-4
6 oz. Juice/wine (not shown)	$5-8
6 1/2 oz. Champagne/sherbet (not shown)	$5-8
9 oz. On-the-rocks (not shown)	$5-10
9 3/4 oz. Goblet (not shown)	$8-10
12 oz. Tumbler (not shown)	$10-12

Shell listed in the 1978 Gift Selection catalog.

SUMMERFIELD OVENWARE

Summerfield Fire-King Ovenware Listed in the 1974 Catalog

Cat. Item No.	Price
WH438/185 (A)	$10-12
WH439/185 (B)	$12-15
WH437/185 (C)	$10-12
WH433/185 (D)	$10-12
W432/185 (E)	$8-10
W431/185 (F)	$10-15
W441/185 (G)	$8-10
W434/185 (H)	$2-4
W429/185 (I)	$10-12
W435/185 (J)	$10-12

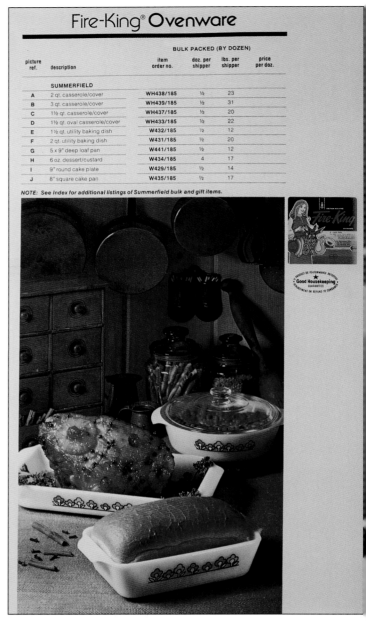

Fire-King® Ovenware

picture ref.	description	item order no.	doz. per shipper	lbs. per shipper	price per doz.
	SUMMERFIELD				
A	2 qt. casserole/cover	WH438/185	½	23	
B	3 qt. casserole/cover	WH439/185	½	31	
C	1½ qt. casserole/cover	WH437/185	½	20	
D	1½ qt. oval casserole/cover	WH433/185	½	22	
E	1½ qt. utility baking dish	W432/185	½	12	
F	2 qt. utility baking dish	W431/185	½	20	
G	5 x 9" deep loaf pan	W441/185	½	12	
H	6 oz. dessert/custard	W434/185	4	17	
I	9" round cake plate	W429/185	½	14	
J	8" square cake pan	W435/185	½	17	

BULK PACKED (BY DOZEN)

NOTE: See Index for additional listings of Summerfield bulk and gift items.

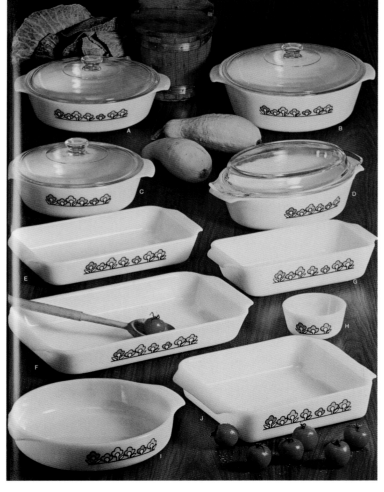

Summerfield Fire-King Ovenware listed in the 1974 catalog.

SWEDISH MODERN

Anchor Hocking made numerous items in the Swedish Modern pattern. Although the majority of the pattern's production was in crystal, some of the bowls were produced in both Forest Green and Royal Ruby. Georges Briard, Silver City Glass Company, Metalyte, Inc., Fred Press, and Culver, Ltd. decorated the bowls (clear and frosted) and cake plate with sterling silver, rhodium, platinum, or 22 kt. gold. These same pieces were also attached to pedestals to make table centerpieces or candy dishes. The prices listed below are for the crystal pieces only.

Swedish Modern Listed in the 1961-2 Catalog

Cat. Item No.	Price	Cat. Item No.	Price
520	$2-4	1053	$3-5
521	$2-4	1054	$3-5
522	$2-4	1074	$2-4
523	$2-4	1078	$1-2
1010	$5-10		

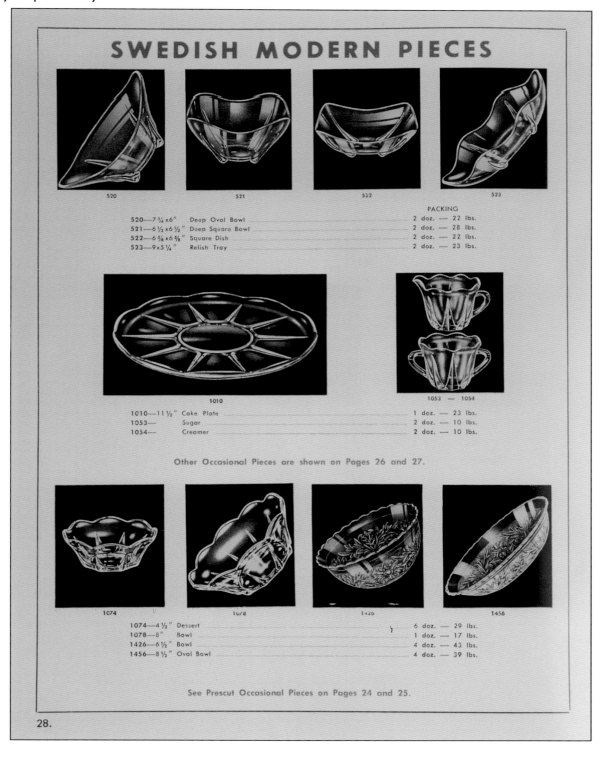

SWEDISH MODERN PIECES

| 520 | 521 | 522 | 523 |

PACKING

520—7 ¼ x 6" Deep Oval Bowl 2 doz. — 22 lbs.
521—6 ½ x 6 ½" Deep Square Bowl 2 doz. — 28 lbs.
522—6 ⅝ x 6 ⅝" Square Dish 2 doz. — 22 lbs.
523—9 x 5 ¼" Relish Tray 2 doz. — 23 lbs.

| 1010 | 1053 — 1054 |

1010—11 ½" Cake Plate 1 doz. — 23 lbs.
1053— Sugar 2 doz. — 10 lbs.
1054— Creamer 2 doz. — 10 lbs.

Other Occasional Pieces are shown on Pages 26 and 27.

| 1074 | 1078 | 1426 | 1456 |

1074—4 ½" Dessert 6 doz. — 29 lbs.
1078—8" Bowl 1 doz. — 17 lbs.
1426—6 ½" Bowl 4 doz. — 43 lbs.
1456—8 ½" Oval Bowl 4 doz. — 39 lbs.

See Prescut Occasional Pieces on Pages 24 and 25.

28.

TEFLON COATED OVENWARE

Teflon Coated Ovenware Listed in the 1965 Catalog

Cat. Item No.	Price
H406/51	$10-12
H407/51	$10-12
H467/51	$12-15
H450/51	$5-10
H409/51	$5-8
H410/51	$5-10
H400/384	$15-20

mira-clean TEFLON coated ovenware

The first glass ovenware with famous DuPont Teflon coating. Featured in magazine color ads and TV. Cocoa brown with appetizing creamy beige Teflon. Casseroles have Fire-King glass covers.

			Doz. Ctn.	Lbs. Ctn.	Price Doz.
H406/51	1 qt	casserole/cover	½	14	$12.00
H407/51	1½ qt	casserole/cover	½	19	13.50
H467/51	1½ qt	oval casserole/ au gratin cover	½	20	13.50
H450/51	8"	round cake pan	½	12	11.40
H409/51	5 x 9"	deep loaf pan	½	12	12.00
H410/51	6½ x 10½"	utility baking pan	½	15	13.50

candlewarmer set

		Sets Ctn.	Lbs. Ctn.	Price Set
H400/384	Round casserole/candle-warmer set, gift carton, 1½ qt casserole/cover, brass-finished candlewarmer	4	20	$ 2.50

NO-STICK COOKING WITH NO-SCOUR CLEAN-UP
TEFLON ®
DU PONT
APPROVED FINISH

TEFLON is Du Pont's registered trademark for its TFE non-stick finish.
A 31428 PRINTED IN U.S.A.

Replacement Offer: If dish breaks from normal oven heat within two years from date of customer's purchase, and Fire-King Ovenware instructions have been followed, the dealer is authorized to make replacement in exchange for the broken pieces.

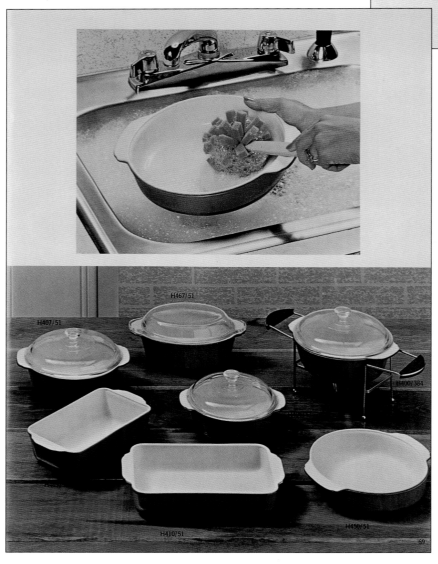

Teflon coated ovenware listed in the 1965 catalog.

WEXFORD

This is one of the patterns that Anchor Hocking made for over twenty years. There are probably at least forty different pieces made in this pattern, not including the Pewter Mist or 22 kt. gold or red lacquer coated pieces. I will include all the pieces in later editions of the book.

Wexford Listed in the 1978 Gift Selection Catalog

Cat. Item No.	Price
4500/148	$30-40 in the original box
4500/99	$15-20 in the original box
4500/110	$40-50 in the original box

Wexford Bar Sets

Elegant Bar Sets with the look of cut crystal, at attractive prices, too!

All packaged in full color label cartons.

4500/148 Crystal NEW 8-Pc. Bar Set. Wexford set with four 9½-oz. on-the-rocks, ice bucket with cover and chrome plated handle and tongs. Packaged in full color gift carton.
4 sets/34 lbs.

4500/99 Crystal 4-Pc. Ice Bucket Set. Wexford ice bucket with cover, handle and tongs. Packed in gift carton.
6 sets/31 lbs.

4500/110 Crystal 4-Pc. Beer Mug Set. Four Wexford 15-oz. beer mugs packaged in full color label gift carton.
6 sets/29 lbs.

18 Beverageware

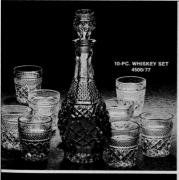

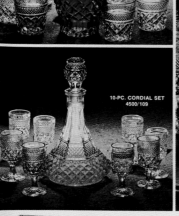

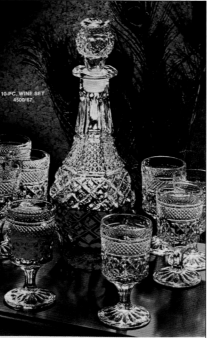

Wexford Listed in the 1978 Gift Selection Catalog

Cat. Item No.	Price
4500/77	$20-25 in the original box
4500/109	$30-35 in the original box
4500/67	$20-25 in the original box

4500/77 Crystal 10-Pc. Whiskey Set. Eight Wexford 9½-oz. on-the-rocks, one 32-oz. Wexford decanter and stopper with sealing feature. In display/gift carton.
2 sets/18 lbs.

4500/67 Crystal 10-Pc. Wine Set. Eight Wexford 5½-oz. stemmed wines, one 32-oz. Wexford decanter and stopper with sealing feature. Packed in display/gift carton.
2 sets/18 lbs.

4500/109 Crystal 10-Pc. Cordial Set. Eight Wexford 3-oz. cordials, one 32-oz. Wexford Captain's decanter and stopper with sealing feature. Packed in gift carton.
2 sets/13 lbs.

See index for additional listings of Wexford gift items. Beverageware 19

Wexford Listed in the 1962 Institutional Glassware Catalog		4516	$1-2
Cat. Item No.	Price	4512	$2-3
		4513	$1-2
4510	$1-2	4574	$2-3
4511	$1-2		

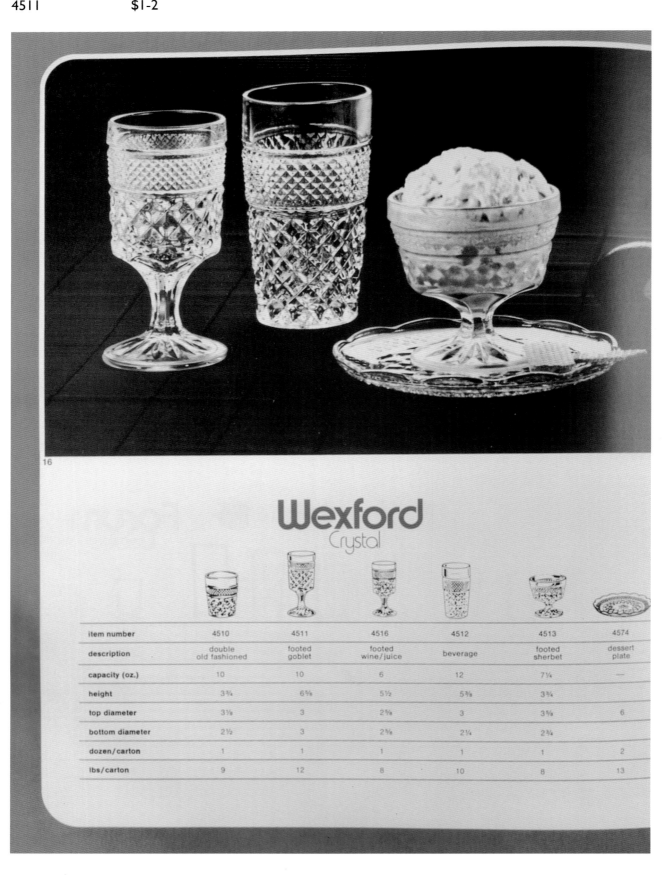

16

Wexford Crystal

item number	4510	4511	4516	4512	4513	4574
description	double old fashioned	footed goblet	footed wine/juice	beverage	footed sherbet	dessert plate
capacity (oz.)	10	10	6	12	7¼	—
height	3¾	6⅝	5½	5⅜	3¾	
top diameter	3⅛	3	2⅝	3	3⅝	6
bottom diameter	2½	3	2⅝	2¼	2¾	
dozen/carton	1	1	1	1	1	2
lbs/carton	9	12	8	10	8	13

WHEAT DINNERWARE

Wheat Dinnerware Listed in the 1965 Catalog

Cat. Item No.	Price	Cat. Item No.	Price
W4679/65	$3-5	W4647/65	$15-20
W4629/65	$2-3	W4653/65	$8-10
W4674/65	$4-5	W4654/65	$5-8
W4638/65	$5-8	W4600/46	$50-60
W4667/65	$8-12	W4600/47	$200+
W4646/65	$5-10	W4600/48	$300+
W4678/65	$10-15		

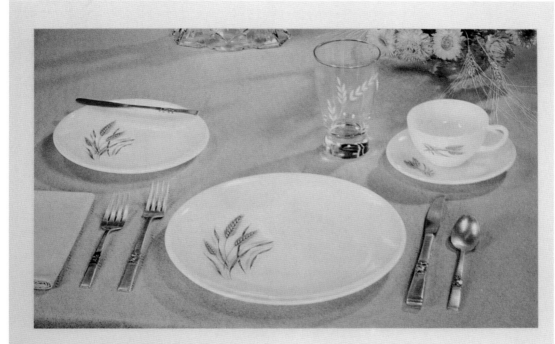

wheat dinnerware

Heat-resistant; golden wheat on a clean contemporary shape.
Matches Wheat ovenware. In open stock and packaged sets.

			Doz. Ctn.	Lbs. Ctn.	Price Doz.
W4679/65	8 oz	cup	3	14	$1.10
W4629/65	5¾″	saucer	3	14	1.10
W4674/65	4⅝″	dessert	3	11	1.10
W4638/65	7⅜″	salad plate	3	23	1.80
W4667/65	6⅝″	soup plate	3	25	1.75
W4646/65	10″	dinner plate	3	44	2.40
W4678/65	8¼″	vegetable bowl	1	14	2.70
W4647/65	12 x 9″	platter	1	20	3.60
W4653/65		sugar/cover	1	9	2.10
W4654/65		creamer	1	7	1.50

Packed Sets		Sets Ctn.	Lbs. Ctn.	Price Set
W4600/46	16 pc set, display carton, 4 cups, 4 saucers, 4 desserts, 4 dinner plates	4	38	$1.90
W4600/47	35 pc set, 6 cups, 6 saucers, 6 desserts, 6 soup plates, 6 dinner plates, vegetable, platter, sugar/cover, creamer	1	23	4.60
W4600/48	53 pc set, 8 cups, 8 saucers, 8 desserts, 8 salad plates, 8 soup plates, 8 dinner plates, vegetable, platter, sugar/cover, creamer	1	34	7.20

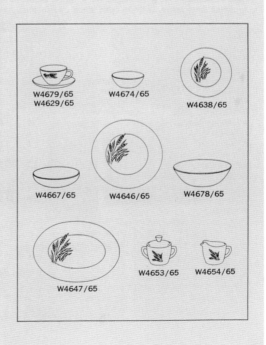

36

WHEAT OVENWARE

Wheat Fire-King Ovenware Listed in the 1965 Catalog

Cat. Item No.	Price
W424/65	$3-5
W405/65	$10-12
W406/65	$12-15
W407/65	$12-15
W497/65	$12-15
W467/65	$15-20
W408/65	$15-20
W488/65	$18-20
W450/65	$12-15
W452/65	$10-12
W409/65	$12-15
W410/65	$15-18
W411/65	$15-20
W420E/65	$3-5
W400/313	$50-75
W400/314	$80-100

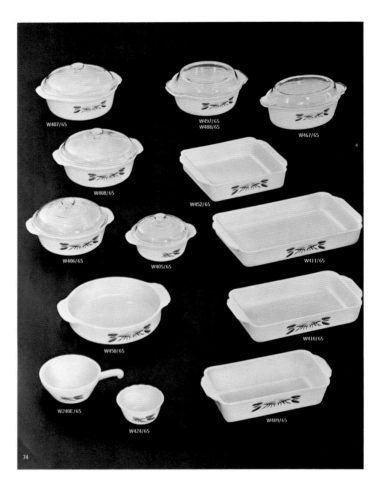

wheat fire-king ovenware

Golden Wheat design matches our Wheat dinnerware and snack sets. Sell singly, in gift sets, or make up your own promotional units. A highly popular ovenware design on translucent white.

			Doz. Ctn.	Lbs. Ctn.	Price Doz.
W424/65	6 oz	dessert/low custard	4	14	$1.14
W405/65	1 pt	casserole/knob cover	1	16	4.55
W406/65	1 qt	casserole/knob cover	½	14	6.28
W407/65	1½ qt	casserole/knob cover	½	19	6.85
W497/65	1½ qt	casserole/ au gratin cover	½	19	6.85
W467/65	1½ qt	oval casserole/ au gratin cover	½	18	6.85
W408/65	2 qt	casserole/knob cover	½	22	7.43
W488/65	2 qt	casserole/ au gratin cover	½	22	7.43
W450/65	8"	round cake pan	½	12	5.12
W452/65	8"	square cake pan	½	17	6.28
W409/65	5 x 9"	deep loaf pan	½	12	5.64
W410/65	6½ x 10½"	utility baking pan	½	15	5.64
W411/65	8 x 12½"	utility baking pan	½	22	7.43
W240E/65	12 oz	French casserole	2	16	2.00

Sets — Gift Carton

W400/313		8 pc set, gift carton, 1 qt casserole/cover, 10½" utility baking pan, 8" cake pan, 4 6 oz desserts	4 sets	34	1.90 set
W400/314		11 pc set, gift carton, 1½ qt casserole/cover, 5 x 9" loaf pan, 8 x 12½ baking pan, 8" square cake pan, 6 6 oz desserts/custards	4 sets	53	2.85 set

Replacement Offer: If dish breaks from normal oven heat within two years from date of customer's purchase, and Fire-King Ovenware instructions have been followed, the dealer is authorized to make replacement in exchange for the broken pieces.

Wheat Fire-King ovenware listed in the 1965 catalog.

Chapter Two
Punch Sets

The majority of the punch sets were made for years and therefore are reasonably easy to find, even in the original boxes. The sets in the original boxes should command a fifty percent increase in price over the unboxed sets. Of all the sets Anchor Hocking produced, the Heritage Hill and Rainflower seem to be the most elusive.

Punch Sets

Item Pattern	Price
Arlington	$20-30
Colonial	$40-50
Heritage Hill	$50-60
Prescut	$30-40
Rainflower	$40-50
Shell	$40-50
Vintage	$20-30
Vintage Frosted	$30-40
Wexford	$20-30

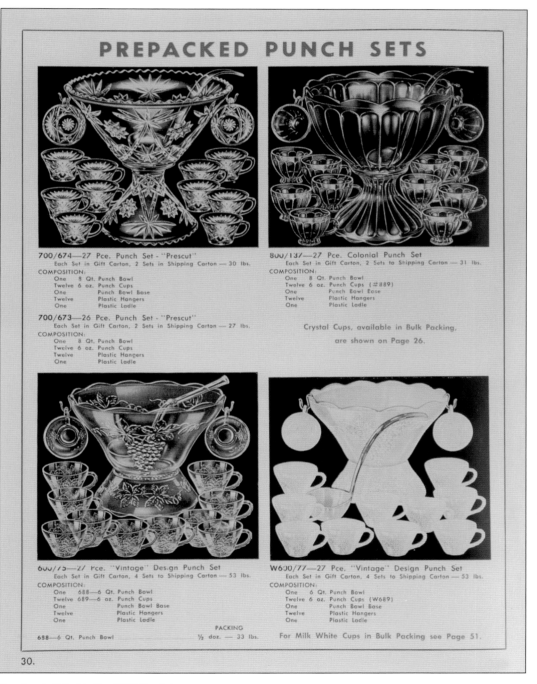

Punch sets listed in the 1961-2 catalog.

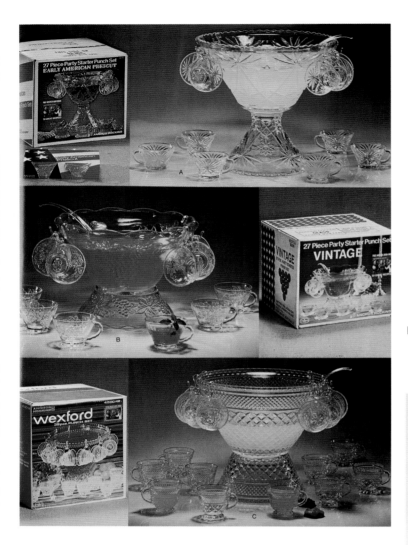

Punch sets listed in the 1974 catalog.

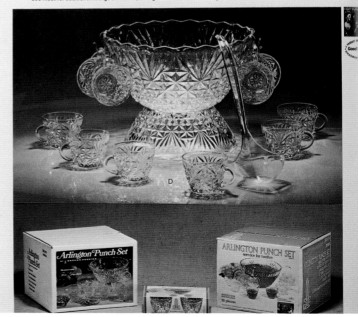

Punch sets listed in the 1974 catalog.

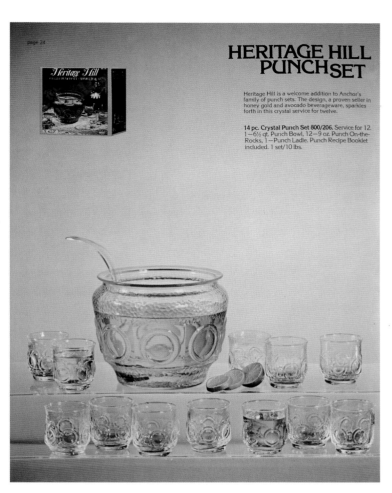

HERITAGE HILL PUNCH SET

Heritage Hill is a welcome addition to Anchor's family of punch sets. The design, a proven seller in honey gold and avocado beverageware, sparkles forth in this crystal service for twelve.

14 pc. Crystal Punch Set 800/206. Service for 12. 1—6½ qt. Punch Bowl, 12—9 oz. Punch On-the-Rocks, 1—Punch Ladle. Punch Recipe Booklet included. 1 set/10 lbs.

Punch sets listed in the 1975 catalog.

Punch sets listed in the 1978 Gift Set Collection catalog.

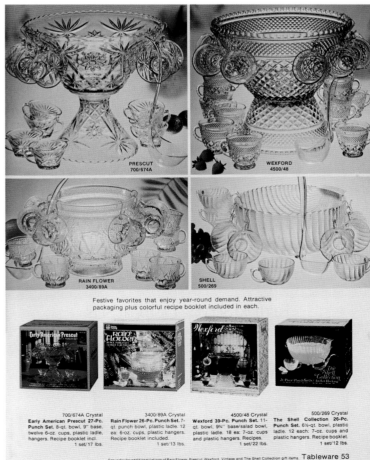

PRESCUT
700/674A

WEXFORD
4500/48

RAIN FLOWER
3400/89A

SHELL
500/269

Festive favorites that enjoy year-round demand. Attractive packaging plus colorful recipe booklet included in each.

700/674A Crystal Early American Prescut 27-Pc. Punch Set. 8-qt. bowl, 9" base, twelve 6-oz. cups, plastic ladle, hangers. Recipe booklet incl. 1 set/17 lbs.

3400/89A Crystal Rain Flower 26-Pc. Punch Set. 7-qt. punch bowl, plastic ladle. 12 ea: 6-oz. cups, plastic hangers. Recipe booklet included. 1 set/13 lbs.

4500/48 Crystal Wexford 39-Pc. Punch Set. 11-qt. bowl, 9¾" base/salad bowl, plastic ladle. 18 ea: 7-oz. cups and plastic hangers. Recipes. 1 set/22 lbs.

500/269 Crystal The Shell Collection 26-Pc. Punch Set. 6½-qt. bowl, plastic ladle. 12 each: 7-oz. cups and plastic hangers. Recipe booklet. 1 set/12 lbs.

See index for additional listings of Rain Flower, Prescut, Wexford, Vintage and The Shell Collection gift items. Tableware 53

Chapter Three
Dinnerware Sets

Many of the patterns, especially Ironstone, have no real established prices. Some collectors do not recognize the patterns as being made by Anchor Hocking. Prices will vary depending upon the applied decoration, style (i.e., coupe or rim shape of Ironstone), and regional availability. I have attempted to group items to simplify pricing.

Dinnerware Sets

Item Description	Price
Dinner plate	$4-5
Salad plate	$2-4
Cup	$1-2
Saucer	$1-2
Creamer	$2-5
Sugar	$2-5
Large serving bowl	$5-10
Soup/cereal bowl	$2-5
Soup/cereal bowl underliner plate	$4-5

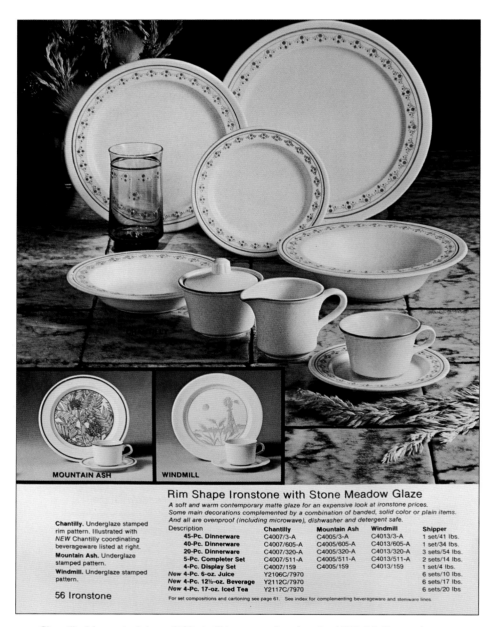

MOUNTAIN ASH **WINDMILL**

Rim Shape Ironstone with Stone Meadow Glaze

A soft and warm contemporary matte glaze for an expensive look at ironstone prices. Some main decorations complemented by a combination of banded, solid color or plain items. And all are ovenproof (including microwave), dishwasher and detergent safe.

Chantilly. Underglaze stamped rim pattern. Illustrated with *NEW* Chantilly coordinating beverageware listed at right.

Mountain Ash. Underglaze stamped pattern.

Windmill. Underglaze stamped pattern.

56 Ironstone

Description	Chantilly	Mountain Ash	Windmill	Shipper
45-Pc. Dinnerware	C4007/3-A	C4005/3-A	C4013/3-A	1 set/41 lbs.
40-Pc. Dinnerware	C4007/605-A	C4005/605-A	C4013/605-A	1 set/34 lbs.
20-Pc. Dinnerware	C4007/320-A	C4005/320-A	C4013/320-A	3 sets/54 lbs.
5-Pc. Completer Set	C4007/511-A	C4005/511-A	C4013/511-A	2 sets/14 lbs.
4-Pc. Display Set	C4007/159	C4005/159	C4013/159	1 set/4 lbs.
New **4-Pc. 6-oz. Juice**	Y2106C/7970			6 sets/10 lbs.
New **4-Pc. 12½-oz. Beverage**	Y2112C/7970			6 sets/17 lbs.
New **4-Pc. 17-oz. Iced Tea**	Y2117C/7970			6 sets/20 lbs

For set compositions and cartoning see page 61. See index for complementing beverageware and stemware lines.

Chantilly, Mountain Ash, and Windmill Ironstone listed in the 1979 Gift Set catalog.

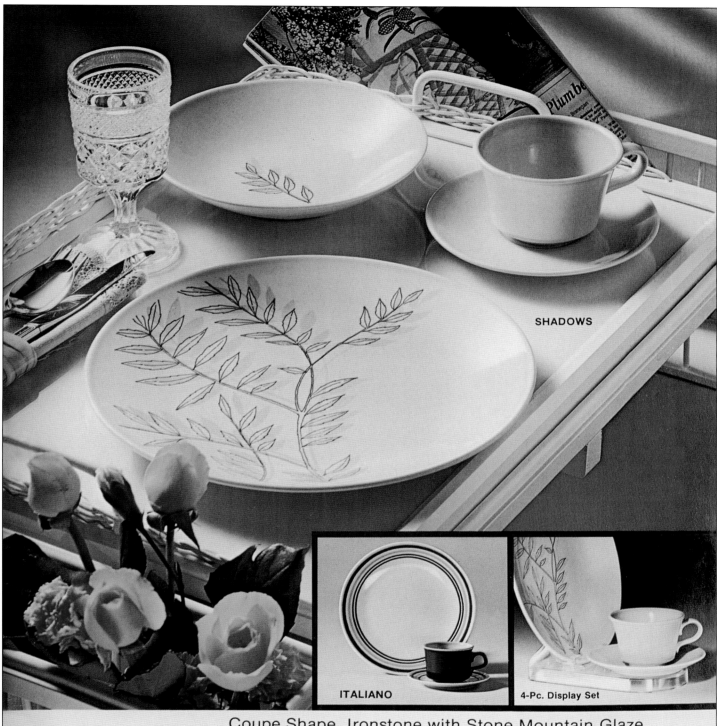

SHADOWS

ITALIANO

4-Pc. Display Set

Coupe Shape Ironstone with Stone Mountain Glaze

Misty shades of a cool gray reflective glaze accent Shadows and Italiano. The Shadows design theme combines selected undecorated items for a most aesthetically pleasing look . . . Italiano is accented with solid color holloware.

Shadows. Underglaze stamped pattern. Ovenproof, detergent and dishwasher safe, microwave safe too. Complementing beverageware shown is "Wexford".

Italiano. Underglaze stamped bands.

Description	Shadows	Italiano	Shipper
45-Pc. Dinnerware	C6062/3-A	C6002/3-A	1 set/38 lbs.
40-Pc. Dinnerware	C6062/605-A	C6002/605-A	1 set/32 lbs.
20-Pc. Dinnerware	C6062/320-A	C6002/320-A	3 sets/48 lbs.
5-Pc. Completer Set	C6062/511-A	C6002/511-A	2 sets/13 lbs.
4-Pc. Display Set	C6062/159	C6002/159	1 set/4 lbs.

For set compositions and cartoning see page 61.
See index for complementing beverageware and stemware lines.

Ironstone 57

Shadows and Italiano Ironstone listed in the 1979 Gift Set catalog.

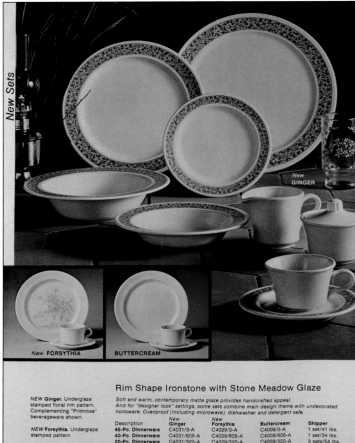

New **GINGER**

New **FORSYTHIA** **BUTTERCREAM**

Ginger, Forsythia, and Buttercream Ironstone
listed in the 1979 Gift Set catalog.

Rim Shape Ironstone with Stone Meadow Glaze

NEW **Ginger.** Underglaze stamped floral rim pattern. Complementing "Primrose" beverageware shown.

NEW **Forsythia.** Underglaze stamped pattern.

Buttercream. Warm earthtone with soft, satiny finish.

Soft and warm, contemporary matte glaze provides handcrafted appeal. And for "designer look" settings, some sets combine main design theme with undecorated holloware. Ovenproof (including microwave), dishwasher and detergent safe.

Description	New Ginger	New Forsythia	Buttercream	Shipper
45-Pc. Dinnerware	C4031/3-A	C4029/3-A	C4009/3-A	1 set/41 lbs.
40-Pc. Dinnerware	C4031/605-A	C4029/605-A	C4009/605-A	1 set/34 lbs.
20-Pc. Dinnerware	C4031/320-A	C4029/320-A	C4009/320-A	3 sets/54 lbs.
5-Pc. Completer Set	C4031/511-A	C4029/511-A	C4009/511-A	2 sets/14 lbs.
4-Pc. Display Set	C4031/159	C4029/159	C4009/159	1 set/4 lbs.

54 Ironstone

For set compositions and cartoning see page 61.
See index for complementing beverageware and stemware lines.

New **WILD CHERRY**

PEPPERCORN **SAGE**

Wild Cherry, Peppercorn, and Sage Ironstone
listed in the 1979 Gift Set catalog.

Rim Shape Ironstone with Stone Meadow Glaze

NEW Wild Cherry. Underglaze stamped pattern. Complementing "Flair" beverageware shown.

Peppercorn. Underglaze "SoftEdge" band.

Sage. Underglaze "SoftEdge" green band.

Soft, warm contemporary matte glaze enhances these patterns. All feature translucent color areas that give an iridescent effect. Wild Cherry theme accented with selected band and plain items for "Designer Look". Ovenproof (microwave too), dishwasher and detergent safe.

Description	New Wild Cherry	Peppercorn	Sage	Shipper
45-Pc. Dinnerware	C4030/3-A	C4021/3-A	C4022/3-A	1 set/41 lbs.
40-Pc. Dinnerware	C4030/605-A	C4021/605-A	C4022/605-A	1 set/34 lbs.
20-Pc. Dinnerware	C4030/320-A	C4021/320-A	C4022/320-A	3 sets/54 lbs.
5-Pc. Completer Set	C4030/511-A	C4021/511-A	C4022/511-A	2 sets/14 lbs.
4-Pc. Display Set	C4030/159	C4021/159	C4022/159	1 set/4 lbs.

For set compositions and cartoning see page 61.
See index for complementing beverageware and stemware lines.

Ironstone 55

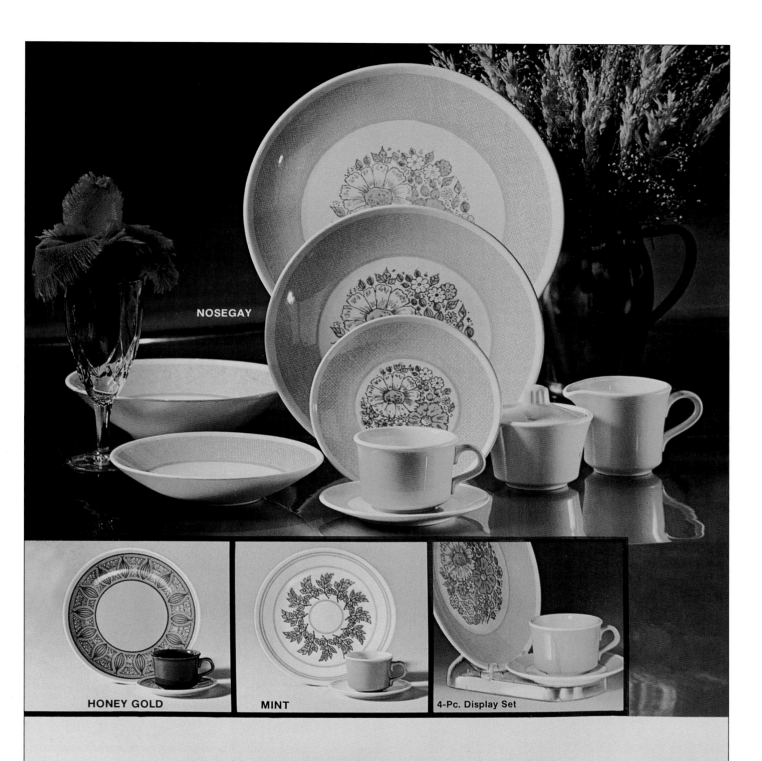

NOSEGAY

HONEY GOLD

MINT

4-Pc. Display Set

Coupe Shape Ironstone with Clear Glaze

For welcome tabletop additions in traditional clear glaze. Delightful patterns accented with solid color holloware. Ovenproof, dishwasher and detergent safe, microwave safe, too!

Nosegay. Underglaze stamped floral pattern. Complementing "Crown Point" stemware shown.

Honey Gold. Underglaze stamped pattern.

Mint. Underglaze stamped band and leaf pattern.

58 Ironstone

Description	Nosegay	Honey Gold	Mint	Shipper
45-Pc. Dinnerware	C6028/3-A	C6001/3-A	C6027/3	1 set/38 lbs.
40-Pc. Dinnerware	C6028/605-A	C6001/605-A	C6027/605	1 set/32 lbs.
20-Pc. Dinnerware	C6028/320-A	C6001/320-A	C6027/320	3 sets/48 lbs.
5-Pc. Completer Set	C6028/511-A	C6001/511-A	C6027/511	2 sets/13 lbs.
4-Pc. Display Set	C6028/159	C6001/159	C6027/159	1 set/4 lbs.

For set compositions and cartoning see page 61.
See index for complementing beverageware and stemware lines.

Nosegay, Honey Gold, and Mint Ironstone listed in the 1979 Gift Set catalog.

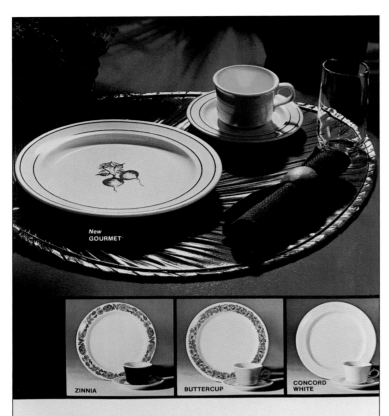

Gourmet, Zinnia, Buttercup, and Concord White
Ironstone listed in the 1979 Gift Set catalog.

Rim Shape Ironstone with Clear Glaze

NEW Gourmet. Underglaze stamped pattern. The complementing glassware shown is "Newport".

Zinnia. Underglaze stamped floral rim pattern.

Buttercup. Underglaze stamped floral rim pattern.

Concord White. Clear glaze.

Handsome offerings in traditional clear glaze accented by matching solid color or undecorated holloware. Pretty, practical and uncommonly durable—ovenproof, dishwasher and detergent safe. Microwave safe, too!

Description	New Gourmet	Zinnia	Buttercup	Concord White	Shipper
45-Pc. Set	C4027/3-A	C4001/3	C4004/3	C4000/3	1 set/41 lbs.
40-Pc. Set	C4027/605-A	C4001/605	C4004/605	C4000/605	1 set/34 lbs.
20-Pc. Set	C4027/320-A	C4001/320	C4004/320	C4000/320	3 sets/54 lbs.
5-Pc. Set	C4027/511-A	C4001/511	C4004/511	C4000/511	2 sets/14 lbs.
4-Pc. Set	C4027/159	C4001/159	C4004/159	C4000/159	1 set/4 lbs.

For set compositions and cartoning see page 61
See index for complementing beverageware and stemware lines.

Ironstone 53

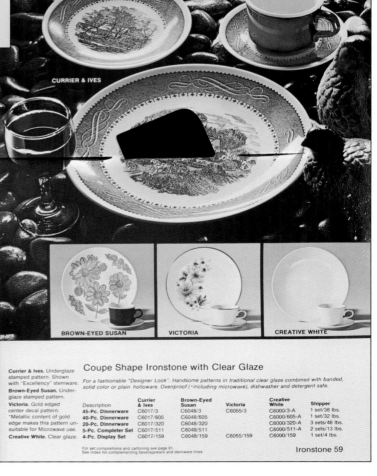

Courier and Ives, Brown-Eyed Susan, Victoria, and Creative
White Ironstone listed in the 1979 Gift Set catalog.

Coupe Shape Ironstone with Clear Glaze

Currier & Ives. Underglaze stamped pattern. Shown with "Excellency" stemware.

Brown-Eyed Susan. Underglaze stamped pattern.

Victoria. Gold edged center decal pattern. *Metallic content of gold edge makes this pattern unsuitable for Microwave use.

Creative White. Clear glaze.

For a fashionable "Designer Look". Handsome patterns in traditional clear glaze combined with banded, solid color or plain holloware. Ovenproof (·including microwave), dishwasher and detergent safe.

Description	Currier & Ives	Brown-Eyed Susan	Victoria	Creative White	Shipper
45-Pc. Dinnerware	C6017/3	C6048/3	C6055/3	C6000/3-A	1 set/38 lbs.
40-Pc. Dinnerware	C6017/605	C6048/605		C6000/605-A	1 set/32 lbs.
20-Pc. Dinnerware	C6017/320	C6048/320		C6000/320-A	3 sets/48 lbs.
5-Pc. Completer Set	C6017/511	C6048/511		C6000/511-A	2 sets/13 lbs.
4-Pc. Display Set	C6017/159	C6048/159	C6055/159	C6000/159	1 set/4 lbs.

For set compositions and cartoning see page 61
See index for complementing beverageware and stemware lines.

Ironstone 59

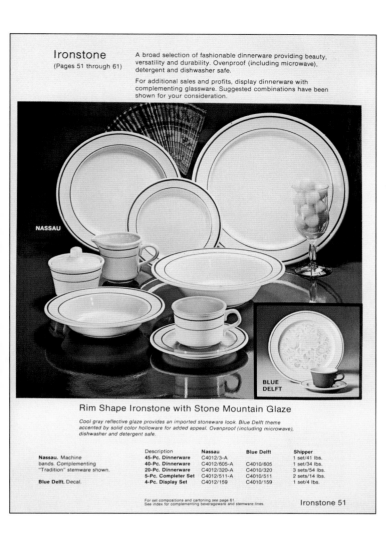

Ironstone
(Pages 51 through 61)

A broad selection of fashionable dinnerware providing beauty, versatility and durability. Ovenproof (including microwave), detergent and dishwasher safe.

For additional sales and profits, display dinnerware with complementing glassware. Suggested combinations have been shown for your consideration.

NASSAU

BLUE DELFT

Rim Shape Ironstone with Stone Mountain Glaze

Cool gray reflective glaze provides an imported stoneware look. Blue Delft theme accented by solid color holloware for added appeal. Ovenproof (including microwave), dishwasher and detergent safe.

Nassau. Machine bands. Complementing "Tradition" stemware shown.

Blue Delft. Decal.

Description	Nassau	Blue Delft	Shipper
45-Pc. Dinnerware	C4012/3-A		1 set/41 lbs.
40-Pc. Dinnerware	C4012/605-A	C4010/605	1 set/34 lbs.
20-Pc. Dinnerware	C4012/320-A	C4010/320	3 sets/54 lbs.
5-Pc. Completer Set	C4012/511-A	C4010/511	2 sets/14 lbs.
4-Pc. Display Set	C4012/159	C4010/159	1 set/4 lbs.

For set compositions and cartoning see page 61.
See index for complementing beverageware and stemware lines.

Ironstone 51

Nassau and Blue Delft Ironstone listed in the 1979 Gift Set catalog.

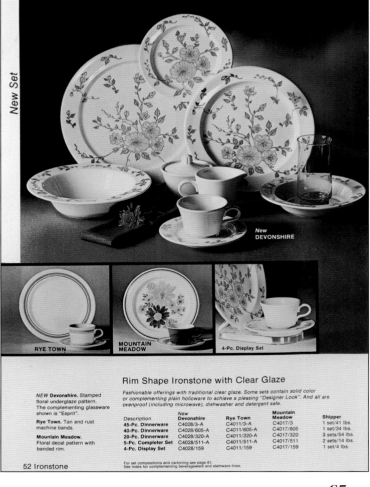

New Set

New DEVONSHIRE

RYE TOWN

MOUNTAIN MEADOW

4-Pc. Display Set

Rim Shape Ironstone with Clear Glaze

Fashionable offerings with traditional clear glaze. Some sets contain solid color or complementing plain holloware to achieve a pleasing "Designer Look". And all are ovenproof (including microwave), dishwasher and detergent safe.

NEW Devonshire. Stamped floral underglaze pattern. The complementing glassware shown is "Esprit".

Rye Town. Tan and rust machine bands.

Mountain Meadow. Floral decal pattern with banded rim.

Description	New Devonshire	Rye Town	Mountain Meadow	Shipper
45-Pc. Dinnerware	C4028/3-A	C4011/3-A	C4017/3	1 set/41 lbs.
40-Pc. Dinnerware	C4028/605-A	C4011/605-A	C4017/605	1 set/34 lbs.
20-Pc. Dinnerware	C4028/320-A	C4011/320-A	C4017/320	3 sets/54 lbs.
5-Pc. Completer Set	C4028/511-A	C4011/511-A	C4017/511	2 sets/14 lbs.
4-Pc. Display Set	C4028/159	C4011/159	C4017/159	1 set/4 lbs.

52 Ironstone

For set compositions and cartoning see page 61.
See index for complementing beverageware and stemware lines.

Devonshire, Rye Town, and Mountain Meadow Ironstone listed in the 1979 Gift Set catalog.

65

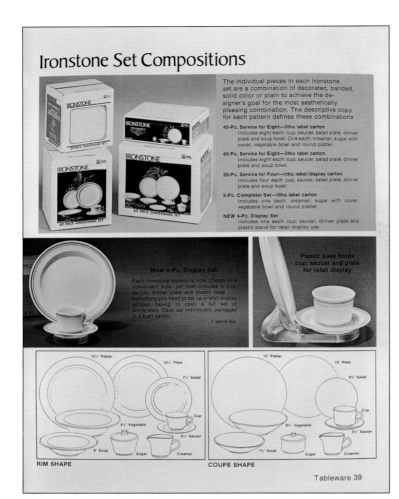

Caption text to the right of image 1:

Ironstone set combinations listed in
the 1978 Gift Set catalog.

Sierra Ironstone listed in the
1978 Gift Set catalog.

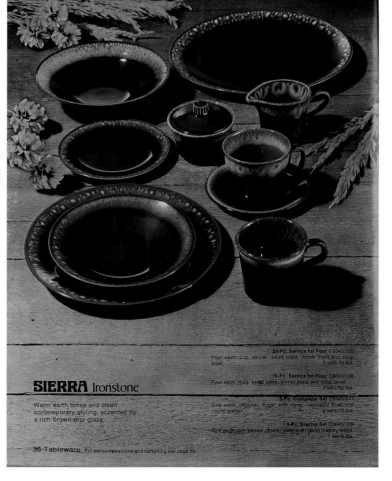

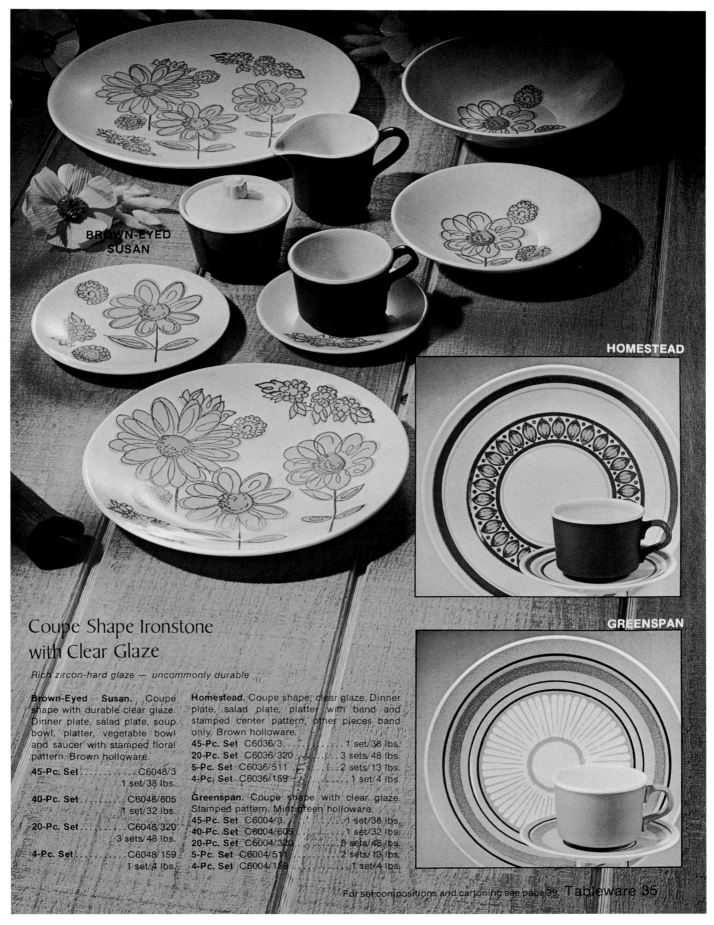

BROWN-EYED SUSAN

HOMESTEAD

GREENSPAN

Coupe Shape Ironstone with Clear Glaze

Rich zircon-hard glaze — uncommonly durable

Brown-Eyed Susan. Coupe shape with durable clear glaze. Dinner plate, salad plate, soup bowl, platter, vegetable bowl and saucer with stamped floral pattern. Brown holloware.

45-Pc. Set	C6048/3	1 set/38 lbs.
40-Pc. Set	C6048/605	1 set/32 lbs.
20-Pc. Set	C6048/320	3 sets/48 lbs.
4-Pc. Set	C6048/159	1 set/4 lbs.

Homestead. Coupe shape, clear glaze. Dinner plate, salad plate, platter with band and stamped center pattern, other pieces band only. Brown holloware.

45-Pc. Set	C6036/3	1 set/38 lbs.
20-Pc. Set	C6036/320	3 sets/48 lbs.
5-Pc. Set	C6036/511	2 sets/13 lbs.
4-Pc. Set	C6036/159	1 set/4 lbs.

Greenspan. Coupe shape with clear glaze. Stamped pattern. Mint green holloware.

45-Pc. Set	C6004/3	1 set/38 lbs.
40-Pc. Set	C6004/605	1 set/32 lbs.
20-Pc. Set	C6004/320	8 sets/48 lbs.
5-Pc. Set	C6004/511	2 sets/13 lbs.
4-Pc. Set	C6004/159	1 set/4 lbs.

For set compositions and cartoning see page 39. Tableware 35

Brown-Eyed Susan, Homestead, and Greenspan Ironstone listed in the 1978 Gift Set catalog.

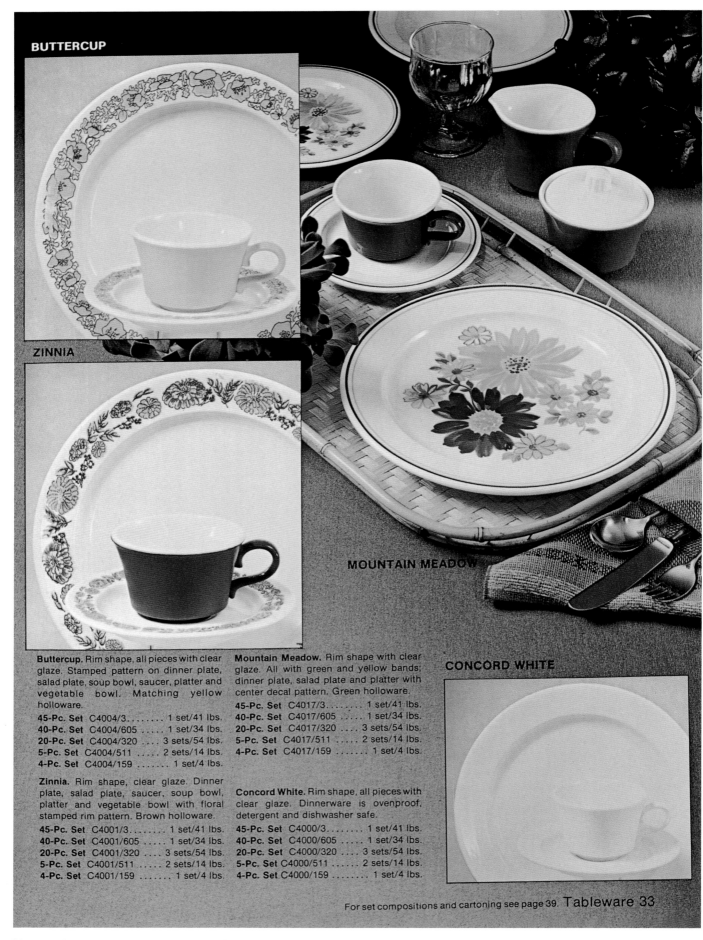

BUTTERCUP

ZINNIA

MOUNTAIN MEADOW

CONCORD WHITE

Buttercup. Rim shape, all pieces with clear glaze. Stamped pattern on dinner plate, salad plate, soup bowl, saucer, platter and vegetable bowl. Matching yellow holloware.

45-Pc. Set C4004/3 1 set/41 lbs.
40-Pc. Set C4004/605 1 set/34 lbs.
20-Pc. Set C4004/320 3 sets/54 lbs.
5-Pc. Set C4004/511 2 sets/14 lbs.
4-Pc. Set C4004/159 1 set/4 lbs.

Zinnia. Rim shape, clear glaze. Dinner plate, salad plate, saucer, soup bowl, platter and vegetable bowl with floral stamped rim pattern. Brown holloware.

45-Pc. Set C4001/3 1 set/41 lbs.
40-Pc. Set C4001/605 1 set/34 lbs.
20-Pc. Set C4001/320 3 sets/54 lbs.
5-Pc. Set C4001/511 2 sets/14 lbs.
4-Pc. Set C4001/159 1 set/4 lbs.

Mountain Meadow. Rim shape with clear glaze. All with green and yellow bands; dinner plate, salad plate and platter with center decal pattern. Green holloware.

45-Pc. Set C4017/3 1 set/41 lbs.
40-Pc. Set C4017/605 1 set/34 lbs.
20-Pc. Set C4017/320 3 sets/54 lbs.
5-Pc. Set C4017/511 2 sets/14 lbs.
4-Pc. Set C4017/159 1 set/4 lbs.

Concord White. Rim shape, all pieces with clear glaze. Dinnerware is ovenproof, detergent and dishwasher safe.

45-Pc. Set C4000/3 1 set/41 lbs.
40-Pc. Set C4000/605 1 set/34 lbs.
20-Pc. Set C4000/320 3 sets/54 lbs.
5-Pc. Set C4000/511 2 sets/14 lbs.
4-Pc. Set C4000/159 1 set/4 lbs.

For set compositions and cartoning see page 39. Tableware 33

Mountain Meadow, Buttercup, Zinnia, and Concord White Ironstone listed in the 1978 Gift Set catalog.

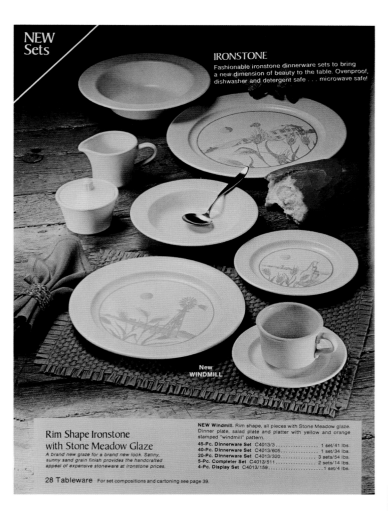

IRONSTONE

Fashionable ironstone dinnerware sets to bring a new dimension of beauty to the table. Ovenproof, dishwasher and detergent safe . . . microwave safe!

New
WINDMILL

Rim Shape Ironstone with Stone Meadow Glaze

A brand new glaze for a brand new look. Satiny, sunny sand grain finish provides the handcrafted appeal of expensive stoneware at ironstone prices.

NEW Windmill. Rim shape, all pieces with Stone Meadow glaze. Dinner plate, salad plate and platter with yellow and orange stamped "windmill" pattern.

45-Pc. Dinnerware Set	C4013/3	1 set/41 lbs.
40-Pc. Dinnerware Set	C4013/605	1 set/34 lbs.
20-Pc. Dinnerware Set	C4013/320	3 sets/54 lbs.
5-Pc. Completer Set	C4013/511	2 sets/14 lbs.
4-Pc. Display Set	C4013/159	1 set/4 lbs.

28 Tableware For set compositions and cartoning see page 39.

Windmill Ironstone listed in the 1978 Gift Set catalog.

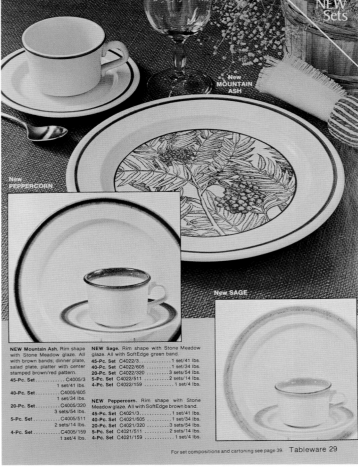

New
MOUNTAIN
ASH

New
PEPPERCORN

New SAGE

Mountain Ash, Peppercorn, and Sage Ironstone listed in the 1978 Gift Set catalog.

NEW Mountain Ash. Rim shape with Stone Meadow glaze. All with brown bands; dinner plate, salad plate, platter with center stamped brown/red pattern.

45-Pc. Set	C4005/3	1 set/41 lbs.
40-Pc. Set	C4005/605	1 set/34 lbs.
20-Pc. Set	C4005/320	3 sets/54 lbs.
5-Pc. Set	C4005/511	2 sets/14 lbs.
4-Pc. Set	C4005/159	1 set/4 lbs.

NEW Sage. Rim shape with Stone Meadow glaze. All with SoftEdge green band.

45-Pc. Set	C4022/3	1 set/41 lbs.
40-Pc. Set	C4022/605	1 set/34 lbs.
20-Pc. Set	C4022/320	3 sets/54 lbs.
5-Pc. Set	C4022/511	2 sets/14 lbs.
4-Pc. Set	C4022/159	1 set/4 lbs.

NEW Peppercorn. Rim shape with Stone Meadow glaze. All with SoftEdge brown band.

45-Pc. Set	C4021/3	1 set/41 lbs.
40-Pc. Set	C4021/605	1 set/34 lbs.
20-Pc. Set	C4021/320	3 sets/54 lbs.
5-Pc. Set	C4021/511	2 sets/14 lbs.
4-Pc. Set	C4021/159	1 set/4 lbs.

For set compositions and cartoning see page 39. Tableware 29

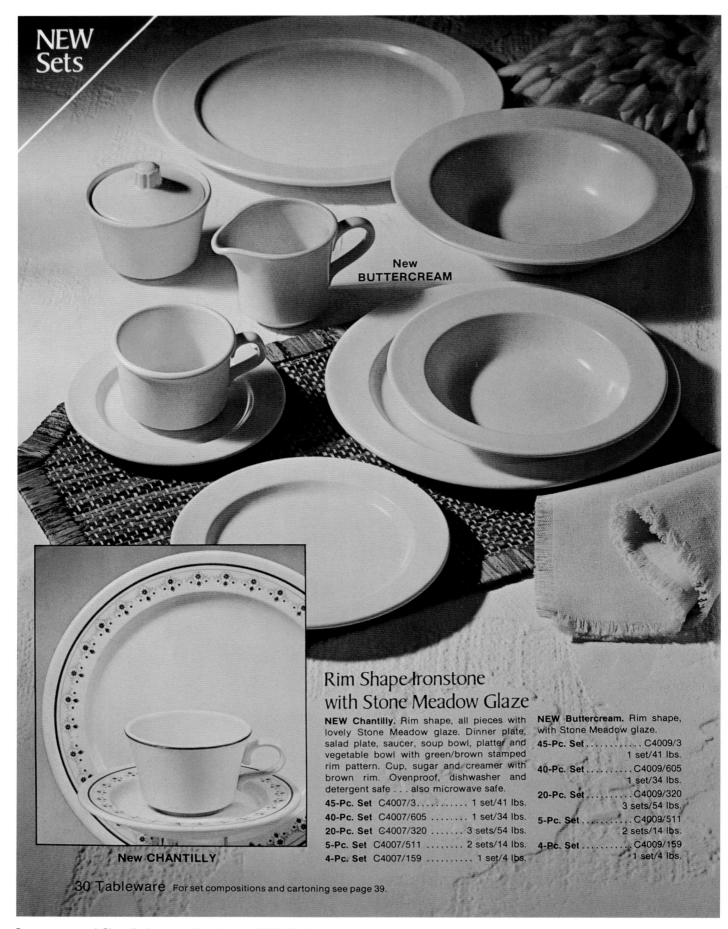

New
BUTTERCREAM

New CHANTILLY

Rim Shape Ironstone with Stone Meadow Glaze

NEW Chantilly. Rim shape, all pieces with lovely Stone Meadow glaze. Dinner plate, salad plate, saucer, soup bowl, platter and vegetable bowl with green/brown stamped rim pattern. Cup, sugar and creamer with brown rim. Ovenproof, dishwasher and detergent safe . . . also microwave safe.

45-Pc. Set	C4007/3	1 set/41 lbs.
40-Pc. Set	C4007/605	1 set/34 lbs.
20-Pc. Set	C4007/320	3 sets/54 lbs.
5-Pc. Set	C4007/511	2 sets/14 lbs.
4-Pc. Set	C4007/159	1 set/4 lbs.

NEW Buttercream. Rim shape, with Stone Meadow glaze.

45-Pc. Set	C4009/3	1 set/41 lbs.
40-Pc. Set	C4009/605	1 set/34 lbs.
20-Pc. Set	C4009/320	3 sets/54 lbs.
5-Pc. Set	C4009/511	2 sets/14 lbs.
4-Pc. Set	C4009/159	1 set/4 lbs.

30 Tableware For set compositions and cartoning see page 39.

Buttercream and Chantilly Ironstone listed in the 1978 Gift Set catalog.

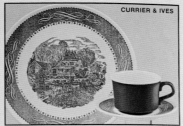
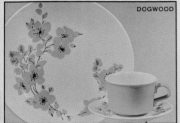
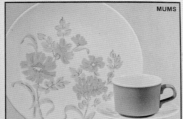

VICTORIA

CURRIER & IVES

DOGWOOD

MUMS

*Fashionable patterns for every taste and lifestyle. Makes a stunning gift . . . to give or receive. Uncommon durability means practicality: ovenproof, dishwasher and detergent safe. *Microwave safe, too!*

MINT

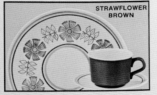

STRAWFLOWER BROWN

Victoria. Coupe shape, clear glaze. All pieces gold edged, center stamped pattern on dinner plate, salad plate and platter. *Metallic content of gold edge makes this ironstone pattern unsuitable for microwave use.
45-Pc. Set C6055/3 1 set/38 lbs.
4-Pc. Set C6055/159 1 set/4 lbs.

Currier & Ives. Coupe shape, clear glaze. Stamped pattern, blue holloware.
45-Pc. Set C6017/3 1 set/38 lbs.
40-Pc. Set C6017/605 1 set/32 lbs.
20-Pc. Set C6017/320 . . . 3 sets/48 lbs.
5-Pc. Set C6017/511 2 sets/13 lbs.
4-Pc. Set C6017/159 1 set/4 lbs.

Dogwood. Coupe shape, clear glaze. Stamped pattern, yellow holloware.
45-Pc. Set C6054/3 1 set/38 lbs.
40-Pc. Set C6054/605 1 set/32 lbs.
20-Pc. Set C6054/320 . . . 3 sets/48 lbs.
5-Pc. Set C6054/511 . . . 2 sets/13 lbs.
4-Pc. Set C6054/159 1 set 4 lbs.

Mums. Coupe shape, clear glaze. Stamped pattern, mint green holloware.
45-Pc. Set C6049/3 1 set/38 lbs.
20-Pc. Set C6049/320 . . . 3 sets/48 lbs.
5-Pc. Set C6049/511 2 sets/13 lbs.
4-Pc. Set C6049/159 1 set/4 lbs.

Mint. Coupe shape with durable clear glaze. Stamped band and leaf pattern, mint green holloware.
45-Pc. Set C6027/3 1 set/38 lbs.
40-Pc. Set C6027/605 1 set/32 lbs.
20-Pc. Set C6027/320 . . . 3 sets/48 lbs.
5-Pc. Set C6027/511 2 sets/13 lbs.
4-Pc. Set C6027/159 1 set/4 lbs.

Strawflower Brown. Coupe shape with clear glaze. Stamped band and floral pattern, brown holloware.
45-Pc. Set C6026/3 1 set/38 lbs.
40-Pc. Set C6026/605 1 set/32 lbs.
20-Pc. Set C6026/320 . . . 3 sets/48 lbs.
5-Pc. Set C6026/511 2 sets/13 lbs.
4-Pc. Set C6026/159 1 set/4 lbs.

For set compositions and cartoning see page 39. Tableware 37

Assorted Ironstone listed in the 1978 Gift Set catalog.

Rye Town Ironstone listed in the 1978 Gift Set catalog.

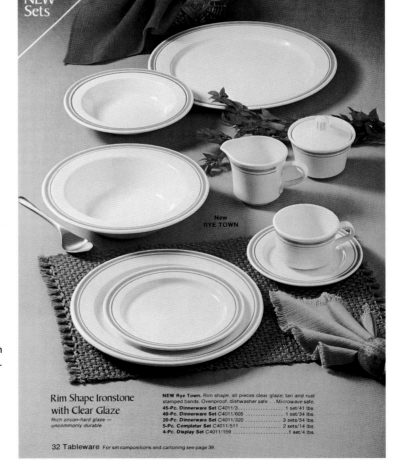

NEW Sets

New RYE TOWN

Rim Shape Ironstone with Clear Glaze
Rich zircon-hard glaze — uncommonly durable

NEW Rye Town. Rim shape, all pieces clear glaze; tan and rust stamped bands. Ovenproof, dishwasher safe . . . Microwave safe.
45-Pc. **Dinnerware Set** C4011/3 1 set/41 lbs.
40-Pc. **Dinnerware Set** C4011/605 1 set/34 lbs.
20-Pc. **Dinnerware Set** C4011/320 3 sets/54 lbs.
5-Pc. **Completer Set** C4011/511 2 sets/14 lbs.
4-Pc. **Display Set** C4011/1591 set/4 lbs.

32 Tableware For set compositions and cartoning see page 39.

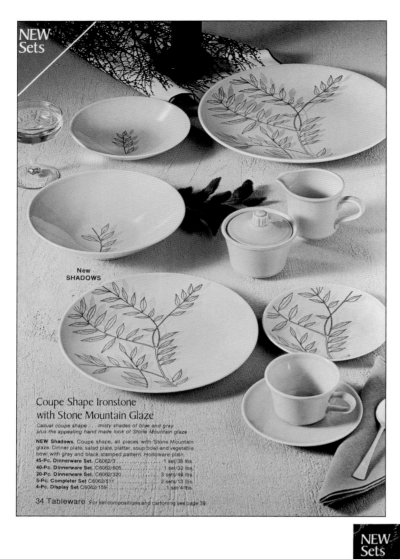

NEW
Sets

New
SHADOWS

Coupe Shape Ironstone with Stone Mountain Glaze

Casual coupe shape . . . misty shades of blue and gray plus the appealing hand made look of Stone Mountain glaze

NEW Shadows. Coupe shape, all pieces with Stone Mountain glaze. Dinner plate, salad plate, platter, soup bowl and vegetable bowl with gray and black stamped pattern. Holloware plain.

45-Pc. Dinnerware Set. C6062/3		1 set/38 lbs.
40-Pc. Dinnerware Set. C6062/605		1 set/32 lbs.
20-Pc. Dinnerware Set. C6062/320		3 sets/48 lbs.
5-Pc. Completer Set C6062/511		2 sets/13 lbs.
4-Pc. Display Set C6062/159		1 set/4 lbs.

34 Tableware For set compositions and cartoning see page 39.

Shadows Ironstone listed in the 1978 Gift Set catalog.

Assorted Ironstone listed in the 1978 Gift Set catalog.

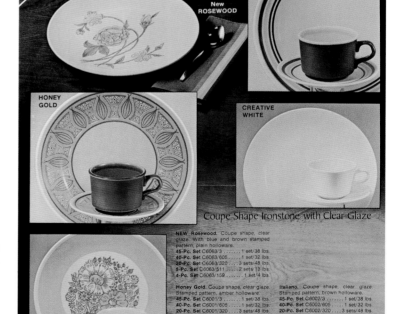

NEW
Sets

ITALIANO

New
ROSEWOOD

HONEY
GOLD

CREATIVE
WHITE

NOSEGAY

Coupe Shape Ironstone with Clear Glaze

NEW Rosewood. Coupe shape, clear glaze. With blue and brown stamped pattern, plain holloware.

45-Pc. Set C6063/3		1 set/38 lbs.
40-Pc. Set C6063/605		1 set/32 lbs.
20-Pc. Set C6063/320		3 sets/48 lbs.
5-Pc. Set C6063/511		2 sets/13 lbs.
4-Pc. Set C6063/159		1 set/4 lbs.

Honey Gold. Coupe shape, clear glaze. Stamped pattern, amber holloware.

45-Pc. Set C6001/3		1 set/38 lbs.
40-Pc. Set C6001/605		1 set/32 lbs.
20-Pc. Set C6001/320		3 sets/48 lbs.
5-Pc. Set C6001/511		2 sets/13 lbs.
4-Pc. Set C6001/159		1 set/4 lbs.

Nosegay. Coupe shape, clear glaze. Stamped pattern, yellow holloware.

45-Pc. Set C6028/3		1 set/38 lbs.
40-Pc. Set C6028/605		1 set/32 lbs.
20-Pc. Set C6028/320		3 sets/48 lbs.
5-Pc. Set C6028/511		2 sets/13 lbs.
4-Pc. Set C6028/159		1 set/4 lbs.

Italiano. Coupe shape, clear glaze. Stamped pattern, brown holloware.

45-Pc. Set C6002/3		1 set/38 lbs.
40-Pc. Set C6002/605		1 set/32 lbs.
20-Pc. Set C6002/320		3 sets/48 lbs.
5-Pc. Set C6002/511		2 sets/13 lbs.
4-Pc. Set C6002/159		1 set/4 lbs.

Creative White. Coupe shape with clear glaze.

45-Pc. Set C6000/3		1 set/38 lbs.
40-Pc. Set C6000/605		1 set/32 lbs.
20-Pc. Set C6000/320		3 sets/48 lbs.
5-Pc. Set C6000/511		2 sets/13 lbs.
4-Pc. Set C6000/159		1 set/4 lbs.

36 Tableware For set compositions and cartoning see page 39.

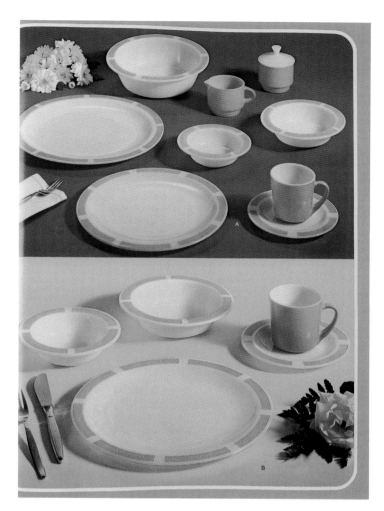

Athena dinnerware listed in the 1972 catalog.

Athena dinnerware listed in the 1972 catalog.

Dinnerware
Gift Sets

Tableware Gift Sets

86

pictorial code	description	contents	item number	sets/carton	lbs/carton
	Athena				
A	45 pc. Dinnerware Set (Gift Package not illus.)	8 – 8 oz. cups 8 – 6¼" saucers 8 – 5¾" dessert bowls 8 – 6¾" salad/cereal bowls 8 – 10½" dinner plates 1 – 12" platter 1 – 9" vegetable bowl 1 – sugar/cover 1 – creamer	W1000/92	1	32
B	20 pc. Starter Set (Gift Package not illus.)	4 – 8 oz. cups 4 – 6¼" saucers 4 – 6¾" salad/cereal bowls 4 – 9" dinner plates 4 – 5¾" dessert bowls	W1000/91	4	13
C	3 pc. Sugar & Creamer Set (Gift Package not illus.)	1 – sugar/cover 1 – creamer	W4600/105	6	10

NOTE: See Index for additional listing of Athena bulk items.

Chapter Four
Potpourri
(Giftware)

Anchor Hocking produced thousands of different items over the last ninety-five years. The items in this chapter were chosen from a variety of catalogs to provide the collector with a time frame for an item's production. Many of the items were produced for periods of time in excess of twenty years. Some of the items were produced in various colors, frosted, plated with metal, or flashed/coated with colored lacquers. The prices for these unusual pieces will vary greatly.

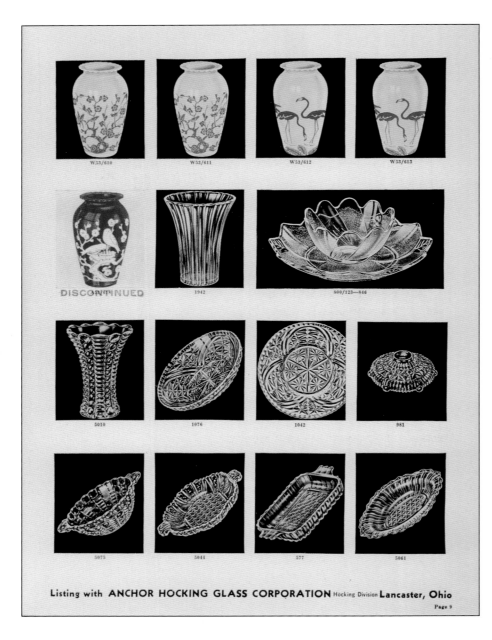

Listing with **ANCHOR HOCKING GLASS CORPORATION** Hocking Division **Lancaster, Ohio**

Page 9

Miscellaneous Items Listed in the Catalogs in the Late 1940s

Cat. Item No.	Price
W53/610	$20-30
W53/611	$20-30
W53/612	$25-30
W53/613	$25-30
A53/618	$30-35
1942	$12-15
800/123	$10-12 (2-pieces in crystal)
800/846	$3-5 (4 3/4" dessert only in crystal)
5010	$10-12
1076	$6-10
1042	$8-10
981	$2-4
5075	$5-8
5044	$4-6
577	$4-6
5061	$5-8

There are other versions of the items listed in this catalog. The #577 6" oblong tray and #5061 7 3/4" oval olive dish were also made in Royal Ruby. The #1942 7" vase (often called Old Café) was made in crystal, pink, and Forest Green. Many authors list this vase in Royal Ruby, but I have never found or seen one. I have seen the lamp with the three feet removed but the hole in the bottom of the vase (lamp) is still there. The #1076 7 1/2" shallow bowl and #1042 8" salad plate can be found in frosted versions. Some of the frosted items have colored accents. The #5044 6" handled mint tray with sterling silver overlay is now on display in the Anchor Hocking Glass Museum. It is interesting to note that this catalog states, "*NOTE: - ALL RUBY WARE HAS BEEN DISCONTINUED."

Miscellaneous Crystal Items Listed in the 1951 Catalog

Cat. Item No.	Price
3974	$1-2
3978	$2-4
594	$3-5
595	$3-5
598	$10-12
896	$6-10
1070	$3-5
1077	$5-8

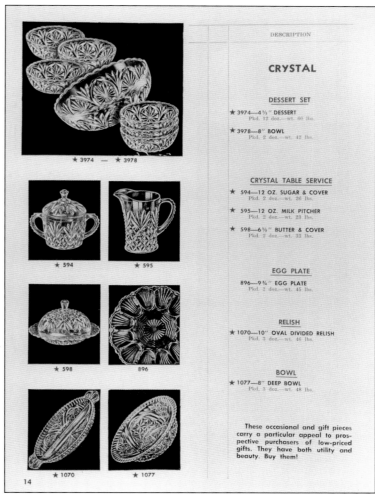

DESCRIPTION

CRYSTAL

DESSERT SET

★ 3974—4½″ DESSERT
Pkd. 12 doz.—wt. 60 lbs.

★ 3978—8″ BOWL
Pkd. 2 doz.—wt. 42 lbs.

CRYSTAL TABLE SERVICE

★ 594—12 OZ. SUGAR & COVER
Pkd. 2 doz.—wt. 26 lbs.

★ 595—12 OZ. MILK PITCHER
Pkd. 2 doz.—wt. 23 lbs.

★ 598—6½″ BUTTER & COVER
Pkd. 2 doz.—wt. 33 lbs.

EGG PLATE

896—9¾″ EGG PLATE
Pkd. 3 doz.—wt. 45 lbs.

RELISH

★ 1070—10″ OVAL DIVIDED RELISH
Pkd. 3 doz.—wt. 46 lbs.

BOWL

★ 1077—8″ DEEP BOWL
Pkd. 3 doz.—wt. 48 lbs.

These occasional and gift pieces carry a particular appeal to prospective purchasers of low-priced gifts. They have both utility and beauty. Buy them!

14

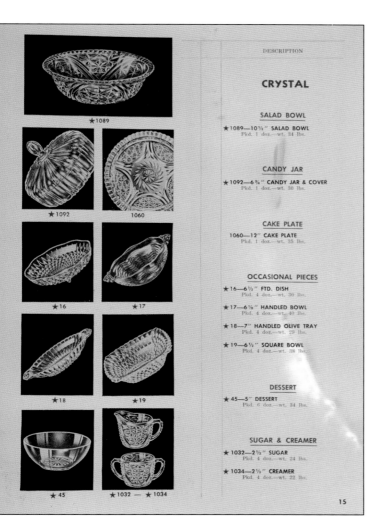

DESCRIPTION

CRYSTAL

SALAD BOWL

★ 1089—10½″ SALAD BOWL
Pkd. 1 doz.—wt. 34 lbs.

CANDY JAR

★ 1092—6¾″ CANDY JAR & COVER
Pkd. 1 doz.—wt. 30 lbs.

CAKE PLATE

1060—12″ CAKE PLATE
Pkd. 1 doz.—wt. 35 lbs.

OCCASIONAL PIECES

★ 16—6½″ FTD. DISH
Pkd. 4 doz.—wt. 30 lbs.

★ 17—6⅛″ HANDLED BOWL
Pkd. 4 doz.—wt. 40 lbs.

★ 18—7″ HANDLED OLIVE TRAY
Pkd. 4 doz.—wt. 29 lbs.

★ 19—6½″ SQUARE BOWL
Pkd. 4 doz.—wt. 38 lbs.

DESSERT

★ 45—5″ DESSERT
Pkd. 6 doz.—wt. 34 lbs.

SUGAR & CREAMER

★ 1032—2½″ SUGAR
Pkd. 4 doz.—wt. 24 lbs.

★ 1034—2½″ CREAMER
Pkd. 4 doz.—wt. 22 lbs.

15

Miscellaneous Crystal Items Listed in the 1951 Catalog

Cat. Item No.	Price
1089	$5-8
1092	$5-10
1060	$10-12
16	$3-5
17	$8-10
18	$6-10
19	$3-4
45	$5-8
1032	$3-5
1034	$3-5

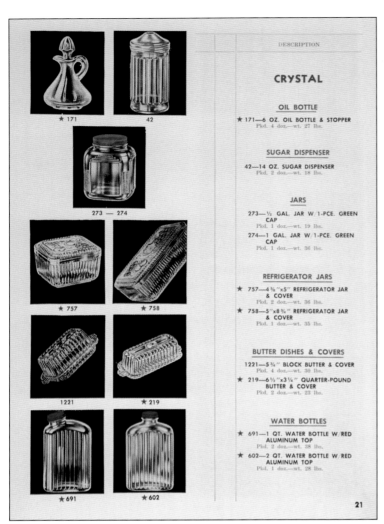

CRYSTAL

OIL BOTTLE

★ 171—6 OZ. OIL BOTTLE & STOPPER
Pkd. 4 doz.—wt. 27 lbs.

SUGAR DISPENSER

42—14 OZ. SUGAR DISPENSER
Pkd. 2 doz.—wt. 18 lbs.

JARS

273—½ GAL. JAR W/1-PCE. GREEN
CAP
Pkd. 1 doz.—wt. 19 lbs.

274—1 GAL. JAR W/1-PCE. GREEN
CAP
Pkd. 1 doz.—wt. 36 lbs.

REFRIGERATOR JARS

★ 757—4⅜"x5" REFRIGERATOR JAR
& COVER
Pkd. 2 doz.—wt. 36 lbs.

★ 758—5"x8¾" REFRIGERATOR JAR
& COVER
Pkd. 1 doz.—wt. 35 lbs.

BUTTER DISHES & COVERS

1221—5¾" BLOCK BUTTER & COVER
Pkd. 4 doz.—wt. 30 lbs.

★ 219—6½"x3¼" QUARTER-POUND
BUTTER & COVER
Pkd. 2 doz.—wt. 23 lbs.

WATER BOTTLES

★ 691—1 QT. WATER BOTTLE W/RED
ALUMINUM TOP
Pkd. 1 doz.—wt. 38 lbs.

★ 602—2 QT. WATER BOTTLE W/RED
ALUMINUM TOP
Pkd. 1 doz.—wt. 28 lbs.

21

Miscellaneous Crystal Items Listed in the 1951 Catalog

Cat. Item No.	Price
171	$2-3
42	$8-10
273	$10-15
274	$12-15
757	$10-12
758	$12-15
1221	$8-10
219	$5-10
691	$10-15
602	$12-15

Miscellaneous Crystal Items Listed in the 1951 Catalog

Cat. Item No.	Price
3354	$1-2
1071	$1-2
1942	$10-15
765/205	$10-12
203	$2-4
205	$3-5
G820	$12-15
A5013	$10-15
A759	$3-5
A5068	$12-15

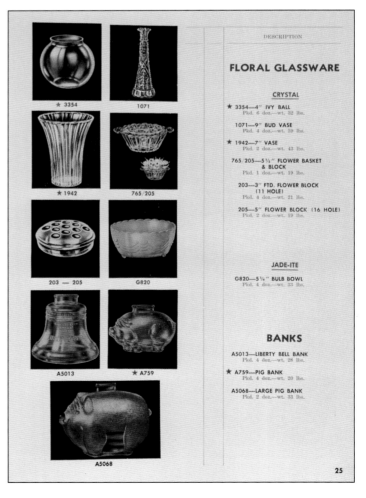

FLORAL GLASSWARE

CRYSTAL

★ 3354—4" IVY BALL
Pkd. 6 doz.—wt. 32 lbs.

1071—9" BUD VASE
Pkd. 4 doz.—wt. 39 lbs.

★ 1942—7" VASE
Pkd. 2 doz.—wt. 43 lbs.

765/205—5½" FLOWER BASKET
& BLOCK
Pkd. 1 doz.—wt. 19 lbs.

203—3" FTD. FLOWER BLOCK
(11 HOLE)
Pkd. 4 doz.—wt. 21 lbs.

205—5" FLOWER BLOCK (16 HOLE)
Pkd. 2 doz.—wt. 19 lbs.

JADE-ITE

G820—5¼" BULB BOWL
Pkd. 4 doz.—wt. 33 lbs.

BANKS

A5013—LIBERTY BELL BANK
Pkd. 4 doz.—wt. 28 lbs.

★ A759—PIG BANK
Pkd. 4 doz.—wt. 20 lbs.

A5068—LARGE PIG BANK
Pkd. 2 doz.—wt. 33 lbs.

25

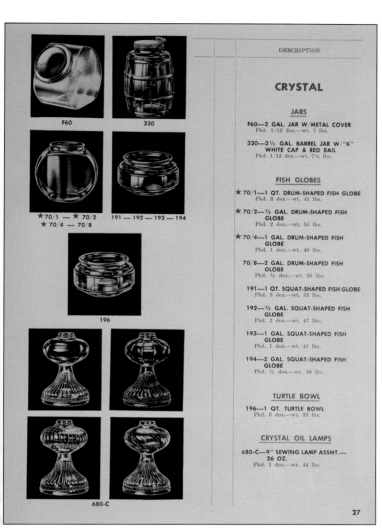

DESCRIPTION

CRYSTAL

JARS

F60—2 GAL. JAR W/METAL COVER
Pkd. 1/12 doz.—wt. 7 lbs.

330—2½ GAL. BARREL JAR W/"K"
WHITE CAP & RED BAIL
Pkd. 1/12 doz.—wt. 7½ lbs.

FISH GLOBES

★70/1—1 QT. DRUM-SHAPED FISH GLOBE
Pkd. 3 doz.—wt. 41 lbs.

★70/2—½ GAL. DRUM-SHAPED FISH
GLOBE
Pkd. 2 doz.—wt. 50 lbs.

★70/4—1 GAL. DRUM-SHAPED FISH
GLOBE
Pkd. 1 doz.—wt. 40 lbs.

70/8—½ GAL. DRUM-SHAPED FISH
GLOBE
Pkd. ½ doz.—wt. 36 lbs.

191—1 QT. SQUAT-SHAPED FISH GLOBE
Pkd. 3 doz.—wt. 33 lbs.

192—½ GAL. SQUAT-SHAPED FISH
GLOBE
Pkd. 2 doz.—wt. 47 lbs.

193—1 GAL. SQUAT-SHAPED FISH
GLOBE
Pkd. 1 doz.—wt. 41 lbs.

194—2 GAL. SQUAT-SHAPED FISH
GLOBE
Pkd. ½ doz.—wt. 38 lbs.

TURTLE BOWL

196—1 QT. TURTLE BOWL
Pkd. 3 doz.—wt. 33 lbs.

CRYSTAL OIL LAMPS

680-C—9" SEWING LAMP ASSMT.—
26 OZ.
Pkd. 1 doz.—wt. 44 lbs.

27

Miscellaneous Crystal Items Listed in the 1951 Catalog

Cat. Item No.	Price
F60	$10-15
330	$10-20
70/1	$3-5
70/2	$3-5
70/4	$5-8
70/8	$5-8
191	$3-5
192	$4-5
193	$5-6
194	$5-8
196	$3-5
680-C	$20-25 without the "anchor over H" mark
680-C	$80-100 with the "anchor over H" mark

Some of the first lamps made were marked with the "anchor over H" mark about half way between the oil font and the base. In five years I have only been able to find three marked lamps. The marked lamps would command a premium price due to their rarity.

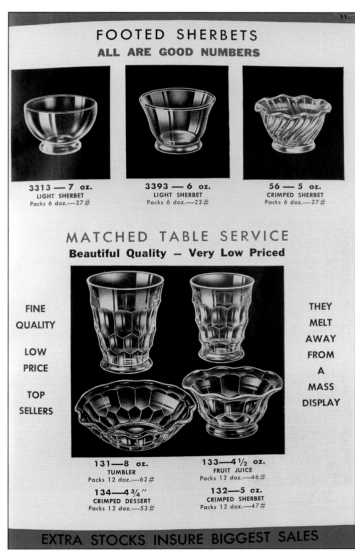

Miscellaneous Crystal Items Listed in the 1952 Catalog

Cat. Item No.	Price
3313	$1-2
3393	$1-2
56	$1-2
131	$3-5
132	$4-5
133	$3-5
134	$5-8

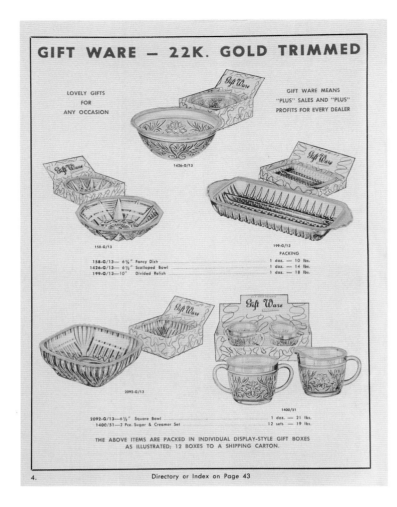

Miscellaneous Crystal Items Listed in the 1956 Catalog

Cat. Item No.	Price for Unboxed Sets
158-G/13	$5-8
1426-G/13	$12-15
199-G/13	$8-10
2092-G/13	$8-10
1400/51	$15-20

Miscellaneous Crystal Items Listed in the 1956 Catalog

Cat. Item No.	Price for Unboxed Sets
W896-G/13	$10-12
W100-G/52	$10-12
3300/134	$10-15 each
3300/135	$15-20 each
3300/136	$10-15 each

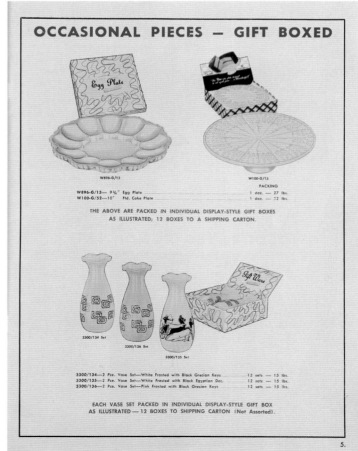

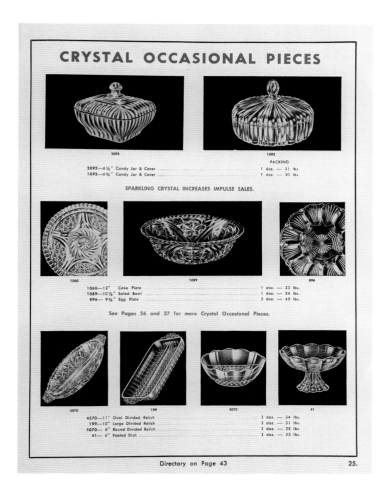

Crystal Occasional Items Listed in the 1956 Catalog

Cat. Item No.	Price
2092	$10-12
1092	$5-10
1060	$10-12
1089	$5-8
896	$6-10
4570	$6-10
199	$8-10
5070	$10-15
41	$10-15

Crystal Items Listed in the 1956 Catalog

Cat. Item No.	Price
156	$3-5
157	$4-6
158	$3-5
159	$3-5
920	$3-5
197	$3-5
594	$3-5
595	$3-5
598	$10-12
255	$6-10

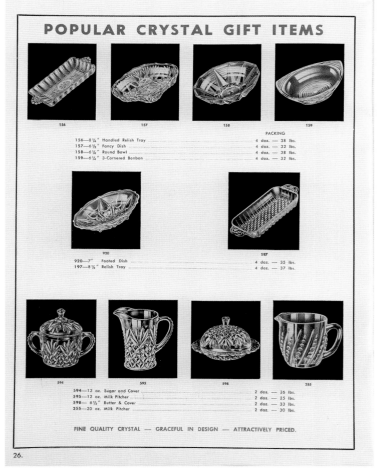

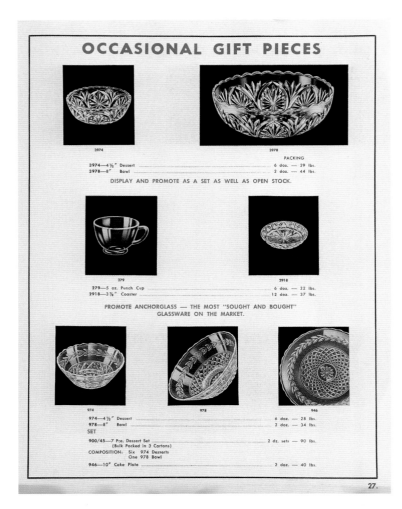

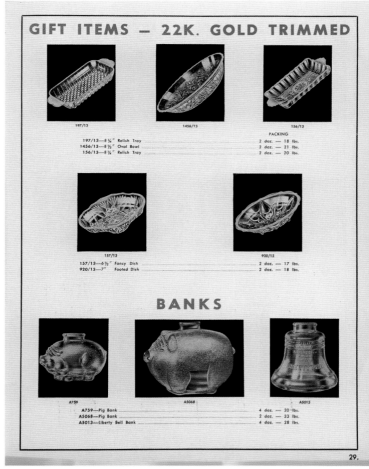

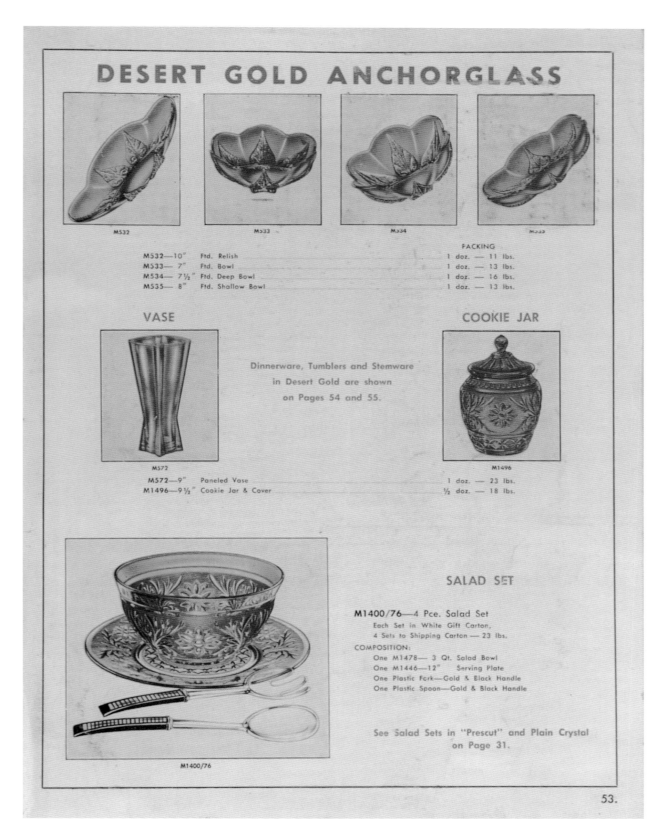

DESERT GOLD ANCHORGLASS

M532 M533 M534 M535

PACKING

M532—10"	Ftd. Relish	1 doz. — 11 lbs.
M533— 7"	Ftd. Bowl	1 doz. — 13 lbs.
M534— 7½"	Ftd. Deep Bowl	1 doz. — 16 lbs.
M535— 8"	Ftd. Shallow Bowl	1 doz. — 13 lbs.

VASE

COOKIE JAR

Dinnerware, Tumblers and Stemware
in Desert Gold are shown
on Pages 54 and 55.

M572

M1496

M572—9"	Paneled Vase	1 doz. — 23 lbs.
M1496—9½"	Cookie Jar & Cover	½ doz. — 18 lbs.

SALAD SET

M1400/76—4 Pce. Salad Set
Each Set in White Gift Carton,
4 Sets to Shipping Carton — 23 lbs.
COMPOSITION:
One M1478— 3 Qt. Salad Bowl
One M1446—12" Serving Plate
One Plastic Fork—Gold & Black Handle
One Plastic Spoon—Gold & Black Handle

See Salad Sets in "Prescut" and Plain Crystal
on Page 31.

M1400/76

53.

Desert Gold Items Listed in the 1961-2 Catalog

Cat. Item No.	Price	Cat. Item No.	Price
M532	$5-8	M572	$20-25
M533	$5-8	M1496	$20-30
M534	$5-8	M1400/76	$40-50 in the original box
M535	$5-8		

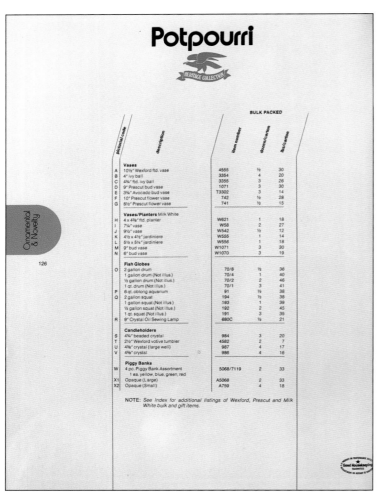

Potpourri

HERITAGE COLLECTION

Pictorial code	description	Item number	BULK PACKED dozen/carton	lbs/carton
	Vases			
A	10½" Wexford ftd. vase	4555	½	30
B	4" ivy ball	3354	4	20
C	4¾" ftd. ivy ball	3355	3	26
D	9" Prescut bud vase	1071	3	30
E	3¾" Avocado bud vase	T3302	3	14
F	10" Prescut flower vase	742	½	28
G	8½" Prescut flower vase	741	½	15
	Vases/Planters Milk White			
H	4 x 4⅜" ftd. planter	W621	1	18
I	7¼" vase	W58	2	27
J	9½" vase	W542	½	12
K	4½ x 4½" jardiniere	W555	1	14
L	5½ x 5¼" jardiniere	W556	1	18
M	9" bud vase	W1071	3	30
N	6" bud vase	W1070	3	19
	Fish Globes			
O	2 gallon drum	70/8	½	36
	1 gallon drum (Not illus.)	70/4	1	40
	½ gallon drum (Not illus.)	70/2	2	46
	1 qt. drum (Not illus.)	70/1	3	41
P	6 qt. oblong aquarium	91	½	38
Q	2 gallon squat	194	½	38
	1 gallon squat (Not illus.)	193	1	39
	½ gallon squat (Not illus.)	192	2	45
	1 qt. squat (Not illus.)	191	3	35
R	9" Crystal Oil Sewing Lamp	680C	½	21
	Candleholders			
S	4¾" beaded crystal	984	3	20
T	2½" Wexford votive tumbler	4582	2	7
U	4⅜" crystal (large well)	987	4	17
V	4⅜" crystal	986	4	16
	Piggy Banks			
W	4 pc. Piggy Bank Assortment 1 ea. yellow, blue, green, red	5068/7119	2	33
X1	Opaque (Large)	A5068	2	33
X2	Opaque (Small)	A759	4	18

NOTE: See Index for additional listings of Wexford, Prescut and Milk White bulk and gift items.

Listing of potpourri items in the 1972 catalog. Most of the vases are priced between $2-10 each depending upon the size and type of glass (i.e., crystal or milk glass). The most noteworthy items are the piggy banks. The banks were flashed with colored lacquer and are hard to find in mint condition. Prices listed are for mint condition banks.

Piggy Banks Listed in the 1972 Catalog

Catalog Item Description	Price
Yellow (W)	$10-15
Green (W)	$12-15
Blue (W)	$15-20
Red (W)	$15-20
Opaque (large-X1)	$10-12
Opaque (small-X2)	$8-10

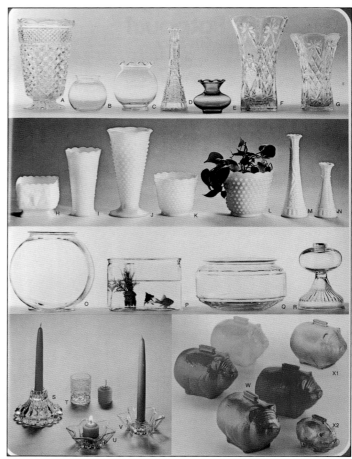

Potpourri Items Listed in the 1976-77 Gift Supplement

Cat. Item No.	Price
330	$15-20 in the original box
7	$2-4
2779	$2-4
3305	$5-8

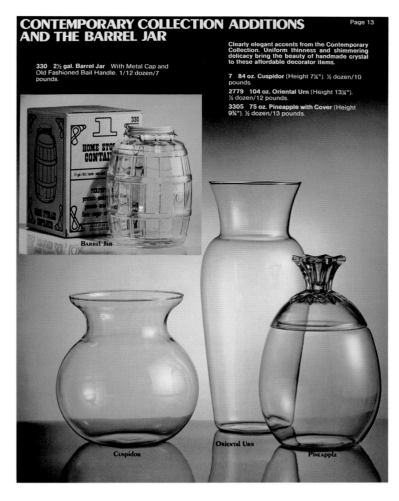

CONTEMPORARY COLLECTION ADDITIONS AND THE BARREL JAR

Clearly elegant accents from the Contemporary Collection. Uniform thinness and shimmering delicacy bring the beauty of handmade crystal to these affordable decorator items.

330 2½ gal. Barrel Jar With Metal Cap and Old Fashioned Bail Handle. 1/12 dozen/7 pounds.

7 84 oz. Cuspidor (Height 7¼"). ½ dozen/10 pounds.

2779 104 oz. Oriental Urn (Height 13¼"). ½ dozen/12 pounds.

3305 75 oz. Pineapple with Cover (Height 9¾"). ½ dozen/13 pounds.

BARREL JAR

Cuspidor

Oriental Urn

Pineapple

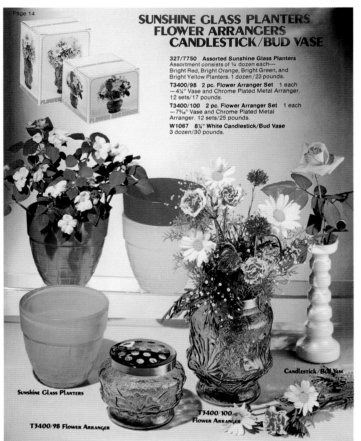

SUNSHINE GLASS PLANTERS FLOWER ARRANGERS CANDLESTICK/BUD VASE

327/7750 Assorted Sunshine Glass Planters Assortment consists of ¼ dozen each—Bright Red, Bright Orange, Bright Green, and Bright Yellow Planters. 1 dozen/23 pounds.

T3400/98 2 pc. Flower Arranger Set 1 each —4¼" Vase and Chrome Plated Metal Arranger. 12 sets/17 pounds.

T3400/100 2 pc. Flower Arranger Set 1 each —7⅝" Vase and Chrome Plated Metal Arranger. 12 sets/25 pounds.

W1067 8¼" White Candlestick/Bud Vase 3 dozen/30 pounds.

Sunshine Glass Planters

T3400/98 Flower Arranger

T3400/100 Flower Arranger

Candlestick/Bud Vase

Potpourri Items Listed in the 1976-77 Gift Supplement

Cat. Item No.	Price
327/7750	$4-5 for each color
T3400/98	$4-5
T3400/100	$4-5
W1067	$2-3

83

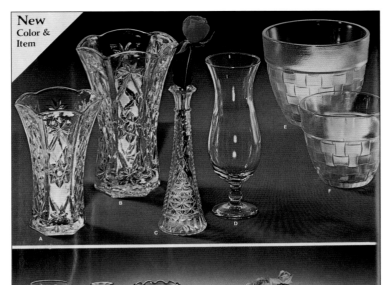

Catalog Item Description	Price
7 3/4" Basketweave planter (E)	$4-5
6 5/8" Basketweave planter (F)	$4-5
5 1/2" Rainflower vase (G)	$4-5
5 1/2" Colonial bud vase (H)	$3-4

Potpourri listed in the 1978 Bulk Catalog. The majority of the items on this page have been priced in other sections of this book, with the exception of the items listed above.

New Color & Item

VASES &

photo ref.	description	glass color	item order no.	BULK PACKED doz.	shipper lbs.
	EARLY AMERICAN PRESCUT				
A	8½" vase	Crystal	741	½	15
B	10" vase	Crystal	742	½	29
C	9" vase	Crystal	1071	3	30
	MISCELLANEOUS				
D	24½ oz. ftd. hurricane vase	Crystal	523F	1	14
E	7¾" bsktwve planter	Crystal	353	½	24
F	6⅝" bsktwve planter	Crystal	327	1	25
	RAINFLOWER				
G	5½" vase	Crystal	3471	2	18

photo ref.	description	glass color	item order no.	BULK PACKED doz.	shipper lbs.
	COLONIAL				
H	New 5½" COLONIAL bud vase	Crystal	1260	1	10
J	4⅜" ivy ball	Crystal	3355	3	26
K	4" ivy ball	Crystal	3354	4	22
L	3¾" flower vase	New Spearmint	G3302	3	15
	FAIRFIELD				
M	6x3¾" ftd. arrangement piece	New Spearmint	G1253	2	35

102 Decorative Glass

Planters listed in the 1978 catalog.

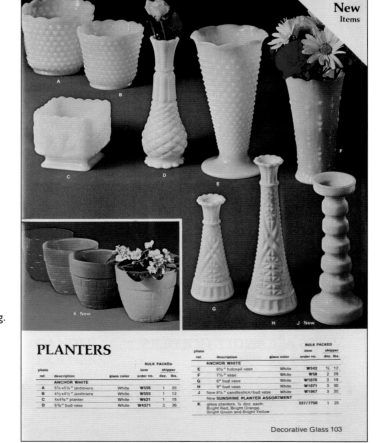

New Items

PLANTERS

photo ref.	description	glass color	item order no.	BULK PACKED doz.	shipper lbs.
	ANCHOR WHITE				
A	5½ x5½" jardiniere	White	W556	1	20
B	4½ x4½" jardiniere	White	W555	1	12
C	4x4¾" planter	White	W621	1	18
D	8⅝" bud vase	White	W4371	3	36

photo ref.	description	glass color	item order no.	BULK PACKED doz.	shipper lbs.
	ANCHOR WHITE				
E	5½" hobnail vase	White	W542	½	12
F	7½" vase	White	W58	2	29
G	6" bud vase	White	W1070	3	19
H	9" bud vase	White	W1071	3	30
J	New 8⅛" candlestick/bud vase	White	W1067	3	30
	NEW SUNSHINE PLANTER ASSORTMENT				
K	glass planters, ¼ doz. each: Bright Red, Bright Orange, Bright Green and Bright Yellow		327/7750	1	25

Decorative Glass 103

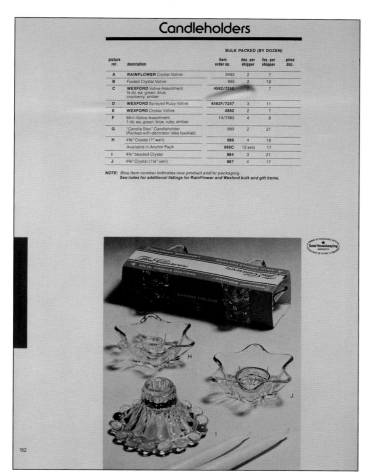

Candleholders

picture ref.	description	item order no.	doz. per shipper	lbs. per shipper	price doz.
			BULK PACKED (BY DOZEN)		
A	**RAINFLOWER** Crystal Votive	3482	2	7	
B	Footed Crystal Votive	985	2	10	
C	**WEXFORD** Votive Assortment ⅓ dz. ea. green, blue, cranberry, amber	4582/7250	2	7	
D	**WEXFORD** Sprayed Ruby Votive	4582F/7247	3	11	
E	**WEXFORD** Crystal Votive	4582	2	7	
F	Mini-Votive Assortment 1 dz. ea. green, blue, ruby, amber	14/7382	4	8	
G	"Candle Stax" Candleholder (Packed with decorator idea booklet)	992	2	21	
H	4⅜" Crystal (1" well)	986	4	16	
	Available in Anchor Pack	986C	12 sets	17	
I	4¾" beaded Crystal	984	3	21	
J	4⅜" Crystal (1½" well)	987	4	17	

NOTE: Blue item number indicates new product and/or packaging.
See index for additional listings for RainFlower and Wexford bulk and gift items.

Candleholders Listed in the 1974 Catalog

Cat. Item No.	Price
3482 (A)	$2-3
985 (B)	$2-3
4582/7250 (C)	$4-5 for each votive color
4582F/7247 (D)	$4-5
4582 (E)	$1-2
14/7382 (F)	$1-2 for each votive color
992 (G)	$3-5 a pair
986 (H)	$1-2
986C (H)	$3-5 for one set
984 (I)	$2-3
987 (J)	$1-2

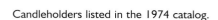

Candleholders listed in the 1974 catalog.

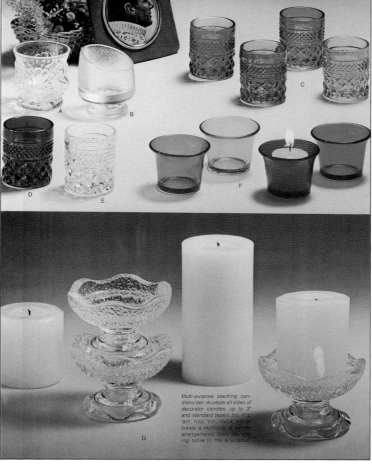

Multi-purpose stacking candleholder. Accepts all sizes of decorator candles up to 3" and standard tapers too. Flip 'em, flop 'em, stack 'em to create a multitude of candle arrangements, from the dining table to the any table.

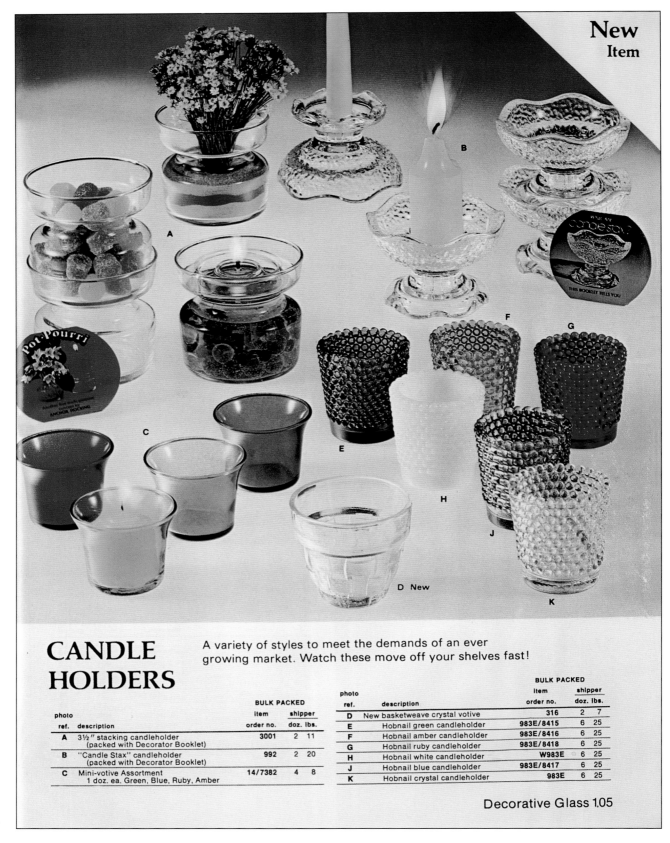

CANDLE HOLDERS

A variety of styles to meet the demands of an ever growing market. Watch these move off your shelves fast!

photo ref.	description	BULK PACKED item order no.	shipper doz.	lbs.
A	3½" stacking candleholder (packed with Decorator Booklet)	3001	2	11
B	"Candle Stax" candleholder (packed with Decorator Booklet)	992	2	20
C	Mini-votive Assortment 1 doz. ea. Green, Blue, Ruby, Amber	14/7382	4	8

photo ref.	description	BULK PACKED item order no.	shipper doz.	lbs.
D	New basketweave crystal votive	316	2	7
E	Hobnail green candleholder	983E/8415	6	25
F	Hobnail amber candleholder	983E/8416	6	25
G	Hobnail ruby candleholder	983E/8418	6	25
H	Hobnail white candleholder	W983E	6	25
J	Hobnail blue candleholder	983E/8417	6	25
K	Hobnail crystal candleholder	983E	6	25

Decorative Glass 1.05

Candleholders Listed in the 1978 Bulk Catalog

Cat. Item No.	Price
3001 (A)	$2-3
992 (B)	$3-5 a pair
14/7382 (C)	$1-2 for each votive color

Cat. Item No.	Price
316 (D)	$1-2
Hobnail (E-H, J, K)	$1-2 for each votive color

Curios Listed in the 1978 Gift Set Collection Catalog

Cat. Item No.	Price
100/520	$10-15
20/6	$12-15
100/524	$8-10
100/525	$10-15
100/526	$10-12

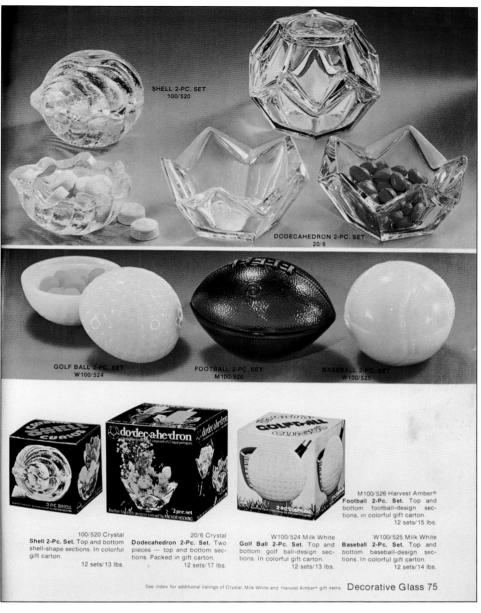

Curios Listed in the 1978 Gift Set Collection Catalog

Cat. Item No.	Price
100/509	$10-15
100/511	$10-15
100/512	$10-15

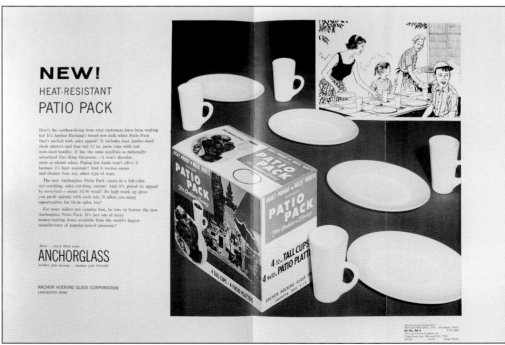

Rare advertising proof for the Patio Pack introduce by Anchor Hocking in 1958.

Chapter Five
Storage Containers

Many of the storage containers in this chapter are not usually thought to be made by Anchor Hocking. They were chosen so collectors would know who produced them. Like many of the potpourri items, certain storage containers were made for numerous years, while patterned containers (i.e., Rainflower) had limited production.

Anchor Hocking made a myriad of decorated candy, storage, and apothecary jars over the last fifty years. Many of the items were also flashed with colored lacquers or etched with a myriad of different designs. The prices of the decorated, flashed, or etched items will be considerably higher than the crystal ones listed below. The storage jars (numbers 2, 3, 4, 5, and 6) were also made in Royal Ruby with crystal tops. Many of the Royal Ruby jars were also decorated with 22 kt. gold designs or etched with numerous decorations.

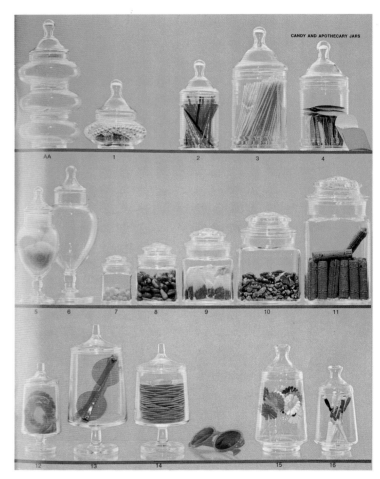

CANDY AND APOTHECARY JARS

Containers Listed in the 1970 Catalog

Catalog Item Description	Price
Pagoda Set (AA)	$2-4 in the original box
12 oz. Jar/cover (1)	$1-2
12 oz. Jar/cover (2)	$1-2
35 oz. Jar/cover (3)	$2-4
24 oz. Jar/cover (4)	$2-3
10 oz. Stemmed candy jar/cover (5)	$3-4
22 oz. Stemmed candy jar/cover (6)	$3-5
4 oz. Jar/cover (7)	$1-2
1/2 lb. Jar/cover (8)	$1-2
1 lb. Jar/cover (9)	$1-2
2 lb. Jar/cover (10)	$1-3
4 lb. Jar/cover (11)	$2-4
10 oz. Stemmed Finlandia jar/ cover (12)	$1-2
34 oz. Stemmed Finlandia jar/ cover (13)	$2-4
24 oz. Stemmed Finlandia jar/ cover (14)	$1-3
24 oz. Jar/cover (15)	$2-4
12 oz. Jar/cover (16)	$1-2

Storage Jars Listed in the 1974 Catalog

Cat. Item No.	Price
3571 (T)	$4-5
3572 (U)	$5-8
3573 (V)	$6-8

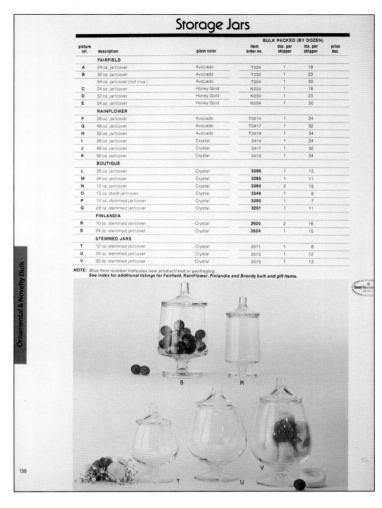

Storage Jars

picture ref.	description	glass color	item order no.	doz. per shipper	lbs. per shipper	price doz.
	FAIRFIELD					
A	24 oz. jar/cover	Avocado	T224	1	18	
B	32 oz. jar/cover	Avocado	T232	1	23	
	54 oz. jar/cover (not illus.)	Avocado	T254	1	30	
C	24 oz. jar/cover	Honey Gold	N224	1	18	
D	32 oz. jar/cover	Honey Gold	N232	1	23	
E	54 oz. jar/cover	Honey Gold	N254	1	30	
	RAINFLOWER					
F	28 oz. jar/cover	Avocado	T3414	1	24	
G	48 oz. jar/cover	Avocado	T3417	1	32	
H	52 oz. jar/cover	Avocado	T3419	1	34	
I	28 oz. jar/cover	Crystal	3414	1	24	
J	48 oz. jar/cover	Crystal	3417	1	32	
K	52 oz. jar/cover	Crystal	3419	1	34	
	BOUTIQUE					
L	35 oz. jar/cover	Crystal	3286	1	13	
M	24 oz. jar/cover	Crystal	3285	1	11	
N	12 oz. jar/cover	Crystal	3284	2	15	
O	12 oz. stack jar/cover	Crystal	3249	1	8	
P	10 oz. stemmed jar/cover	Crystal	3290	1	7	
Q	22 oz. stemmed jar/cover	Crystal	3291	1	11	
	FINLANDIA					
R	10 oz. stemmed jar/cover	Crystal	2620	2	16	
S	24 oz. stemmed jar/cover	Crystal	2624	1	15	
	STEMMED JARS					
T	12 oz. stemmed jar/cover	Crystal	3571	1	8	
U	25 oz. stemmed jar/cover	Crystal	3572	1	12	
V	32 oz. stemmed jar/cover	Crystal	3573	1	13	

NOTE: Blue item number indicates new product/and or packaging.
See index for additional listings for Fairfield, RainFlower, Finlandia and Brandy bulk and gift items.

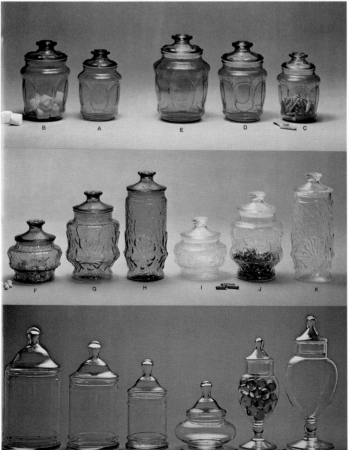

Only the storage jars not listed on other pages are priced here.

Storage Jars Listed in the 1974 Catalog

Cat. Item No.	Price
T224 (A)	$3-5
T232 (B)	$4-6
T254 not illustrated	$6-8
N224 (C)	$3-5
N232 (D)	$4-6
N254 (E)	$6-8
T3414 (F)	$3-5
T3417 (G)	$4-6
T3419 (H)	$8-10
3414 (I)	$4-5
3417 (J)	$6-8
3419 (K)	$1-12

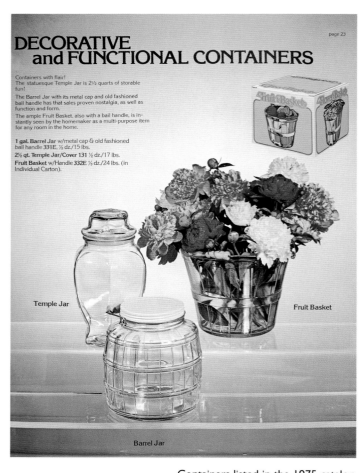

Containers listed in the 1975 catalog.

Contemporary Containers Listed in the 1978 Bulk Catalog

Cat. Item No.	Price
3308 (A)	$8-10
3304 (B)	$8-10
2686 (C)	$1-2
2696 (D)	$1-3

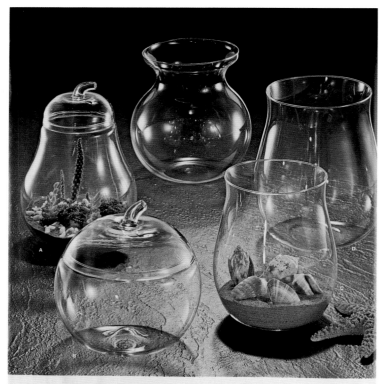

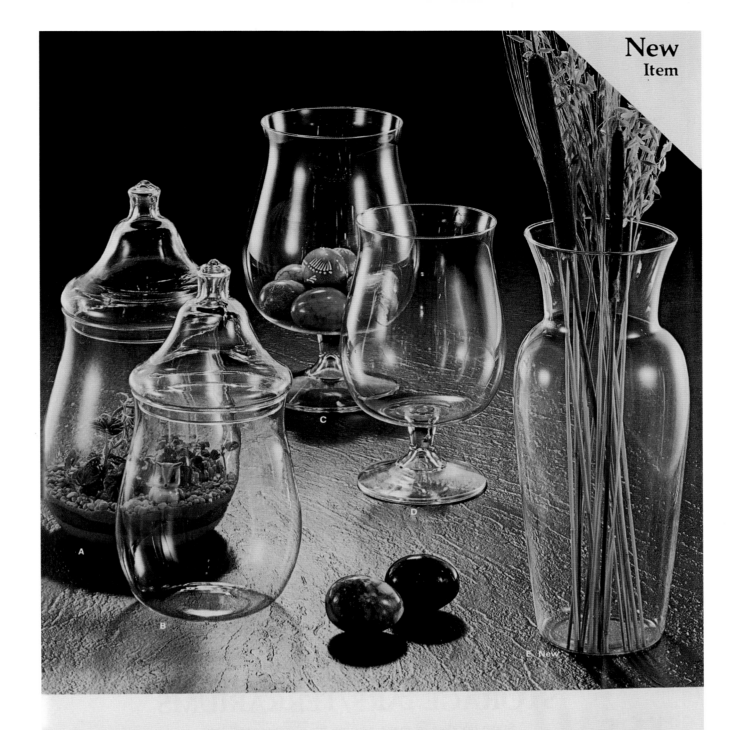

photo ref.	description	BULK PACKED		
		item order no.	shipper doz.	lbs.
A	130 oz. decorator jar/cover	2697	½	12
B	86 oz. decorator jar/cover	2687	½	11
C	130 oz. giant brandy snifter	2698	½	14
D	86 oz. giant brandy snifter	2688	½	10
E	New 104 oz. Oriental urn	2779	½	12

The Contemporary Collection is produced with a special process that provides a uniform thickness and shimmering delicacy that are outstanding in machine-made glass.

CONTEMPORARY COLLECTION
ANCHOR HOCKING USA

Each piece has attractive transparent blue label

Decorative Glass 95

Contemporary Containers Listed in the 1978 Bulk Catalog

Cat. Item No.	Price		Cat. Item No.	Price
2697 (A)	$10-12		2688 (D)	$1-2
2687 (B)	$8-10		2779 (E)	$1-2
2698 (C)	$1-2			

Storage Jars Listed in the 1978 Catalog

Cat. Item No.	Price
348E (A)	$8-10
349H (B)	$10-15
372 (C)	$12-20
274 (D)	$8-10
59E (E)	$8-10
60 (F)	$10-15
331E (G)	$8-12
330 (H)	$10-20

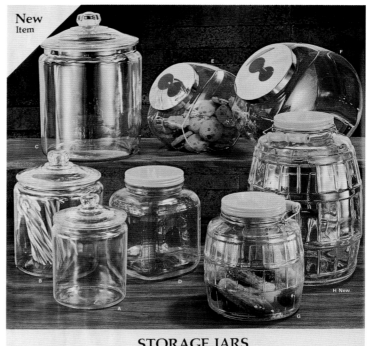

STORAGE JARS

An assortment of large containers—nostalgic touches of grandma's pantry and days gone by.

photo ref.	description	item order no.	BULK PACKED shipper doz. lbs.	
A	½ gal. jar/cover	348E	1/3	13
B	1 gal. jar/cover	349H	1/3	20
C	2 gal. jar/cover	372	1/12	10
D	1 gal. jar/tan cover	274	1	36
E	1 gal. jar/metal cover	59E	1/3	16
F	2 gal. jar/metal cover	60	1/12	6
G	1 gal. barrel jar/handle	331E	1/3	15
H	New 2½ gal. barrel jar/handle	330	1/12	7

100 Decorative Glass

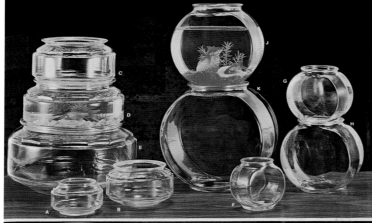

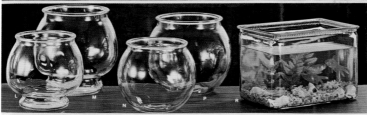

Fish Bowls Listed in the 1978 Bulk Catalog

Cat. Item No.	Price
124 (A)	$2-4
191 (B)	$3-5
192 (C)	$4-5
193 (D)	$5-6
194 (E)	$5-8
125 (F)	$2-4
70/1 (G)	$3-5
70/2 (H)	$3-5
70/4 (J)	$5-8
70/8 (K)	$5-8
92 (L)	$3-5
98 (M)	$3-5
93 (N)	$3-5
97 (P)	$3-5
91 (R)	$8-12

FISH BOWLS

From guppies to goldfish...a complete line of fish bowls to meet the needs of all aquatic creature lovers.

photo ref.	description	item order no.	BULK PACKED shipper doz. lbs.	
A	14 oz. mini-squat	124	3	22
B	1 qt. squat	191	3	37
C	½ gal. squat	192	2	46
D	1 gal. squat	193	1	40
E	2 gal. squat	194	½	38
F	16 oz. mini-drum	125	3	26
G	1 qt. drum	70/1	3	41

photo ref.	description	item order no.	BULK PACKED shipper doz. lbs.	
H	½ gal. drum	70/2	2	48
J	1 gal. drum	70/4	1	41
K	2 gal. drum	70/8	½	33
L	½ gal. ftd. fish bowl/terrarium	92	1	26
M	1 gal. ftd. fish bowl/terrarium	98	½	24
N	½ gal. round bowl/terrarium	93	1	26
P	1 gal. round bowl/terrarium	97	½	22
R	6 qt. oblong aquarium	91	½	38

Decorative Glass 101

Mixing Bowls and Refrigerator Dishes Listed in the Butler Brothers Catalog

Catalog Item

Number	Description	Price
52X-505G	5" Rolled edge mixing bowl	$10-15
52X-506G	6" Rolled edge mixing bowl	$10-15
52X-507G	7" Rolled edge mixing bowl	$12-15
52X-508G	8" Rolled edge mixing bowl	$15-20
52X-509G	9" Rolled edge mixing bowl	$15-20
52X-510G	10" Rolled edge mixing bowl	$15-25
52X-149G	5 Piece mixing bowl set	$75-100
52X-20G	4" x 4" Refrigerator jar	$15-20
52X-23G	6" x 6" Refrigerator jar	$15-25
52X-994G	7" x 4" Butter jar	$20-30
52X-21G	8" x 4" Oblong jar	$15-25
52X-31G	6" Oval jar	$15-20
52X-33G	7" Oval jar	$15-25
52X-35G	8" Oval jar	$20-30
52X-601G	1 qt. Refrigerator bottle	$20-25
52X-602G	2 qt. Refrigerator bottle	$15-25
52X-92G	8 Piece refrigerator jar set	$60-75
52X-152G	Oval jar set	$75-100

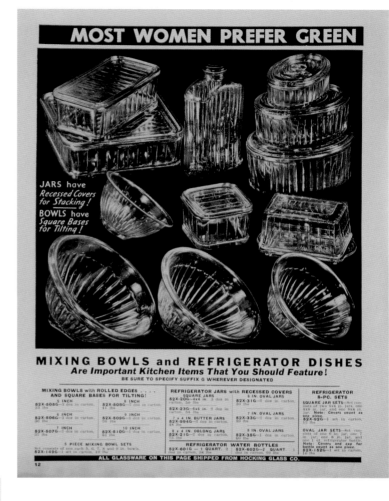

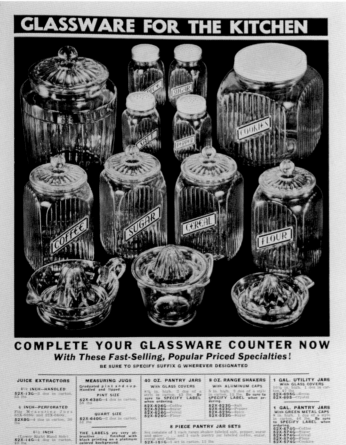

Mixing Bowls and Refrigerator Dishes Listed in the Butler Brothers Catalog

Catalog Item

Number	Description	Price
52X-13G	8 1/2" Juice extractor	$20-30
52X8G	6" Perforated juice extractor	$15-20
52X-14G	6 1/2" Juice extractor	$15-20
52X-638G	Pint measuring jug	$12-15
52X-640G	Quart measuring jug	$15-20
52X-526G	40 oz. Pantry jar	$25-35 each
52X-523G	8 oz. Range shakers	$10-15 each
52X-151G	8 Piece pantry jar set	$150-200
52X-695G	1 Gallon utility jar	$45-60 (green)
52X-695	1 Gallon utility jar	$45-50 (crystal)
52X-574G	1 Gallon pantry jars	$30-45 each

Chapter Six
Ashtrays

Anchor Hocking made a myriad of ashtrays over the years. Some ashtrays were made in abundance and some are quite rare. Many of the ashtrays have lacquer finishes that are easily rubbed off. Prices will vary depending upon the pattern, size, style, applied finish, color, and regional availability. I have attempted to group items to simplify pricing.

Ashtrays

Ashtray Color	Price
Crystal	$1-5
Aquamarine	$2-5
Sky Blue	$5-10
Laser Blue	$4-10
Honey Gold	$1-5
Avocado Green	$1-4
Spearmint Green	$8-10
Forest Green	$5-8
Royal Ruby	$8-10
Flashed Colors	$8-15

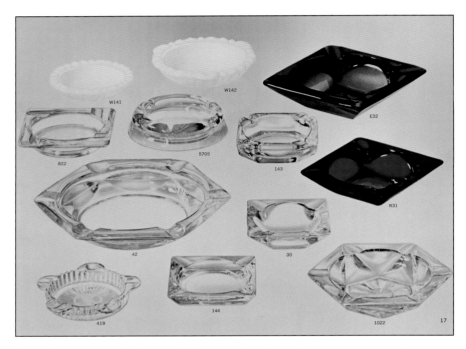

Many of the ashtrays listed in the 1964 Anchor Hocking catalog were made in other colors. The #822 and #419 were made in Royal Ruby, while the #1022, #42, and #419 were made in Forest Green.

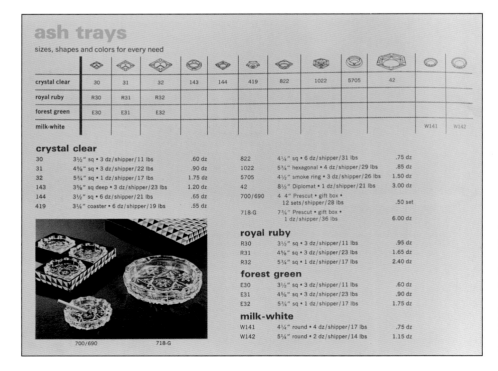

ash trays
sizes, shapes and colors for every need

	30	31	32	143	144	419	822	1022	5705	42		
crystal clear	30	31	32	143	144	419	822	1022	5705	42		
royal ruby	R30	R31	R32									
forest green	E30	E31	E32									
milk-white											W141	W142

crystal clear
30	3½" sq • 3 dz/shipper/11 lbs	.60 dz		822	4¼" sq • 6 dz/shipper/31 lbs	.75 dz	
31	4⅝" sq • 3 dz/shipper/22 lbs	.90 dz		1022	5¾" hexagonal • 4 dz/shipper/29 lbs	.85 dz	
32	5¾" sq • 1 dz/shipper/17 lbs	1.75 dz		5705	4½" smoke ring • 3 dz/shipper/26 lbs	1.50 dz	
143	3⅝" sq deep • 3 dz/shipper/23 lbs	1.20 dz		42	8½" Diplomat • 1 dz/shipper/21 lbs	3.00 dz	
144	3½" sq • 6 dz/shipper/21 lbs	.65 dz		700/690	4" Prescut • gift box • 12 sets/shipper/28 lbs	.50 set	
419	3¼" coaster • 6 dz/shipper/19 lbs	.55 dz		718-G	7¾" Prescut • gift box • 1 dz/shipper/36 lbs	6.00 dz	

royal ruby
R30	3½" sq • 3 dz/shipper/11 lbs	.95 dz
R31	4⅝" sq • 3 dz/shipper/23 lbs	1.65 dz
R32	5¾" sq • 1 dz/shipper/17 lbs	2.40 dz

forest green
E30	3½" sq • 3 dz/shipper/11 lbs	.60 dz
E31	4⅝" sq • 3 dz/shipper/23 lbs	.90 dz
E32	5¾" sq • 1 dz/shipper/17 lbs	1.75 dz

milk-white
W141	4¼" round • 4 dz/shipper/17 lbs	.75 dz
W142	5¼" round • 2 dz/shipper/14 lbs	1.15 dz

The large Early American Prescut ashtray listed in the 1964 catalog was also made in Royal Ruby. The majority of the Royal Ruby ashtrays are marked with the "anchor over H" emblem on the inside surface of the ashtray. Anchor Hocking did make experimental Early American Prescut ashtrays in Laser Blue and Spicy Brown. The only surviving examples can be seen in the Anchor Hocking Glass Museum in San Antonio, Texas.

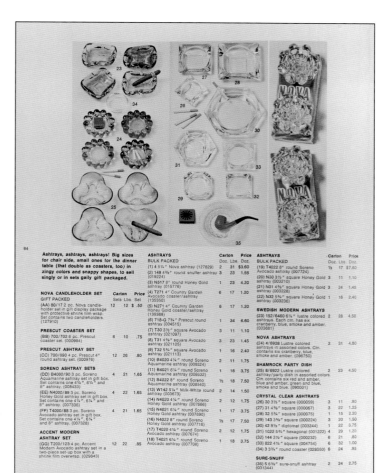

Ashtrays, ashtrays, ashtrays! Big sizes for chair side, small ones for the dinner table (that double as coasters, too) in zingy colors and snappy shapes, to sell singly or in sets gaily gift packaged.

NOVA CANDLEHOLDER SET

GIFT PACKED	Carton Sets	Lbs.	Price Set
(AA) 80/17 2 pc. Nova candleholder set in gift display package with protective shrink film wrap. Set contains two candleholders. (127910)	12	12	$.50

PRESCUT COASTER SET

	Carton	Lbs.	Price
(BB) 700/702 6 pc. Prescut coaster set. (000984)	6	10	.75

PRESCUT ASHTRAY SET

(CC) 700/890 4 pc. Prescut 4" round ashtray set. (000976)	12	26	.80

SORENO ASHTRAY SETS

(DD) B4000/90 3 pc. Soreno Aquamarine ashtray set in gift box. Set contains one 4¾", 6¼" and 8" ashtray. (008433)	4	21	1.65
(EE) N4000/89 3 pc. Soreno Honey Gold ashtray set in gift box. Set contains one 4¾", 6¼" and 8" ashtray. (007336)	4	22	1.65
(FF) T4000/88 3 pc. Soreno Avocado ashtray set in gift box. Set contains one 4¾", 6¼" and 8" ashtray. (007328)	4	21	1.65

ACCENT MODERN ASHTRAY SET

(GG) T200/123 4 pc. Accent Modern Avocado ashtray set in a two-piece set-up box with a shrink film overwrap. (029843)	12	22	.85

ASHTRAYS

BULK PACKED	Carton Doz.	Lbs.	Price Doz.
(1) 4 5¼" Nova ashtray (127829)	2	31	$3.60
(2) 148 4⅝" round snuffer ashtray (019224)	3	23	1.55
(3) N517 6" round Honey Gold ashtray (015776)	1	23	4.20
(4) T271 4" Country Garden Avocado coaster/ashtray (135350)	6	17	1.20
(5) N271 4" Country Garden Honey Gold coaster/ashtray (135368)	6	17	1.20
(6) 718-G 7¾" Prescut round ashtray (004515)	1	34	6.60
(7) T30 3½" square Avocado ashtray (021097)	3	11	1.10
(8) T31 4⅝" square Avocado ashtray (021105)	3	23	1.45
(9) T32 5¾" square Avocado ashtray (021113)	1	16	2.40
(10) B4020 4¾" round Soreno Aquamarine ashtray (008524)	2	11	1.75
(11) B4021 6¼" round Soreno Aquamarine ashtray (008532)	1	16	3.75
(12) B4022 8" round Soreno Aquamarine ashtray (008540)	½	18	7.50
(13) W142 5¼" Milk-White round ashtray (003673)	2	14	1.50
(14) N4020 4¾" round Soreno Honey Gold ashtray (007666)	2	12	1.75
(15) N4021 6¼" round Soreno Honey Gold ashtray (007590)	1	17	3.75
(16) N4022 8" round Soreno Honey Gold ashtray (007716)	½	17	7.50
(17) T4020 4¾" round Soreno Avocado ashtray (007674)	2	12	1.75
(18) T4021 6¼" round Soreno Avocado ashtray (007708)	1	18	3.75

ASHTRAYS

BULK PACKED	Carton Doz.	Lbs.	Price Doz.
(19) T4022 8" round Soreno Avocado ashtray (007724)	½	17	$7.50
(20) N30 3½" square Honey Gold ashtray (003210)	3	11	1.10
(21) N31 4⅝" square Honey Gold ashtray (003228)	3	24	1.45
(22) N32 5¾" square Honey Gold ashtray (003236)	1	16	2.40

SWEDISH MODERN ASHTRAYS

(23) 152/6460 6¼" lustre colored ashtrays. Each ctn. has six cranberry, blue, smoke and amber. (003681)	2	28	4.50

NOVA ASHTRAYS

(24) 4/6928 Lustre colored ashtrays in assorted colors. Ctn. contains six cranberry, blue, smoke and amber. (096750)	2	31	4.80

SHAMROCK PARTY DISH

(25) 8/6922 Lustre colored ashtray/party dish in assorted colors. Ctn. contains six red and amber, blue and amber, green and blue, smoke and blue. (090001)	2	23	4.50

CRYSTAL CLEAR ASHTRAYS

(26) 30 3½" square (000059)	3	11	.90
(27) 31 4⅝" square (000067)	3	22	1.25
(28) 32 5¾" square (000075)	1	15	2.20
(29) 143 3⅝" square (000224)	3	20	1.50
(30) 42 8½" diplomat (003244)	1	22	3.75
(31) 1022 5¾" hexagonal (001222)	4	29	1.20
(32) 144 3½" square (000232)	6	21	.80
(33) 822 4¾" square (004754)	6	32	1.00
(34) 3 3¾" round coaster (026050)	6	24	.95

SURE-SNUFF

(35) 5 6⅝" sure-snuff ashtray (031344)	2	24	2.75

94

Many Lustre (flashed with colored lacquer) ashtrays were listed in the 1970 catalog. It is difficult to find mint condition Lustre colored Swedish Modern, Nova, or Shamrock party dish/ashtrays since the lacquer is easily rubbed off.

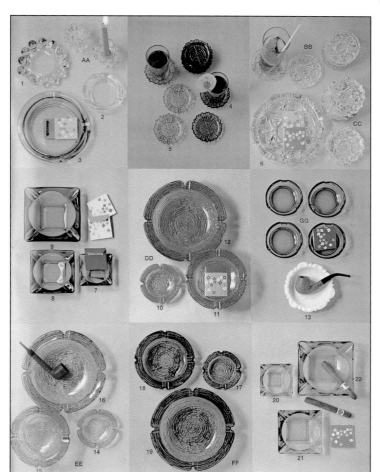

Numerous ashtrays listed in the 1970 catalog.

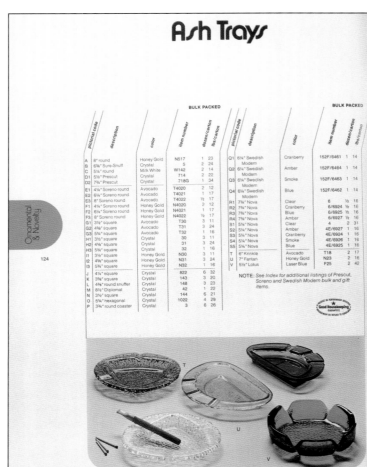

Ash Trays

pictorial code	description	color	item number	dozen/carton	lbs/carton
A	8" round	Honey Gold	N517	1	23
B	6⅛" Sure-Snuff	Crystal	5	2	24
C	5¼" round	Milk White	W142	2	14
D1	5⅛" Prescut	Crystal	714	2	22
D2	7¾" Prescut	Crystal	718G	1	34
E1	4¼" Soreno round	Avocado	T4020	2	12
E2	6¼" Soreno round	Avocado	T4021	1	17
E3	8" Soreno round	Avocado	T4022	½	17
F1	4¼" Soreno round	Honey Gold	N4020	2	12
F2	6¼" Soreno round	Honey Gold	N4021	1	17
F3	8" Soreno round	Honey Gold	N4022	½	17
G1	3½" square	Avocado	T30	3	11
G2	4⅜" square	Avocado	T31	3	24
G3	5¼" square	Avocado	T32	1	16
H1	3½" square	Crystal	30	3	11
H2	4⅜" square	Crystal	31	3	24
H3	5¼" square	Crystal	32	1	16
I1	3½" square	Honey Gold	N30	3	11
I2	4⅜" square	Honey Gold	N31	3	24
I3	5¼" square	Honey Gold	N32	1	16
J	4¼" square	Crystal	822	6	32
K	3⅞" square	Crystal	143	3	20
L	4⅜" round snuffer	Crystal	148	3	23
M	8½" Diplomat	Crystal	42	1	22
N	3½" square	Crystal	144	6	21
O	5¼" hexagonal	Crystal	1022	4	29
P	3¾" round coaster	Crystal	3	6	26
Q1	6¼" Swedish Modern	Cranberry	152F/6461	1	14
Q2	6¼" Swedish Modern	Amber	152F/6464	1	14
Q3	6¼" Swedish Modern	Smoke	152F/6463	1	14
Q4	6¼" Swedish Modern	Blue	152F/6462	1	14
R1	7¾" Nova	Clear	6	½	16
R2	7¾" Nova	Cranberry	6/6924	½	16
R3	7¾" Nova	Blue	6/6925	½	16
R4	7¾" Nova	Amber	6/6927	½	16
S1	5¼" Nova	Clear	4	2	31
S2	5¼" Nova	Amber	4E/6927	1	16
S3	5¼" Nova	Cranberry	4E/6924	1	16
S4	5¼" Nova	Smoke	4E/6926	1	16
S5	5¼" Nova	Blue	4E/6925	1	16
T	6" Krinkle	Avocado	T18	2	17
U	7" Fantan	Honey Gold	N23	2	16
V	5½" Lotus	Laser Blue	F25	2	42

NOTE: See Index for additional listings of Prescut, Soreno and Swedish Modern bulk and gift items.

The Krinkle, Fanfare, and Lotus ashtrays listed in the 1972 catalog can be difficult to find, especially if the ashtray was made in Smoke or Spicy Brown.

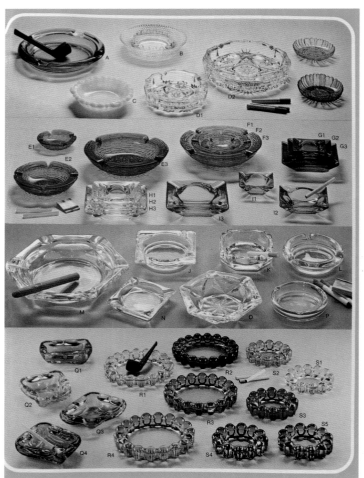

More ashtrays listed in the 1972 catalog.

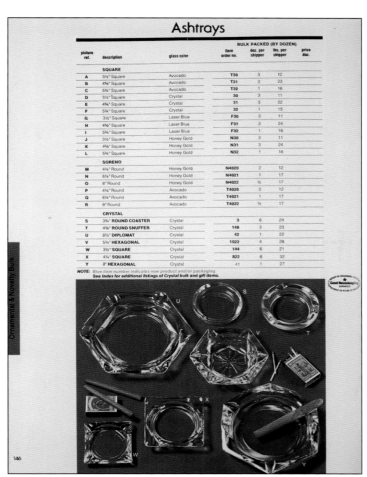

Ashtrays

picture ref.	description	glass color	item order no.	doz. per shipper	lbs. per shipper	price doz.
	SQUARE					
A	3½" Square	Avocado	T30	3	12	
B	4⅝" Square	Avocado	T31	3	23	
C	5¾" Square	Avocado	T32	1	16	
D	3½" Square	Crystal	30	3	11	
E	4⅝" Square	Crystal	31	3	22	
F	5¾" Square	Crystal	32	1	15	
G	3½" Square	Laser Blue	F30	3	11	
H	4⅝" Square	Laser Blue	F31	3	24	
I	5¾" Square	Laser Blue	F32	1	16	
J	3½" Square	Honey Gold	N30	3	11	
K	4⅝" Square	Honey Gold	N31	3	24	
L	5¾" Square	Honey Gold	N32	1	16	
	SORENO					
M	4¼" Round	Honey Gold	N4020	2	12	
N	6¼" Round	Honey Gold	N4021	1	17	
O	8" Round	Honey Gold	N4022	½	17	
P	4¼" Round	Avocado	T4020	2	12	
Q	6¼" Round	Avocado	T4021	1	17	
R	8" Round	Avocado	T4022	½	17	
	CRYSTAL					
S	3⅞" ROUND COASTER	Crystal	3	6	24	
T	4⅝" ROUND SNUFFER	Crystal	148	3	23	
U	8½" DIPLOMAT	Crystal	42	1	22	
V	5¾" HEXAGONAL	Crystal	1022	4	26	
W	3½" SQUARE	Crystal	144	6	21	
X	4¼" SQUARE	Crystal	822	6	32	
Y	8" HEXAGONAL	Crystal	41	1	27	

NOTE: Blue item number indicates new product and/or packaging.
See Index for additional listings of Crystal bulk and gift items.

146

Ashtrays listed in the 1974 catalog.

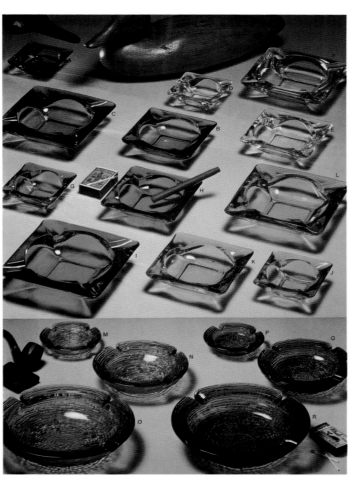

The Laser Blue square ashtray in the 1974 catalog can be hard to find.

Ashtrays

picture ref.	description	color	item order no.	doz. per shipper	lbs. per shipper	price doz.
				BULK PACKED (BY DOZEN)		
	LOTUS					
A	4¾" Lotus	Laser Blue	F24	2	18	
B	5½" Lotus	Laser Blue	F25	2	42	
C	7" Lotus	Laser Blue	F26	½	13	
D	4¾" Lotus	Spicy Brown	Y24	2	18	
E	5½" Lotus	Spicy Brown	Y25	2	42	
F	7" Lotus	Spicy Brown	Y26	½	13	
	NOVA					
G	5¼" Nova	Cranberry	4E/6924	1	16	
H	7¾" Nova	Cranberry	6/6924	½	18	
I	5¼" Nova	Blue	4E/6925	1	16	
J	7¾" Nova	Blue	6/6925	½	16	
K	5¼" Nova	Smoke	4E/6926	1	16	
L	5¼" Nova	Amber	4E/6927	1	16	
M	7¾" Nova	Amber	6/6927	½	16	
N	5¼" Nova	Clear	4	2	31	
O	7¾" Nova	Clear	6	½	16	
	SURE-SNUFF					
P	4¾" Sure-Snuff	Clear	35	4	23	
Q	6⅜" Sure-Snuff	Clear	5	2	24	
	FAIRFIELD					
R	6¼" Fairfield	Avocado	T1216	1	22	
S	6¼" Fairfield	Honey Gold	N1216	1	22	
	MISCELLANEOUS					
T	3⅜" SQUARE	Crystal	143	3	20	
U	3⅜" SQUARE	Honey Gold	N143	3	20	
V	5½" PRESCUT	Crystal	714	2	22	
W	5¼" ROUND	Milk White	W142	2	14	
X	8" ROUND	Honey Gold	N517	1	23	

NOTE: Blue item number indicates new product and/or packaging.
See Index for additional listings of Lotus, Nova, Fairfield, Prescut and Crystal bulk and gift items.

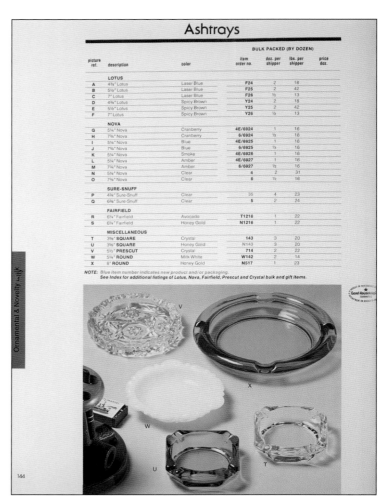

144

The Spicy Brown Lotus ashtray in the 1974 catalog is difficult to find.

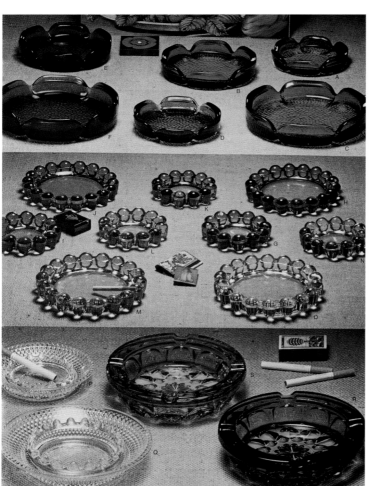

The Fairfield pattern ashtray (item R and S) in the 1974 catalog was only listed in Avocado Green and Honey Gold. The ashtray was produced in Sky Blue in 1975 and in Spearmint Green in 1978. The Sky Blue and Spearmint Green Fairfield ashtrays are very hard to find due to their limited production.

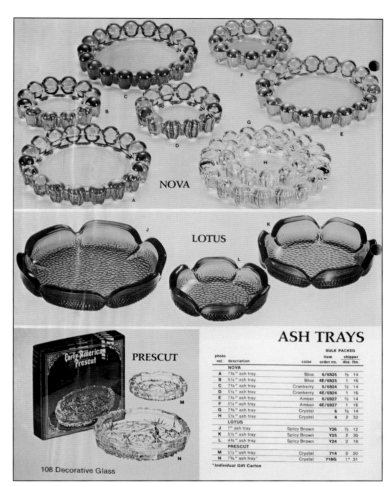

Ashtrays listed in the 1978 Bulk Catalog.

NOVA

LOTUS

PRESCUT

Early American Prescut

108 Decorative Glass

ASH TRAYS

photo ref.	description	color	item order no.	BULK PACKED shipper doz.	lbs.
	NOVA				
A	7¾" ash tray	Blue	6/6925	½	14
B	5¼" ash tray	Blue	4E/6925	1	16
C	7¾" ash tray	Cranberry	6/6924	½	14
D	5¼" ash tray	Cranberry	4E/6924	1	16
E	7¾" ash tray	Amber	6/6927	½	14
F	5¼" ash tray	Amber	4E/6927	1	16
G	7¾" ash tray	Crystal	6	½	14
H	5¼" ash tray	Crystal	4	2	32
	LOTUS				
J	7" ash tray	Spicy Brown	Y26	½	12
K	5½" ash tray	Spicy Brown	Y25	2	30
L	4½" ash tray	Spicy Brown	Y24	2	18
	PRESCUT				
M	5½" ash tray	Crystal	714	2	20
N	7¾" ash tray*	Crystal	718G	1*	31

*Individual Gift Carton

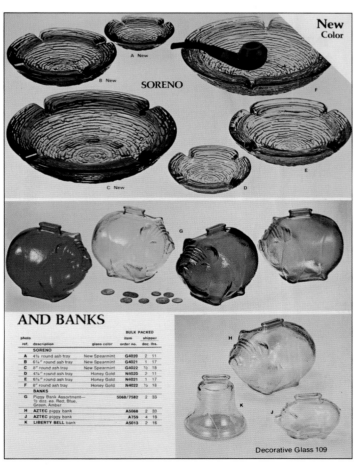

New Color

SORENO

AND BANKS

photo ref.	description	glass color	item order no.	BULK PACKED shipper doz.	lbs.
	SORENO				
A	4½" round ash tray	New Spearmint	G4020	2	11
B	6¼" round ash tray	New Spearmint	G4021	1	17
C	8" round ash tray	New Spearmint	G4022	½	18
D	4½" round ash tray	Honey Gold	N4020	2	11
E	6¼" round ash tray	Honey Gold	N4021	1	17
F	8" round ash tray	Honey Gold	N4022	½	18
	BANKS				
G	Piggy Bank Assortment—½ doz. ea. Red, Blue, Green, Amber		5068/7582	2	33
H	AZTEC piggy bank		A5068	2	33
J	AZTEC piggy bank		A759	4	19
K	LIBERTY BELL bank		A5013	2	16

Decorative Glass 109

Spearmint Green Soreno ashtrays were introduced in the 1978 Bulk Catalog.

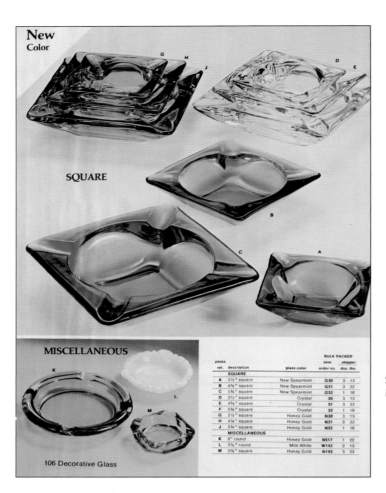

New Color

SQUARE

MISCELLANEOUS

photo ref.	description	glass color	BULK PACKED item order no.	shipper doz.	lbs.
SQUARE					
A	3½" square	New Spearmint	G36	3	13
B	4⅛" square	New Spearmint	G31	3	22
C	5¾" square	New Spearmint	G32	1	16
D	3½" square	Crystal	30	3	13
E	4⅛" square	Crystal	31	3	22
F	5¾" square	Crystal	32	1	16
G	3½" square	Honey Gold	N30	3	13
H	4⅛" square	Honey Gold	N31	3	22
J	5¾" square	Honey Gold	N32	1	16
MISCELLANEOUS					
K	8" round	Honey Gold	NS17	1	22
L	5⅝" round	Milk White	W142	2	13
M	3½" square	Honey Gold	N143	3	22

106 Decorative Glass

Spearmint Green square ashtrays were introduced in the 1978 Bulk Catalog.

The 1978 Bulk Catalog ashtray listing.

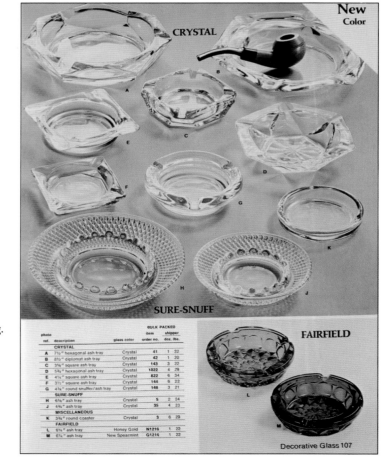

New Color

CRYSTAL

SURE-SNUFF

FAIRFIELD

photo ref.	description	glass color	BULK PACKED item order no.	shipper doz.	lbs.
CRYSTAL					
A	7½" hexagonal ash tray	Crystal	41	1	22
B	8½" diplomat ash tray	Crystal	42	1	20
C	3¾" square ash tray	Crystal	143	3	22
D	5¾" hexagonal ash tray	Crystal	1022	4	29
E	4½" square ash tray	Crystal	822	6	34
F	3½" square ash tray	Crystal	144	6	22
G	4¾" round snuffer/ash tray	Crystal	146	3	21
SURE-SNUFF					
H	6¾" ash tray	Crystal	5	2	24
J	4½" ash tray	Crystal	35	4	33
MISCELLANEOUS					
K	3¾" round coaster	Crystal	3	6	29
FAIRFIELD					
L	6¼" ash tray	Honey Gold	N121S	1	22
M	6¼" ash tray	New Spearmint	G121S	1	22

Decorative Glass 107

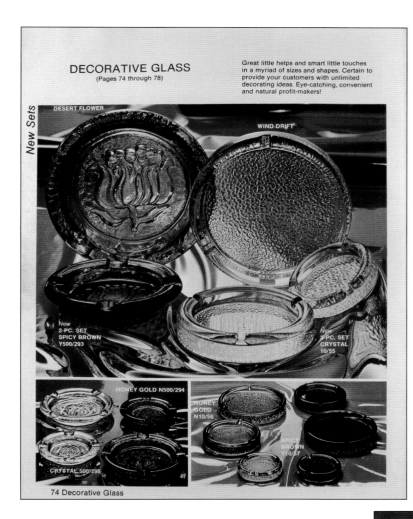

New Sets

DECORATIVE GLASS
(Pages 74 through 78)

Great little helps and smart little touches in a myriad of sizes and shapes. Certain to provide your customers with unlimited decorating ideas. Eye-catching, convenient and natural profit-makers!

DESERT FLOWER

WIND DRIFT

New
2-PC. SET
SPICY BROWN
Y500/293

New
2-PC. SET
CRYSTAL
10/55

HONEY GOLD N500/294

HONEY GOLD N10/56

CRYSTAL 500/295

SPICY BROWN Y10/57

74 Decorative Glass

Desert Flower and Wind Drift ashtrays were introduced in the 1979 Gift Set Collection catalog.

Sunburst, Desert Flower, and Wind Drift ashtrays were also introduced in the 1979 Bulk Catalog A-24.

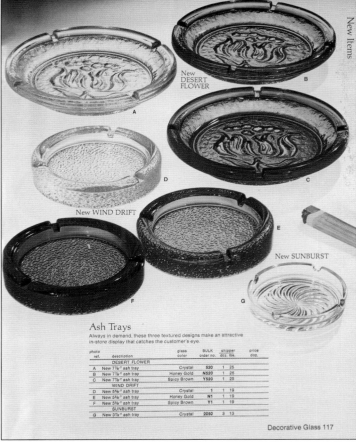

New Items

New DESERT FLOWER

A

B

New WIND DRIFT

D

C

E

New SUNBURST

F

G

Ash Trays
Always in demand, these three textured designs make an attractive in-store display that catches the customer's eye.

photo ref.	description	glass color	BULK order no.	shipper doz. lbs.		price doz.
	DESERT FLOWER					
A	New 7⅞" ash tray	Crystal	520	1	25	
B	New 7⅞" ash tray	Honey Gold	N520	1	25	
C	New 7⅞" ash tray	Spicy Brown	Y520	1	25	
	WIND DRIFT					
D	New 5⅝" ash tray	Crystal	1	1	19	
E	New 5⅝" ash tray	Honey Gold	N1	1	19	
F	New 5⅝" ash tray	Spicy Brown	Y1	1	19	
	SUNBURST					
G	New 3⅞" ash tray	Crystal	2050	3	13	

Decorative Glass 117

Chapter Seven
Etched Glassware

Many of the etched patterns were given away as promotional items in variety stores and service stations. This accounts for the great abundance of some of the patterns. If the etching was done on colored glassware, then the prices would escalate significantly. The prices below are for crystal glassware only.

Etched Glassware

Item Description	Price	Item Description	Price
Bowls	$5-8	Plates	$5-8
Cocktail shakers	$30-40	Saucers	$2-4
Cups	$2-5	Glasses	$2-4
Decanters	$30-40	Stemmed glasses	$5-10
Pitchers	$20-30		

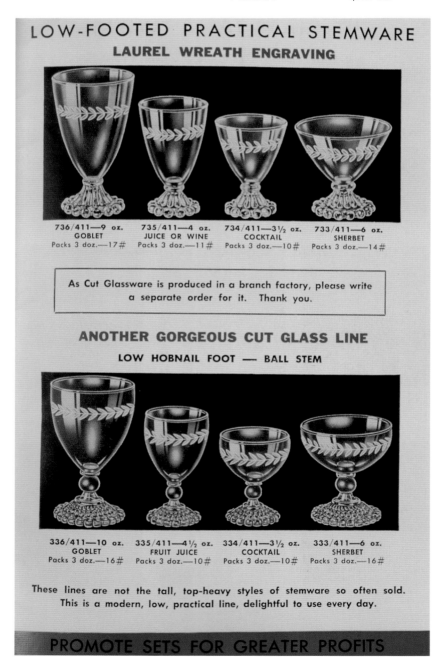

Etched glassware in the 1952 catalog.

CUT GLASS TABLE TUMBLERS
BEAUTIFULLY ENGRAVED

3361/401	3368/401	3651/411 — 9 oz.	3509/401 — 9 oz.
9 OZ. TUMBLER	14 OZ. ICED TEA	TABLE TUMBLER	TABLE TUMBLER
6 doz.—27#	6 doz.—34#	Packs 6 doz.—26#	Packs 6 doz.—25#

3316/411 — 10 oz.	3538/411 — 9½ oz.	3519/120 — 9 oz.
FTD. GOBLET	TABLE TUMBLER	TALL TUMBLER
Packs 6 doz.—37#	Packs 6 doz.—35#	Packs 6 doz.—25#

CUT GLASS HIGH BALLS or ICED TEAS

3658/411 — 13 oz.	3539/411 — 12 oz.	3616/411 — 12 oz.
ICED TEA	TALL TUMBLER	HIGH BALL
Packs 6 doz.—32#	Packs 6 doz.—40#	Packs 6 doz.—46#

SPOTLIGHT YOUR GLASS COUNTER

Miscellaneous etched glassware listed in the 1952 catalog.

Miscellaneous etched glassware listed in the 1952 catalog.

CUT GLASS FRUIT JUICE GLASSES
DISTINCTIVELY DIFFERENT

3311/411 — 5 oz.	3653/411 — 5 oz.	3363/401 — 5 oz.
FTD. FRUIT JUICE	FRUIT JUICE	FRUIT JUICE
Packs 6 doz.—20#	Packs 6 doz.—16#	Packs 6 doz.—22#

3312/411 — 3½ oz.	3537/411 — 7¾ oz.	3536/411 — 6 oz.
FTD. COCKTAIL	OLD FASHIONED	FRUIT JUICE
Packs 6 doz.—16#	Packs 6 doz.—31#	Packs 6 doz.—23#

THREE WHIRLWIND SPECIALS

3514/401 — 10 oz.	3362/401 — 3½ oz.	3313/411 — 7 oz.
HIGH BALL	COCKTAIL	SHERBET
Packs 6 doz.—27#	Packs 6 doz.—16#	Packs 6 doz.—29#

PROPER LIGHTING SELLS GLASS

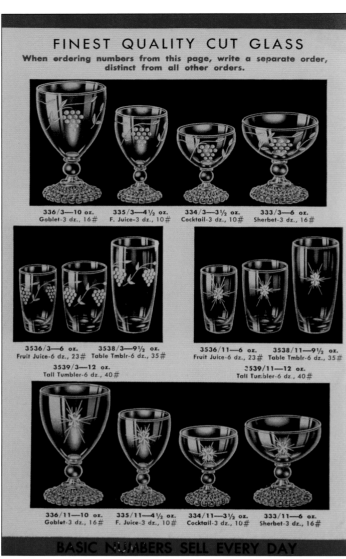

Miscellaneous etched glassware listed in the 1952 catalog.

Laurel cutting listed in the 1964 catalog.

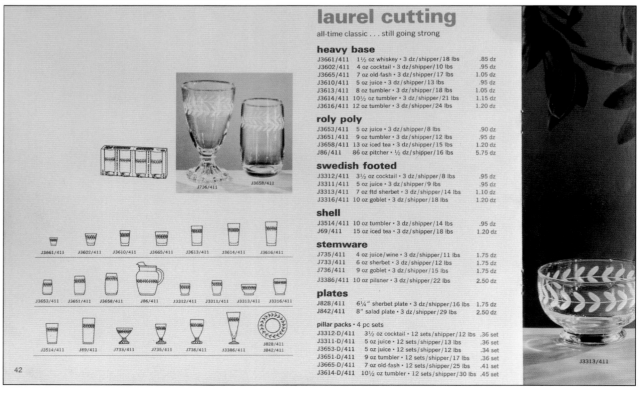

laurel cutting
all-time classic . . . still going strong

heavy base

J3661/411	1½ oz whiskey • 3 dz/shipper/18 lbs	.85 dz
J3602/411	4 oz cocktail • 3 dz/shipper/10 lbs	.95 dz
J3665/411	7 oz old-fash • 3 dz/shipper/17 lbs	1.05 dz
J3610/411	5 oz juice • 3 dz/shipper/13 lbs	.95 dz
J3613/411	8 oz tumbler • 3 dz/shipper/18 lbs	1.05 dz
J3614/411	10½ oz tumbler • 3 dz/shipper/21 lbs	1.15 dz
J3616/411	12 oz tumbler • 3 dz/shipper/24 lbs	1.20 dz

roly poly

J3653/411	5 oz juice • 3 dz/shipper/8 lbs	.90 dz
J3651/411	9 oz tumbler • 3 dz/shipper/12 lbs	.95 dz
J3658/411	13 oz iced tea • 3 dz/shipper/15 lbs	1.20 dz
J86/411	86 oz pitcher • ½ dz/shipper/16 lbs	5.75 dz

swedish footed

J3312/411	3½ oz cocktail • 3 dz/shipper/8 lbs	.95 dz
J3311/411	5 oz juice • 3 dz/shipper/9 lbs	.95 dz
J3313/411	7 oz ftd sherbet • 3 dz/shipper/14 lbs	1.10 dz
J3316/411	10 oz goblet • 3 dz/shipper/18 lbs	1.20 dz

shell

J3514/411	10 oz tumbler • 3 dz/shipper/14 lbs	.95 dz
J69/411	15 oz iced tea • 3 dz/shipper/18 lbs	1.20 dz

stemware

J735/411	4 oz juice/wine • 3 dz/shipper/11 lbs	1.75 dz
J733/411	6 oz sherbet • 3 dz/shipper/12 lbs	1.75 dz
J736/411	9 oz goblet • 3 dz/shipper/15 lbs	1.75 dz
J3386/411	10 oz pilsner • 3 dz/shipper/22 lbs	2.50 dz

plates

J828/411	6¼" sherbet plate • 3 dz/shipper/16 lbs	1.75 dz
J842/411	8" salad plate • 3 dz/shipper/29 lbs	2.50 dz

pillar packs • 4 pc sets

J3312-D/411	3½ oz cocktail • 12 sets/shipper/12 lbs	.36 set
J3311-D/411	5 oz juice • 12 sets/shipper/13 lbs	.36 set
J3653-D/411	5 oz juice • 12 sets/shipper/12 lbs	.34 set
J3651-D/411	9 oz tumbler • 12 sets/shipper/17 lbs	.36 set
J3665-D/411	7 oz old-fash • 12 sets/shipper/25 lbs	.41 set
J3614-D/411	10½ oz tumbler • 12 sets/shipper/30 lbs	.45 set

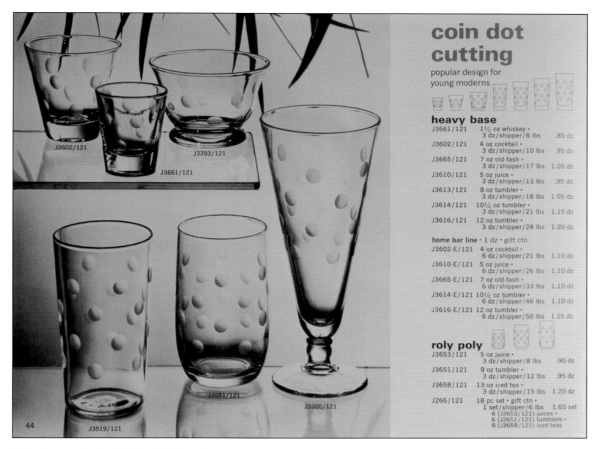

coin dot cutting

popular design for young moderns

heavy base

J3661/121	1½ oz whiskey •		
	3 dz/shipper/8 lbs	.85 dz	
J3602/121	4 oz cocktail •		
	3 dz/shipper/10 lbs	.95 dz	
J3665/121	7 oz old-fash •		
	3 dz/shipper/17 lbs	1.05 dz	
J3610/121	5 oz juice •		
	3 dz/shipper/13 lbs	.95 dz	
J3613/121	8 oz tumbler •		
	3 dz/shipper/18 lbs	1.05 dz	
J3614/121	10½ oz tumbler •		
	3 dz/shipper/21 lbs	1.15 dz	
J3616/121	12 oz tumbler •		
	3 dz/shipper/24 lbs	1.20 dz	

home bar line • 1 dz • gift ctn

J3602-E/121	4 oz cocktail •		
	6 dz/shipper/21 lbs	1.10 dz	
J3610-E/121	5 oz juice •		
	6 dz/shipper/26 lbs	1.10 dz	
J3665-E/121	7 oz old-fash •		
	6 dz/shipper/33 lbs	1.10 dz	
J3614-E/121	10½ oz tumbler •		
	6 dz/shipper/46 lbs	1.10 dz	
J3616-E/121	12 oz tumbler •		
	6 dz/shipper/50 lbs	1.25 dz	

roly poly

J3653/121	5 oz juice •		
	3 dz/shipper/8 lbs	.90 dz	
J3651/121	9 oz tumbler •		
	3 dz/shipper/12 lbs	.95 dz	
J3658/121	13 oz iced tea •		
	3 dz/shipper/15 lbs	1.20 dz	
J266/121	18 pc set • gift ctn		
	1 set/shipper/6 lbs	1.65 set	
	6 (J3653/121) juices •		
	6 (J3651/121) tumblers •		
	6 (J3658/121) iced teas		

Coin Dot cutting listed in the 1964 catalog.

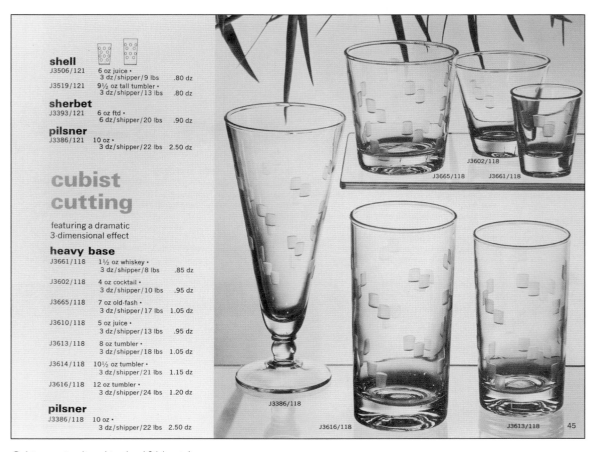

shell

J3506/121	6 oz juice •		
	3 dz/shipper/9 lbs	.80 dz	
J3519/121	9½ oz tall tumbler •		
	3 dz/shipper/13 lbs	.80 dz	

sherbet

J3393/121	6 oz ftd •		
	6 dz/shipper/20 lbs	.90 dz	

pilsner

J3386/121	10 oz •		
	3 dz/shipper/22 lbs	2.50 dz	

cubist cutting

featuring a dramatic 3-dimensional effect

heavy base

J3661/118	1½ oz whiskey •		
	3 dz/shipper/8 lbs	.85 dz	
J3602/118	4 oz cocktail •		
	3 dz/shipper/10 lbs	.95 dz	
J3665/118	7 oz old-fash •		
	3 dz/shipper/17 lbs	1.05 dz	
J3610/118	5 oz juice •		
	3 dz/shipper/13 lbs	.95 dz	
J3613/118	8 oz tumbler •		
	3 dz/shipper/18 lbs	1.05 dz	
J3614/118	10½ oz tumbler •		
	3 dz/shipper/21 lbs	1.15 dz	
J3616/118	12 oz tumbler •		
	3 dz/shipper/24 lbs	1.20 dz	

pilsner

J3386/118	10 oz •		
	3 dz/shipper/22 lbs	2.50 dz	

Cubist cutting listed in the 1964 catalog.

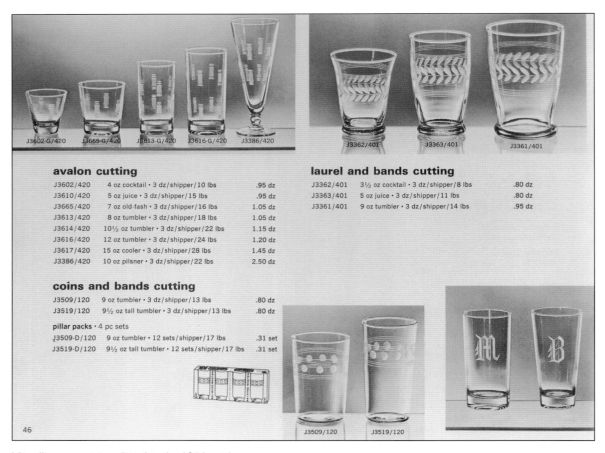

avalon cutting

J3602/420	4 oz cocktail • 3 dz/shipper/10 lbs	.95 dz
J3610/420	5 oz juice • 3 dz/shipper/15 lbs	.95 dz
J3665/420	7 oz old-fash • 3 dz/shipper/16 lbs	1.05 dz
J3613/420	8 oz tumbler • 3 dz/shipper/18 lbs	1.05 dz
J3614/420	10½ oz tumbler • 3 dz/shipper/22 lbs	1.15 dz
J3616/420	12 oz tumbler • 3 dz/shipper/24 lbs	1.20 dz
J3617/420	15 oz cooler • 3 dz/shipper/28 lbs	1.45 dz
J3386/420	10 oz pilsner • 3 dz/shipper/22 lbs	2.50 dz

coins and bands cutting

J3509/120	9 oz tumbler • 3 dz/shipper/13 lbs	.80 dz
J3519/120	9½ oz tall tumbler • 3 dz/shipper/13 lbs	.80 dz
pillar packs • 4 pc sets		
J3509-D/120	9 oz tumbler • 12 sets/shipper/17 lbs	.31 set
J3519-D/120	9½ oz tall tumbler • 12 sets/shipper/17 lbs	.31 set

laurel and bands cutting

J3362/401	3½ oz cocktail • 3 dz/shipper/8 lbs	.80 dz
J3363/401	5 oz juice • 3 dz/shipper/11 lbs	.80 dz
J3361/401	9 oz tumbler • 3 dz/shipper/14 lbs	.95 dz

Miscellaneous cuttings listed in the 1964 catalog.

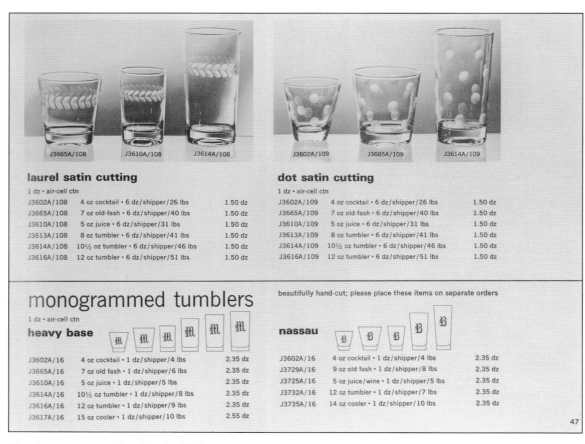

laurel satin cutting

1 dz • air-cell ctn

J3602A/108	4 oz cocktail • 6 dz/shipper/26 lbs	1.50 dz
J3665A/108	7 oz old-fash • 6 dz/shipper/40 lbs	1.50 dz
J3610A/108	5 oz juice • 6 dz/shipper/31 lbs	1.50 dz
J3613A/108	8 oz tumbler • 6 dz/shipper/41 lbs	1.50 dz
J3614A/108	10½ oz tumbler • 6 dz/shipper/46 lbs	1.50 dz
J3616A/108	12 oz tumbler • 6 dz/shipper/51 lbs	1.50 dz

dot satin cutting

1 dz • air-cell ctn

J3602A/109	4 oz cocktail • 6 dz/shipper/26 lbs	1.50 dz
J3665A/109	7 oz old-fash • 6 dz/shipper/40 lbs	1.50 dz
J3610A/109	5 oz juice • 6 dz/shipper/31 lbs	1.50 dz
J3613A/109	8 oz tumbler • 6 dz/shipper/41 lbs	1.50 dz
J3614A/109	10½ oz tumbler • 6 dz/shipper/46 lbs	1.50 dz
J3616A/109	12 oz tumbler • 6 dz/shipper/51 lbs	1.50 dz

monogrammed tumblers

beautifully hand-cut; please place these items on separate orders

1 dz • air-cell ctn

heavy base

J3602A/16	4 oz cocktail • 1 dz/shipper/4 lbs	2.35 dz
J3665A/16	7 oz old fash • 1 dz/shipper/6 lbs	2.35 dz
J3610A/16	5 oz juice • 1 dz/shipper/5 lbs	2.35 dz
J3614A/16	10½ oz tumbler • 1 dz/shipper/8 lbs	2.35 dz
J3616A/16	12 oz tumbler • 1 dz/shipper/9 lbs	2.35 dz
J3617A/16	15 oz cooler • 1 dz/shipper/10 lbs	2.55 dz

nassau

J3602A/16	4 oz cocktail • 1 dz/shipper/4 lbs	2.35 dz
J3729A/16	9 oz old-fash • 1 dz/shipper/8 lbs	2.35 dz
J3725A/16	5 oz juice/wine • 1 dz/shipper/5 lbs	2.35 dz
J3732A/16	12 oz tumbler • 1 dz/shipper/7 lbs	2.35 dz
J3735A/16	14 oz cooler • 1 dz/shipper/10 lbs	2.35 dz

Miscellaneous cuttings listed in the 1964 catalog.

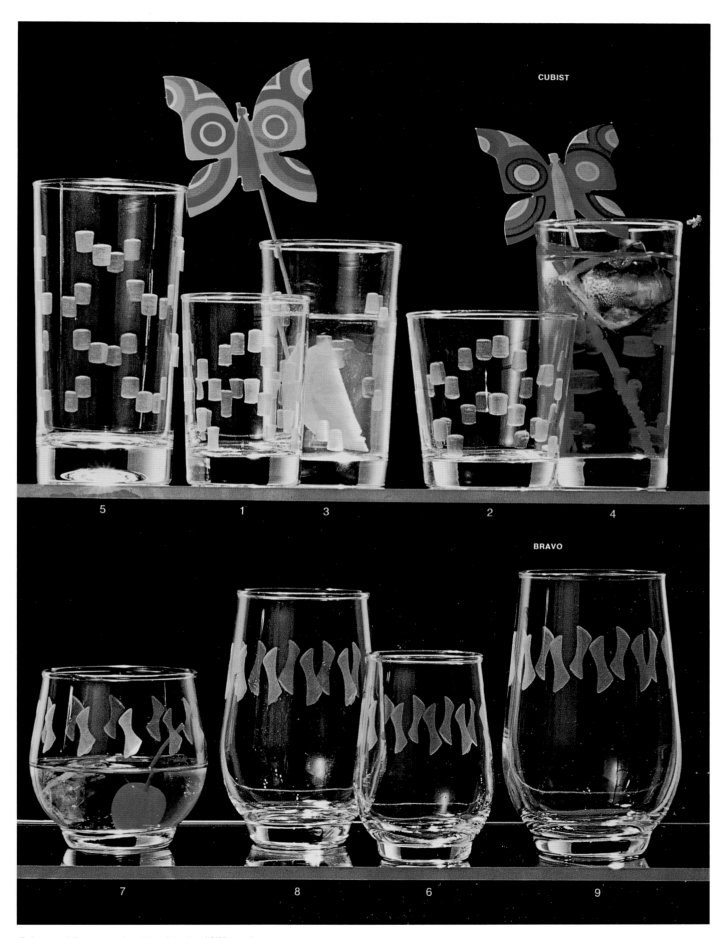

CUBIST

BRAVO

5 1 3 2 4

7 8 6 9

Cubist and Bravo cuttings listed in the 1970 catalog.

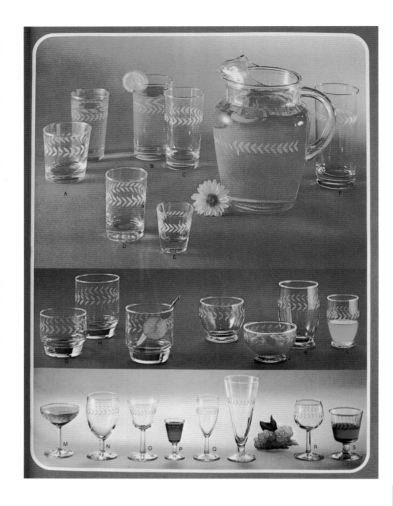

Miscellaneous cuttings
listed in the 1972 catalog.

Miscellaneous cuttings
listed in the 1972 catalog.

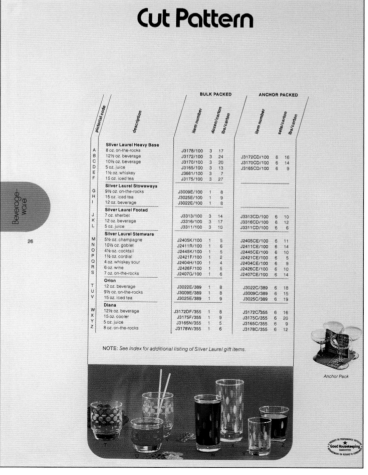

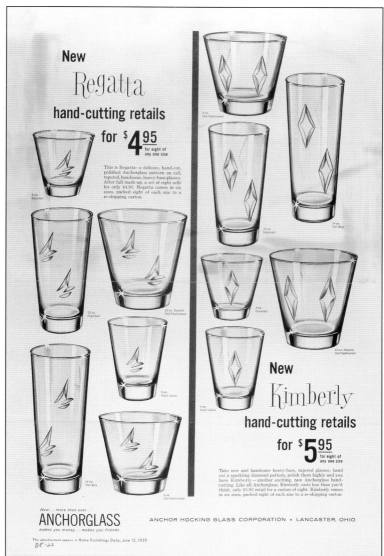

Rare advertising proof with the Regatta cutting.

Below:
Rare advertising proof with the Holiday and Capistrano cuttings.

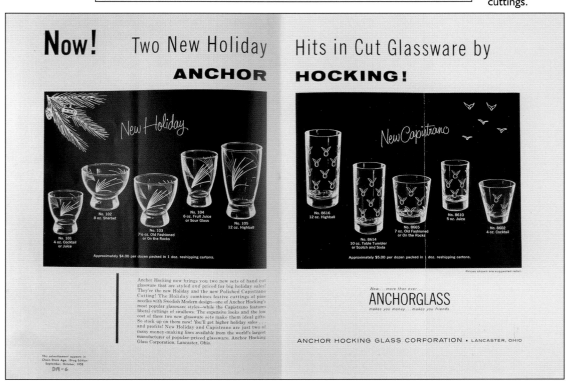

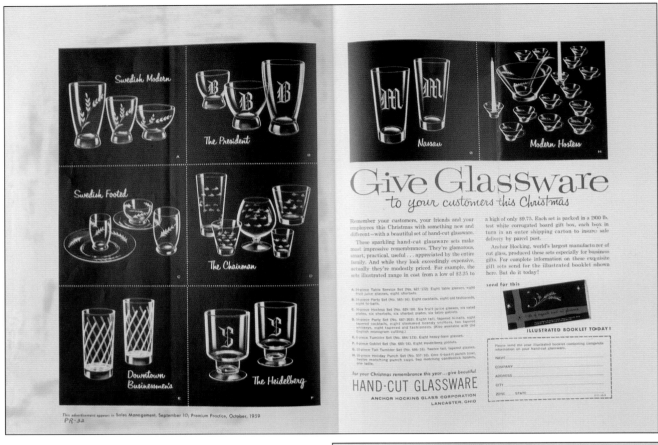

Rare advertising proof with miscellaneous cuttings.

Rare advertising proof with the Riviera cutting.

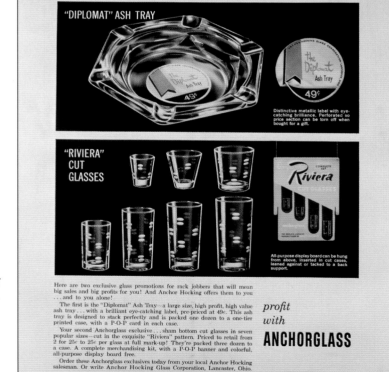

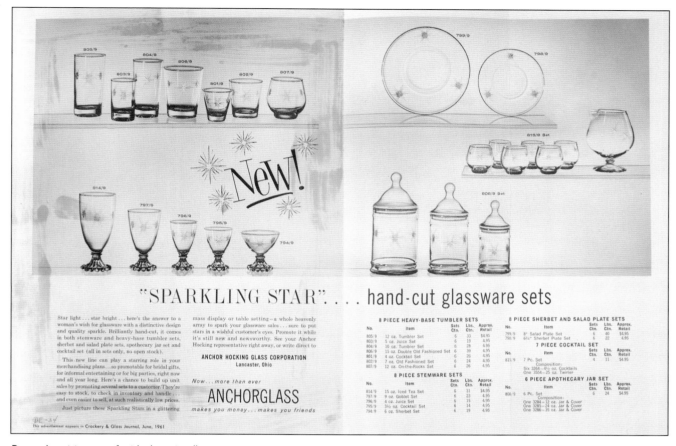

Rare advertising proof with the miscellaneous cuttings.

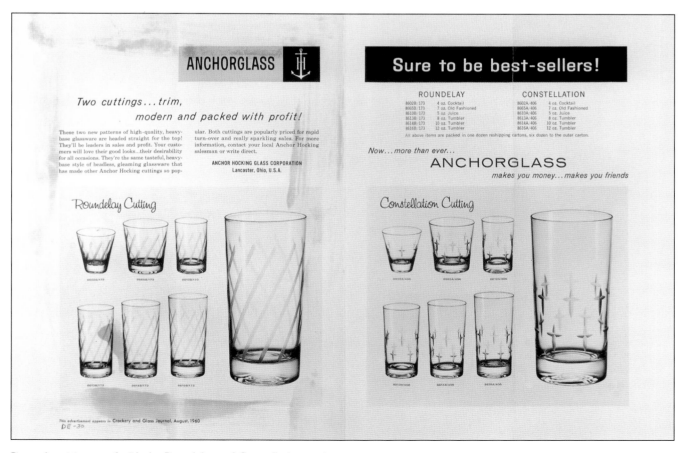

Rare advertising proof with the Roundelay and Constellation cutting.

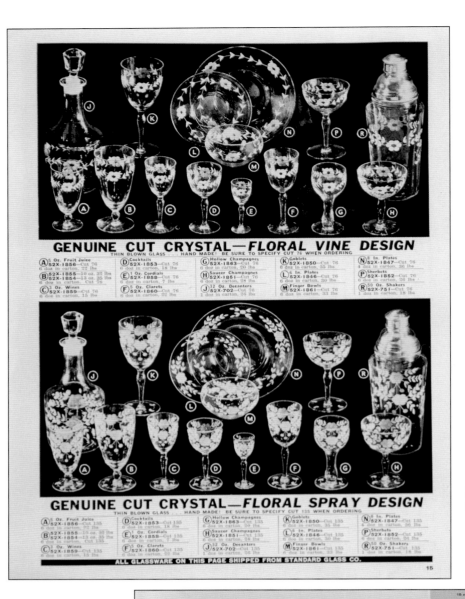

Floral Vine design cuttings listed in the Butler Brothers catalog.

Rare advertising proof with miscellaneous etchings and decorations.

Chapter Eight
Salt and Pepper Shakers

I only selected a sampling of Anchor Hocking salt and pepper shakers. Many more exist and are usually associated with specific glass patterns (i.e., Miss America). The price of most shakers will vary with color, applied design, or glass pattern.

Crystal Salt and Pepper Shakers Listed in the 1951 Catalog

Cat. Item No.	Price
6S	$3-5
6P	$3-5
47S	$3-5
47P	$3-5
151S	$1-3
151P	$1-3
886S	$5-8
886P	$5-8
1830S	$1-2
1830P	$1-2
2985S	$4-5
2985P	$4-5
2986S	$5-6
2986P	$5-6
943S	$8-10
943P	$8-10
40	$12-15
7	$15-20

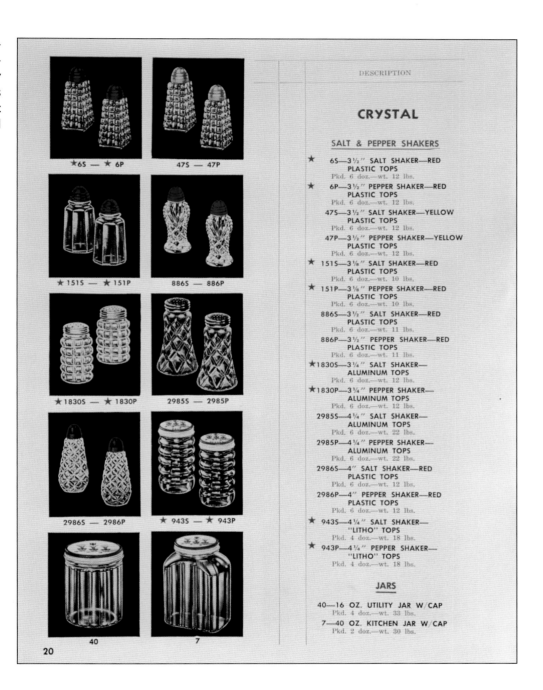

DESCRIPTION

CRYSTAL

SALT & PEPPER SHAKERS

★ 6S—3½" SALT SHAKER—RED PLASTIC TOPS
Pkd. 6 doz.—wt. 12 lbs.

★ 6P—3½" PEPPER SHAKER—RED PLASTIC TOPS
Pkd. 6 doz.—wt. 12 lbs.

47S—3½" SALT SHAKER—YELLOW PLASTIC TOPS
Pkd. 6 doz.—wt. 12 lbs.

47P—3½" PEPPER SHAKER—YELLOW PLASTIC TOPS
Pkd. 6 doz.—wt. 12 lbs.

★ 151S—3⅛" SALT SHAKER—RED PLASTIC TOPS
Pkd. 6 doz.—wt. 10 lbs.

★ 151P—3⅛" PEPPER SHAKER—RED PLASTIC TOPS
Pkd. 6 doz.—wt. 10 lbs.

886S—3½" SALT SHAKER—RED PLASTIC TOPS
Pkd. 6 doz.—wt. 11 lbs.

886P—3½" PEPPER SHAKER—RED PLASTIC TOPS
Pkd. 6 doz.—wt. 11 lbs.

★1830S—3¼" SALT SHAKER—ALUMINUM TOPS
Pkd. 6 doz.—wt. 12 lbs.

★1830P—3¼" PEPPER SHAKER—ALUMINUM TOPS
Pkd. 6 doz.—wt. 12 lbs.

2985S—4¼" SALT SHAKER—ALUMINUM TOPS
Pkd. 6 doz.—wt. 22 lbs.

2985P—4¼" PEPPER SHAKER—ALUMINUM TOPS
Pkd. 6 doz.—wt. 22 lbs.

2986S—4" SALT SHAKER—RED PLASTIC TOPS
Pkd. 6 doz.—wt. 12 lbs.

2986P—4" PEPPER SHAKER—RED PLASTIC TOPS
Pkd. 6 doz.—wt. 12 lbs.

★ 943S—4¼" SALT SHAKER—"LITHO" TOPS
Pkd. 4 doz.—wt. 18 lbs.

★ 943P—4¼" PEPPER SHAKER—"LITHO" TOPS
Pkd. 4 doz.—wt. 18 lbs.

JARS

40—16 OZ. UTILITY JAR W/CAP
Pkd. 4 doz.—wt. 33 lbs.

7—40 OZ. KITCHEN JAR W/CAP
Pkd. 2 doz.—wt. 30 lbs.

Image labels: ★6S — ★6P · 47S — 47P · ★151S — ★151P · 886S — 886P · ★1830S — ★1830P · 2985S — 2985P · 2986S — 2986P · ★943S — ★943P · 40 · 7

The Georgian salt and pepper shakers were made in other colors. The shakers came be found in Royal Ruby, Spearmint Green, Smoke, and Avocado Green.

Salt and Pepper Shakers Listed in the 1972 Catalog

Catalog Item Description	Price (per set)
Bold Colors (A-F)	$5-8 for tall shakers
Bold Colors (A-F)	$6-8 for short shakers
Crystal (G)	$4-5
Crystal (H)	$3-5
Georgian (I)	$8-10
Georgian (J)	$8-10
Springtime (K)	$8-10
Springtime (L)	$5-8 per set

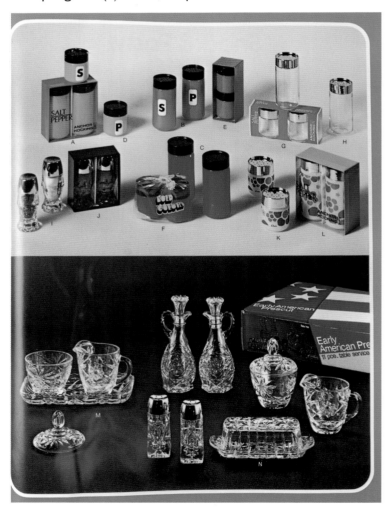

Shakers listed in the 1972 catalog.

Hot Poppy Kitchen Helps Listed in the 1972 Catalog

Cat. Item No.	Price (pre set)
W50/7 (O)	$10-15
10/31 (P)	$8-10
10/32 (Q)	$10-12

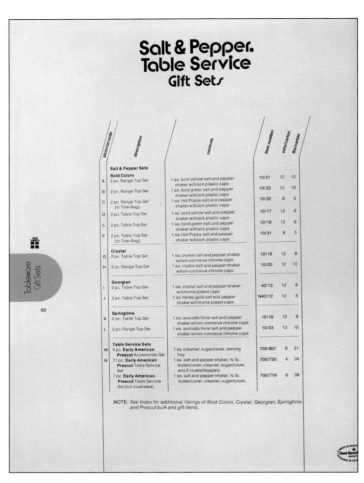

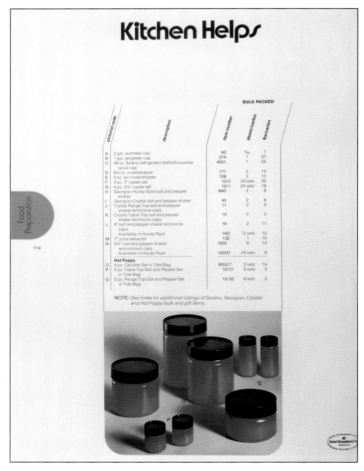

Salt and Pepper Shakers Listed in the 1978 Bulk Catalog

Cat. Item No.	Price (per set)
106 (A)	$5-8
16 (B)	$2-4
1830E (C)	$1-2
10 (D)	$4-5
11 (E)	$3-5
725 (F)	$4-6
10/52 (G)	$4-5
10/53 (H)	$4-5
10/48 (J)	$6-8
N1225 (K)	$8-10
N45 (L)	$10-12
G45 (M)	$8-10
45 (N)	$8-10

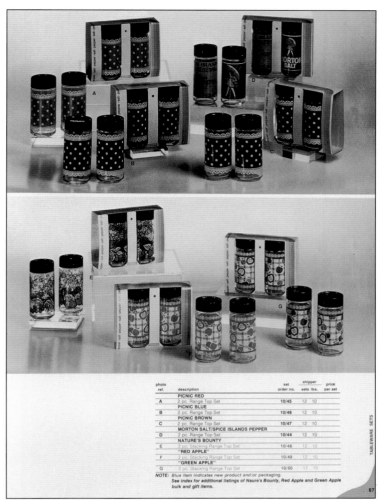

photo ref.	description	set order no.	shipper sets	lbs.	price per set
	PICNIC RED				
A	2 pc. Range Top Set	10/45	12	10	
	PICNIC BLUE				
B	2 pc. Range Top Set	10/46	12	10	
	PICNIC BROWN				
C	2 pc. Range Top Set	10/47	12	10	
	MORTON SALT/SPICE ISLANDS PEPPER				
D	2 pc. Range Top Set	10/44	12	10	
	NATURE'S BOUNTY				
E	2 pc. Stacking Range Top Set	10/48	12	10	
	"RED APPLE"				
F	2 pc. Stacking Range Top Set	10/49	12	10	
	"GREEN APPLE"				
G	2 pc. Stacking Range Top Set	10/50	12	10	

NOTE: Blue item indicates new product and/or packaging.
See index for additional listings of Naure's Bounty, Red Apple and Green Apple bulk and gift items.

TABLEWARE SETS

87

Anchor Hocking made accessory items for many of the pitchers. The Nature's Bounty, Picnic, and Apple decorations were originally applied to Chateau design pitchers during the early 1970s. After the pitchers and glasses were introduced, the company made salt and pepper shakers, storage jars, mugs, and water/juice servers. They did not make the accessory items for every pattern of decorated pitcher. They probably analyzed sales data to determine if there were sufficient sales of any particular pattern to warrant production of the accessories.

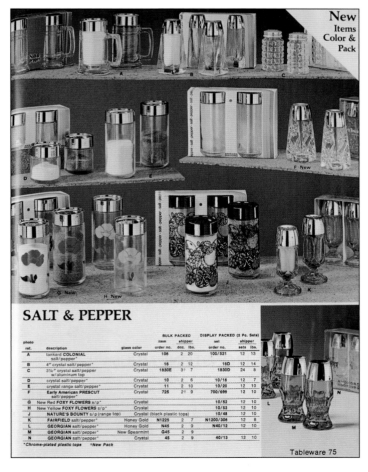

New Items Color & Pack

SALT & PEPPER

photo ref.	description	glass color	BULK PACKED item order no.	dnz.	lbs.	DISPLAY PACKED (2 Pc. Sets) set order no.	sets	lbs.
A	tankard COLONIAL salt/pepper*	Crystal	106	2	20	100/521	12	13
B	4" crystal salt/pepper*	Crystal	16	2	12	16D	12	14
C	3¾" crystal salt/pepper w/aluminum top	Crystal	1830E	3⅓	7	1830D	24	8
D	crystal salt/pepper*	Crystal	10	2	6	10/16	12	7
E	crystal range salt/pepper*	Crystal	11	2	10	10/20	12	10
F	Early American PRESCUT salt/pepper*	Crystal	725	2⅓	9	700/699	12	10
G	New Red FOXY FLOWERS s/p*	Crystal				10/52	12	10
H	New Yellow FOXY FLOWERS s/p*	Crystal				10/53	12	10
J	NATURE'S BOUNTY s/p (range top)	Crystal (black plastic tops)				10/48	12	10
K	FAIRFIELD salt/pepper*	Honey Gold	N1225	2	7	N1200/306	12	8
L	GEORGIAN salt/pepper*	Honey Gold	N45	2	9	N40/12	12	10
M	GEORGIAN salt/pepper*	New Spearmint	G45	2	9			
N	GEORGIAN salt/pepper*	Crystal	45	2	9	40/13	12	10

*Chrome-plated plastic tops ⁺New Pack

Tableware 75

Chapter Nine
Miscellaneous Bowls

This is another area where Anchor Hocking made countless hundreds of different bowls designs, colors, or patterns. The majority of the bowls can be found with a specific glass pattern. The bowls listed in this chapter illustrate the wide variety of bowl production.

Chip and Dip Sets Listed in the 1970 Catalog
Catalog Item

Description	Price
Prescut (AA)	$10-12
Wexford (BB)	$8-10
Soreno (CC)	$8-10
Soreno (DD)	$5-8
Soreno (EE)	$6-8
Crystal (FF)	$5-8
Accent Modern (GG)	$5-8
Daisy (HH)	$10-12
Swedish (JJ)	$5-8
Swedish (KK)	$4-5
Swedish (LL)	$8-10
Country Estate (MM)	$8-10
Country Estate (NN)	$4-5

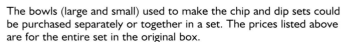

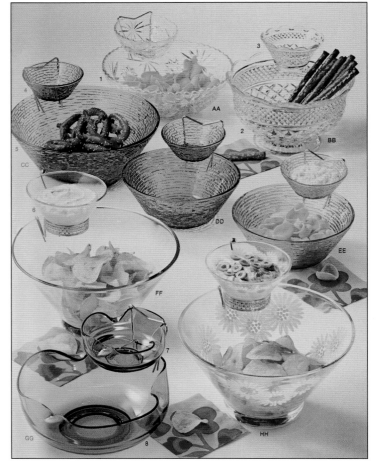

The bowls (large and small) used to make the chip and dip sets could be purchased separately or together in a set. The prices listed above are for the entire set in the original box.

Chip and dip sets listed in the 1970 catalog.

Console Sets and Salads Sets Listed in the 1970 Catalog

Catalog Item Description	Price
Wexford (AA)	$12-15
Wexford (BB)	$20-30
Accent Modern (CC)	$10-15
Accent Modern (DD)	$20-25
Country Estate (EE)	$8-10
Country Estate (FF)	$10-12
Country Estate (GG)	$20-25
Crystal (JJ)	$8-10
Prescut (KK)	$15-20
Soreno (LL)	$10-15
Daisy (MM)	$10-15

The prices listed at right are for the entire set in the original box.

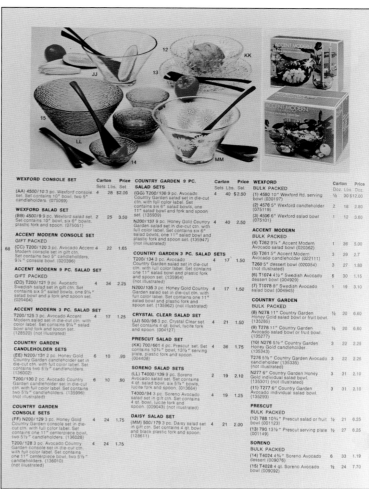

WEXFORD CONSOLE SET

	Carton Sets	Lbs.	Price Set
(AA) 4500/10 3 pc. Wexford console set. Set contains 10" bowl, two 5" candleholders. (075069)	4	28	$2.00

WEXFORD SALAD SET

	Carton Sets	Lbs.	Price Set
(BB) 4500/9 9 pc. Wexford salad set. Set contains 10" bowl, six 6" bowls, plastic fork and spoon. (075051)	2	25	3.50

ACCENT MODERN CONSOLE SET GIFT PACKED

	Carton Sets	Lbs.	Price Set
(CC) T200/123 3 pc. Avocado Accent Modern console set in gift ctn. Set contains two 5" candleholders, 9¼" console bowl. (020396)	4	22	1.65

ACCENT MODERN 9 PC. SALAD SET GIFT PACKED

	Carton Sets	Lbs.	Price Set
(DD) T200/121 9 pc. Avocado Swedish salad set in gift ctn. Set contains six 5" salad bowls, one 9¼" salad bowl and a fork and spoon set. (020404)	4	34	2.25

ACCENT MODERN 3 PC. SALAD SET

	Carton Sets	Lbs.	Price Set
T200/125 3 pc. Avocado Accent Modern salad set in die-cut ctn. with color label. Set contains 9¼" salad bowl and fork and spoon set. (128520) (not illustrated)	4	17	1.25

COUNTRY GARDEN CANDLEHOLDER SETS

	Carton Sets	Lbs.	Price Set
(EE) N200/131 2 pc. Honey Gold Country Garden candleholder set in die-cut ctn. with full color label. Set contains two 5½" candleholders. (136002)	6	10	.90
T200/130 2 pc. Avocado Country Garden candleholder set in die-cut ctn. with full color label. Set contains two 5½" candleholders. (135996) (not illustrated)	6	10	.90

COUNTRY GARDEN CONSOLE SETS

	Carton Sets	Lbs.	Price Set
(FF) N200/129 3 pc. Honey Gold Country Garden console set in die-cut ctn. with full color label. Set contains one 11" centerpiece bowl, two 5½" candleholders. (136028)	4	24	1.75
T200/128 3 pc. Avocado Country Garden console set in die-cut ctn. with full color label. Set contains one 11" centerpiece bowl, two 5½" candleholders. (136010) (not illustrated)	4	24	1.75

COUNTRY GARDEN 9 PC. SALAD SETS

	Carton Sets	Lbs.	Price Set
(GG) T200/136 9 pc. Avocado Country Garden salad set in die-cut ctn. with full color label. Set contains six 6" salad bowls, one 11" salad bowl and fork and spoon set. (135939)	4	40	$2.50
N200/137 9 pc. Honey Gold Country Garden salad set in die-cut ctn. with full color label. Set contains six 6" salad bowls, one 11" salad bowl and plastic fork and spoon set. (135947) (not illustrated)	4	40	2.50

COUNTRY GARDEN 3 PC. SALAD SETS

	Carton Sets	Lbs.	Price Set
T200/134 3 pc. Avocado Country Garden salad set in die-cut ctn. with full color label. Set contains one 11" salad bowl and plastic fork and spoon set. (135954) (not illustrated)	4	17	1.50
N200/135 3 pc. Honey Gold Country Garden salad set in die-cut ctn. with full color label. Set contains one 11" salad bowl and plastic fork and spoon set. (135962) (not illustrated)	4	17	1.50

CRYSTAL CLEAR SALAD SET

	Carton Sets	Lbs.	Price Set
(JJ) 500/98 3 pc. Crystal Clear set. Set contains 4 qt. bowl, lucite fork and spoon. (004127)	4	21	1.50

PRESCUT SALAD SET

	Carton Sets	Lbs.	Price Set
(KK) 700/66 4 pc. Prescut set. Set contains 10¾" bowl, 13½" serving plate, plastic fork and spoon. (004408)	4	36	1.75

SORENO SALAD SETS

	Carton Sets	Lbs.	Price Set
(LL) T4000/139 9 pc. Soreno Avocado salad set. Set contains 4 qt. salad bowl, six 5⅞" bowls, lucite fork and spoon. (013664)	2	19	2.10
T4000/94 3 pc. Soreno Avocado salad set in gift ctn. Set contains 4 qt. bowl, lucite fork and spoon. (009043) (not illustrated)	4	19	1.25

DAISY SALAD SET

	Carton Sets	Lbs.	Price Set
(MM) 500/179 3 pc. Honey Gold Country Daisy salad set in gift ctn. Set contains 4 qt. bowl and black plastic fork and spoon. (128611)	4	21	2.00

WEXFORD BULK PACKED

	Carton Doz.	Lbs.	Price Doz.
(1) 4580 10" Wexford ftd. serving bowl. (030197)	½	30	$12.00
(2) 4576 5" Wexford candleholder. (075119)	2	18	2.80
(3) 4506 6" Wexford salad bowl. (075101)	1	12	3.60

ACCENT MODERN BULK PACKED

	Carton Doz.	Lbs.	Price Doz.
(4) T262 9¼" Accent Modern Avocado salad bowl. (020362)	1	36	5.00
(5) T261 5" Accent Modern Avocado candleholder. (022111)	3	29	2.7
T260 5" dessert bowl. (020354) (not illustrated)	3	27	1.80
(6) T1074 4½" Swedish Avocado dessert bowl. (004929)	6	30	1.15
(7) T1078 8" Swedish Avocado salad bowl. (004945)	1	19	3.10

COUNTRY GARDEN BULK PACKED

	Carton Doz.	Lbs.	Price Doz.
(8) N278 11" Country Garden Honey Gold salad bowl or fruit bowl. (135285)	½	20	6.60
(9) T278 11" Country Garden Avocado salad bowl or fruit bowl. (135277)	½	20	6.60
(10) N276 5½" Country Garden Honey Gold candleholder. (135301) (not illustrated)	3	22	2.25
T276 5½" Country Garden Avocado candleholder. (135335)	3	22	2.25
N277 6" Country Garden Honey Gold individual salad bowl. (135301) (not illustrated)	3	31	2.10
(11) T277 6" Country Garden Avocado individual salad bowl. (135293)	3	31	2.10

PRESCUT BULK PACKED

	Carton Doz.	Lbs.	Price Doz.
(12) 788 10¾" Prescut salad or fruit bowl (001123)	½	21	6.25
(13) 790 13½" Prescut serving plate (001149)	½	27	6.25

SORENO BULK PACKED

	Carton Doz.	Lbs.	Price Doz.
(14) T4024 4¾" Soreno Avocado dessert (009076)	6	33	1.19
(15) T4028 4 qt. Soreno Avocado bowl (009092)	½	24	7.70

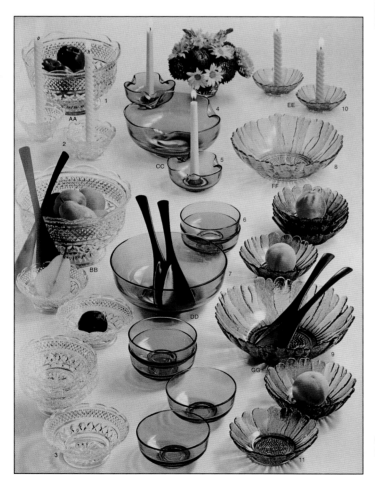

Console sets and salads sets listed in the 1970 catalog.

Desert Time and Springtime Bowls Listed in the 1970 Catalog

Cat. Item No.	Price
W455/6771 (5)	$3-4
W456/6768 (6)	$4-5
W457/6769 (7)	$5-8
W458/6770 (8)	$10-12
W455/7043 (1)	$5-8
W456/7044 (2)	$8-10
W457/7045 (3)	$10-15
W458/7046 (4)	$12-15
W400/530 (AA)	$35-50 in the original box
W400/477 (BB)	$25-30 in the original box
W400/531 (CC)	$30-40 in the original box

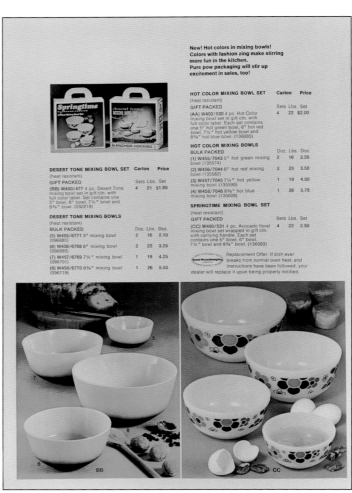

New! Hot colors in mixing bowls!
Colors with fashion zing make stirring
more fun in the kitchen.
Pure pow packaging will stir up
excitement in sales, too!

HOT COLOR MIXING BOWL SET
(heat resistant)

GIFT PACKED

	Sets	Lbs.	Set
(AA) W400/530 4 pc. Hot Color mixing bowl set in gift ctn. with full color label. Each set contains one 5" hot green bowl, 6" hot red bowl, 7½" hot yellow bowl and 8⅝" hot blue bowl. (136085)	4	22	$2.00

HOT COLOR MIXING BOWLS
BULK PACKED

	Doz.	Lbs.	Doz.
(1) W455/7043 5" hot green mixing bowl (135574)	2	16	2.35
(2) W456/7044 6" hot red mixing bowl (135582)	2	23	3.50
(3) W457/7045 7½" hot yellow mixing bowl (135590)	1	19	4.50
(4) W458/7046 8⅝" hot blue mixing bowl (135608)	1	26	5.75

SPRINGTIME MIXING BOWL SET
(heat resistant)

GIFT PACKED

	Sets	Lbs.	Set
(CC) W400/531 4 pc. Avocado floral mixing bowl set wrapped in gift ctn. with carrying handle. Each set contains one 5" bowl, 6" bowl, 7½" bowl and 8⅝" bowl. (136093)	4	22	2.50

DESERT TONE MIXING BOWL SET
(heat resistant)

GIFT PACKED

	Carton		Price
(BB) W400/477 4 pc. Desert Tone mixing bowl set in gift ctn. with full color label. Set contains one 5" bowl, 6" bowl, 7½" bowl and 8⅝" bowl. (032219)	4	21	$1.90

DESERT TONE MIXING BOWLS
(heat resistant)

BULK PACKED

	Doz.	Lbs.	Doz.
(5) W455/6771 5" mixing bowl (096693)	2	16	2.10
(6) W456/6768 6" mixing bowl (096693)	2	23	3.25
(7) W457/6769 7½" mixing bowl (096701)	1	19	4.25
(8) W458/6770 8⅝" mixing bowl (096719)	1	26	5.50

Replacement Offer: If dish ever breaks from normal oven heat, and instructions have been followed, your dealer will replace it upon being properly notified.

Bold color mixing bowls
listed in the 1970 catalog.

Nine Piece Salad Sets Listed in the 1974 Catalog

Catalog Item Description	Price
Fairfield (A)	$30-40
Covington B)	$40-50
Accent Modern (C)	$30-40
Early American Prescut (D)	$20-30

The prices listed below are for the entire set in the original box. The 6" and 9" salad Fairfield pattern bowls were also made in Aquamarine, Honey Gold, and Crystal. The smaller Fairfield bowl was also made in Spearmint Green and Smoke. Any bowls in these two colors are reasonably rare.

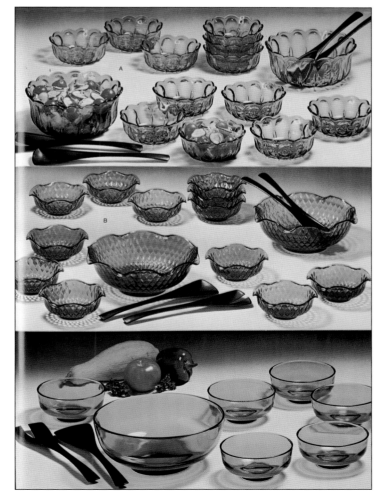

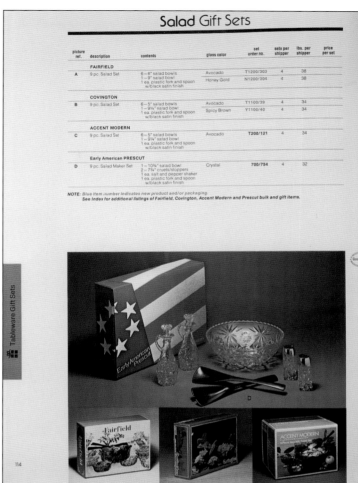

Salad Gift Sets

picture ref.	description	contents	glass color	set order no.	sets per shipper	lbs. per shipper	price per set
	FAIRFIELD						
A	9 pc. Salad Set	6—6" salad bowls 1—9" salad bowl 1 ea. plastic fork and spoon w/black satin finish	Avocado Honey Gold	T1200/303 N1200/304	4 4	38 38	
	COVINGTON						
B	9 pc. Salad Set	6—5" salad bowls 1—9¼" salad bowl 1 ea. plastic fork and spoon w/black satin finish	Avocado Spicy Brown	T1100/39 Y1100/40	4 4	34 34	
	ACCENT MODERN						
C	9 pc. Salad Set	6—5" salad bowls 1—9¼" salad bowl 1 ea. plastic fork and spoon w/black satin finish	Avocado	T200/121	4	34	
	Early American PRESCUT						
D	9 pc. Salad Maker Set	1—10¾" salad bowl 2—7¾" cruets/stoppers 1 ea. salt and pepper shaker 1 ea. plastic fork and spoon w/black satin finish	Crystal	700/754	4	32	

NOTE: Blue item number indicates new product and/or packaging.
See Index for additional listings of Fairfield, Covington, Accent Modern and Prescut bulk and gift items.

Nine piece salad sets
listed in the 1974 Catalog.

Table and Buffet Accessories Listed in the 1978 Bulk Catalog

Cat. Item No.	Price	Cat. Item No.	Price
1278 (A)	$10-12	3978 (F)	$4-5
1078 (B)	$4-5	3974 (G)	$1-2
1074 (C)	$1-2	G3978 (H)	$5-8
N3978 (D)	$5-8	G3974 (J)	$1-3
N3974 (E)	$1-3	594 (K)	$2-5
		595 (L)	$3-5
		598 (M)	$8-10

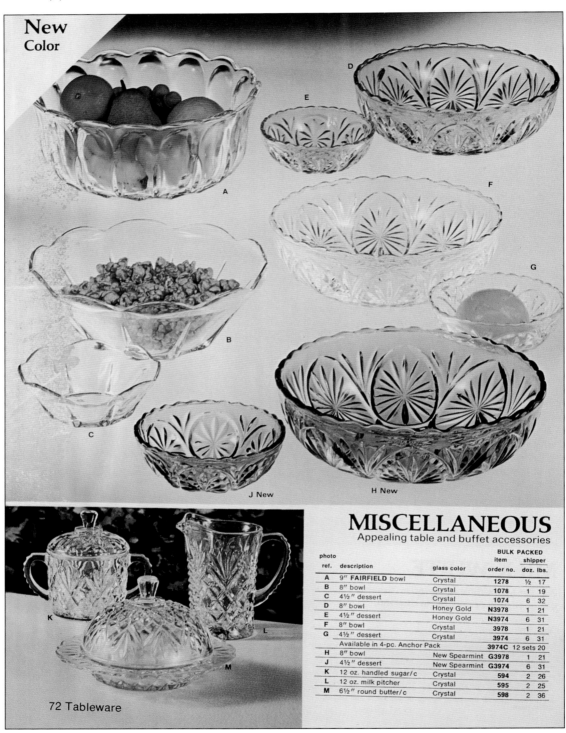

New Color

A / B / C / D / E / F / G / H New / J New / K / L / M

72 Tableware

MISCELLANEOUS
Appealing table and buffet accessories

photo ref.	description	glass color	BULK PACKED item order no.	shipper doz.	lbs.
A	9" FAIRFIELD bowl	Crystal	1278	½	17
B	8" bowl	Crystal	1078	1	19
C	4½" dessert	Crystal	1074	6	32
D	8" bowl	Honey Gold	N3978	1	21
E	4½" dessert	Honey Gold	N3974	6	31
F	8" bowl	Crystal	3978	1	21
G	4½" dessert	Crystal	3974	6	31
	Available in 4-pc. Anchor Pack		3974C	12 sets	20
H	8" bowl	New Spearmint	G3978	1	21
J	4½" dessert	New Spearmint	G3974	6	31
K	12 oz. handled sugar/c	Crystal	594	2	26
L	12 oz. milk pitcher	Crystal	595	2	25
M	6½" round butter/c	Crystal	598	2	36

The #1074 and 1078 bowls were also listed in the catalogs as the Swedish Modern pattern. These bowls are also available in Royal Ruby, Honey Gold, Aquamarine, and Avocado Green. Many of the larger #1078 bowls were frosted or plated with sterling silver, rhodium, platinum or 22 kt. gold. The patterned bowls (D, E, F, G, H, and J in the catalog) were not given a pattern name. This was typical of many Anchor Hocking items listed in the catalogs.

Salad Bowls Listed in the 1982 Catalog

Cat. Item No.	Price
N874 (A)	$2-3
N878 (B)	$5-8
Y874 (C)	$8-10
Y878 (D)	$10-15
874 (E)	$1-2
878 (F)	$3-5
V874 (G)	$6-8
V878 (H)	$10-12
615 (J)	$2-3
618 (K)	$5-8

The Swedish Modern pattern name was applied to a variety of items that really are dissimilar in shape or form. Most of the Swedish Modern bowls have vertical ribs on the side. The Anchor Hocking Glass Museum has several tumblers with Swedish Modern labels, yet they are identical to the Jubilee pattern made in 1967-8. The unusual labels even include the item price (two for 29 cents).

SWEDISH MODERN

PEACH LUSTRE

SERVINGWARE
...good specialties for impulse sales.

photo ref.	description	glass color	BULK PACKED item order no.	shipper doz. lbs.
A	8" Salad Plate	Crystal	842	3 26
B	6½" Sherbet Plate	Crystal	828	3 17
C	5¼" Salad Bowl	Crystal	586	3 25
D	4 qt. Punch/Con. Bowl	Crystal	580E	½ 25
E	9¾" Div. Dish	Peach Lustre	L898	1 23
	(in ind. gift ctn.)	Peach Lustre	L898H	1 26
F	8" Bowl	Peach Lustre	L1678	1 18
G	4½" Bowl	Peach Lustre	L1664	3 15
H	6 oz. PRESCUT Cup	Crystal	789	6 26
J	6 oz. Cup	Crystal	279	3 13
K	6 oz. RAIN FLOWER Cup	Crystal	3479	2 12

Tableware 73

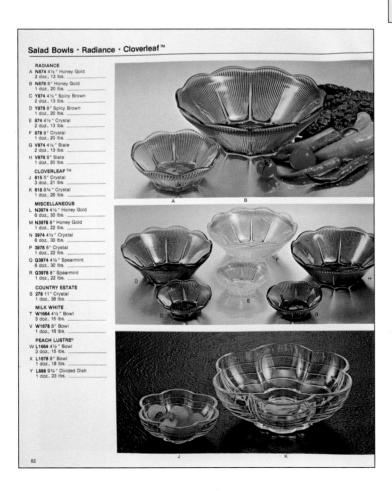

Salad Bowls · Radiance · Cloverleaf™

RADIANCE
A N874 4½" Honey Gold
2 doz., 13 lbs.
B N878 8" Honey Gold
1 doz., 20 lbs.
C Y874 4½" Spicy Brown
2 doz., 13 lbs.
D Y878 8" Spicy Brown
1 doz., 20 lbs.
E 874 4½" Crystal
2 doz., 13 lbs.
F 878 8" Crystal
1 doz., 20 lbs.
G V874 4½" Slate
2 doz., 13 lbs.
H V878 8" Slate
1 doz., 20 lbs.

CLOVERLEAF™
J 615 5" Crystal
3 doz., 21 lbs.
K 618 8¾" Crystal
1 doz., 26 lbs.

MISCELLANEOUS
L N3974 4½" Honey Gold
6 doz., 30 lbs.
M N3978 8" Honey Gold
1 doz., 22 lbs.
N 3974 4½" Crystal
6 doz., 30 lbs.
P 3978 8" Crystal
1 doz., 22 lbs.
Q G3974 4½" Spearmint
6 doz., 30 lbs.
R G3978 8" Spearmint
1 doz., 22 lbs.

COUNTRY ESTATE
S 278 11" Crystal
1 doz., 38 lbs.

MILK WHITE
T W1664 4½" Bowl
3 doz., 15 lbs.
V W1678 8" Bowl
1 doz., 18 lbs.

PEACH LUSTRE®
W L1664 4½" Bowl
3 doz., 15 lbs.
X L1678 8" Bowl
1 doz., 18 lbs.
Y L898 9¾" Divided Dish
1 doz., 23 lbs.

62

Early American Bowls Listed in the 1952 Catalog

Cat. Item No.	Price
1100/35	$20-30
1124	$2-3
1128	$10-12

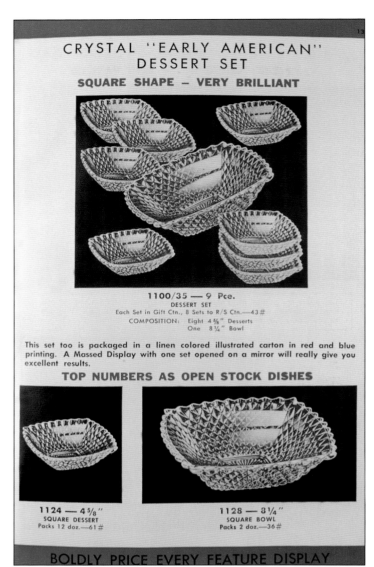

CRYSTAL "EARLY AMERICAN" DESSERT SET

SQUARE SHAPE — VERY BRILLIANT

1100/35 — 9 Pce.
DESSERT SET
Each Set in Gift Ctn., 8 Sets to R/S Ctn.—43#
COMPOSITION: Eight 4⅝" Desserts
One 8¼" Bowl

This set too is packaged in a linen colored illustrated carton in red and blue printing. A Massed Display with one set opened on a mirror will really give you excellent results.

TOP NUMBERS AS OPEN STOCK DISHES

1124 — 4⅝"
SQUARE DESSERT
Packs 12 doz.—61#

1128 — 8¼"
SQUARE BOWL
Packs 2 doz.—36#

BOLDLY PRICE EVERY FEATURE DISPLAY

Below:
Mixing Bowls Listed in the 1964 Catalog

Catalog Item Description	Price
W4157	10-12
355	$2-3
4 7/8" Green bowl	$6-10
6" Blue bowl	$8-10
7 1/4" Yellow bowl	$10-15
8 3/8" Red bowl	$12-15

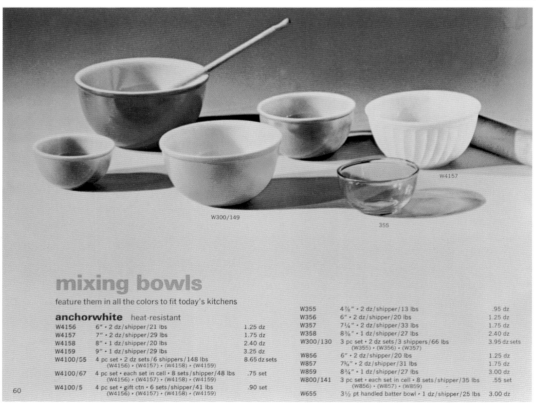

W300/149 W4157 355

mixing bowls

feature them in all the colors to fit today's kitchens

anchorwhite heat-resistant

W4156	6" · 2 dz/shipper/21 lbs	1.25 dz
W4157	7" · 2 dz/shipper/29 lbs	1.75 dz
W4158	8" · 1 dz/shipper/20 lbs	2.40 dz
W4159	9" · 1 dz/shipper/29 lbs	3.25 dz
W4100/55	4 pc set · 2 dz sets/6 shippers/148 lbs (W4156) · (W4157) · (W4158) · (W4159)	8.65 dz sets
W4100/67	4 pc set · each set in cell · 8 sets/shipper/48 lbs (W4156) · (W4157) · (W4158) · (W4159)	.75 set
W4100/5	4 pc set · gift ctn · 6 sets/shipper/41 lbs (W4156) · (W4157) · (W4158) · (W4159)	.90 set

W355	4⅞" · 2 dz/shipper/13 lbs	.95 dz
W356	6" · 2 dz/shipper/20 lbs	1.25 dz
W357	7¼" · 2 dz/shipper/33 lbs	1.75 dz
W358	8⅜" · 1 dz/shipper/27 lbs	2.40 dz
W300/130	3 pc set · 2 dz sets/3 shippers/66 lbs (W355) · (W356) · (W357)	3.95 dz sets
W856	6" · 2 dz/shipper/20 lbs	1.25 dz
W857	7¾" · 2 dz/shipper/31 lbs	1.75 dz
W859	8¾" · 1 dz/shipper/27 lbs	3.00 dz
W800/141	3 pc set · each set in cell · 8 sets/shipper/35 lbs (W856) · (W857) · (W859)	.55 set
W655	3½ pt handled batter bowl · 1 dz/shipper/25 lbs	3.00 dz

60

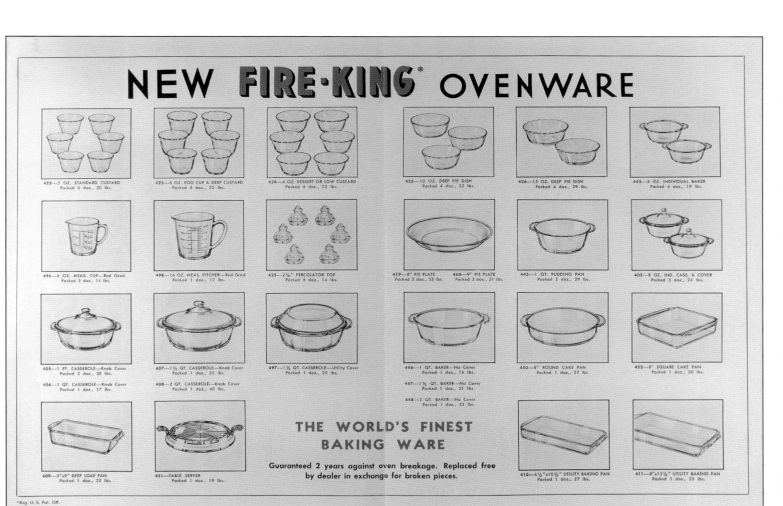

NEW FIRE·KING* OVENWARE

422—5 OZ. STANDARD CUSTARD
Packed 6 doz., 20 lbs.

423—6 OZ. EGG CUP & DEEP CUSTARD
Packed 6 doz., 25 lbs.

424—6 OZ. DESSERT OR LOW CUSTARD
Packed 6 doz., 23 lbs.

425—10 OZ. DEEP PIE DISH
Packed 4 doz., 22 lbs.

426—15 OZ. DEEP PIE DISH
Packed 4 doz., 29 lbs.

442—8 OZ. INDIVIDUAL BAKER
Packed 4 doz., 19 lbs.

496—8 OZ. MEAS. CUP—Red Grad.
Packed 2 doz., 14 lbs.

498—16 OZ. MEAS. PITCHER—Red Grad.
Packed 1 doz., 12 lbs.

435—2½" PERCOLATOR TOP
Packed 6 doz., 14 lbs.

459—8" PIE PLATE
Packed 2 doz., 25 lbs.

460—9" PIE PLATE
Packed 2 doz., 31 lbs.

443—1 QT. PUDDING PAN
Packed 2 doz., 29 lbs.

402—8 OZ. IND. CASS. & COVER
Packed 3 doz., 24 lbs.

405—1 PT. CASSEROLE—Knob Cover
Packed 2 doz., 30 lbs.

406—1 QT. CASSEROLE—Knob Cover
Packed 1 doz., 27 lbs.

407—1½ QT. CASSEROLE—Knob Cover
Packed 1 doz., 35 lbs.

408—2 QT. CASSEROLE—Knob Cover
Packed 1 doz., 40 lbs.

497—1½ QT. CASSEROLE—Utility Cover
Packed 1 doz., 35 lbs.

446—1 QT. BAKER—No Cover
Packed 1 doz., 16 lbs.

447—1½ QT. BAKER—No Cover
Packed 1 doz., 21 lbs.

448—2 QT. BAKER—No Cover
Packed 1 doz., 23 lbs.

450—8" ROUND CAKE PAN
Packed 1 doz., 22 lbs.

452—8" SQUARE CAKE PAN
Packed 1 doz., 30 lbs.

409—5"x9" DEEP LOAF PAN
Packed 1 doz., 22 lbs.

451—TABLE SERVER
Packed 1 doz., 19 lbs.

THE WORLD'S FINEST BAKING WARE

Guaranteed 2 years against oven breakage. Replaced free
by dealer in exchange for broken pieces.

410—6½"x10½" UTILITY BAKING PAN
Packed 1 doz., 27 lbs.

411—8"x12½" UTILITY BAKING PAN
Packed 1 doz., 33 lbs.

*Reg. U. S. Pat. Off.

New Fire-King Ovenware Listed in the 1951 Bulletin

Cat. Item No.	Price	Cat. Item No.	Price
422	$1-2	425	$1-2
423	$1-2	426	$1-2
424	$1-2	442	$3-5
496	$2-4	459	$4-6
498	$3-5	460	$5-8
435	$3-5	443	$10-12
405	$3-5	402	$10-15
406	$3-5	446	$3-5
407	$6-8	447	$5-8
408	$8-10	448	$6-8
409	$5-8	450	$10-12
497	$10-12	452	$8-10
451	$5-8	410	$8-12
		411	$10-15

New Fire-King Ovenware Listed in the 1951 Bulletin

Cat. Item No.	Price
400/96	$15-20
400/94	$15-20
400/95	$35-45

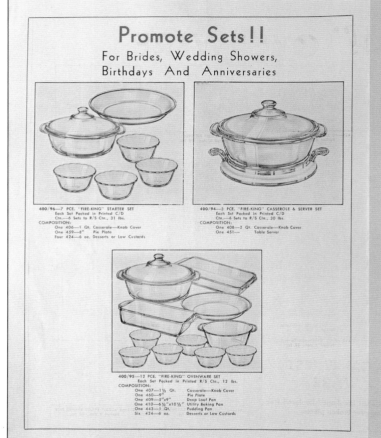

Chapter Ten
Miscellaneous Glasses

You will notice Anchor Hocking did not name most of the earlier glass patterns. While collectors often assign names to these patterns (i.e., Diamond Line, High Point, Criss Cross, etc.) there were no pattern names listed in the actual company catalogs. Many of the pages were selected to illustrate this point.

Notice the "Prescut" name was first used to describe the #121, #123, and #128 tumbler. The #1506 1 oz. whiskey was first produced in crystal but later produced in Royal Ruby and several decorated versions.

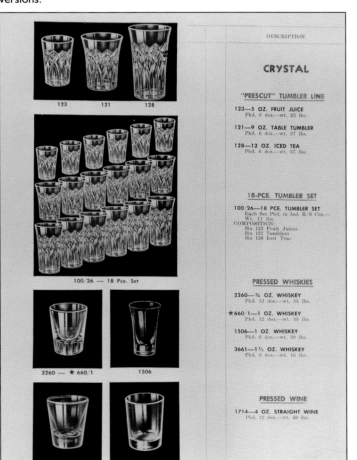

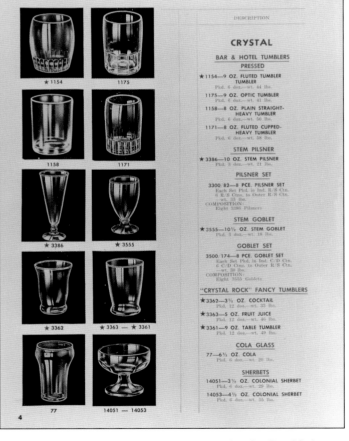

The #3555 10 1/2 oz. goblet was also produced with a Royal Ruby top and crystal base. These tumblers are hard-to-find and command a premium price.

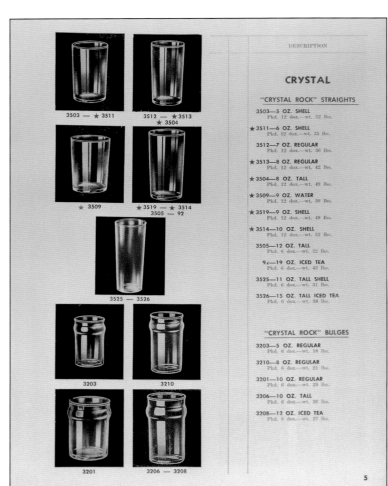

CRYSTAL

"CRYSTAL ROCK" STRAIGHTS

3503—5 OZ. SHELL
Pkd. 12 doz.—wt. 32 lbs.

★ 3511—6 OZ. SHELL
Pkd. 12 doz.—wt. 35 lbs.

3512—7 OZ. REGULAR
Pkd. 12 doz.—wt. 36 lbs.

★ 3513—8 OZ. REGULAR
Pkd. 12 doz.—wt. 42 lbs.

★ 3504—8 OZ. TALL
Pkd. 12 doz.—wt. 49 lbs.

★ 3509—9 OZ. WATER
Pkd. 12 doz.—wt. 50 lbs.

★ 3519—9 OZ. SHELL
Pkd. 12 doz.—wt. 49 lbs.

★ 3514—10 OZ. SHELL
Pkd. 12 doz.—wt. 52 lbs.

3505—12 OZ. TALL
Pkd. 6 doz.—wt. 32 lbs.

92—19 OZ. ICED TEA
Pkd. 6 doz.—wt. 43 lbs.

3525—11 OZ. TALL SHELL
Pkd. 6 doz.—wt. 31 lbs.

3526—15 OZ. TALL ICED TEA
Pkd. 6 doz.—wt. 38 lbs.

"CRYSTAL ROCK" BULGES

3203—5 OZ. REGULAR
Pkd. 6 doz.—wt. 18 lbs.

3210—8 OZ. REGULAR
Pkd. 6 doz.—wt. 21 lbs.

3201—10 OZ. REGULAR
Pkd. 6 doz.—wt. 25 lbs.

3206—10 OZ. TALL
Pkd. 6 doz.—wt. 26 lbs.

3208—12 OZ. ICED TEA
Pkd. 6 doz.—wt. 27 lbs.

5

The straight shells were also produced in Royal Ruby and Forest Green. The "crystal rock" bulges were also listed in the institutional glassware catalogs.

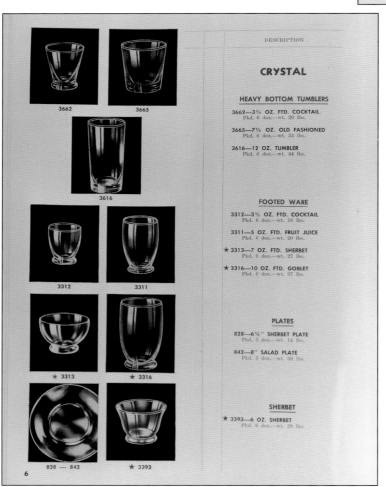

CRYSTAL

HEAVY BOTTOM TUMBLERS

3662—3½ OZ. FTD. COCKTAIL
Pkd. 6 doz.—wt. 20 lbs.

3665—7½ OZ. OLD FASHIONED
Pkd. 6 doz.—wt. 34 lbs.

3616—12 OZ. TUMBLER
Pkd. 6 doz.—wt. 44 lbs.

FOOTED WARE

3312—3½ OZ. FTD. COCKTAIL
Pkd. 6 doz.—wt. 16 lbs.

3311—5 OZ. FTD. FRUIT JUICE
Pkd. 6 doz.—wt. 20 lbs.

★ 3313—7 OZ. FTD. SHERBET
Pkd. 6 doz.—wt. 27 lbs.

★ 3316—10 OZ. FTD. GOBLET
Pkd. 6 doz.—wt. 37 lbs.

PLATES

828—6¼" SHERBET PLATE
Pkd. 3 doz.—wt. 14 lbs.

842—8" SALAD PLATE
Pkd. 3 doz.—wt. 30 lbs.

SHERBET

★ 3393—6 OZ. SHERBET
Pkd. 6 doz.—wt. 20 lbs.

6

The footed ware was also produced in Royal Ruby and Forest Green. In these colors, the pattern was called Baltic.

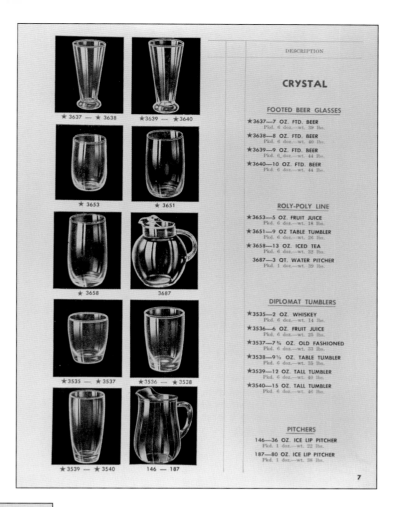

CRYSTAL

DESCRIPTION

FOOTED BEER GLASSES

★3637—7 OZ. FTD. BEER
Pkd. 6 doz.—wt. 39 lbs.

★3638—8 OZ. FTD. BEER
Pkd. 6 doz.—wt. 40 lbs.

★3639—9 OZ. FTD. BEER
Pkd. 6 doz.—wt. 44 lbs.

★3640—10 OZ. FTD. BEER
Pkd. 6 doz.—wt. 44 lbs.

ROLY-POLY LINE

★3653—5 OZ. FRUIT JUICE
Pkd. 6 doz.—wt. 18 lbs.

★3651—9 OZ TABLE TUMBLER
Pkd. 6 doz.—wt. 26 lbs.

★3658—13 OZ. ICED TEA
Pkd. 6 doz.—wt. 32 lbs.

3687—3 QT. WATER PITCHER
Pkd. 1 doz.—wt. 39 lbs.

DIPLOMAT TUMBLERS

★3535—2 OZ. WHISKEY
Pkd. 6 doz.—wt. 14 lbs.

★3536—6 OZ. FRUIT JUICE
Pkd. 6 doz.—wt. 25 lbs.

★3537—7¾ OZ. OLD FASHIONED
Pkd. 6 doz.—wt. 31 lbs.

★3538—9½ OZ. TABLE TUMBLER
Pkd. 6 doz.—wt. 35 lbs.

★3539—12 OZ. TALL TUMBLER
Pkd. 6 doz.—wt. 40 lbs.

★3540—15 OZ. TALL TUMBLER
Pkd. 6 doz.—wt. 46 lbs.

PITCHERS

146—36 OZ. ICE LIP PITCHER
Pkd. 1 doz.—wt. 22 lbs.

187—80 OZ. ICE LIP PITCHER
Pkd. 1 doz.—wt. 38 lbs.

7

Many of the patterns are really difficult to find in crystal. This is especially true of the #146 and 187 pitchers. Anchor Hocking used this design for over ten years, but the majority of the pitchers had applied decorations.

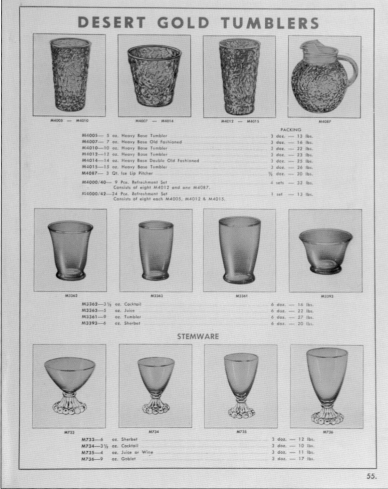

55.

Desert Gold Glassware Listed in the 1961-2 Catalog

Cat. Item No.	Price
M4005	$1-3
M4007	$1-3
M4010	$2-3
M4012	$2-3
M4014	$2-3
M4015	$2-5
M4087	$22-30
M4000/40	$50-60 in the original box
M4000/42	$80-100 in the original box
M3361	$5-8
M3362	$2-5
M3363	$5-8
M3393	$4-5
M733	$2-5
M734	$3-5
M735	$6-8
M736	$8-10

You will notice that most of the patterns that collectors have named (i.e., Diamond line, Criss Cross, etc.) actually were never named by Anchor Hocking. The #155 2 oz. footed wine was also made in Royal Ruby and the #521 9 oz. table tumbler and #523 5 oz. fruit juice tumbler were also made in pink. The catalog does not list the larger 14 oz. 5 1/4" glass in crystal or pink. Some of the crystal #521 and #523 glasses are marked with the "anchor over H" emblem on the bottom. There is a matching juice and water pitcher in both crystal and pink to match the #521 and #523 glasses. There is also a crystal pitcher to match the #923 and #921 glasses.

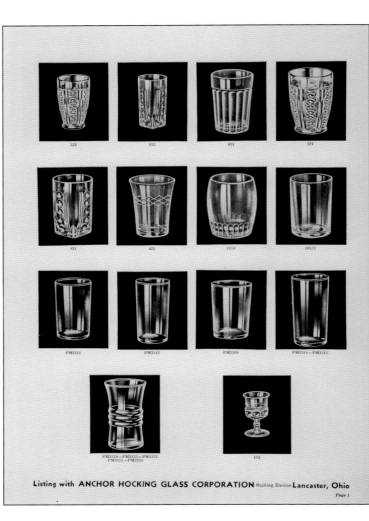

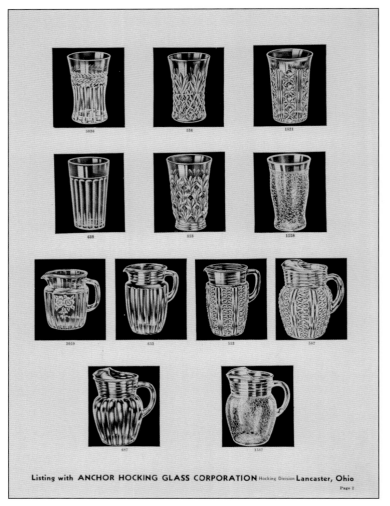

You will notice that, like the glasses, many of the patterns named by collectors were never actually named by Anchor Hocking. The #653 and #687 pitchers are often called Pillar Optic while the #1587 pitcher is called crackle or tree of life. The #553 and #587 pitchers are often called Diamond Line.

Chapter Eleven
Store Displays

Anchor Hocking did include examples of store displays in many of their catalogs. The majority of the displays were illustrated in the *Notions Manual of Chain Store Age*. This manual was devoted exclusively to display techniques for department stores. Still, wouldn't it be unique to walk into a store a see an entire aisle of Jadeite, Royal Ruby, and other patterns?

Feature Gift-Packed Sets This Way!
A PROVEN MERCHANDISING IDEA

BOLD PRICE

W4100/21 — 8 Pce. Coffee Set
Each Set in Gift Ctn., 12 Sets to R/S Ctn.—43#
COMPOSITION: Four Cups and Four Saucers

This illustration shows our linen-white Gift Cartons in which we pack many of our Sets, as indicated throughout this booklet. It also suggests the proper method of displaying Sets, with one set opened and placed on a mirror. Feature Displays of any sets we recommend, will bring you surprisingly profitable results. Cash in on the appeal of Sets; they suggest sizable purchases, easily carried home.

FEATURE DISPLAYS MELT AWAY

Store display in the 1952 catalog.

HERE'S HOW TO SELL GLASSWARE!

BOLD PRICES BOLD PRICES BOLD PRICES

OUR PROVEN PLAN FOR INCREASED GLASSWARE SALES
1. Show daily the Basic Numbers selected from Pages 4 and 5.
2. Keep three feature displays on each counter. Change features every two weeks.
3. Promote Prepacked Sets in Gift Cartons. They produce sizable purchases.
4. Use Bold Price Cards - - they suggest real bargains.
5. Spotlight your counters. Light sells glassware.

BOLD PRICES BOLD PRICES BOLD PRICES

Store display in the 1952 catalog.

Store display in the 1964 catalog.

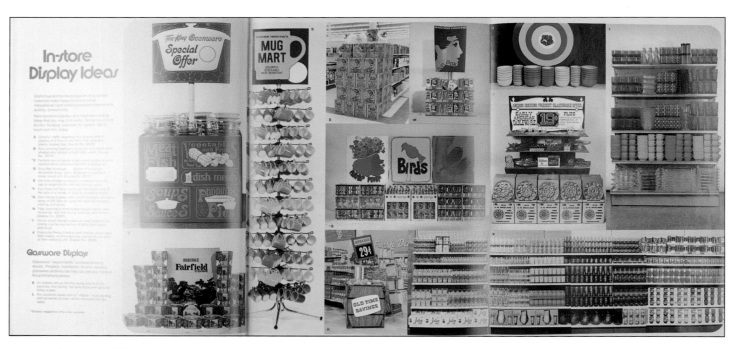

Store display in the 1972 catalog.

The American Experience

Consumer preference testing and award-winning designs are a start. But Anchor does more than create beautiful glassware. We help you *sell* it too ... with a unique one-source service organization carefully built to help move products on and off your shelves.

Anchor salesmen, located in every major city, can introduce you to a total one-stop source of fast-moving, profitable glassware. Expedited by computer-controlled order processing, efficient warehousing, the most extensive pool-car distribution system in the industry ... *and* a full range of point-of-purchase merchandising ideas to help you sell.

Anchor Hocking — with more customer services than any other company in its field. Anchor Hocking — the one-source supplier.

- Largest sales force
- Broadest product line
- Most extensive pool-car distribution system
- Computer-controlled order processing
- Modern, efficient warehousing
- Pre-tested, proven product line
- Proven year-round promotions
- Creative merchandising ideas

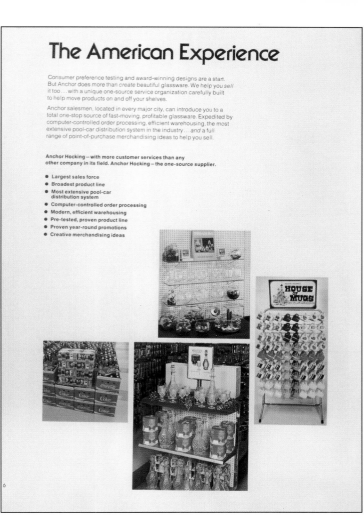

Store display in the 1974 catalog.

sales strategy for
glassware departments

A bright, well stocked glassware department can attract more store traffic, and at the same time invite more sales from existing aisle traffic. That's why more and more retailers of every type are featuring complete glassware departments, enlarging their present areas, and in many cases featuring Anchor Hocking products exclusively. As the pioneer in complete glassware departments, Anchor Hocking can help you plan the best assortment for your retailing operation, to make that 40 to 50 percent gross profit mean more in terms of faster turnover. The resultant savings that come from concentrating on Anchor Hocking can mean greater net profits, too. Find out how Anchor Hocking's diversity of lines and depth of experience can be of real benefit to you.

Typical examples of Anchor Hocking sales strategy glassware displays.

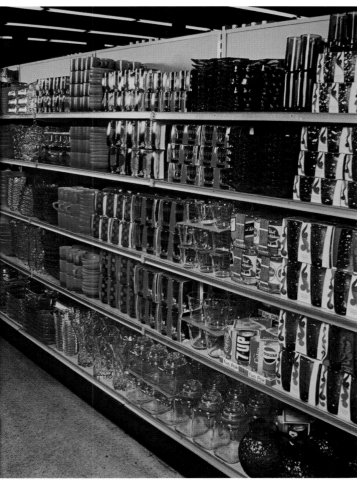

Store display in the 1974 catalog.

Original Catalog Pricelists

Prices were included in some of the company catalogs; however, the majority of the catalogs had attached pricelists. It is interesting to see what people paid for glass when it was new and before it became a collector's item. Notice that most of the listed prices were not for individual items. Instead, they were for larger purchases by the dozen, carton with multiple dozen, or gross (12 dozen).

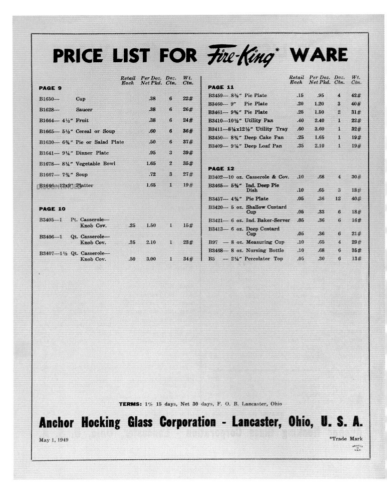

Pricelist for the 1949 catalog.

PRICE LIST FOR *Fire-King* WARE

PAGE 2

		Per Doz. Net Pkd.	Doz. Ctn.	Wt. Ctn.
G3879—	Cup	$.45	6	23#
G3829—	Saucer	.45	6	29#
G3874— 4⅝"	Dessert	.45	6	23#
G3875— 5⅜"	Cereal or Oatmeal	.60	6	33#
G3838— 7⅜"	Salad Plate	.95	3	26#
G3841— 9¼"	Dinner Plate	1.20	3	37#
G3867— 7⅜"	Soup Plate	.95	3	29#
G3878— 8¼"	Vegetable Bowl	1.65	1	13#
G3853—	Sugar and Cover	.95	3	22#
G3854—	Creamer	.65	3	14#
G3847—12"x9"	Platter	1.65	1	17#

PAGE 3

		Per Doz. Net Pkd.	Doz. Ctn.	Wt. Ctn.
W384 —9 oz.	St. Denis Cup	.60	4	25#
W327 —5⅜"	Saucer	.60	4	23#
W291 —5"	Soup or Cereal	.65	4	32#
W341 —9¼"	Dinner Plate	1.20	3	37#
W383 —8 oz.	Ransom Cup	.60	4	22#
W327 —5⅜"	Saucer	.60	4	23#
W1212—8 oz.	Coffee Mug	.65	4	32#
G1212—8 oz.	Coffee Mug	.65	4	32#
G384 —9 oz.	St. Denis Cup	.90	4	22#
G327 —5⅜"	Saucer	.60	4	19#
G291 —5"	Soup or Cereal	.65	4	31#
G341 —9¼"	Dinner Plate	1.20	3	36#
G383 —8 oz.	Ransom Cup	.60	4	22#
G327 —5⅜"	Saucer	.60	4	19#

PAGE 4

		Per Doz. Net Pkd.	Doz. Ctn.	Wt. Ctn.
G846 —4⅜"	Dessert Cup	.65	4	20#
G847 —8"	Salad Plate	.95	4	38#
G846/847—	2 Pce. Dessert Set	1.60 dz. sets	2 dz. sets	29#
G807 —3½"	Flower Pot	.60	4	25#
G810 —5"	Vase	.65	4	30#
G820 —5¼"	Bulb Bowl	.65	4	33#
G388 —8½"	Fancy Bowl	1.50	2	30#
G822 —4¼"	Ash Tray	.60	4	19#

PAGE 5

		Retail Each	Per Doz. Net Pkd.	Doz. Ctn.	Wt. Ctn.
G4156 —6"	Mixing Bowl		.95	2	18#
G4157 —7"	Mixing Bowl		1.25	2	27#
G4158 —8"	Mixing Bowl		1.65	1	19#
G4159 —9"	Mixing Bowl		2.25	1	27#
G4100/1 —	4 Pce. Mixing Bowl Set		.57 set	6 sets	34#
G3400/73—	6 Pce. Refrigerator Set		.60 set	6 sets	34#
G786 —5⅜"	Kitchen Bowl		.60	4	27#
G3494 —4½"x5"	Refrigerator Jar & Cov.		1.65	2	31#
G3499 —5¼"x9¼"	Refrigerator Jar & Cov.		3.25	1	31#

PAGE 6

		Retail Each	Per Doz. Net Pkd.	Doz. Ctn.	Wt. Ctn.
W405—1 Pt.	Casserole & Cov.	.45	5.40	1	13#
W406—1 Qt.	Casserole & Cov.	.60	7.20	1	26#
W407—1½ Qt.	Casserole & Cov.	.75	9.00	1	35#
W408—2 Qt.	Casserole & Cov.	1.00	12.00	1	38#
W450—9"	Cake Pan	.45	5.40	1	20#
W451—	Table Server	.50	6.00	1	15#
W460—9"	Pie Pan	.30	3.60	2	28#

PAGE 7

		Retail Each	Per Doz. Net Pkd.	Doz. Ctn.	Wt. Ctn.
W410—10½"	Baking Pan	.50	6.00	1	23#
W409—9¼"	Deep Loaf Pan	.50	6.00	1	18#
W465—5⅜"	Ind. Deep Pie Dish	.15	1.80	3	18#
W413— 6 oz.	Egg or Custard Cup	2/15c	.90	6	23#
W421— 6 oz.	Individual Baker	2/15c	.90	6	18#
W420— 5 oz.	Dessert	2/15c	.90	6	18#

PAGE 8

		Retail Each	Per Doz. Net Pkd.	Doz. Ctn.	Wt. Ctn.
W400—12 Pce. "Sweetheart" Baking Set			$8.40 dz. sets	4 sets	50#
W401— 3 Pce. Casserole & Table Server Set			18.00 dz. sets	6 sets	33#

Above prices on Ivory Fire-King are subject to 50% discount on orders for 10 cartons or more.

TERMS: 1% 15 days, Net 30 days, F. O. B. Lancaster, Ohio

Anchor Hocking Glass Corporation - Lancaster, Ohio, U. S. A.

May 1, 1949 *Trade Mark

Pricelist for the 1949 catalog.

PRICE LIST FOR CATALOG O

		Per Doz. Net Pkd. Less than 5 Gross	Doz. Ctn.	Wt. Ctn.
PAGE 2				
* 633 — 5 oz.	Fruit Juice	$.33	12	43#
631 — 9 oz.	Table Tumbler	.36	12	63#
638 —12 oz.	Iced Tea	.55	6	48#
687 —80 oz.	Ice Lip Pitcher	2.90	1	37#
1201 — 9 oz.	Table Tumbler	.36	12	65#
1287 —80 oz.	Ice Lip Pitcher	2.90	1	37#
PAGE 3				
123 — 5 oz.	Fruit Juice	.36	6	23#
121 — 9 oz.	Table Tumbler	.50	6	37#
128 —12 oz.	Iced Tea	.66	6	57#
100/26 —18 Pce.	Tumbler Set	.95 Set	1 Set	11#
2260 — ¾ oz.	Whiskey	.33	12	33#
* 660/1 — 1 oz.	Whiskey	.33	12	35#
1506 — 1 oz.	Whiskey	.33	6	20#
3661 — 1¼ oz.	Whiskey	.33	6	16#
1714 — 4 oz.	Straight Wine	.33	12	49#
PAGE 4				
* 1154 — 9 oz.	Fluted Barrel Tumbler	.61	6	44#
1175 — 9 oz.	Optic Tumbler	.61	6	41#
1158 — 8 oz.	Straight Tumbler	.66	6	50#
1171 — 8 oz.	Cupped Pilsner	.71	6	58#
*3386 —10 oz.	Stem Pilsner	1.65	3	31#
3300/82 — 8 Pce.	Pilsner Set	1.20 Set	6 Sets	33#
*3555 —10½ oz.	Stem Goblet	1.65	3	18#
3500/174 — 8 Pce.	Goblet Set	1.20 Set	6 Sets	32#
*3362 — 3½ oz.	Cocktail	.36	12	39#
3383 — 5 oz.	Ftd. Juice	.39	12	46#
*3361 — 9 oz.	Table Tumbler	.43	12	49#
77 — 6½ oz.	Cola	.46	6	20#
14051 — 3½ oz.	Colonial Sherbet	.55	6	29#
14053 — 4½ oz.	Colonial Sherbet	.66	6	35#
PAGE 5				
3503 — 5 oz.	Shell	.39	12	32#
*3511 — 6 oz.	Shell	.39	12	35#
3512 — 7 oz.	Regular	.42	12	42#
*3513 — 8 oz.	Regular	.43	12	42#
*3504 — 8 oz.	Tall	.43	12	50#
*3509 — 9 oz.	Water	.43	12	50#
*3519 — 9 oz.	Shell	.43 —3	12	49#
*3514 —10 oz.	Tall	.50	12	52#
3505 —12 oz.	Tall	.57	6	32#
92 —10 oz.	Iced Tea	.75	6	41#
3521 —14 oz.	Tall Shell	.50	6	31#
3526 —15 oz.	Tall Iced Tea	.60	6	38#
3203 — 5 oz.	Regular	.43	6	18#
3210 — 8 oz.	Regular	.48	6	21#
3201 —10 oz.	Regular	.52	6	25#
3206 —10 oz.	Tall	.53	6	26#
3208 —12 oz.	Iced Tea	.59	6	27#
PAGE 6				
3662 — 3½ oz.	Ftd. Cocktail	.52	6	20#
3665 — 7½ oz.	Old Fashioned	.57	6	34#
3616 —12 oz.	Tumbler	.73	6	44#
3312 — 3½ oz.	Ftd. Cocktail	.50	6	16#
3311 — 5 oz.	Ftd. Fruit Juice	.50	6	20#
*3313 — 7 oz.	Ftd. Sherbet	.55	6	27#
*3316 —10 oz.	Ftd. Goblet	.72	6	37#
828 —6¼"	Salad Plate	.70	6	34#
842 — 8"	Salad Plate	1.25	3	30#
*3393 — 6 oz.	Sherbet	.38	6	20#
PAGE 7				
*3637 — 7 oz.	Ftd. Beer	.77	6	39#
*3638 — 8 oz.	Ftd. Beer	.83	6	40#
*3639 — 9 oz.	Ftd. Beer	.88	6	44#
*3640 —10 oz.	Ftd. Beer	.95	6	44#
*3653 — 5 oz.	Fruit Juice	.45	6	18#
*3651 — 9 oz.	Table Tumbler	.50	6	26#
1658 —13 oz.	Iced Tea	.60	6	40#
3687 — 2	Qt. Water Pitcher	2.90	1	39#
3525 — 2 oz.	Whiskey	.52	6	14#

		Per Doz. Net Pkd. Less than 5 Gross	Doz. Ctn.	Wt. Ctn.
PAGE 7—Continued				
*3536 — 6 oz.	Fruit Juice	$.54	6	25#
*3537 — 7½ oz.	Old Fashioned	.58	6	33#
*3538 — 9½ oz.	Table Tumbler	.70	6	35#
*3539 —12 oz.	Tall Tumbler	.73	6	40#
*3540 —15 oz.	Tall Tumbler	.95	6	46#
146 —36 oz.	Ice Lip Pitcher	1.80	1	22#
187 —80 oz.	Ice Lip Pitcher	2.90	1	38#
		Per Doz. Net Pkd.	Doz. Ctn.	Wt. Ctn.
PAGE 8				
* E3653 — 5 oz.	Fruit Juice	.50	6	18#
* E3651 — 9 oz.	Table Tumbler	.60	6	26#
E3658 —13 oz.	Iced Tea	.70	6	34#
* E3687 — 3	Qt. Water Pitcher	3.30	1	39#
* E3600/65 —24 Pce.	Roly Poly Set	1.30 Set	1 Set	9#
* E1900/3 — 7 Pce.	Fruit Juice Set	.50 Set	6 Sets	22#
E3600/77 — 9 Pce.	Iced Tea Set	.95 Set	3 Sets	48#
E3316 —10 oz.	Ftd. Goblet	.70	6	36#
E92 —19 oz.	Iced Tea	.85	6	43#
E1946 —36 oz.	Pitcher	1.85	1	22#
E3526 —16 oz.	Long Boy Iced Tea	.65	3	20#
E3821 — 9 oz.	Tall Tumbler	.43	12	60#
PAGE 9				
* E2200/11 —16 Pce.	Luncheon Set	1.20 Set	1 Set	10#
* E2229 —	Cup	.65	6	29#
E2229 —	Saucer	.65	6	30#
* E2275 — 4¾"	Dessert or Cereal	.65	6	35#
E2267 — 6"	Soup	1.05	3	26#
E2237 — 6¾"	Salad Plate	1.05	3	21#
E2241 — 8¾"	Luncheon Plate	1.35	3	39#
E2277 — 7¾"	Bowl	1.85	2	39#
E2247 —11"	Platter	1.85	1	19#
E2253 —	Sugar	.72	3	15#
E2254 —	Creamer	.72	3	14#
E2200/16 —20 Pce.	Luncheon Set	1.60 Set	1 Set	13#
PAGE 10				
* R3653 — 5 oz.	Fruit Juice	.50	6	19#
* R3651 — 9 oz.	Table Tumbler	.60	6	26#
R3658 —13 oz.	Iced Tea	.70	6	35#
R3687 — 3	Qt. Water Pitcher	3.30	1	40#
R3600/32 — 9 Pce.	Iced Tea Set	.95 Set	3 Sets	48#
R3600/44 —24 Pce.	Refreshment Set	1.30 Set	1 Set	9#
R3600/5 —19 Pce.	Refreshment Set	1.45 Set	1 Set	11#
R3316 —10 oz.	Ftd. Goblet	.70	6	36#
R2279 —	Cup	.60	6	28#
R2229 — 5¾"	Saucer	.60	6	31#
R2275 — 4¾"	Dessert	.60	6	37#
R2241 — 8¾"	Plate	1.35	3	40#
R2200/4 —16 Pce.	Luncheon Set	1.20 Set	1 Set	10#
PAGE 11				
W4179 —	Cup	.50	6	29#
W4129 —	Saucer	.50	6	30#
W4141 — 9½"	Dinner Plate	1.85	3	36#
W4100/20 —12 Pce.	Set	.85 Set	6 Sets	48#
W4100/21 — 8 Pce.	Coffee Set	.85 Set	12 Sets	43#
* W384 — 8 oz.	St. Denis Cup	.55	4	24#
* W383 — 8 oz.	Ransom Cup	.50	4	22#
* W375 — 6"	Cereal	.65	4	30#
* W341 — 9½"	Dinner Plate	1.05	3	39#
* W291 — 5"	Soup or Cereal	.70	4	30#
* W1212 — 8 oz.	Coffee Mug	.70	4	32#
PAGE 12				
G384 — 9 oz.	St. Denis Cup	.55	4	22#
G327 — 5¾"	Saucer	.50	4	19#
G375 — 6"	Cereal	.65	4	28#
G341 — 9¼"	Dinner Plate	1.05	3	36#
* G291 — 5"	Soup or Cereal	.70	4	31#
* G1212 — 8 oz.	Coffee Mug	.70	4	32#
* G3800 —12 Pce.	Starter Set	.85 Set	6 Sets	46#

4-51

		Per Doz. Net Pkd.	Doz. Ctn.	Wt. Ctn.
PAGE 13				
* G3879 —	Cup	$.50	6	25#
* G3829 —	Saucer	.50	6	31#
* G3874 — 4¾"	Dessert	.50	6	28#
* G3875 — 5¾"	Cereal or Oatmeal	.65	6	41#
* G3838 — 7¾"	Salad Plate	1.05	3	28#
* G3841 — 9¼"	Dinner Plate	1.35	3	36#
* G3867 — 7¾"	Soup Plate	1.05	3	27#
* G3878 — 8¼"	Vegetable Bowl	1.85	1	13#
* G3847 —12"x9"	Platter	1.85	1	19#
* G3853 —	Sugar & Cover	1.05	3	24#
* G3854 —	Creamer	.72	3	16#
PAGE 14				
* 3974 — 4½"	Dessert	.36	12	60#
* 2979 — 8"	Bowl	1.25	2	42#
* 594 —12 oz.	Sugar & Cover	1.25	2	26#
* 595 —12 oz.	Milk Pitcher	1.00	2	31#
* 598 — 6½"	Butter & Cover	1.65	2	33#
896 — 9¾"	Egg Plate	1.80	2	45#
* 1070 —10"	Oval Divided Relish	1.05	3	46#
* 1077 — 8"	Deep Bowl	1.05	3	44#
PAGE 15				
* 1089 —10½"	Salad Bowl	2.35	1	34#
* 1092 — 6½"	Candy Jar & Cover	2.35	1	30#
1060 —12"	Cake Plate	2.35	1	35#
* 16 — 6½"	Ftd. Dish	.65	4	34#
* 17 — 6½"	Handled Bowl	.65	4	40#
* 18 — 7"	Handled Olive Tray	.65	4	29#
* 19 — 6½"	Square Bowl	.65	4	38#
* 45 — 5"	Dessert	.40	6	34#
* 1032 — 2½"	Sugar	.50	4	24#
* 1084 — 2½"	Creamer	.50	4	22#
PAGE 16				
* 1124 — 4¾"	Square Dessert	.36	12	61#
* 1128 — 8½"	Square Bowl	1.35	2	39#
* 56 — 5 oz.	Crimped Sherbet	.65	6	39#
* 55 — 7¼"	Crimped Bowl	.95	3	40#
200/28 — 8 Pce.	Serva-Snack Set	.65 Set	6 Sets 32#	
200/30 — 2 Pce.	Serva-Snack Set	1.65 Dz.	3 Sets 48#	
R200/42 — 8 Pce.	Serva-Snack Set	.70 Set	6 Sets 32#	
* 50 —11½"x6"	Party Snack Tray	1.65	2	36#
PAGE 17				
* E1874 — 4¾"	Fruit	.36	12	53#
E1878 — 8½"	Bowl	1.35	2	36#
E5069 — 6½"	Crimped Bonbon	1.25	2	29#
E200/36 — 8 Pce.	Serva-Snack Set	.65 Set	6 Sets 32#	
E200/37 — 2 Pce.	Serva-Snack Set	1.65 Dz.	3 Ds. 48#	
E200/40 — 8 Pce.	Serva-Snack Set	.70 Set	6 Sets 46#	
PAGE 18				
* 736 — 9 oz.	Goblet	1.05	3	15#
* 735 — 4 oz.	Juice or Wine	1.05	3	11#
* 734 — 3½ oz.	Cocktail	1.05	3	10#
* 733 — 6 oz.	Sherbet	1.05	3	12#
828 — 6¼"	Sherbet Plate	.70	3	14#
842 — 8"	Salad Plate	1.25	3	30#
8700/1 — 8 Pce.	Goblet Set	.77 Set	6 Sets 14#	
8700/2 — 8 Pce.	Juice or Wine Set	.77 Set	6 Sets 16#	
8700/3 — 8 Pce.	Cocktail Set	.77 Set	6 Sets 15#	
8700/4 — 8 Pce.	Sherbet Set	.77 Set	6 Sets 17#	
8700/5 — 8 Pce.	Sherbet Plate Set	.60 Set	6 Sets 21#	
8700/6 — 8 Pce.	Salad Plate Set	.90 Set	6 Sets 42#	
E3588 — 5 oz.	Ftd. Fruit Juice	.50	6	22#
E3581 — 9 oz.	Ftd. Table Tumbler	.60	6	32#
E3586 —12 oz.	Ftd. Tall Tumbler	.70	6	44#
E3587 — 2	Qt. Water Pitcher	3.30	1	39#
E3500/164 —24 Pce.	Ftd. Refreshment Set	1.30 Set	1 Set 16#	
PAGE 19				
* 855 — 4¾"	Mixing Bowl	.40	3	21#
* 856 — 6"	Mixing Bowl	.65	3	34#
* 857 — 7¼"	Mixing Bowl	1.00	3	57#
* 800/128 —3 Pce.	Mixing Bowl Set	2.05 Dz.	3 Ds. 112#	

		Per Doz. Net Pkd.	Doz. Ctn.	Wt. Ctn.
PAGE 19—Continued				
761 — 5"	Bowl	$.46	6	35#
* 5 — 2¼"	Percolator Top	.31	6	14#
* 97 — 8 oz.	Measuring Cup	.65	3	22#
255 — 1 pt.	Measuring Pitcher	.95	4	49#
* 43 — 5½"	Lemon Reamer	.90	3	22#
* 713 — 7"	Juice Extractor	1.25	3	48#
PAGE 20				
* 6S —3½"	Salt Shkr.-Red Plas. Tops	.33	6	12#
* 6P —3½"	Pepper Shkr.-Red Plas. Tops	.33	6	12#
47S —3½"	Salt Shkr.-Yel. Plas. Tops	.33	6	10#
47P —3½"	Pepper Shkr.-Yel. Plas. Tops	.33	6	12#
* 181S —3½"	Salt Shkr.-Red Plas. Tops	.33	6	10#
* 1517 —3½"	Pepper Shkr.-Red Plas. Tops	.33	6	11#
886S —3½"	Salt Shkr.-Red Plas. Tops	.36	6	11#
886P —3½"	Pepper Shkr.-Red Plas. Tops	.33	6	11#
* 1830S —3½"	Salt Shkr.-Alum. Tops	.33	6	12#
* 1830P —3½"	Pepper Shkr.-Alum. Tops	.33	6	12#
2985S —4¾"	Salt Shkr.-Alum. Tops	.36	6	22#
2985P —4¾"	Pepper Shkr.-Alum. Tops	.33	6	22#
2986S —4"	Salt Shkr.-Red Plas. Tops	.36	6	18#
2986P —4"	Pepper Shkr.-Red Plas. Tops	.33	6	18#
* 943S —4¼"	Salt Shkr.-"Litho" Tops	.39	4	18#
* 943P —4¼"	Pepper Shkr.-"Litho" Tops	.39	4	18#
40 —16 oz.	Utility Jar W/Cap	.70	4	33#
7 — 7 oz.	Kitchen Jar W/Cap	1.50	2	30#
PAGE 21				
* 171 — 6 oz.	Oil Bottle & Stopper	1.05	4	27#
42 —14 oz.	Sugar Dispenser	1.65	2	18#
273 — ¾ gal.	Jar W/1-Pce. Cap	1.65	1	19#
274 — 1 Gal.	Jar W/1-Pce. Gr. Cap	2.30	1	36#
* 757 — 4¾"x5"	Refrig. Jar & Cover	1.25	2	36#
758 — 5"x8"	Refrig. Jar & Cover	1.95	1	35#
1221 — 5¾"	Block Butter & Cover	.95	4	32#
* 219 — 6½"x3¼"	¼-Lb. Butter & Cover	1.25	2	23#
691 — 1 Qt.	Water Bottle W/Red Aluminum Top	1.25	2	38#
* 602 — 2 Qt.	Water Bottle W/Red Aluminum Top	1.75	1	38#
PAGE 22				
* W23S —4¼"	Salt Shaker-"Litho" Tops	.72	4	18#
* W23P —4¼"	Pepper Shaker-"Litho" Tops	.72	4	18#
W24 —16 oz.	Canister-"Litho" Tops	1.05	4	32#
* W355 —4¾"	Mixing Bowl	.65	3	19#
* W356 —6"	Mixing Bowl	1.05	3	34#
* W357 —7¼"	Mixing Bowl	1.70	3	55#
* W300/130 —3 Pce.	Mixing Bowl Set	3.45 Dz.	3 Ds. 108#	
* G23S —4¼"	Salt Shaker-"Litho" Tops	.65	4	18#
* G23P —4¼"	Pepper Shaker-"Litho" Tops	.72	4	18#
G24 —16 oz.	Canister-"Litho" Tops	1.05	4	32#
* G355 —4¾"	Mixing Bowl	.65	3	19#
* G356 —6"	Mixing Bowl	1.05	3	34#
* G357 —7¼"	Mixing Bowl	1.70	3	55#
* G300/129 —3 Pce.	Mixing Bowl Set	3.45 Dz.	3 Ds. 108#	
* G300/131 —6 Pce.	Kitchen Set	.65 Set	1 Set 5#	
PAGE 23				
* W4156 —6"	Mixing Bowl	1.05	2	19#
* W4157 —7"	Mixing Bowl	1.40	2	27#
* W4158 —8"	Mixing Bowl	1.80	1	20#
* W4159 —9"	Mixing Bowl	2.50	1	30#
* G4156 —6"	Mixing Bowl	1.05	2	20#
* G4157 —7"	Mixing Bowl	1.40	2	29#
* G4158 —8"	Mixing Bowl	1.80	1	22#
* G4159 —9"	Mixing Bowl	2.50	1	32#
PAGE 24				
* R3354 — 4"	Ivy Ball	.65	6	32#
R3354 — 4"	Ivy Ball	.65	6	33#
* R3345 — 6½"	Vase	.95	4	34#
* E3345 — 6½"	Vase	.95	4	35#
* E3346 — 6½"	Vase	.95	4	35#
R3346 — 6½"	Vase	.95	4	35#
R53 — 9"	Vase	1.65	2	36#

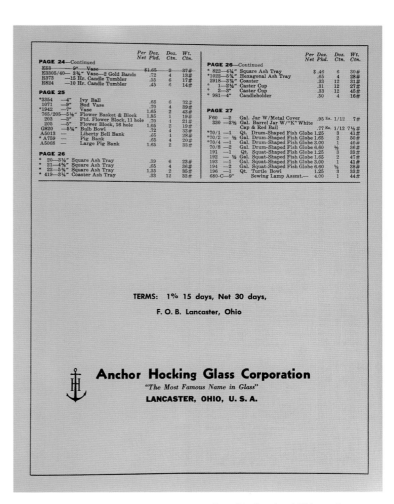

Pricelist for the 1951 catalog.

		Per Doz. Net Pkd.	Doz. Ctn.	Wt. Ctn.
PAGE 24—Continued				
E53 — 9"	Vase	$1.65	2	37#
E3305/40 — 3¾"	Vase—2 Gold Bands	.72	4	13#
R373 —15 Hr.	Candle Tumbler	.55	6	17#
R824 —10 Hr.	Candle Tumbler	.45	6	14#
PAGE 25				
*3354 — 4"	Ivy Ball	.65	6	33#
1071 — 9"	Bud Vase	.70	4	39#
*1942 — 7"	Vase	1.65	2	43#
765/205 —5½"	Flower Basket & Block	1.85	1	19#
203 — 3"	Ftd. Flower Block, 11 hole	.70	1	12#
205 —	Flower Block, 16 hole	1.05	2	19#
G820 — 5¾"	Bulb Bowl	.72	3	33#
A5013 —	Liberty Bell Bank	.65	4	33#
* A759 —	Pig Bank	.65	4	27#
A5068 —	Large Pig Bank	1.65	2	33#
PAGE 26				
* 20 —3½"	Square Ash Tray	.39	6	23#
* 21 —4¾"	Square Ash Tray	.65	4	36#
* 22 —5¾"	Square Ash Tray	1.35	2	35#
* 419 —3¾"	Coaster Ash Tray	.33	12	33#

		Per Doz. Net Pkd.	Doz. Ctn.	Wt. Ctn.
PAGE 26—Continued				
* 822 —4¼"	Square Ash Tray	$.46	6	30#
* 1022 —5¾"	Hexagonal Ash Tray	.65	4	28#
2918 —3½"	Coaster	.33	12	31#
* 1 —2½"	Caster Cup	.31	12	27#
* 2 —3"	Caster Cup	.33	12	45#
* 981 —4"	Candleholder	.50	4	16#
PAGE 27				
F60 — 2	Gal. Jar W/Metal Cover	.95 Ea.	1/12	7#
330 —2½	Gal. Barrel Jar W/"K" White Cap & Red Ball	.77 Ea.	1/12	7½#
*70/1 —1	Qt. Drum-Shaped Fish Globe	1.25	3	41#
*70/2 — ½	Gal. Drum-Shaped Fish Globe	1.65	2	40#
*70/4 —1	Gal. Drum-Shaped Fish Globe	3.00	1	27#
70/8 — 2	Gal. Drum-Shaped Fish Globe	6.60	½	36#
191 — 1	Qt. Squat-Shaped Fish Globe	1.25	3	33#
192 — ½	Gal. Squat-Shaped Fish Globe	1.65	2	47#
193 —1	Gal. Squat-Shaped Fish Globe	3.00	1	41#
194 — 2	Gal. Squat-Shaped Fish Globe	6.60	½	38#
196 — 1	Qt. Turtle Bowl	1.25	3	33#
680-C —9"	Sewing Lamp Assmt.	4.00	1	44#

TERMS: 1% 15 days, Net 30 days,

F. O. B. Lancaster, Ohio

⚓ **Anchor Hocking Glass Corporation**
"The Most Famous Name in Glass"
LANCASTER, OHIO, U. S. A.

Pricelist for the 1951 catalog.g

Pricelist for the 1951 catalog.

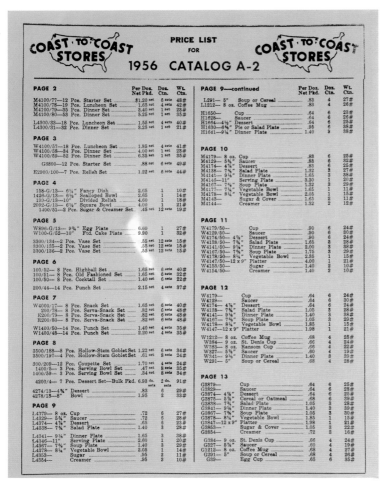

COAST·TO·COAST STORES

PRICE LIST FOR 1956 CATALOG A-2

PAGE 2

Item	Per Doz. Net Pkd.	Doz. Ctn.	Wt. Ctn.
M4100/77—12 Pce. Starter Set	$1.20 set	6 sets	48#
M4100/78—19 Pce. Luncheon Set	1.65 set	4 sets	42#
M4100/79—35 Pce. Dinner Set	3.40 set	1 set	35#
M4100/80—53 Pce. Dinner Set	5.25 set	1 set	35#
L4300/33—18 Pce. Luncheon Set	1.55 set	4 sets	40#
L4300/31—32 Pce. Dinner Set	3.25 set	1 set	21#

PAGE 3

Item	Per Doz. Net Pkd.	Doz. Ctn.	Wt. Ctn.
W4100/57—18 Pce. Luncheon Set	1.85 set	4 sets	41#
W4100/58—34 Pce. Dinner Set	4.00 set	1 set	33#
W4100/59—52 Pce. Dinner Set	6.35 set	1 set	35#
G3800—12 Pce. Starter Set	.88 set	6 sets	49#
E2900/100—7 Pce. Relish Set	1.22 set	6 sets	44#

PAGE 4

Item	Per Doz. Net Pkd.	Doz. Ctn.	Wt. Ctn.
158-G/13—6¼" Fancy Dish	2.65	1	10#
1426-G/13—6½" Scalloped Bowl	2.65	1	14#
159-G/13—10" Divided Relish	4.60	1	18#
2092-G/13—6½" Square Bowl	4.00	1	21#
1400/51—2 Pce. Sugar & Creamer Set	.45 set	12 sets	19#

PAGE 5

Item	Per Doz. Net Pkd.	Doz. Ctn.	Wt. Ctn.
W894-G/13—9¾" Egg Plate	6.60	1	27#
W100-G/52—10" Ftd. Cake Plate	9.90	1	29#
3300/134—2 Pce. Vase Set	.55 set	12 sets	15#
3300/135—2 Pce. Vase Set	.55 set	12 sets	15#
3300/136—2 Pce. Vase Set	.55 set	12 sets	15#

PAGE 6

Item	Per Doz. Net Pkd.	Doz. Ctn.	Wt. Ctn.
100/52—8 Pce. Highball Set	1.65 set	6 sets	40#
100/51—8 Pce. Old Fashioned Set	1.65 set	6 sets	32#
100/50—8 Pce. Cocktail Set	1.40 set	6 sets	22#
200/44—14 Pce. Punch Set	2.15 set	4 sets	37#

PAGE 7

Item	Per Doz. Net Pkd.	Doz. Ctn.	Wt. Ctn.
W4000/17—8 Pce. Snack Set	1.65 set	6 sets	40#
200/78—8 Pce. Serva-Snack Set	.82 set	6 sets	48#
E200/79—8 Pce. Serva-Snack Set	.82 set	6 sets	48#
R200/80—8 Pce. Serva-Snack Set	.82 set	6 sets	48#
W4100/50—14 Pce. Punch Set	1.40 set	4 sets	35#
W1400/48—14 Pce. Punch Set	2.20 set	4 sets	35#

PAGE 8

Item	Per Doz. Net Pkd.	Doz. Ctn.	Wt. Ctn.
3500/188—8 Pce. Hollow-Stem Goblet Set	1.22 set	6 sets	34#
3500/197—4 Pce. Hollow-Stem Goblet Set	.61 set	8 sets	24#
300/209—12 Pce. Coupette Set	1.70 set	4 sets	24#
1400/5— 3 Pce. Serving Bowl Set	.47 set	8 sets	35#
1400/59— 3 Pce. Serving Bowl Set	.34 set	8 sets	34#
4200/4— 7 Pce. Dessert Set—Bulk Pkd.	6.93 dz.	2 ds.	91#
4274/13—4¾" Dessert	.83	6	29#
4278/13—8" Bowl	1.95	1	33#

PAGE 9

Item	Per Doz. Net Pkd.	Doz. Ctn.	Wt. Ctn.
L4379—8 oz. Cup	.72	6	27#
L4329—5⅜" Saucer	.72	6	23#
L4374—4⅝" Dessert	.65	6	23#
L4338—7⅜" Salad Plate	1.40	3	28#
L4341—9¼" Dinner Plate	1.65	3	38#
L4346—11" Serving Plate	2.60	1	29#
L4367—7⅜" Soup Plate	1.40	3	29#
L4378—8¼" Vegetable Bowl	2.05	1	14#
L4353— Sugar	.95	2	11#
L4354— Creamer	.95	2	10#

PAGE 9—continued

Item	Per Doz. Net Pkd.	Doz. Ctn.	Wt. Ctn.
L291— 5" Soup or Cereal	.83	4	27#
L1212— 8 oz. Coffee Mug	.83	4	26#
H1650— Cup	.64	6	28#
H1628— Saucer	.64	6	26#
H1654—4½" Dessert	.64	6	25#
H1630—6¾" Pie or Salad Plate	.95	6	28#
H1641—9¾" Dinner Plate	1.40	3	38#

PAGE 10

Item	Per Doz. Net Pkd.	Doz. Ctn.	Wt. Ctn.
M4179— 8 oz. Cup	.83	6	25#
M4129— 5¾" Saucer	.83	6	32#
M4174— 4⅝" Dessert	.83	6	25#
M4138— 7¾" Salad Plate	1.32	3	27#
M4141— 9¼" Dinner Plate	1.65	3	38#
M4146—11" Serving Plate	3.30	1	20#
M4167— 7¾" Soup Plate	1.32	3	29#
M4177— 7¾" Vegetable Bowl	1.65	1	11#
M4178— 8¼" Vegetable Bowl	2.05	1	18#
M4143— Sugar & Cover	1.65	2	11#
M4144— Creamer	1.32	2	12#

PAGE 11

Item	Per Doz. Net Pkd.	Doz. Ctn.	Wt. Ctn.
W4179/50— Cup	.90	6	24#
W4129/50— Saucer	.90	6	30#
W4174/50— 4⅝" Dessert	.90	6	24#
W4138/50— 7¾" Salad Plate	1.65	3	28#
W4141/50— 9¼" Dinner Plate	2.00	3	38#
W4167/50— 7¾" Soup Plate	1.75	3	29#
W4178/50— 8¼" Vegetable Bowl	2.35	1	18#
W4147/50—12 x 9" Platter	4.00	1	21#
W4153/50— Sugar	1.40	2	10#
W4154/50— Creamer	1.40	2	10#

PAGE 12

Item	Per Doz. Net Pkd.	Doz. Ctn.	Wt. Ctn.
W4179— Cup	.64	6	24#
W4129— Saucer	.64	6	30#
W4174— 4⅝" Dessert	.64	6	24#
W4138— 7¾" Salad Plate	1.05	3	28#
W4141— 9¼" Dinner Plate	1.40	3	38#
W4167— 7¾" Soup Plate	1.05	3	30#
W4178— 8¼" Vegetable Bowl	1.85	1	15#
W4147—12 x 9" Platter	1.98	1	21#
W1212— 8 oz. Coffee Mug	.68	4	25#
W384— 9 oz. St. Denis Cup	.66	4	24#
W785— 8 oz. Ransom Cup	.64	4	22#
W327— 5⅝" Saucer	.60	4	19#
W341— 9¼" Dinner Plate	1.40	3	30#
W291— 5" Soup or Cereal	.68	4	28#

PAGE 13

Item	Per Doz. Net Pkd.	Doz. Ctn.	Wt. Ctn.
G8879— Cup	.64	6	25#
G8829— Saucer	.64	6	25#
G8874— 4⅝" Dessert	.64	6	25#
G8875— 5⅝" Cereal or Oatmeal	.68	6	39#
G8838— 7⅜" Salad Plate	1.05	3	23#
G8841— 9¼" Dinner Plate	1.40	3	30#
G8867— 7⅝" Soup Plate	1.05	3	30#
G8878— 8¼" Vegetable Bowl	1.85	1	15#
G8847—12 x 9" Platter	1.98	1	21#
G8853— Sugar & Cover	1.05	3	21#
G8854— Creamer	.72	3	16#
G384— 9 oz. St. Denis Cup	.66	4	24#
G327— 5⅝" Saucer	.60	4	19#
G1212— 8 oz. Coffee Mug	.68	4	27#
G291— 5" Soup or Cereal	.68	6	26#
G39— Egg Cup	.65	6	28#

Pricelist for the 1956 catalog.

PAGE 14

Item	Per Doz. Pkd.	Doz. Ctn.	Wt. Ctn.
G221—7¼ x 2¾" Quarter Pound Butter & Cover	1.40	2	18#
G256—4 x 4" Refrig. Jar W/Crystal Fire-Ring Cover	1.40	2	20#
G257—4 x 8" Refrig. Jar W/Crystal Fire-Ring Cover	2.50	1	25#
G200/84— 6 Pce. Refrigerator Set	.66 set	6 sets	25#
G200/87—12 Pce. Refrigerator Set	1.10 set	4 sets	30#
G4156—6" Mixing Bowl	1.05	2	20#
G4157—7" Mixing Bowl	1.40	2	29#
G4158—8" Mixing Bowl	1.95	1	22#
G4159—9" Mixing Bowl	2.65	1	29#
G4100/1 —4 Pce. Mixing Bowl Set	.78 set	6 sets	41#
G4100/54—4 Pce. Mixing Bowl Set	7.05 dz.	2 ds. sets	151#
G4100/66—4 Pce. Mixing Bowl Set	.69 set	8 sets	48#
G355—4¾" Mixing Bowl	.70	2	15#
G356—6" Mixing Bowl	1.05	2	23#
G357—7¼" Mixing Bowl	1.70	2	37#
G300/129—3 Pce. Mixing Bowl Set	3.45 dz. sets	2 ds. sets	75#

PAGE 15

Item	Per Doz. Pkd.	Doz. Ctn.	Wt. Ctn.
W221—7¼ x 2¾" Quarter Pound Butter & Cover	1.40	2	18#
W256—4 x 4" Refrig. Jar W/Crystal Fire-Ring Cover	1.40	2	20#
W257—4 x 8" Refrig. Jar W/Crystal Fire-Ring Cover	2.50	1	25#
W200/85— 6 Pce. Refrigerator Set	.66 set	6 sets	25#
W200/88—12 Pce. Refrigerator Set	1.10 set	4 sets	30#
W4156—6" Mixing Bowl	1.05	2	19#
W4157—7" Mixing Bowl	1.40	2	29#
W4158—8" Mixing Bowl	1.95	1	23#
W4159—9" Mixing Bowl	2.65	1	29#
W4100/5 —4 Pce. Mixing Bowl Set	.78 set	6 sets	41#
W4100/55—4 Pce. Mixing Bowl Set	7.05 dz.	2 ds. sets	150#
W4100/67—4 Pce. Mixing Bowl Set	.60 set	8 sets	48#
W355—4¾" Mixing Bowl	.70	2	14#
W356—6" Mixing Bowl	1.05	2	23#
W357—7¼" Mixing Bowl	1.70	2	37#
W300/180—3 Pce. Mixing Bowl Set	3.45 dz. sets	2 ds. sets	74#

PAGE 16

Item	Per Doz. Pkd.	Doz. Ctn.	Wt. Ctn.
L4157—7" Mixing Bowl	1.65	2	31#
L4158—8" Mixing Bowl	2.15	2	20#
L4159—9" Mixing Bowl	3.00	1	20#
L4100/47—3 Pce. Mixing Bowl Set	6.80 dz.	2 ds. sets	129#
L4100/48—3 Pce. Mixing Bowl Set	.75 set	6 sets	34#
L4100/68—3 Pce. Mixing Bowl Set	.61 set	8 sets	41#
W300/149—4 Pce. Mixing Bowl Set	1.15 set	4 sets	35#
G655—Handled Batter Bowl	2.35	1	22#
L235—12 oz. French Casserole & Cover	1.95	2	23#
L200/89— 8 Pce. Casserole Set	.83 set	6 sets	30#
L200/90—16 Pce. Casserole Set	1.65 set	4 sets	40#

PAGE 17

Item	Per Doz. Pkd.	Doz. Ctn.	Wt. Ctn.
W300/148—4 Pce. Mixing Bowl Set	1.60 set	4 sets	38#
W300/182—4 Pce. Mixing Bowl Set	1.60 set	4 sets	38#
W300/150—4 Pce. Range Set	.61 set	8 sets	24#
W300/183—4 Pce. Range Set	.61 set	8 sets	22#

PAGE 18

Item	Per Doz. Pkd.	Doz. Ctn.	Wt. Ctn.
221—7¼ x 2¾" Quarter Pound Butter & Cover	1.32	2	18#
256—4 x 4" Refrig. Jar & Cover	1.32	2	20#
257—4 x 8" Refrig. Jar & Cover	2.35	1	20#
200/83— 6 Pce. Refrigerator Set	.61 set	6 sets	25#
200/86—12 Pce. Refrigerator Set	1.00 set	4 sets	30#

PAGE 18—continued

Item	Per Doz. Pkd.	Doz. Ctn.	Wt. Ctn.
691—1 Qt. Water Bottle W/Red Alum. Cap	1.60	2	41#
692—2 Qt. Water Bottle W/Red Alum. Cap	2.05	1	28#
219—6½ x 3¼" Quarter Pound Butter & Cover	1.32	2	23#
282—40 oz. Refrig. Chiller W/Red Plastic Cap	1.32	2	31#
283/39 —40 oz. Refrig. Chiller W/Red Plastic Cap	1.32	2	31#
283/367—40 oz. Refrig. Chiller W/Red Plastic Cap	2.00	2	31#

PAGE 19

Item	Per Doz. Pkd.	Doz. Ctn.	Wt. Ctn.
355—4¾" Mixing Bowl	.64	2	13#
356—6" Mixing Bowl	.80	2	23#
357—7¼" Mixing Bowl	1.27	2	37#
358—8¾" Mixing Bowl	1.85	1	28#
300/128—3 Pce. Mixing Bowl Set	2.70 dz. sets	2 ds. sets	75#
300/134—4 Pce. Mixing Bowl Set	4.56 dz. sets	2 ds. sets	131#
655—3½ Pt. Handled Batter Bowl	1.95	1	24#
365—5⅝" Splash-Proof Mixing Bowl	.80	3	36#
761—5" Bowl	.55	6	40#
97—8 oz. Measuring Cup	.80	3	23#
713—7" Juice Extractor	1.60	2	35#

PAGE 20

Item	Per Doz. Pkd.	Doz. Ctn.	Wt. Ctn.
6 S—3¼" Salt—Red Plastic Top	.39	6	12#
6 P—3¼" Pepper—Red Plastic Top	.39	6	12#
47 S—3¼" Salt—Yellow Plastic Top	.39	6	12#
47 P—3¼" Pepper—Yel. Plastic Top	.39	6	12#
151 S—3¼" Salt—Red Plastic Top	.39	6	11#
151 P—3¼" Pepper—Red Plastic Top	.39	6	11#
1830 S—3¼" Salt—Aluminum Top	.39	6	14#
1830 P—3¼" Pepper—Aluminum Top	.39	6	14#
2985 S—4¼" Salt—Aluminum Top	.46	6	23#
2985 P—4¼" Pepper—Aluminum Top	.46	6	23#
943 S—4¼" Salt—Litho Top	.50	4	18#
943 P—4¼" Pepper—Litho Top	.50	4	18#
171—6 oz. Oil Bottle & Stopper	1.22	2	14#
273—¼ Gal. Jar W/1-Pce. Green Cap	1.82	1	19#
274—1 Gal. Jar W/1-Pce. Green Cap	2.60	1	36#
F60—2 Gal. Jar W/Metal Cover	1.00 Ea. 1/12		7#
330—2½ Gal. Barrel Jar W/K White Cap & Red Bail	.82 Ea. 1/12		5#

PAGE 21

Item	Per Doz. Pkd.	Doz. Ctn.	Wt. Ctn.
70/1— 1 Qt. Fish Globe	1.25	3	38#
70/2—½ Gal. Fish Globe	1.65	3	48#
70/4— 1 Gal. Fish Globe	3.00	1	40#
70/8—2 Gal. Fish Globe	6.60	½	36#
191— 1 Qt. Fish Globe	1.25	3	33#
192—½ Gal. Fish Globe	1.65	3	48#
193— 1 Gal. Fish Globe	3.00	1	39#
194—2 Gal. Fish Globe	6.60	½	36#
680-C—9" Sewing Lamp Assmt.	4.50	1	40#

PAGES 22 & 23

Item	Per Doz. Pkd.	Doz. Ctn.	Wt. Ctn.
H422— 5 oz. Standard Custard	.36	6	18#
H423— 6 oz. Egg Cup & Deep Custard	.50	6	22#
H424— 6 oz. Dessert or Low Custard	.50	6	18#
H425—10 oz. Deep Pie Dish	.65	4	23#
H426—15 oz. Deep Pie Dish	.85	4	30#
H442— 8 oz. Individual Baker	.65	4	21#
H435— 2¾" Percolator Top	.36	6	12#
H496— 8 oz. Meas. Cup—Red Grad.	1.60	2	18#
H498—16 oz. Meas. Pitcher—Red Grad.	2.50	1	18#
H499— 1 Qt. Meas. Pitcher—Red Grad.	4.40	1	24#
H459—8" Pie Plate	1.60	2	18#
H460—9" Pie Plate	1.85	2	31#
H461—9" Deep Pie Plate	2.50	1	19#
H443—1 Qt. Pudding Pan	1.85	2	28#

Pricelist for the 1956 catalog.

Pricelist — Pages 22 & 23 continued through Page 34

PAGES 22 & 23—continued	Per Doz. Net Pkd.	Doz. Ctn.	Wt. Ctn.
H402—8 oz. Ind. Casserole & Cover	1.20	3	33#
H405—1 Pt. Casserole—Knob Cover	1.85	2	32#
H406—1 Qt. Casserole—Knob Cover	3.75	1	32#
H407—1½ Qt. Casserole—Knob Cover	4.40	1	37#
H408—2 Qt. Casserole—Knob Cover	5.05	1	41#
H497—1½ Qt. Casserole—Utility Cover	4.40	1	38#
H446— Qt. Baker—No Cover	1.85	1	16#
H447—1½ Qt. Baker—No Cover	1.85	1	22#
H448—2 Qt. Baker—No Cover	2.10	1	24#
H450—8" Round Cake Pan	2.50	1	24#
H452—8" Square Cake Pan	3.75	1	34#
H409—5" x 9" Deep Loaf Pan	3.10	1	22#
H440—6¼" x 7¼" Square Baking Pan	3.10	1	21#
H410—6½" x 10½" Utility Baking Pan	3.10	1	30#
H411—8" x 12½" Utility Baking Pan	4.40	1	44#
H451— Table Server	2.50	1	15#
PAGE 24			
H400/96— 7 Pce. Starter Set	.72 set	6 sets	29#
H400/94— 3 Pce. Casserole & Server Set	.72 set	6 sets	30#
H400/95—12 Pce. Ovenware Set	1.45 set	4 sets	50#
PAGE 25			
2092— 6½" Candy Jar & Cover	3.20	1	31#
1092— 6¾" Candy Jar & Cover	2.60	1	30#
1060—12" Cake Plate	2.60	1	32#
1089—10½" Salad Bowl	2.60	1	34#
896— 9¾" Egg Plate	1.95	2	45#
4570—11" Oval Divided Relish	1.28	2	34#
199—10" Large Divided Relish	1.28	2	31#
5070— Round Divided Relish	1.28	2	24#
41— 6" Footed Dish	1.28	2	23#
PAGE 26			
156—8¼" Handled Relish Tray	.80	4	38#
157—6½" Fancy Dish	.80	4	32#
158—6¼" Round Bowl	.80	4	38#
159—6¼" 3-Cornered Bonbon	.80	4	33#
920—7" Footed Dish	.80	4	35#
197—8¼" Relish Tray	.80	4	37#
594—12 oz. Sugar & Cover	1.60	2	26#
595—12 oz. Milk Pitcher	1.22	2	25#
598— 6¾" Butter & Cover	1.66	2	32#
255—20 oz. Milk Pitcher	1.28	2	30#
PAGE 27			
3974— 4½" Dessert	.46	6	29#
3978— 8" Bowl	1.65	2	44#
279— 5 oz. Punch Cup	.61	6	22#
2918— 3¾" Coaster	.39	12	37#
974— 4½" Dessert	.46	6	28#
978— 8" Bowl	1.65	2	34#
900/45— 7 Pce. Dessert Set—Bulk Pkd.	4.41 ds.	2 ds.	90#
946—10" Cake Plate	1.65	2	40#
PAGE 28			
1473— 5 oz. Crimped Sherbet	.46	6	23#
1474— 5" Crimped Dessert	.46	6	26#
1456—5¾" Oval Bowl	.80	4	40#
1426—6½" Bowl	.80	4	41#
1427—7" Bowl	1.28	2	33#
1453— Sugar	.66	3	25#
1454— Creamer	.66	3	23#
981— 4" Candleholder	.61	4	16#
184—4¾" "Drip-Catch" Candleholder	.65	4	25#
984—4¾" Candleholder	.83	4	29#
PAGE 29			
197/13—8¾" Relish Tray	1.65	2	19#
1456/13—8½" Oval Bowl	1.65	2	21#
156/13—8¾" Relish Tray	1.65	2	20#
157/13—6½" Fancy Dish	1.54	2	17#
920/13—7" Footed Dish	1.65	2	18#

PAGE 29—continued	Per Doz. Net Pkd.	Doz. Ctn.	Wt. Ctn.
A759— Pig Bank	.65	4	20#
A5068— Pig Bank	1.65	2	38#
A5013— Liberty Bell Bank	.65	4	28#
PAGE 30			
E159— 6½" 3-Cornered Bonbon	.80	4	32#
E5069— 6½" Scalloped Bowl	.80	4	35#
E156— 8¼" Handled Relish Tray	.80	4	42#
E55— 7½" Crimped Bowl	1.28	2	26#
E1874— 4¾" Fruit	.46	6	22#
E1878— 8½" Bowl	1.65	2	39#
E356— 6" Mixing Bowl	.80	3	34#
E357— 7¼" Mixing Bowl	1.27	2	33#
E365— 5¾" Splash-Proof Bowl	.80	3	37#
E3653— 5 oz. Fruit Juice	.53	6	16#
E3651— 9 oz. Table Tumbler	.61	6	26#
E3658—13 oz. Iced Tea	.72	6	31#
E86—86 oz. Ice Lip Pitcher	3.20	1	32#
E1946—36 oz. Pitcher	2.35	1	22#
PAGE 31			
E336—9½ oz. Goblet	1.32	3	18#
E335—5½ oz. Fruit Juice	1.32	3	11#
E334—4½ oz. Cocktail	1.32	3	12#
E333—6 oz. Sherbet	1.32	3	17#
E3524—14 oz. Tall Iced Tea	.72	6	37#
E3526—15 oz. Long Boy Iced Tea	.78	6	38#
E3375—32 oz. Giant Iced Tea	1.22	2	20#
E71— 9 oz. Tumbler	.46	6	23#
E3597—9¼ oz. Tall Tumbler	.61	6	29#
E65—11 oz. Tumbler	.61	6	28#
E69—15 oz. Tall Iced Tea	.78	6	39#
E93—22 oz. Giant Iced Tea	1.05	3	26#
PAGE 32			
30— 3½" Square Ash Tray	.46	6	21#
31—4¾" Square Ash Tray	.83	3	23#
32—5¾" Square Ash Tray	1.60	2	29#
822—4¾" Square Ash Tray	.61	6	29#
1022—5¾" Hexagonal Ash Tray	.72	4	31#
419—3¾" Coaster Ash Tray	.39	12	35#
E30—3½" Ash Tray	.46	6	21#
E31—4¾" Ash Tray	.83	3	23#
E32—5¾" Ash Tray	1.60	2	29#
E1022—5¾" Hexagonal Ash Tray	.72	4	31#
182/13—4¾" Square Ash Tray	1.60	3	24#
30/5632—3½" Square Ash Tray	1.00	3	11#
31/5632—4¾" Square Ash Tray	1.65	1½	12#
32/5632—5¾" Square Ash Tray	3.80	1	16#
30/1—3 Pce. Ash Tray Set	.63 set	6 sets	16#
PAGE 33			
702— 2 oz. Whiskey	.50	3	9#
703— 5 oz. Fruit Juice	.61	6	18#
701— 9½ oz. Tumbler	.95	3	28#
708—12 oz. Iced Tea	1.22	3	38#
633— 5 oz. Fruit Juice	.44	6	21#
631— 9 oz. Table Tumbler	.46	6	33#
638—12 oz. Iced Tea	.80	6	48#
687—80 oz. Ice Lip Pitcher	3.20	1	37#
1403— 5 oz. Fruit Juice	.44	6	22#
1401— 9 oz. Tumbler	.46	6	33#
112—12 oz. Handled Party Glass	1.05	2	24#
PAGE 34			
106—1½ oz. Whiskey	.66	6	18#
101— 4½ oz. Cocktail	.72	6	24#
102— 8 oz. Sherbet	.95	6	36#
103— 7½ oz. Old Fashioned	.95	6	39#
104— 6 oz. Fruit Juice	.83	6	28#
105—12 oz. Highball	1.05	6	50#
100/47—24 Pce. Sewdish Modern Set	1.95 set	4 sets	55#
100/49—40 Pce. Swedish Modern Set	3.45 set	1 set	21#

Pricelist for the 1956 catalog.

Pricelist for the 1956 catalog.

PAGE 34—continued	Net Pkd. Per Doz.	Ctn. Doz.	Ctn. Wt.
3362— 3½ oz. Cocktail	.46	6	16#
3368— 5 oz. Fruit Juice	.50	6	23#
3361— 9 oz. Table Tumbler	.61	6	27#
3369—15 oz. Iced Tea	.78	6	42#
PAGE 35			
734— 3½ oz. Cocktail	1.05	3	10#
733— 6 oz. Sherbet	1.27	3	12#
735— 4 oz. Juice or Wine	1.05	3	11#
736— 9 oz. Goblet	1.27	3	17#
737—15 oz. Iced Tea	1.60	3	21#
828— 6¼" Sherbet Plate	1.00	3	14#
842— 8" Salad Plate	1.65	3	27#
8700/1—8 Pce. Goblet Set	.95 set	6 sets	24#
8700/2—8 Pce. Juice or Wine Set	.82 set	6 sets	16#
8700/3—8 Pce. Cocktail Set	.82 set	6 sets	15#
8700/4—8 Pce. Sherbet Set	.95 set	6 sets	18#
3653— 5 oz. Fruit Juice	.53	6	16#
3651— 9 oz. Table Tumbler	.61	6	24#
3658—13 oz. Iced Tea	.72	6	32#
J3653— 5 oz. Fruit Juice	.61	6	16#
J3651— 9 oz. Table Tumbler	.66	6	24#
J3658—13 oz. Iced Tea	.72	6	32#
J2600/222—24 Pce. Wisteria Set	1.65 set	1 set	9#
PAGE 36			
3536— 6 oz. Table Tumbler	.66	6	25#
3537— 7¼ oz. Old Fashioned	.75	6	32#
3538— 9 oz. Table Tumbler	.70	6	35#
3539—12 oz. Tall Tumbler	.88	6	40#
3312— 3½ oz. Footed Cocktail	.50	6	16#
3311— 5 oz. Footed Fruit Juice	.55	6	20#
3313— 7 oz. Footed Sherbet	.64	6	27#
3316—10 oz. Footed Goblet	.66	6	34#
3393— 6 oz. Sherbet	.46	6	20#
3353— 6 oz. Fruit Juice	.50	6	20#
3375—32 oz. Giant Iced Tea	1.22	2	20#
PAGE 37			
3064— 1¼ oz. Shammed Whiskey	.46	6	16#
3661— 1½ oz. Shammed Whiskey	.42	6	16#
3662— 3½ oz. Cocktail	.49	6	19#
3665— 7 oz. Old Fashioned	.75	6	37#
3610— 6 oz. Heavy Base Tumbler	.66	6	28#
3611— 6 oz. Heavy Base Tumbler	.70	6	30#
3612— 7 oz. Heavy Base Tumbler	.73	6	31#
3613— 8 oz. Heavy Base Tumbler	.75	6	38#
3614—10 oz. Heavy Base Tumbler	.80	6	43#
3616—12 oz. Heavy Base Tumbler	.88	6	49#
3617—15 oz. Heavy Base Tumbler	1.16	6	49#
3557— 7 oz. Heavy Base Tumbler	.75	6	35#
146—36 oz. Ice Lip Pitcher	2.35	1	27#
86—86 oz. Ice Lip Pitcher	3.20	1	32#
PAGE 38			
3508— 5 oz. Shell	.50	6	17#
3511—10 oz. Shell	.56	6	19#
3512— 7 oz. Regular	.56	6	19#
3513— 8 oz. Regular	.56	6	24#
3504— 9 oz. Tall	.56	6	24#
3509—10 oz. Water	.61	6	25#
3519— 9 oz. Shell	.61	6	20#
3514—10 oz. Shell	.61	6	29#
3505—12 oz. Tall	.72	6	32#

PAGE 38—continued	Per Doz. Net Pkd.	Doz. Ctn.	Wt. Ctn.
69—15 oz. Tall Iced Tea	.78	6	38#
92—19 oz. Large Iced Tea	.95	3	24#
93—22 oz. Giant Iced Tea	1.05	3	26#
3524—14 oz. Tall Iced Tea	.72	6	37#
3526—15 oz. Tall Iced Tea	.78	6	39#
3556—12 oz. Hollow-Stem Goblet	1.32	4	28#
3558—15 oz. Hollow-Stem Goblet	1.65	2	17#
3559—16 oz. Hoffman House Goblet	1.60	2	15#
3586—10 oz. Stem Pilsner	1.85	3	22#
PAGE 39			
3636— 6 oz. Tall Footed Beer Glass	.68	6	22#
3637— 7 oz. Tall Footed Beer Glass	.71	6	37#
3638— 8 oz. Tall Footed Beer Glass	.72	6	38#
3639— 9 oz. Tall Footed Beer Glass	.80	6	44#
3640—10 oz. Tall Footed Beer Glass	.83	6	44#
3203— 5 oz. Juice	.55	6	18#
3210— 8 oz. Water	.63	6	22#
3201—10 oz. Water	.65	6	22#
3208—12 oz. Iced Tea	.78	6	31#
77— 6½ oz. Cola	.55	6	24#
79—10 oz. Soda	.72	6	28#
81—12 oz. Soda	.78	6	33#
340— 9 oz. Coupette	1.65	3	18#
PAGE 40			
3664—1¼ oz. Shammed Whiskey	.46	6	18#
3661—1½ oz. Whiskey	.42	6	16#
662—1¾ oz. Whiskey	.39	6	16#
2260— ¾ oz. Whiskey	.42	6	18#
1506—1 oz. Whiskey	.42	6	20#
1150— ⅞ oz. Whiskey	.42	6	18#
660/1—1 oz. Whiskey	.42	6	18#
1704—3½ oz. Tall Fruit Juice	.66	6	23#
1714—4 oz. Straight Wine	.46	6	22#
14051—5¼ oz. Colonial Sherbet	.72	6	26#
14053—4½ oz. Colonial Sherbet	.83	6	35#
1154—9 oz. Fluted Barrel Tumbler	.68	6	44#
1175—9 oz. Optic Tumbler	.74	6	44#
1158—8 oz. Plain Straight Tumbler	.78	6	50#
1171—8 oz. Fluted Cupped Tumbler	.85	6	50#
PAGE 41			
E2302—3¾" Bud Vase	.72	4	18#
E2306—6½" Crimped Top Vase	.80	4	32#
E2345—6½" Vase	.80	4	33#
E3346—6½" Vase	.50	4	35#
3306—6½" Crimped Top Vase	.80	4	39#
1071—9" Bud Vase	.70	4	39#
1942—7" Vase	1.65	2	44#
3306/127—6½" Crimped Top Vase—Blk.	1.65	3	18#
3306/128—6½" Crimped Top Vase—Red	1.65	3	18#
PAGE 42			
3354—4" Ivy Ball	.65	4	22#
3355—4¾" Footed Ivy Ball	1.65	3	26#
3355/127—4¾" Footed Ivy Ball—Black	1.65	3	26#
203—3" Footed Flower Block—11 Holes	.95	4	21#
R279— 5 oz. Punch Cup	.61	6	21#
R373—15 Hr. Candle Tumbler	.72	6	10#
R824—10 Hr. Candle Tumbler	.61	6	14#
1—2¼" Caster Cup	.35	12	25#
2—3" Caster Cup	.37	12	43#
10/1—4 Pce. Caster Cup Set	.15 set	18 sets	23#
10/2—4 Pce. Caster Cup Set	.16 set	18 sets	24#

INSTRUCTIONS FOR FACTORY SHIPMENT ORDERING

1. USE YOUR "A" DIRECT ORDER FORMS
2. INDICATE ON ROUTING PORTION OF "A" ORDER FORM YOUR NEAREST DISTRIBUTION POINT AS SHOWN ON PAGE 2 OF THE 1956 ANCHOR GLASS CATALOG
3. ORDERS MUST WEIGH 200 POUNDS OR MORE

ROUTING
F. O. B.

PRICE LIST
for
NEW Fire-King* OVENWARE

			Retail Price Ea.	Per Doz. Net Pkd.	Doz. Ctn.	Wt. Ctn.
422—	5 oz.	Standard Custard	$.05	$.36 -33	6	20#
423—	6 oz.	Egg Cup & Deep Custard	2/15	.50	6	25#
424—	6 oz.	Dessert or Low Custard	2/15	.50	6	23#
425—	10 oz.	Deep Pie Dish	.10	.65	4	22#
426—	15 oz.	Deep Pie Dish	2/25	.85	4	29#
442—	8 oz.	Individual Baker	.10	.65	4	19#
496—	8 oz.	Measuring Cup—Red Graduations	.20	1.35	2	14#
498—	16 oz.	Measuring Pitcher—Red Graduations	.30	2.00	1	12#
435—	2⅜"	Percolator Top	.05	.33	6	14#
459—	8"	Pie Plate	.20	1.35 -.80	2	25#
460—	9"	Pie Plate	.25	1.65	2	31#
443—	1 qt.	Pudding Pan	.25	1.65	2	29#
402—	8 oz.	Individual Casserole & Cover	.15	1.00 -.75	3	24#
405—	1 pt.	Casserole—Knob Cover	.25	1.65	2	30#
406—	1 qt.	Casserole—Knob Cover	.50	3.30	1	27#
407—	1½ qt.	Casserole—Knob Cover	.60	4.00	1	35#
408—	2 qt.	Casserole—Knob Cover	.70	4.65	1	40#
497—	1½ qt.	Casserole—Utility Cover	.60	4.00 -3.30	1	35#
446—	1 qt.	Baker—No Cover	.30	2.00	1	16#
447—	1½ qt.	Baker—No Cover	.35	2.30	1	21#
448—	2 qt.	Baker—No Cover	.40	2.65	1	23#
450—	8"	Round Cake Pan	.35	2.30 -1.85	1	22#
452—	8"	Square Cake Pan	.50	3.30	1	30#
409—	5x9"	Deep Loaf Pan	.40	2.65 -2.30	1	22#
451—		Table Server	.30	2.00	1	19#
410—	6½ x 10½"	Utility Baking Pan	.40	2.65	1	27#
411—	8 x 12½"	Utility Baking Pan	.65	4.30	1	33#

			Retail Price Ea.	Per Set Net Pkd.	Sets Ctn.	Wt. Ctn.
400/96—	7 Pce. "Fire-King" Starter Set		$1.00	$.60	6	31#
400/94—	3 Pce. "Fire-King" Casserole & Server Set		1.00	.60	6	30#
400/95—	12 Pce. "Fire-King" Ovenware Set		2.00	1.20	1	12#

TERMS: 1% 15 days, Net 30 days,
F. O. B. Lancaster, Ohio

Anchor Hocking Glass Corporation
LANCASTER, OHIO U. S. A.

Reg. U. S. Pat. Off.

*Reg. U. S. Pat. Off.

4-51

Pricelist for the Fire King Ovenware catalog.

sales offices

Listing of sales offices found in the 1964 catalog.

	Tel. Area Code
ALABAMA	
BIRMINGHAM — City Federal Bldg., Room 2, 1908 29th Ave., S. Birmingham, Alabama 35209	205-871-1492
ARIZONA	
PHOENIX — 2814 N. 15th Ave., Phoenix, Arizona 85007	602-265-3421
CALIFORNIA	
LOS ANGELES — 2717 Tanager Ave., City of Commerce, Los Angeles, California 90022	213-722-1450
SAN FRANCISCO — 550 California St., San Francisco, California 94104	415-981-0505
CANADA	
TORONTO — 30 Industrial St., Leaside, Ontario	416-421-6555
COLORADO	
DENVER — 1863 Wazee St., Room 505, Denver, Colorado 80202	303-222-3427
CONNECTICUT	
HARTFORD — 43 Woodbine Court, Berlin, Connecticut 06037	203-828-3363
DISTRICT OF COLUMBIA	
WASHINGTON — 205 Keller Bldg., Silver Springs, Maryland 20910	202-589-2095
FLORIDA	
JACKSONVILLE — Prudential Bldg., Room 1408, Jacksonville, Florida 32207	305-298-4566 / 305-298-4567
MIAMI — 7941 S. W. 36 Terrace, Miami, Florida 33134	305-398-4567
TAMPA — 10709 Lake Carrol Way, Tampa, Florida 33618	813-229-6830
GEORGIA	
ATLANTA — 1430 W. Peachtree St., N. W., Atlanta, Georgia 30324	404-875-8994
COLUMBUS — 3833 Winkfield Place, Columbus, Georgia 31904	404-322-2010
HAWAII	
HONOLULU — 1726 Kapiolani Blvd., Room 6, Honolulu, Hawaii	999-1134
ILLINOIS	
CHICAGO — 1571 Merchandise Mart Plaza, Chicago, Illinois 60654	312-337-4200
PEORIA — 1211 N.E. Glendale Ave., Apartment #1, Peoria, Illinois 61603	309-674-2621
ROCKFORD — 1401 Apache Drive, Rockford, Illinois 61107	815-398-3199
INDIANA	
INDIANAPOLIS — 3969 Meadows Dr., Indianapolis, Indiana 46205	317-547-1385
SOUTH BEND — 1133 Ebeling Dr., South Bend, Indiana 46624	219-232-9389
IOWA	
DES MOINES — 822 Insurance Exchange Bldg., Des Moines, Iowa 50309	515-282-8691
KANSAS	
WICHITA — 6623 E. Kellogg St., Wichita, Kansas 57207	316-684-7031

	Tel. Area Code
KENTUCKY	
LOUISVILLE — 303 Liberty Bank Bldg., 3415 Bardstown Rd., Louisville, Kentucky 40218	502-451-9302
LOUISIANA	
NEW ORLEANS — 3200 St. Bernard Ave., Suite 409, New Orleans, Louisiana 70119	504-944-2421
MAINE	
SOUTH PORTLAND — Box 2168, South Portland, Maine 04106	207-774-1661
MARYLAND	
BALTIMORE — 100 Latrobe Bldg., 2 E. Read St., Baltimore, Maryland 21202	301-685-0924 / 301-685-0925
MASSACHUSETTS	
BOSTON — 505 Kendall Square Bldg., 238 Main St., Cambridge, Massachusetts 02142	617-864-9242
MICHIGAN	
DETROIT — 17500 W. Eight Mile Rd., Southfield, Michigan 48235	313-537-7730 / 313-356-8500
GRAND RAPIDS — 318 Murray Bldg., 48 N. Division St., Grand Rapids, Michigan 49506	616-456-6426
MINNESOTA	
MINNEAPOLIS — 1515 W. Lake St., Minneapolis, Minnesota 55408	612-827-5577
MISSOURI	
KANSAS CITY — 817 Columbia Bank Bldg., 921 Walnut St., Kansas City, Missouri 64106	816-421-1939
ST. LOUIS — Suite 313, Slavin Bldg., 8000 Bonhomme Ave., Clayton, Missouri 63105	314-727-2297
NEBRASKA	
OMAHA — 212 Picardy Lane, Council Bluffs, Iowa 51501	402-322-0953
NEW JERSEY	
NEWARK — Room 404, National Newark Bldg., 744 Broad St., Newark, New Jersey 07102	201-642-0441
NEW YORK	
BUFFALO — 610 Crosby Bldg., Buffalo, New York 14202	716-854-1460
NEW YORK — 415 Madison Ave., New York, New York 10017	212-838-9300
SYRACUSE — 209 Andruson Bldg., 201 S. Main St., North Syracuse, New York 13212	315-458-3246
NORTH CAROLINA	
CHARLOTTE — 715 Liberty Life Bldg., 112 S. Tryon St., Charlotte, North Carolina 28202	704-376-2844
RALEIGH — First Citizens Bank Bldg., 617 Hillsboro St., Raleigh, North Carolina 27603	919-833-8084

	Tel. Area Code
OHIO	
AKRON — Prior Business Arts Bldg., 527 Portage Trail, Cuyahoga Falls, Ohio 44221	216-928-7568
CINCINNATI — 1501 Madison Rd., Suite 312, Cincinnati, Ohio 45206	513-281-6111
CLEVELAND — 460 Union Commerce Bldg., 925 Euclid Ave., Cleveland, Ohio 44114	216-781-9170
COLUMBUS — Kingsview Bldg., Room 124, 1500 W. Third Ave., Columbus, Ohio 43212	614-486-1774
OKLAHOMA	
OKLAHOMA CITY — 129 N.W. 44th St., Oklahoma City, Oklahoma 73118	405-524-4010
OREGON	
PORTLAND — 201 Transfer Bldg., 1238 N.W. Glisan St., Portland, Oregon 97209	503-228-4500
PENNSYLVANIA	
HARRISBURG — 3902 Park St., Camp Hill, Pa. 17011	717-234-4289
PHILADELPHIA — 2017 Philadelphia Savings Fund Bldg., 12 S. 12th St., Philadelphia, Pa. 19107	215-627-6820
PITTSBURGH — Two Parkway Center, 875 Greentree Rd., Pittsburgh, Pa. 15220	412-922-4144
SOUTH CAROLINA	
GREENVILLE — Rt. 4, Ikes Rd., Taylors, South Carolina 29602	803-232-2839
TENNESSEE	
MEMPHIS — Park Central Bldg., 3637 Park Ave., Memphis, Tennessee 38111	901-324-8484
NASHVILLE — 105 Whitehall Bldg., 1700 Broad St., Nashville, Tennessee 37203	615-255-5188
TEXAS	
DALLAS — 110 W. R. Horn Bldg., 6211 Denton Drive, Dallas, Texas 75235	214-357-1791
HOUSTON — 3200 Travis St., Room 403, Houston, Texas 77006	713-529-8214
LUBBOCK — 3803 — 38th St., Lubbock, Texas 79416	806-795-9459
SAN ANTONIO — 615 Perez St., San Antonio, Texas 78207	512-222-2442
UTAH	
SALT LAKE CITY — 554 Gale St., Salt Lake City, Utah 84101	801-355-4177
VIRGINIA	
RICHMOND — 8123 Michaels Rd., Richmond, Virginia 23229	703-643-0682
WASHINGTON	
SEATTLE — 1000 Fourth Ave., S., Seattle, Washington 98134	206-623-3444
WEST VIRGINIA	
CHARLESTON — 907 Laurel Rd., Charleston, West Virginia 25304	304-346-2651
WISCONSIN	
MILWAUKEE — 744 N. 4th St., Room 432, Milwaukee, Wisconsin 53203	414-276-2686

78

Chapter Thirteen
Advertising Avenues for Anchor Hocking

Anchor Hocking promoted their wares in a variety of magazines, trading stamp catalogs, trade publications, and wholesale company catalogs. Many hardware stores, restaurants, banks, service stations, and a host of other commercial businesses gave away Anchor Hocking glass as sales promotional items. This accounts for the wide availability of many colors and patterns. The majority of the postcards will command a price between $10-20 each depending upon the pattern, condition, and company using the card as a promotion.

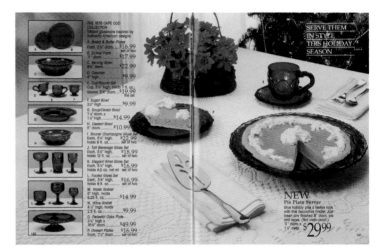

1992 Avon catalog listing the Cape Cod glassware.

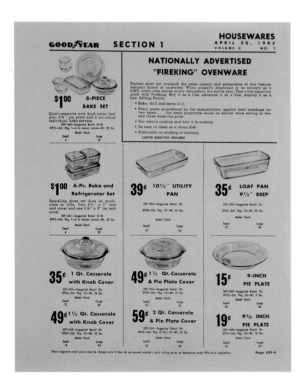

Page from the Good Year sales catalog.

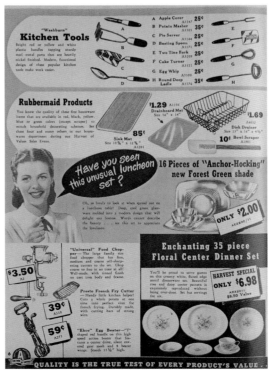

"American" Hardware Store advertisement for Forest Green Charm dinnerware.

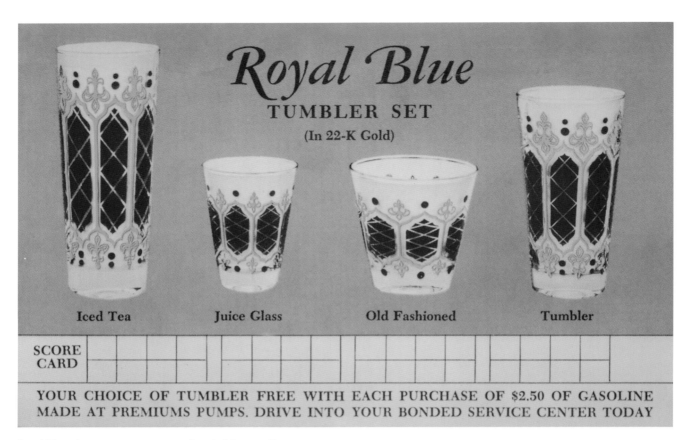

Royal Blue
TUMBLER SET
(In 22-K Gold)

	Iced Tea		Juice Glass		Old Fashioned		Tumbler	

SCORE CARD																		

YOUR CHOICE OF TUMBLER FREE WITH EACH PURCHASE OF $2.50 OF GASOLINE
MADE AT PREMIUMS PUMPS. DRIVE INTO YOUR BONDED SERVICE CENTER TODAY

Royal Blue glassware given away at Bonded Service Centers.

Tankard mugs given away by Gulf Oil.

"THIS GENUINE CUT GLASS SET CAN BE YOURS"

Dot etched Roly Poly glasses given away at DeTurk Hardware Company in Kutztown, Pennsylvania.

Tiger pitcher and tumblers were given away at Esso gas stations.

Fireside Statewide Thrift gave away Swedish Modern glasses in celebration of opening the nineteenth Fireside office.

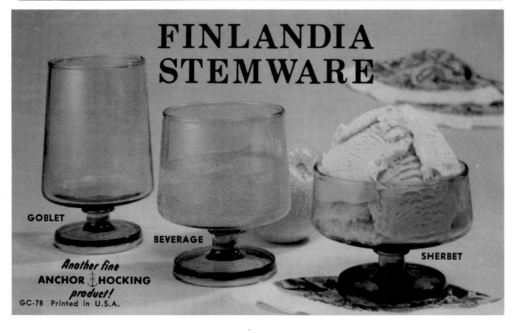

Finlandia stemware was another gas station premium gift.

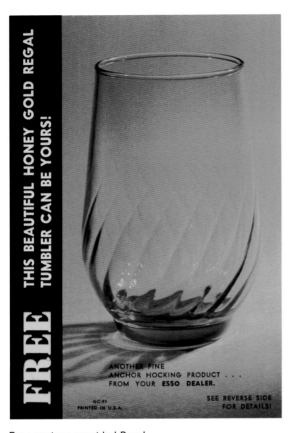

Esso stations provided Regal
pattern glasses to its customers.

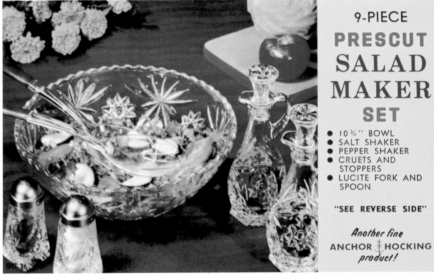

When you added to or opened an account at Schoenfelds in Tacoma, Washington, you
received EAPC glassware.

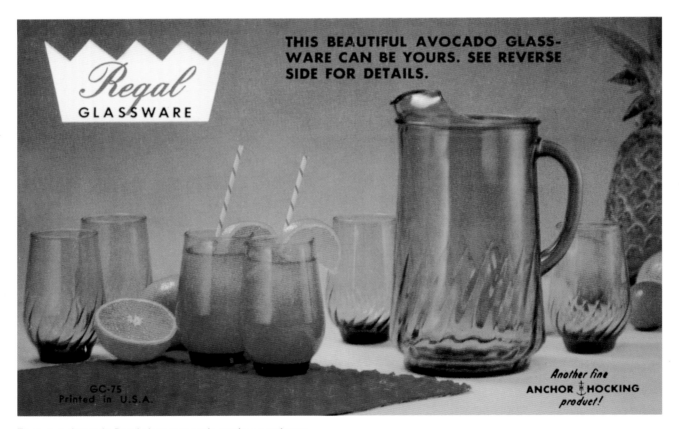

Enco gave Avocado Regal glassware with gasoline purchases.

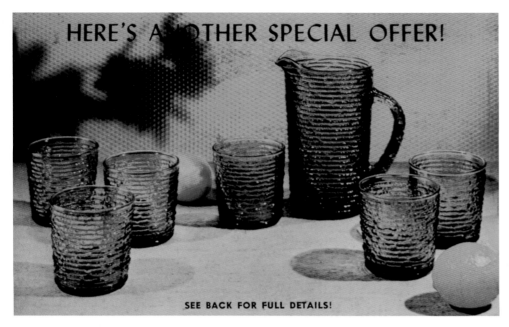

Ashland Oil Company used Soreno glassware as premiums.

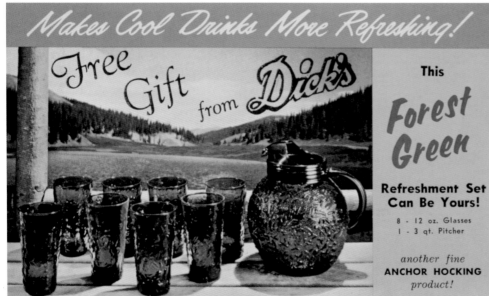

Dick's in Platteville and Darlington (state unknown) gave away Forest Green refreshment sets.

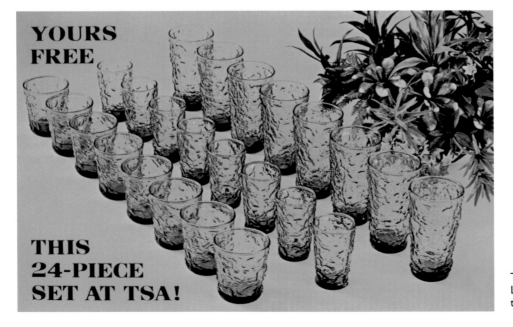

Topeka Savings Association used Avocado Lido glasses as an incentive to open or add to your present passbook account.

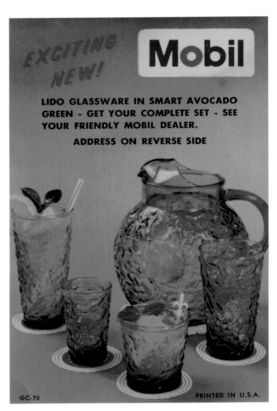

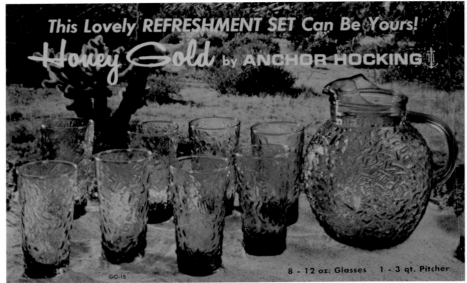

Phillips 66 used Honey Gold Lido glassware as a premium.

Even Mobil Oil decided to use the Avocado colored Lido glassware as premium giveaways.

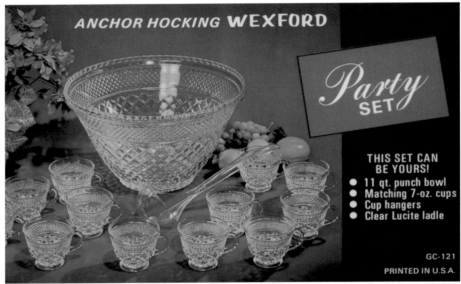

The Wexford Party Set was also used as a premium giveaway by some companies.

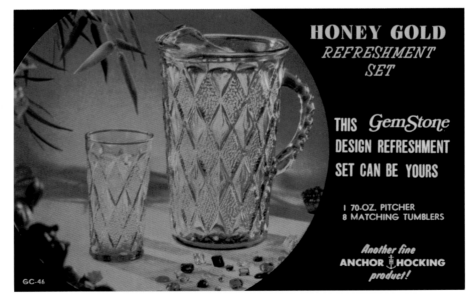

Gemstone was another Anchor Hocking pattern that was a popular premium giveaway. The Gemstone name was first used in 1967 to describe a completely different design of pitchers and glasses. In 1968, the design was changed but the name was retained. The redesigned Gemstone pattern was only listed in the 1968 catalog in Honey Gold, Avocado Green, and Aquamarine; however, I have seen the pitcher in Crystal.

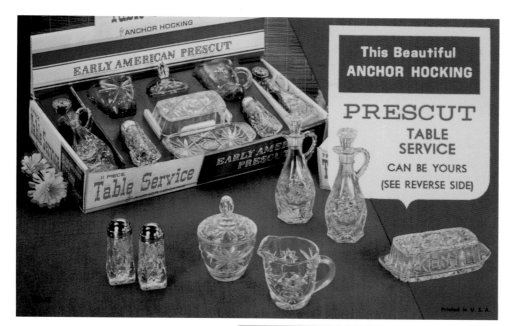

There are so many of the Prescut sets on the market because they were also given away as premiums.

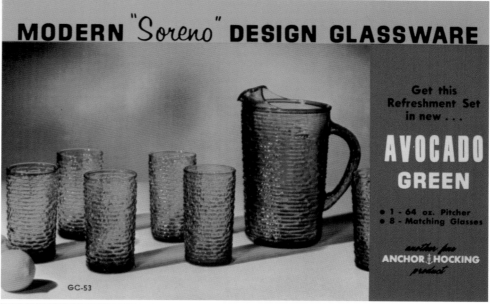

Avocado Green Soreno was given away as pitcher and glass sets.

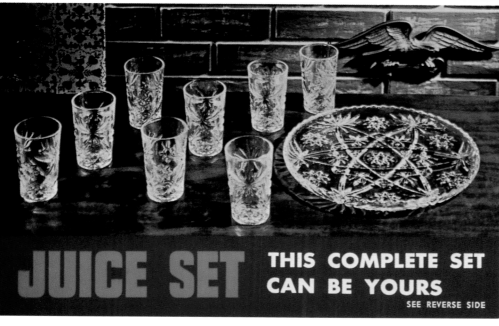

Early American Prescut was also given away as premiums.

143

Index